*A cartoon book.*

# A STUDY IN AESTHETICS

*by*

## LOUIS ARNAUD REID
M.A., Ph.D.

*Independent Lecturer on Philosophy in the University
of Liverpool*

## GREENWOOD PRESS, PUBLISHERS
### WESTPORT, CONNECTICUT

Library of Congress Cataloging in Publication Data

Reid, Louis Arnaud, 1895–
   A study in aesthetics.

     Reprint of the 1954 ed. published by Macmillan,
   New York.
     1. Aesthetics. I. Title.
   BH201.R4  1973      111.8'5     70-114546
   ISBN 0-8371-4794-8

Originally published in 1954 by The Macmillan Compan
New York

Reprinted by Greenwood Press,
a division of Williamhouse-Regency Inc.

First Greenwood Reprinting 1973
Second Greenwood Reprinting 1974

Library of Congress Catalog Card Number 70-114546

ISBN 0-8371-4794-8

Printed in the United States of America

TO

My Friends in California

# PREFACE

This book was conceived some years ago; since then it has assumed a good many shapes. It started as an essay on ethics and aesthetics, it went on as an essay on aesthetics and truth, and when some critics of a work which I published in 1923 were good enough to say that they wished for further discussion of 'non-propositional truth', I took courage and persevered. Later I delivered, at Stanford University, California, a course of lectures on 'Truth and its Place in Reality'. Conversations there suggested to me the plan of a book which was to have the rather magnificent title 'The Approaches to Reality', and which was to deal with nothing less than perceptual, intellectual, aesthetic, and religious experience. Fortunately the plan shrank, first to a scheme for discussing perceptual and aesthetic experience, and finally to an essay on aesthetics alone. But unhappily in shrinking it also expanded—a common trick in philosophy. Here in these covers is the result.

I have been told that aesthetics is an 'impossible' subject. I almost agree. Aesthetics, if not wholly impossible, is, I verily believe, as difficult as anything could well be. It is difficult because it courts vagueness and evades precision. The aesthetic experience—and the aesthetic object—is a delicate and elusive thing, vanishing at a touch. When we think we have the object, solid, coloured, resonant, we find but the dampness of a disappearing cloud or the smell of a passing smoke. Aesthetics is difficult because it demands treble qualification—the qualification of being a sensitive aesthetic experient, of being a competent witness, and of being able to analyse the given data clearly and philosophically. It is difficult because we must avoid the mere *obiter dicta* of artists and connoisseurs on the one hand and mere *a priori* pronouncements of system-making philosophers on the other. It is difficult because there is not one aesthetic experience but many, and it simply will not do to

manufacture a theory which fits one art and fits none of the rest. On the other hand, aesthetic theory must be as exact as it can, and must not, in its attempt to be general, lapse into nebulousness.

This book is not a learned work but an essay. It touches neither the history of art—whether modern or very ancient— nor the history of aesthetic as such. Nor have I made any attempt to review or to criticise even the major theories of the present day. There are naturally a number of references to other works, but I have made these only when they seemed to bear upon the positive thesis put forward. Of the treatment of almost any topic it will be possible for the critic to say, 'He has only touched the fringe of this subject, with its long history.' On the other hand, I have certainly tried to deal with essentials, to ask the really important questions, to analyse each problem philosophically, and to build up bit by bit the statement of a constructive theory. Perhaps this may be felt to outweigh the disadvantages of an inevitable incompleteness.

I venture to hope, with some slight diffidence, that this *Study* may interest two, or perhaps even three, classes of reader. I hope it may interest those who read *philosophy*; for aesthetics has not, in this country at least, attracted the attention of philosophers as it deserves. I hope too that the *critic* will not easily be turned aside by the fact that the author is a professional teacher of philosophy; for it is not impossible (as I have argued in the Preliminary Chapter) that the critic's business has more relation to philosophy than he sometimes realises. The critic often enough talks —or assumes—philosophy without knowing it, and it may not be a bad thing that what is more or less implicit in his mind should be made explicit.

(The third type of possible reader is the artist. But of that more in the Preliminary Chapter.)

Perhaps, in view of these possible different classes of reader, I may be allowed to make a few comments on the

contents. The Preliminary Chapter is of general interest. Chapter I is introductory, and works up to a provisional definition, the terms of which are discussed at length in Chapters II to V. In Chapter II the non-philosophical reader might like to skip Section VI and the footnote on aesthetic 'types'. Parts of Chapters III and IV he may find dull, though it is difficult to pick out paragraphs here and there, as these chapters contain a development of the ideas of the central thesis. Chapter V contains much that is philosophically technical, and the general reader may leave it out. VI, on the other hand, on 'functional beauty', is of common interest, in view of present-day tendencies. Chapters VII to XIII deal with problems arising out of art, most of which must appear of major importance to both critics and philosophers. The main exceptions are Chapter X, Sections I and II (which deal with philosophical problems of the truth of propositions), and possibly Chapter XII (concerned largely, though not exclusively, with technical questions of art criticism). The last chapter, on 'The Enigma of Natural Beauty', is again of general interest, except that Sections VIII to the end imply some metaphysical background.

It may be that I should apologise for, or at least explain, two things. One is the frequency of the directions in footnote, 'See below'. This I found difficult to avoid in the earlier parts. Provisional definitions are always necessary, but the whole test of the truth of aesthetic definitions lies in the working out and in the application to concrete instances. This cannot come at the initial stages, and I am sure that a certain amount of obscurity at these stages is quite unavoidable. The other explanation concerns concrete instances themselves. There are comparatively few of them: for a convincing demonstration there ought to be a vast number, chosen from every possible aesthetic sphere. I can only point out that it is obviously impossible to give

many examples, that, further, concentration on examples involves a certain danger of irrelevant disputes on matters of taste, and that, if justifiability implies applicability, the failure to apply explicitly does not imply *un*justifiability! I may add that I have honestly tried to carry out in my own mind, and within the limits of my own aesthetic experiences, the process of concrete testing in different spheres. I am only too well aware of the limits of these experiences, and I shall be ready and grateful to be corrected on a thousand points of detail. But, as everyone knows, even errors have their uses.

My acknowledgments should be many. To all the authors with whom one appears mainly to disagree it is impossible to pay tribute; but there are a number of friends whose help it would be ungracious not to mention. First comes my wife, without whose presence, whose encouragement, and whose immense practical help as amanuensis, typist, and general secretary, I should have lost heart. To the keen critical mind of Dr. W. Olaf Stapledon (who read the whole book in typescript) and to our many arguments I owe more than I can say. To Professor Dorward and Dr. R. A. Lillie, who read the proofs, I here offer my warm thanks; to Professor J. H. Muirhead, Professor L. C. Martin, Dr. J. E. Turner, and Mr. Arthur Ratcliffe I am greatly indebted for comments.

L. A. R.

THE UNIVERSITY OF LIVERPOOL
*December,* 1930

# CONTENTS

CHAPTER IV

CHAPTER V

# CONTENTS

## CHAPTER XII

## CHAPTER XIII

## CHAPTER XIV

# A STUDY IN AESTHETICS

## PRELIMINARY

## ARTISTS, CRITICS, AND PHILOSOPHERS

Few quarrels, it is said, are more bitter than family quarrels, and few jealousies more profound than those between parties who have, without always recognising it, some important cause in common. The very intensity of the interest in an end, produces an intensity of interest in the means to the end, so that when intellectual or other differences about means arise, they are apt to swamp all sense of common interest in the common object or good. We have only to think of the frequent violence of religious, or of political, opinions to furnish ourselves with ample illustration of this truth.

Three parties there are who may be said to have an interest, whether recognised or not, in the fact of aesthetic experience.[1] They are the artists, the critics, and the aesthetic theorists, the theorists being either philosophers or psychologists, or both. It is indubitable that these three groups do have in common the fact of interest in aesthetic experience. On the other hand, their different relations respectively to this fact tend to obscure their community and their family relatedness to one another. It is not, as with those whose interest is mainly political, or religious, a matter of different opinions about means to a common end. It is rather a matter of different relations of different minds to the same thing. Very roughly, the artist desires to *feel* an aesthetic experience by making something beautiful, the critic desires to *recognise* it through beautiful art-objects, and the

[1] I will leave out the lover of 'natural beauty' till Chapter XIV, which is reserved for him. This exception holds good throughout, and may be made quite without prejudice to the question of 'natural' beauty.

philosopher[1] desires to *comprehend* it. These interests are indeed so patently different that, in spite of the community of object between them, the artists, the critics, and the philosophers might be content to follow each their own paths were it not for a certain interrelation between their respective activities, concerning which a good deal of confusion, and often of resulting jealousy and friction, is apt to arise. As in these quarrels it is the philosopher who most frequently finds himself attacked, it is necessary, before entering upon any discussion of aesthetic philosophy, to remove, as far as may be, entangling and prejudicing misunderstandings.

The philosopher is sometimes attacked by the artist as an interfering meddler who tries to teach artists their proper business, by laying down a priori laws about matters concerning which he is unfit to judge. The artist has also been known to attack the critic for very much the same reasons, whilst the critic finds fault with the philosopher for meddling with *his* affairs. Let us investigate the grounds of these quarrels between artist and philosopher, artist and critic, and critic and philosopher.

The artist's complaint against the critic arises chiefly from temperament. The artist is creative, and in the glow of achievement he naturally tends to feel angry with the critic when the latter regards his work coldly or adversely. 'What right has this fellow', he may say, 'to find fault with me when he himself is (it may be) incompetent to compose a sonata  or write a sonnet or a play, or put paint decently upon canvas?' The artist's complaint is natural, requires no explanation, and it is likely to vary with the smiles or the frowns of the critic.

With the philosopher, the artist as such has naturally less commerce. Artists may have their own philosophical views, but when they run across philosophers who chance to be interested in the philosophical problems underlying the

[1] I shall take the philosopher here as the type of aesthetic theorist. His relation to the psychologist will be discussed below.

artist's work and experience, they often find their jargon incomprehensible, or, if not wholly incomprehensible, either dull or wrong-headed. Artists there are, of course, who possess a *flair* for abstract inquiry. But the artist, *qua* artist, is concerned with making, and not with pulling ideas to pieces in abstract inquiry. Abstract inquiry, the artist tends to think, is a tedious business compared with the excitements of creating. If we are to theorise, let us do it quickly, and relevantly to the matter in hand, without introducing vague generalisations which can help nobody.

The artist's opinion of the philosopher is not of great importance, just because the artist's job is to produce art, and not to define or to attack philosophy (or indeed to discuss it at all). The artist is forgiven all irritabilities of temperament if only he does create well what it is in him to create. The critic's opinion of the philosopher (we need not here consider the critic's relation to the artist) is, on the other hand, more important, because, although the critic deals on the one hand with works of art, the critic is also a writer or a speaker, and deals in ideas about art. He thus approaches, if he does not at some points cover, the same ground as the philosopher.

That the interests of the critic and the philosopher very often overlap, I am going to suggest. But the critic is by no means always so aware as he ought to be of the close relation of his calling, on the one side of it, to philosophy. He has been known, as we said, to attack philosophy. There is a critic of a certain type who is only too ready to ask, Why should we analyse our experiences of beautiful things at all? Why should we not be content with our feelings and emotions about beautiful things? Is not each beautiful thing unique, and so elusive that it stands by itself? And is not the attempt to set up abstract standards or general principles only a revelation of ignorance of the uniqueness of each beautiful thing? Is philosophical analysis not murdering to dissect?

This point of view is very clearly expressed by Walter Pater in the preface to his *Renaissance*. "Many attempts", he says, "have been made by writers on art and poetry to define beauty in the abstract, to express it in the most general terms, to find some universal formula for it. The value of these attempts has most often been in the suggestive and penetrating things said by the way. Such discussions help us little to enjoy what has been well done in art and poetry, to discriminate between what is more and what is less excellent in them, or to use words like beauty, excellence, art, poetry, with a more precise meaning than they would otherwise have. Beauty, like all other qualities presented to human experience, is relative; and the definition of it becomes unmeaning and useless in proportion to its abstractness. To define beauty, not in the most abstract but in the most concrete terms possible, to find not its universal formula, but the formula which expresses most adequately this or that special manifestation of it, is the aim of the true student of aesthetics.

" 'To see the object as in itself it really is', has been justly said to be the aim of all true criticism whatever." And he who does this distinctly, who can experience vividly, "has no need to trouble himself with the abstract question what beauty is in itself, or what is its exact relation to truth or experience—metaphysical questions, as unprofitable as metaphysical questions elsewhere. He may pass them all by as being, answerable or not, of no interest to him."

A more recent author writes :[1] "Into vague generalisations about 'Art' this is in any case no place to go. At best very little can be said that is worth saying, about things as different as a cathedral and a sonnet, a statue and a symphony." The same writer in another passage speaks[2] of Hegel's theory of tragedy as "one more instance of the rashness of metaphysicians who venture into regions where their speculations can for once be checked." These are certainly

[1] F. L. Lucas, *Tragedy*, p. 14.    [2] Ibid., p. 43.

charges against philosophy. We shall return in a moment or two to consider how seriously they are to be taken, if they are to be taken seriously at all.

The philosopher, then, is attacked by the artist and the critic. If the philosopher in turn can be said to attack at all (apart from defending himself or retaliating) his attack is more of the nature of an assumption of a certain common ground or subject-matter between himself and the critic. He seldom presumes—and as philosopher he has never any right to presume—to interfere positively with the critic's business of intuitive judgment, even although he may be heard to murmur that he wishes that some art-critics occasionally had a little more philosophy in them.

The philosopher's attack, I have suggested, is of the nature of an assumption, and it is this assumption which is resented by the artist and the art-critic, chiefly by the latter. The assumption which is made by the philosopher is that he has some right to theorise about art and about aesthetic experience generally.[1] The critic is so far justified in his resentment in that this assumption has sometimes in fact been made by philosophers who have obviously been possessed of little first-hand experience of beautiful things.

In this matter it is of vital importance to be clear at the outset. It is of vital importance to be clear that generalisations about art and about aesthetic experience can only be justified when they are based upon immediately experienced aesthetic intuition. Without aesthetic intuition of individual beautiful things, generalisations about aesthetic experience are "but words and breath". Critics are right when they resent 'high priori' ways of thinking and speaking of art. It may be possible to use the concept of beauty as the completion of a system of philosophy, as some philosophers have done; it may be even possible for the metaphysician to define beauty more or less correctly, out of a very general and vague sort of experience. But this kind of thing, even

[1] Including, once again, the possible aesthetic experience of nature.

in the hands of genius, is not worth a great deal, unless it is based on experience of many beautiful things, and of many sorts of beautiful things. Aesthetic hypotheses have this in common with scientific ones, that they must be tried and tested and adjusted to suit the rich variety of particular facts. If anyone to-day exists who really believes that there is a purely deductive science, then it is certain that aesthetics can have nothing to do with it. Aesthetic generalisations must always be merely tentative, they must be hypotheses to be tested by experience, until by degrees the body of aesthetic theory grows into as coherent a system as we can make it. There must be the continual movement, familiar in science, from the individual facts to generalisation, and from generalisation back again to individual facts. And so on.

In this connection there is a common misunderstanding between artists and critics on the one hand, and philosophers on the other hand, which is typified in the use of the word 'must'. The philosopher is often heard to say, 'The artist *must* do so and so.' This sounds exactly as if the philosopher were laying down the law to the artist. But the philosopher is using the term 'must' not in a normative sense, not in the sense of some categorical imperative, but rather as describing, as far as he can see, what *does* in fact happen with the best artists. The philosopher is puzzled; he talks aloud; he asks himself questions. 'What is the explanation of this?' he asks. And after reflection he answers, '*This* is the explanation; this is what the artist *must* be doing.' Of course the philosopher's discoveries through analysis *might* be, after many days, of practical value to the working artist. But that is another matter. The philosopher's business is to know, not to prescribe, and it is an injustice to think that, because he uses the word 'must', he is laying down the law.

Having emphasised, then, that the business of the aesthetic philosopher is intellectual analysis and construction, and that, in order to analyse and construct to any purpose, he must also have first-hand acquaintance with beautiful

things, we may now return to meet the objections already cited to the philosopher's making any attempt at all to analyse beautiful things.

The most direct—and perhaps the final—answer that can be given to the question, Why analyse? is that we have a fundamental impulse to do it, that we usually do it badly, and that if done at all it ought to be done well. Everyone has notions about what art or beauty is, even although these notions never become expressed in words. We do not merely feel, we think also. And it is unanalysed notions and preconceptions which, entering into our feelings about beautiful things, more often than not mislead us and induce false attitudes towards them. If we are to have preconceptions at all—and we can never avoid having them—then it is surely better, if opportunity offers itself, that we should take a little trouble in trying to acquire true preconceptions for future occasions. These true conceptions are worth acquiring for their own sake, for the sake of their truth, but it is almost certain that in the end they also help us to appreciate more truly.

Leaving this last point for the present, let us consider the main issue, in relation to that part of Pater's statement (given above) which denies that definitions do help us to use words like beauty, art, etc., with more precise meaning. It is surely plain falsity that, in general, definitions do not aid mental precision. Pater's point however is that, in particular, it is *beauty* and its like which cannot be defined, because beauty is essentially an individual thing, and not a general concept. But though this has its truth, and though it may also be true, as Pater says, that beauty is in some sense relative to us, yet the fact that there are certain *kinds* of objects which many people agree in calling beautiful, and certain *kinds* of mental experience called aesthetic, is a sign that there is some quality—the aesthetic quality— common to all the particular instances. Whether or not this quality is relative to our minds, the whole history of criticism

shows that it is, in some sense, describable, a describable quality. It is precisely this quality which it is the object of aesthetics to discover and to define. To say that we must define beauty, not in the most abstract, but in the most concrete terms possible, is to overlook the very nature of definition; it is to refuse to define at all. This is, of course, a procedure which is open to anyone who pleases, but he who adopts it, if he is to be consistent, must be content with the creation or enjoyment of this or that beautiful thing, and must entirely refrain from talking of it, from even murmuring the words 'art', or 'beauty'. Even to murmur 'art', 'beauty', is to commit oneself to the supposition that there is some general 'abstract' idea to which the words refer. Pater himself is—in his own individual way— undeniably an expert in the business of enjoying art, and he is always fascinating when he is acting what Oscar Wilde called 'the Critic as Artist', when he is, through his own medium of artistic prose, making us *feel* beauty. (It may be questioned whether he is at these times a good *critic*.) The rest of the time he is continually violating his own principles and talking 'abstractly'. He has, strictly speaking, no right even to call his book *Studies in Art and Poetry*, because the terms 'art' and 'poetry' are abstract terms and therefore (to him) 'meaningless'. If it be replied, "Yes, that is all very well, but you know perfectly that Pater meant, not 'art' and 'poetry' in the abstract, but particular works of art and particular works of poetry", we may answer again, "Yes, but why call them all by the *name* of 'art' or 'poetry'? The terms must have some *general* meaning and they are without doubt hopelessly 'abstract'. " It is fortunate that Pater does violate his own principles, that his practice is better than his precept, for his generalisa- tions are often illuminating. But it is a pity that he should have encouraged in himself and in so many of his admirers the old and muddled idea—so stupid as to be unworthy of attack, were it not for its prevalence—that to define is to

destroy, that to try to form a clear general conception of anything is to do something which is much inferior to the act of direct perception. To generalise is not inferior, nor is it superior, to perceiving; it is simply different. It has a different aim and a different function, a function which has a directly theoretical object, and which has, indirectly perhaps, practical effects.

The same things are true of the quotation given from Mr. Lucas. It is no doubt the case that it is difficult to make general statements about things as different from one another as cathedrals, sonnets, statues, symphonies, and it is true that the difficulty of making generalisations tends to produce vagueness in the generalisations, and that good generalisations may *appear* vague because they are abstract and difficult to understand. But, once again, has the word 'art' no meaning? Surely cathedrals and sonnets and statues and symphonies are, in at least one important respect, *more* like one another than they are like coal-heaving, sugar-selling, or taxi-driving? It is that which they have in common in which the philosopher is interested.

We have been saying that criticism involves abstraction. It may, however, be denied that the critic in any sense deals in abstractions, that his function is to discuss theories. There are, indeed, several views about the aims of criticism which it may be as well to enumerate now—without attempting neatness or detail of classification—before going on to speak of the relation of criticism to aesthetic philosophy.

The simplest kind of criticism, perhaps, is what is sometimes known as 'signpost' criticism. Its aim is merely to point out what is good and what is bad in art. This has a useful function, largely the function of a guide-book or a good newspaper; it tells the uninitiated what to seek and what to avoid. It is hardly likely to be found by itself. Another kind of criticism is what may be called 'technical' criticism; it is the kind of criticism which interests artists

and others who are concerned with the processes of the actual building up of works of art. It is the kind of criticism which, applied to painting, includes comments on composition, on the balancing of lines, planes, and volumes, on tactual and colour values, on the expression of depth. In poetry this class of criticism is concerned with things like the disposition of vowel- and consonant-sounds, or of assonance and rhyme and rhythm and metre. Music also has its own technical jargon. 'Technical' criticism is necessary and valuable in that it directs attention to the structural elements in art and their relation to the whole; without any such accurate discrimination, appreciation would be a vague and nebulous thing. 'Historical' criticism (including what might be called 'biographical' criticism) is another kind of criticism. This endeavours to evaluate works of art by showing them to be expressions of general classified tendencies in the history of art and also perhaps of circumstances in the private lives of artists. This again is, no doubt, of considerable value in helping us to understand the artist's point of view in its historical background. (It is part of what has been called, mainly in France, 'scientific' criticism.) On the other hand, there is the danger that the historical or biographical critic may place what interests him historically before what is of intrinsic artistic importance.

There is, again, 'artistic' criticism, described in Wilde's essay, *The Critic as Artist*, to which we referred in speaking of Pater. This is perhaps better known generally in this country and abroad as 'impressionistic' criticism. Impressionism is in intention really a development of 'signpost' criticism, with the great difference that the 'signpost' becomes an impressionable living artist who records his impressions of a work of art, and who does not merely record them, but expresses them so intensely that a new, and literary, work of art is produced. The critic records his 'adventures of the soul' in a lyric which in its own way may rival (as also it may not rival) the original object of

appreciation. The main trouble with this kind of criticism is that it is apt to stop being criticism at all. The better an artist such a 'critic' is, the more he may detach our attention from the original and fix it upon his own product. (Pater's lyricising on *La Gioconda* is an obvious example which comes to mind.) This may sometimes be very pleasant, and the end may justify the means. But it is not what we want when we go out to find criticism. It is like a geologist who should ask for a stone and be offered cakes and honey. In criticism the weekly newspaper signpost is better than this.

But indeed of criticism we ask something more than is given by any or all of the four kinds I have enumerated. All criticism implies good 'taste', implies competence of aesthetic intuition. But this is not all that is required. Nor are technical, historical, and biographical knowledge, and the gift of literary expression, adequate supplements. Philosophy is required also. The interest of the critic is, of course, in individual works of art, and, as we have said, no amount of general knowledge is of the least use as a substitute for this. But surely it is also the business of the completely equipped critic to give reasons, if required, for the faith which is in him? I do not suggest that he must always be doing so, or that he is mainly concerned with theory. But he should be able to do so: his should be a *'thinking study'* of art. He can point, or he can talk round the issue, or he can sing as the poet sings. But as the complete critic he is, if he merely does these things, a comparative (not a complete) failure, for though he has likes and dislikes, though he may know *what* is good, he has no idea *why*. He is not interested in the question. All good critics must put to themselves from time to time such questions as, Why is this or that good? Why is this technical device to be preferred to that? Why is this or that historical development important? Such questions directly involve others, such as, What is the meaning of good, or of bad, in art? What is the difference between the 'beautiful' and the 'ugly', between

the 'great' and the 'trifling', between the 'tragic' and the 'comic', between the 'classical' and the 'romantic'? And these are—however little this be realised by critics themselves—most emphatically *philosophical* questions.

This is not to say that criticism is the same thing as aesthetic philosophy. Rather criticism implies (and, of course, is implied by) aesthetic philosophy. The difference is perhaps one of the focus of interest. The critic as such may be compelled, willy-nilly, to enter into philosophy, but his main interest is in individual works of art. The aesthetic philosopher, on the other hand, though he should be competently acquainted with as great a variety of works of art as possible, is, as philosopher, interested chiefly in the theory. It ought not to be necessary to add that his interest in *general* theory carries with it no sort of implication that he denies that each work of art is in a real sense particular, individual, and unique, or that he is so completely foolish as to think that artists will successfully produce works of art from theories alone. It *ought* not, I say, to be necessary to add this. But in view of obstinate misunderstandings it is necessary to do so.

Our interest here will be aesthetic philosophy. But what of psychology? In discussing aesthetic philosophy it is impossible to avoid continually bordering upon psychology. As aesthetics is sometimes—wrongly, I think—identified with psychology, a word or two as to their relations may be in place here.

Psychology is concerned with mental processes, and to some extent with physiological processes so far as these have a bearing on mental processes and mental problems. (The subject-matter of aesthetic psychology is, broadly speaking, our processes of mind when we have aesthetic experience.) There are, as we know, two general methods of investigation which can be employed in psychology, one of them is direct or internal observation, or introspection, and the other is the external observation of behaviour.

Both these methods may be used either in a freer, or in a more restricted and proscribed way. The introspecting subject may offer a running description of his experiences, or he may be asked to answer certain specific questions, carefully planned by the psychologist. Similarly, behaviour may be simply observed and recorded as it occurs, or it may be studied under definitely experimental conditions. A good deal of investigation has been carried out in these various ways in the psychology of aesthetics. Most stress has perhaps been laid upon experimental aesthetics, where the conditions can be controlled so that the experimenter is able to tabulate more accurately the results obtained either from introspection or from observation. This field of experimental aesthetics is a wide one and round the subject there has sprung up a considerable literature. What should be the relation of this experimental aesthetics to philosophy?

One part of the answer seems to me obvious. It is that aesthetic philosophy should take everything from the results of experiment it can make use of. An aesthetic philosophy which refuses to consider what psychology offers to it must indeed be blind and prejudiced. But two qualifications may be made. (*a*) One is that philosophy has a right, and a duty, to be sceptical. It must be critical of that which psychology offers to it. There is no possible objection to the principle of experimentation; but experimentation is difficult to manage, and the results of experimentation in a subject like aesthetics are perhaps not always so significant as its advocates sometimes imagine. Experiment may be conducted with some profit when the experimenter is concerned with experiences of simple colours and sounds, and the results obtained have undoubtedly their value, as I shall try to show, in helping us to discern some of the less complex characters of aesthetic experience. But it is a mistake to think of these simple experiences of colour and sound as typically aesthetic experiences. To understand aesthetic experience properly we have to go to the more

complex examples of it, to the experience of works of art, of pictures, symphonies, poems, cathedrals. And in these cases, where the aesthetic experience is at its fullest and richest, the arrangement of experiment becomes most difficult of all. I do not in the least suggest that it is impossible to arrange experiments in such cases, or that it is unlikely that the technique of experiment will be greatly improved as time goes on. But it is certain that any mature aesthetic experience is a vastly complex concrete whole, and that the necessary isolation of elements, the selection of fundamental aspects to be tested, is extremely difficult, so difficult that it has probably not, up to the present, been successfully achieved. Further, this selection can only be arrived at after a very carefully reflective—and philosophic—study of private and personal aesthetic experiences as complex concrete wholes. In other words, experiment implies hypotheses, and hypotheses are the outcome of reflection upon direct, pre-experimental experience. And it is particularly the business of aesthetic philosophy to form hypotheses and to scrutinise the hypotheses behind all experimental work. One's general impression is that experimental aesthetics has tended to suffer from a too great eagerness to 'get results', and that a more philosophic scrutiny of fundamentals is needed before really significant experiments can be devised. Aesthetic experience is so peculiarly susceptible to the danger of piece-meal treatment.

The results of the experimental psychology of aesthetics, then, must be received critically, though open-mindedly, by philosophy, and aesthetics cannot, for this reason, be identified with a part of experimental psychology. The second remark[1] (b) which may be made, is that aesthetics cannot be identified with psychology (or with any part of it) because psychology is concerned with processes of mind, whilst the field of aesthetics contains more than this. Aesthetics is concerned also with objects and products;

[1] See beginning of the last paragraph.

it concerns the *things* which we call beautiful, ugly, sublime, ridiculous, and so on. With these objects pure psychology could, by the definition of its nature, have nothing to do. The nature of objects is, however—in a certain sense—the proper subject-matter of the part philosophy called ontology. So again there arise problems of the relation of object to subject. These again fall outside psychology, but they are the very sphere of 'epistemology', or the theory of knowledge. Logical questions there are, too, in aesthetics, as when it is said that tragedy is the expression of the 'universal'. Investigation in aesthetics, again, is essentially philosophical in that it treats these various problems not as separate, not as strictly speaking isolable, but as in relation to one another.

The chief and the fundamental aim of philosophy—in aesthetics or anywhere else—is truth. But philosophical aesthetics, like other philosophy, may in the long run affect our feelings, and affect practice. I have tried to show that the critic, if he is to be a complete critic, must call upon the aid of philosophy. Not only the intellectual explanations of the critic, however, but critical appreciation itself, may in the end be affected by philosophy. For aesthetic experience, as we have said, is not mere feeling; it is knowledge. And into knowledge there enters at any moment a vast complexity of assumptions and presumptions and past judgments. This needs little, if any, argument, since we all admit that aesthetic appreciation may be trained, and training means the direction of attention upon essentials which are in turn determined for us partly by analysis. As in the realm of perception we 'see' the snow to be cold, so in the realm of aesthetic experience we may be said to 'see' the thing in this or that *way*, because of a certain history, a certain training, a certain tradition, which is partly determined at every point by some sort of reflection. And if the reflection has been profound and thoroughgoing and true, surely the actual vision will be clarified? Pater is mistaken when he assumes that the only aim of trying to define is to help us to

enjoy better; for definition, where possible, is a good in itself. It is overwhelmingly probable, however, that Pater is not only wrong in this assumption, but that he is wrong when he says that definitions help us very little to enjoy the best things in art and poetry. Definitions, to repeat, are no substitute for taste, but surely definitions, when they have become assimilated by our minds, must in some sense, and at some time, qualify the thing we call taste?

If this is true of appreciation, why should it not be true even of art-production itself? Of course, as we have said, the artist does not act in this or that way because he (consciously) *thinks* that a theory demands it. But surely even the artist, like the critic, is influenced by theories? We tend to accept grudgingly the idea that the artist can be helped by theories. And yet we are very ready to admit that his work is apt to be influenced by *bad* theories. For example, Wordsworth. But if bad theories affect, so may good theories affect. Why not as good theories as can be found?

Let us rid ourselves, then, of lingering prejudices. It is high time to be quit of irritating and elementary confusions about functions. There is no reason in the world why artists and critics and philosophers should not live peaceably and profitably together under the wide roof of heaven. As for aesthetic philosophy in particular, it is possible, necessary, good in itself, and probably, after many days, aesthetically useful. Let us see for ourselves what its problems really are.[1]

---

[1] For the general scheme of this book, and for suggestions to readers, see remarks in Preface, p. 5.

# CHAPTER I

# SOME GENERAL CHARACTERISTICS OF AESTHETIC EXPERIENCE

# I. METHODS OF APPROACH

There are at least three possible ways in which one may begin an inquiry into the problem of aesthetics. One may begin by attempting to define 'beauty', or by considering the experience of the creative artist, or by analysing what is called the 'aesthetic experience' which may arise when we contemplate works of art, and perhaps when we contemplate natural objects.

Each of these ways has its advantages and no one of them is without drawbacks. It is important[1] that the problems of beauty, and of artistic creation proper, and of aesthetic contemplation, should be distinguished; and any procedure which begs the question by taking it for granted that any of them is identical with, or is reducible to, either or both of the others, is to be condemned. It is also true that however we begin—whether by defining beauty, or otherwise—our choice of a starting-point is bound to reveal our intellectual preferences in aesthetic theory. On the other hand, we must begin somewhere, and so long as we realise that our plan will have to justify itself, it does not greatly matter where we begin. The starting-point is, relatively speaking, indifferent; [for thought is a system with implications not in one, but in all directions.] Temporal sequence is not of the greatest importance logically; although psychologically, in its effect on the writer or the reader, it may be of some little importance.] *like in objective rational behaviour?*

The method I propose to adopt here is to start with some general considerations about aesthetic experience, and to postpone the fuller investigation of the problems of art and of beauty. This procedure may give, as has been said, a hint of future general conclusions about beauty and perhaps about art. But that will not matter. Our initial explorations can settle nothing. They can only raise problems,

[1] See A. C. A. Rainer, "The Field of Aesthetics," *Mind*, XXXVIII, No. 150.

however categorically we may, for brevity's sake, have to express ourselves. I propose then, in this chapter, to make some very general and provisional statements about aesthetic experience. In the next three chapters we shall discuss the implications of an important idea which will come into prominence almost at once—the idea, namely, of 'expression'. Later we shall endeavour to define art and beauty,[1] and to give content to the idea of beauty by a consideration of some of the chief problems which are raised by art, and, to some extent, by 'nature'.

Let us begin, then, with aesthetic experience, remembering (to repeat) that each statement we make now can only be shown to be true or false by means of a much more detailed examination. This it takes time to carry out.

## II. Sensation, Perception, Images, and Aesthetic Experience

The term 'aesthetic' is derived from αἴσθησις, 'perception by the senses'. Can we say that the derivation of the word 'aesthetic' has any importance? Can we say with truth that the *aesthetic* experience is already *perceptual* experience?

Certainly we cannot say that 'aesthetic' experience is

[1] Let me say here, in order to avoid possible future confusions, that the view of beauty which I shall defend will be that beauty is perfect expressiveness. This is a different view from one very commonly held, that the 'beautiful' is the serene, the well-proportioned, that which makes an immediate appeal on account of its harmoniousness and balance. I shall not deny that all these qualities may, and perhaps in *some* sense do always, enter into concretely beautiful things, or that there is a kind of concrete beauty which does make immediate appeal on account of these qualities. But I do not believe that beauty can with profit be *defined* in this way, and I shall argue for a view of beauty as expressiveness, which confines it not merely to such serene objects as the Apollo of Belvidere or the Aphrodite of Melos, but which may include also much of what is at first sight adjudged to be ugly, and which certainly does include much that is 'difficult'. But see *below* Chapter VIII, especially Section IX.

merely perceptual experience. To say this would be to overlook an obvious distinction which we make, even in our quite unreflective moments, between simply perceiving a thing in the ordinary sense, and having an 'aesthetic' experience of a thing. The term 'aesthetic' (or derivatives of it) is, of course, sometimes used in application to sensation or perception; the first part of Kant's *Critique of Pure Reason* has this kind of thing as its title and subject, and there are in current use such terms as 'coenaesthesis' and 'anaesthesia'. But when we ordinarily talk of an 'aesthetic experience', or of an 'aesthetic' person, we are certainly referring to much more than sensory or perceptual qualities. When we see *Antony and Cleopatra*, or listen to Beethoven's Seventh Symphony, we may be perceiving and having sensations, but in calling these experiences 'aesthetic' we are referring to something more, and to something in certain ways more important. But granting all this, can we still say that all aesthetic experience is perceptual experience, though not perceptual experience *only* but something more as well?

To this, there is an obvious barrier. It seems fairly clear that we may have the kind of experiences which are usually supposed to be aesthetic, when we are not actually perceiving. Suppose, for example, I read the lines

> "In the golden glade the chestnuts are fallen all;
> From the sered boughs of the oak the acorns fall,
> The beech scatters her ruddy fire;
> The lime hath stripped to the cold,
> And standeth naked above her yellow attire. . . ."

I am here having an experience of something about which the poet is writing, which is yet not wholly a perceptual experience. I am, it is true, seeing and reading, and, if the poem is read aloud, I hear the words; and this is a perceptual experience which accompanies my other experience of apprehending that of which the poet is writing. The words, again, are no doubt of first-rate aesthetic importance,

as we shall have reason to see. But ignore for the time being the reading of the words and concentrate on the apprehension of the "golden glade" itself. That is not literally perceived, but imagined. And yet our apprehension of it would usually be called, I suppose, an 'aesthetic' experience. So too it would generally be said that the vivid remembering, or possibly the vivid constructive imagining, of, say, a piece of music by a man like Mozart, is a real aesthetic experience. The same is true of landscapes, or pictures of them. And so on.

Suppose, then, we modify our original question still further, and ask now whether aesthetic experience is always (at least) either perceptual experience, or imaginary perceptual experience, or both? It is clear that it is a possibility that it might be either *or* both. Sometimes, for example, we listen to music, sometimes we 'imagine' it only. Sometimes, as in poetry, we have before us things (i.e. words) which we 'perceive', and things (e.g. pictorial images) which we 'imagine' or 'image'. Is this *all* that we do in aesthetic experience? Should we be right in answering our question in the affirmative?

Before attempting to give an answer, let us note two things in passing about the use of the word 'imagination'. (*a*) We have used the phrase "imaginary perceptual experience". Imagination is an ambiguous word, and we shall have much occasion later to use it in a different sense from that in which it is now being used, a sense in which it will form a chief part of the differentia of aesthetic experiences from other experiences. Let us therefore distinguish between the two uses by speaking (1) of imaging and imaginal, and (2) of imagining, imagination, imaginative. This terminology is arbitrary but convenient. The other remark (*b*) concerns the phrase "imaginary *perceptual* experience". (This, in our new terminology, means *imaged* or *imaginal* perceptual experience.) The word 'perceptual' is in a sense superfluous, but it has been put in intentionally to emphasise a not

unimportant fact. It emphasises the assumption that what we apprehend when we image is not a different *kind* of world, e.g. a world of images made of 'mental' or 'psychical' stuff, but that it is the same world as the world which we perceive in ordinary life. (The act of imaging may of course be selective and constructive so that we may, and do, continually image what has not been, and again, what could not be, actually perceived.) The theory of the status of images is of course a difficult question which one ought not to prejudge. But perhaps without doing so I may be allowed to state that sense-perception is here being taken as the *type* of experience which is part of at least much aesthetic experience; it is therefore emphasised. It is enough to say that when we image that of which the poet is speaking, or if we image music or pictures, we must image *as if* we were perceiving.

### III. Is there a Beauty of pure Concepts?

We may now return to our question, Is aesthetic experience always at least either perceptual or imaginal experience (or both)? It is fairly clear that a very large proportion of aesthetic objects contain as an essential part of them a perceptual or imaginal side. We have only to think of the arts, with their various media—of words, of colour, of marble, of bronze, of musical sounds, of the movements of dancing. But can we not have aesthetic experience of things which have no essentially perceptual or imaginal aspect, of a moral character, for example, or of a mathematical proof, or of a scientific or philosophical system? May not a mathematical proof be beautiful? Or a moral action, or moral character?

This is a difficult question to answer. It might be said, of course, that when anyone claims that his experience of mathematics (or of a moral character) is 'aesthetic', he is simply mis-describing his experience. He might be making a mistake analogous to the mistakes people sometimes

make when they speak of the satisfaction of a ravenous hunger as 'beautiful'. There is no doubt that the terms 'beautiful' and 'aesthetic' are much misused.

But this method of outright denial could hardly be applied here, since the claim that mathematics (for example) possesses beauty is frequently made by persons of discrimination, judgment, and taste, who are also familiar with those aesthetic experiences which do contain perceptual elements, such as experiences of any of the arts. The contention would be difficult to disprove here in any case, because we have not as yet discovered what the essentials of any aesthetic experience really are. One way out, it is true, would be possible, if valid. This would be to assert that whenever there occurs an (alleged) aesthetic experience of the kind mentioned there are present also perceptual and imaginal elements.

Of course neither mathematical proofs as such nor moral character can be literally objects of perception, actual or imaged. They can only be conceived. But in 'figuring them out' to ourselves, as the phrase goes, we picture them, and may it not be our pictures which are aesthetically experienced? A mathematical proof is actually expressed in symbols, and though the symbols themselves, as mere marks or noises, need not be aesthetically satisfying, the symbols, as expressive of meaning, may be—as expressive, e.g., of pleasing conceptual unity, symmetry, coherence. Again, we do, metaphorically, think of a character as 'well-balanced', or 'rounded'. May it not be this imaginal *embodiment* rather than any system of concepts which is judged 'beautiful'?

This is possible; and if it is always so there is no difficulty. But it is sometimes contended that systems of pure disembodied concepts may be apprehended aesthetically. What are we to say to this?

Speaking purely for myself, I cannot claim to have experienced more than a certain limited amount of satis-

faction in such things. Whether the satisfaction that some
mathematicians claim to experience ought to be called
aesthetic or not I do not know. It *may* be that there is, here
or there, confusion because of the common elements of
structure in the two cases, the structure being (wrongly, as
I should argue) identified with the 'beauty' instead of being
taken (as I should urge) to be expressive of *values*. But all
this at the present stage is rather uncertain, and it seems
clear enough that we have no positive right to deny here
that such experiences may be 'aesthetic', and may be
experienced as intensely as a Shakespearean play, or a
symphony by Beethoven. The Prince Consort used to say
that a mathematical proof affected him in the same way
as a movement in a piece of music. And Mr. Russell speaks
somewhere, I think, of the rapture of pure mathematics,
which is a kind of escape from the imperfections of ordinary
life. In similar phrases Schopenhauer writes of aesthetic
experience.

But whilst it would be dogmatic to deny that there can be
aesthetic experiences which contain no sensuous or imaginal
element, I shall content myself in this book with exploring
those aesthetic experiences which do contain, as an integral
part of them, perceiving or imaging, or both. Aesthetic
experience without perceptual parts in its content may
certainly exist, but without the life of perception the vast
bulk of what is called aesthetic experience would vanish into
emptiness. Of the arts, not a vestige would be left, and of the
beauty of nature but a small fragment.

"Poetry is not written", said Mallarmé,[1] "with ideas;
it is written with words." In a purple passage Mr. Santayana
writes:[2] "The Parthenon not in marble, the king's crown
not of gold, and the stars not of fire, would be feeble and
prosaic things." "Nor would Samarcand be anything but
for the mystery of the desert and the picturesqueness of

---

[1] Quoted from Lytton Strachey's Introduction to Ryland's *Words and
Poetry*.      [2] *The Sense of Beauty*, p. 78.

caravans, nor would an argosy be poetic if the sea had no voices and no foam, the winds and oars no resistance, and the rudder and taut sheets no pull."[1]

If, then, we are to concern ourselves with the aesthetic experience, which is *at least* a perceptual or imaginal experience, we may proceed to ask, What of its specific differences? (We have already said that there *are* differences —that the term 'aesthetic' is not to be taken here as identical with 'perceptual' or 'imaginal'.) Let us, for brevity's sake, concentrate on the differences between aesthetic experience and ordinary *perception*, leaving out of the picture for the time being the imaginal side (which is secondary).

## IV. AESTHETIC EXPERIENCE, AND EXISTENCE

Two closely connected ways in which aesthetic experience is distinguished from ordinary perception stand out. The first (*a*) concerns our interest in the relation of what we perceive aesthetically, to *existence* or *reality*,[2] and the second (*b*) concerns its relation to our *practical* needs and interests.[3]

(*a*) In aesthetic experience we are not interested in the relation of what we perceive to any independent reality or existence *outside* what we are perceiving. In aesthetic experience the distinction between existence and non-existence in this sense, between reality and non-reality, does not in fact arise for us. We are interested in what appears. We are interested in the Macbeth or the Wolsey or the Hamlet of *the plays*: aesthetically we do not care a rap whether or not any of them actually existed outside the plays. Ordinary perception, on the other hand, is contact with a ragged-edged fragment of the world, which is continually implying things outside itself. The tree which we

⤷ *I'm not sure about this.*

---

[1] *The Sense of Beauty*, p. 68.  [2] Here taken as identical.
[3] These distinctions are the familiar impedimenta of aesthetics, and were stressed by Kant, who also held that aesthetic judgment is not concerned with concepts.

ordinarily see is a 'real' tree which is causally connected with a world which, in time and space, stretches far beyond *ok* our perceptions. The tree seen aesthetically is an appearance, interesting in itself, and, in its own way, perfectly complete. →*o k* Bosanquet writes: "Man is not civilised, aesthetically, till he has learnt to value the semblance above the reality." It is true that he adds: "It (the semblance) is, indeed, as we shall see, in one sense the higher reality—the soul and life of things, what they are in themselves."[1] The meaning contained in such a proviso is indeed important; for aesthetic experience does, as we shall see,[2] give rise to claims— perhaps justified—of insight of a special kind into the most 'real' kind of reality. Nevertheless, the original statement, that aesthetic experience is not concerned with the 'reality' of objects outside the circle of present experience, holds good. If aesthetic experience does in any sense 'reveal' reality, it reveals it 'out of itself' as it were, and not through its pointing to an existence beyond itself. The realm of aesthetic experience is a kind of self-contained world of its own: what it reveals is enough. If these statements sound obscure, let them stand now. They will trouble us suffi- ciently often. *In really scared.*

## V. AESTHETIC EXPERIENCE AS CONTEMPLATIVE; AESTHETIC IMAGINATION; SIGNIFICANT FORM

The second point (*b*) is closely connected with the first. It is that in aesthetic perception we are primarily *spectators*, and that our spectatorship is not coloured by the needs of practical action as is ordinary perception. Our ordinary perception of the external world is of a world in which we have to act, and perceptual interest in things is interest conditioned by that need to act. If I am in ordinary life in a sense the spectator of a tree, it is as something I must avoid when I walk along. Aesthetic experience in large part takes

[1] *Three Lectures on Aesthetic*, p. 10.     [2] See below, pp. 267 sqq.

over the highly qualified world presented to it through ordinary perception, but it adopts a new attitude to the world, the common world of trees and fields, of solid, hard, coloured, resonant objects, of spatio-temporal relations. It stops to contemplate it.

Now to say this is not, in the first place, to say anything which tells us very much about *aesthetic* experience. For there are contemplative experiences which are non-aesthetic. We may contemplate philosophically, or scientifically; we may even (perhaps) contemplate 'practically', i.e. in the sense of having some practical result ultimately, though not immediately, in view. We do this, for example, when we spend time in simply looking at a puzzle before attempting to touch it. But none of these kinds of contemplation is, as such, aesthetic. Once again, as before, we have to be very qualified in our statements, and say that aesthetic experience is *at least* contemplative: and it becomes incumbent upon us to state the difference between 'aesthetic' contemplation and other kinds of contemplation. In the second place, it must be observed that in saying that aesthetic (or any other) experience is contemplative, we are not saying that it is a merely passive experience, that it excludes activity. Certainly contemplation involves activity of both body and mind. What is meant, negatively, by contemplativeness is that our activities are directed rather to apprehension of an object than to adjustment of ourselves to it or of it to us. The tree interests us as an object in itself, not as something to be steered past or to be cut down.

What then differentiates aesthetic contemplation from other kinds of contemplation? The difference may be indicated very roughly by pointing out that in aesthetic, as distinct from other kinds of contemplation, the object is so regarded that the very arrangement of the perceptual data as we apprehend them seems in itself to embody some valuable meaning, something the apprehension of which moves, interests, excites us. The full significance—both for

experience and for theory—of this special kind of attitude can of course only be understood when we are familiar with, and when we comprehend, the whole of the aesthetic attitude. It is the basis of that which we call aesthetic 'imagination'.[1] At present we can only proceed haltingly, by using negatives and by simply pointing to the experience itself. The negations have already been used; aesthetic contemplation is *not* sustained by scientific, *nor* by philosophic interests. We do not contemplate aesthetically in order to solve theoretic problems. Nor is it sustained by practical and biological interests. "Biologically speaking, art is a blasphemy. We were given our eyes to see things, not to look at them."[2] And, positively, we can point to approximations to the contemplative aesthetic experience itself by instancing certain other familiar and striking experiences. What happens when, suddenly and unexpectedly, we see the real world reflected pictorially in a convex mirror, or when, as we stand on the brow of a hill, the mist suddenly lifts and we see the country below us flat yet three-dimensional as in a picture, or when, perhaps in search of new sensations, we stand on our heads and see a new and fascinating world— what happens at these times is something at least very like an aesthetic experience. In such moods we contemplate, for the sheer interest of what they seem to say to us, the sensuous and formal characters of what we see. And this contemplativeness, with its positive and negative characteristics, thus illustrated from the visual sphere, seems to be an adjective of all aesthetic apprehension.

We have just said that in visual aesthetic experience we contemplate, "for the sheer interest of what they seem to say to us, the sensuous and formal characters of what we see". "*Of what they seem to say to us.*" In aesthetic seeing there is already more than seeing: in what is seen there is meaning of a very special kind. Aesthetic seeing is, in other words,

[1] Which is, as has been said, distinct from mere imaging.
[2] Roger Fry, *Vision and Design*, p. 47. Chatto & Windus.

the kind of seeing which is called *imaginative* seeing. This special quality of 'imaginativeness', properly understood, contains perhaps the most important differentia of all between aesthetic and other experiences. But, once again, its full meaning cannot possibly be conveyed in a few sentences, for it is the very life itself of aesthetic experience. We must, however, attempt to describe briefly the first conditions of imaginative aesthetic apprehension.

Aesthetic experience is perception, but something more. On the one hand, we apprehend the perceptual data; we listen to the sounds in their relations, we apprehend the coloured shapes—lines, planes, and solids—and our interest in them is not, as we have said, interest in them as existing things, it is interest in appearance. On the other hand, our interest is interest in appearance for the sake of a meaning, a significance, a value, which could not be contained literally in a mere perceptual appearance, but must in some sense transcend it. On the one hand, that which is presented to us in perception is an essential part of the whole content, and if we lose sight of it the aesthetic experience dissolves. It is essential that our attention should not wander, by a process of mere free association, to other objects or experiences which the perceptual objects may suggest, though this is not to say that association may not play an important part in aesthetic experience. If, on looking at a picture, our minds are led away from the picture to some pleasant memory which it suggests; if, on listening to a symphony, we allow our thoughts to wander from the music, to indulge in pretty pictorial fancies, we may be sure our experience has, for the time being, and thus far, ceased to be a purely aesthetic one. As Bosanquet might put it, our 'feelings' must be *relevant* to the perceived object. On the other hand, the arranged forms of the picture or the statue or the music are for our minds more than merely arrangements of perceived patterns. For one reason or for another, for reasons which we shall have to discuss in the chapters

which follow, the perceptual data have come to 'embody' valuable meanings: pictures and statues and symphonies yield a delight and a pleasure which is certainly in part sensuous, but is never only so. It is certainly for pleasure or enjoyment of a sort that we go to picture galleries or concert halls, or to the theatre to see great tragedies. But no aesthetic theory which identified such satisfaction with the mere sense-pleasure of a perception could be worthy of consideration. Such a theory might account—though in fact it is almost certain that it does not—for the 'aesthetic pleasure' in simple colour- or sound-combinations. But a theory of aesthetic experience must also account for those aesthetic experiences which seem to shake the very foundations of our being. The temple is a pile of stones, the symphony a conglomeration of sounds, the dance a set of movements. But these possess meanings for aesthetic contemplation which it is beyond words to describe. It is beyond words to describe them, not merely because they may appear profound as life itself, but because they are in their essence untranslatable, being just the embodied meanings of stones, sounds, movements. To understand the nature of this embodiment in its untranslatableness is to understand the essence of aesthetic.

Mr. Clive Bell's well-known phrase "significant form"—if we may use it without committing ourselves to the whole of his interpretation of it—unites in conception the aspects of meaning and of perceived forms. It is just the function of what we call aesthetic 'imagination' or 'imaginativeness' to unite, in apprehension, these two aspects. "What quality", asks Mr. Bell,[1] "is shared by all objects that provoke our aesthetic emotions? What quality is common to Sta. Sophia and the windows at Chartres, Mexican sculpture, a Persian bowl, Chinese carpets, Giotto's frescoes at Padua, and the masterpieces of Poussin, Piero della Francesca, and Cézanne? Only one answer seems possible—

[1] *Art*, p. 8. Chatto & Windus.

significant form. In each, lines and colours combined in a particular way, certain forms and relations of forms stir our aesthetic emotions. These relations and combinations of lines and colours, these aesthetically moving forms, I call 'Significant Form'; and 'Significant Form' is the one quality common to all works of visual art." And, we might add (reserving the right to interpret the phrase for ourselves), common to all works of art whatsoever.

## VI. PROVISIONAL DEFINITION OF AESTHETIC EXPERIENCE, AND SOME PROBLEMS RAISED

We may now suggest a provisional definition of aesthetic experience.

When an object of perception—whether actual or imaginal perception or both—is contemplated 'imaginatively', that is, so that it appears in its very qualities and forms to express or embody valuable meaning, and when that embodied meaning is enjoyed intrinsically, for its own sake, and not for its practical, or cognitive, or existential implications, then the contemplation is 'aesthetic' contemplation, and the total complex before the mind we may call an 'aesthetic' object.

This provisional definition is intentionally very general. It is meant to include the minima as well as the maxima of aesthetic experience, the aesthetic apprehension of a colour or of a wild rose as well as the apprehension of, say, Bach's complete *Goldberg* variations. In the latter experience doubtless much more is required of imagination than in the former. In it, the demand for imaginative *synthesis* is immense. But the difference, it would appear, is one of degree rather than of kind, and our definition attempts to mark out what is essential in all aesthetic contemplation, though there is no attempt as yet to define accurately its constituents.

Some of the issues which are raised by this general account

have already been touched upon. There are many others; it is impossible to allude to them all, but a few may be simply mentioned in order to show the complexity of our problem.

In the first place, is our definition not too 'subjective'? Does it not put the whole stress on *our* contemplation and none, or too little, on the object? Is the question of the 'objectivity' of beauty thereby prejudged? Shall we have to suppose that 'beauty' is nothing but the 'imputation' of our own feelings? Is aesthetic experience discovery, or is it merely projection? In aesthetic experience have we to do *merely* with an appearance (to a mind) and with *nothing* more? What then happens to our 'standards' of aesthetic taste? In the second place, a question is set by the first phrase of the definition. Can *any* object of perception be an aesthetic object, or is this true only of certain *kinds* of objects, viz. 'beautiful' objects? What is the relation of aesthetic experience to beauty? And what is beauty? Again, it may be thought by some that we are in danger of laying too much emphasis upon the 'imaginative' experiences, which may be suggested by what we perceive, and too little on pure sense or on pure form. Or, again, whence arises the extraordinary importance of aesthetic experience in the higher levels of human life? Again, do we make no distinction between art and nature? And what of the ugly, the comic, the sublime? Can these be classed as aesthetic experiences? Do they fall within the range of our definition? Again, more generally, what of the 'unity of variety', which is so often taken to be the criterion of the aesthetic object? Further, is the aesthetic experience an 'esoteric' and 'aristocratic' experience? Something which isolates us from the rest of the common world? Something which lifts us to a heaven of pure bliss? Is aesthetic experience *sui generis*? Or is it just a special kind of 'ordinary' experience? And, finally in this most random list, and not the least important, *how* does the phenomenon of aesthetic 'meaning' take place?

What is aesthetic 'embodiment' or 'expression', and what is its difference, if any, from other kinds of 'expression'?

These are a few of the problems which arise more directly—or more indirectly—out of our provisional account. Many others, we may be quite certain, lurk horribly in the background. On some or all of them we must touch in what follows, upon some lightly, upon some more firmly, upon some, it is to be feared, even heavily.

Let us begin by discussing the term 'expression'.

# CHAPTER II

# EXPRESSION AND AESTHETIC EXPRESSION

## I. Some Common uses of the term 'Expression'

The term 'expression' is used in many senses, some of them extremely vague. I do not propose to attempt the tedious task of trying to enumerate them all. But we may notice a few of them in order better to understand what is the special characteristic of 'aesthetic' expression.

We may begin by following Croce in excluding from further consideration such use, or abuse, of the term 'expression' as is exemplified when we speak of the effect being an 'expression' of its cause.[1] To speak of the falling barometer as the 'expression' of humidity in the atmosphere, or the height of the Exchange as the 'expression' of the depreciation of the currency, is not specially illuminating or helpful; the meaning is probably much better expressed in causal terms. Again, to speak of fever as the 'expression' of the state of the blood is an unnecessary circumlocution. In this case there is perhaps slightly more reason in the use, because the fever-heat, as tested by means of a thermometer, is the *external* manifestation of a state of the blood *inside* the body—although if we argue in this way we ought to say that the falling barometer too is an external and physical sign of something which is not directly apparent in the 'outside' world. But these are both trivial instances.

The term 'expression' means, literally, a 'pressing' or 'squeezing out'. But in any sense at all relevant to our discussion it is obvious that the phrase must be accepted not literally but merely as a vivid metaphor, and even then a metaphor to be used with caution, a metaphor perhaps to be rejected in the end as dangerous. Expression, we shall argue, implies 'embodiment' of some sort in a 'body'. This is the 'out' aspect. And in some sense something *other* than the 'body' must be 'embodied'. This will represent roughly *what* is 'squeezed out'. The 'squeezing' part of the metaphor must be taken with a very large dose of reserve indeed.

[1] See Croce, *Aesthetic*, Ainslie's translation, Second Edition, p. 95.

But taking the metaphor for the little that it is worth, and for no more, one kind of *what* which is embodied or revealed in the *out*side world will be states of mind. The kind of thing of which Darwin writes in his *The Expression of the Emotions in Man and Animals* provides a good instance with which to begin. We can say, without entering at the moment into the question of the biological function of bodily expression of emotion, that bodily attitudes and movements do, in some sense, 'express' emotions. A man in danger of death from the horns of a bull screams and runs, or he remains transfixed with terror. His screams, his running, or his transfixation, in some sense 'express' his emotional state. Similarly the blush expresses shame or embarrassment; clenched fists, anger; and so on. There may be causal efficacy at work, but there is expression as well—in the sense that the outer states reveal to us the inner ones.

There is another sense in which 'expression' is used, a sense which is not exclusive of the last, but which refers to a different aspect of the matter. I mean the use of the term 'expression' when it means release of some inner *tension* (mental or bodily or both) by means of external behaviour. When I become irritable through overwork (or underwork), or if inhibitions prevent normal release of some impulse, I may act explosively. I may 'express' myself by strong language or hard exercise or unjustifiable abuse, according to my temperament. Or, when feeling perplexed, I may, if I am a lady, and am like the love-embarrassed young lady of Bicester (or *one* of the young ladies), get great relief by slapping my sister. We 'express' and so 'get rid of' disturbing feelings. This, as we have just said, is not an entirely new sense but partly overlaps the first, though it stresses another aspect of it.

A further development of the same thing is that sort of expression which is carried out for the *satisfaction* of some conscious desire. Thus if I am anxious about the derivation of a word, and go and look it up, my activity is 'expressive',

in the sense that it is an external process (involving of course more) which satisfies my desire to know. This is again in common currency, and it is, again, not exclusive of the other senses. Only it refers primarily, not to the revelation of an inner state, nor to the relatively haphazard relief of a tension, but to the more consciously rational satisfaction of a desire.

A still more advanced and developed type of expression is so-called *self-expression*, i.e. where an action or set of actions is clearly regarded not only as the satisfying of a profound desire, but as somehow also embodying or externalising a self. In its simplest forms this 'self-expression' may be little more than the satisfaction of self-display, which may show itself in crude gestures or in the production of crude monuments which have no very intimate or subtle relation to the self which is expressed, though they serve to draw attention to that self. An example of the latter would be the gifting of an expensive and ornate public building with the name of the donor prominently inscribed. At the upper end of the scale of self-expression are those externalisations which bear both striking and subtle relation to the 'self'. Thus the self is said to be 'expressed' in moral conduct, or in the making of a garden or a house, or in the practice of an art like dancing. The term '*self*-expression'[1] is of course vague; there are values other than values of the self expressed. But for the moment we are concerned with current usages rather than with definitions.

[A special case, something akin to this last use of 'expression', would be the 'Einfühlung' or 'Empathy' of mental and bodily states in an object. In aesthetic experience, our mental and bodily states, it is sometimes said, in some sense seem to 'get into' the object (and therefore to get *out* of us *into* the object). The symphony is 'tender', 'strong', 'tense', 'excited'. How far this is true we shall inquire in the next chapter.]

[1] On so-called self-expression as a factor in art, see below, p. 185.

## II. Expression and Aesthetic Expression. Plan

These are some senses in which the term 'expression' is used. Are such expressions as these aesthetic expressions, or does the definition of the aesthetic require to take into account other and different factors? On one theory, the theory of Croce, the expressions of which we have been speaking are not truly expressions; [1] for Croce the only true kind of expression, the only expression there is, is aesthetic expression; the others are for him not aesthetic expressions (and are therefore not expressions at all).

This is partly a matter of terminology, and partly not. We may agree or disagree with much of Croce's theory and with much of his terminology: in point of terminology it seems to me more convenient to include as expressions those 'expressions' in the popular sense to which we have referred. But that is a minor matter. What is not a minor matter is that aesthetic expressions may be (among other things) expressions in a finer, in a subtler, in a more accurate— though also in a less literal and in a more imaginative— sense than, say, an 'expression' which is a mere relief of tension or the mere satisfaction of some desire. I shall argue, in fact, that it is so. But to justify this we must describe, as clearly as we can at this stage, what aesthetic expression really is, and what are its necessary conditions. Let us try to do this, still confining ourselves for the present mainly to the consideration of examples of bodily manifestations, as these are more literally and less disputably 'expressions' in the general sense of the word, than are the objects perceived as outside the body (say, shapes and colours and sounds) with which developed aesthetic expression has so much to do. To these we shall return in the chapters which follow.

What, then, are the characteristics of aesthetic expression the knowledge of which enables us to differentiate 'bodily

[1] *Aesthetic*, Ainslie's translation, pp. 95-96.

expressions' which are 'aesthetic', from bodily expressions which are not? There would appear to be two main problems involved. The first problem (*a*) really includes several closely allied ones. It includes the problem of the general conditions of aesthetic experience, of the meanings which the mind brings to its perception of objects, and of the relation of these meanings to the perceived object. The second problem (*b*) concerns the fitness of the characters possessed (literally) by the perceived object to suggest to mind a harmonious system of meanings in a whole which we call beautiful. In both these problems there is (*c*) a fundamental question involved, namely, How do perceived objects come at all to appear to convey to mind meanings which they do not literally in themselves possess? How do colours appear 'cheerful'? How does music appear 'yearning'?

To the second and third of these problems I shall return in the chapters which follow. The first group of problems is our main concern now. And the discussion of them will consist, not in the discovery of any new aesthetic principle, but in the development of the provisional account of aesthetic experience which has been given in Chapter I. This is what we should expect, for the difference between a non-aesthetic object and an aesthetic object depends primarily [1] on the presence of imaginative activity in relation to the latter. So, bodily expressions being, *as such*, aesthetically neutral, what is required primarily to give them aesthetic character is some relation of them to aesthetic imagination. This is the differentia of aesthetic expression for which we are looking, and it is no new thing. Let us now try to put it a little less bluntly and more finely, by going over and developing our original provisional definition of aesthetic experience.[2] We said there in effect that in

[1] Not exclusively, as I have just hinted. The perceived object also must fulfil certain conditions in order to satisfy. But this for the present I am ignoring, in order to concentrate on the primary and fundamental fact of imaginativeness.           [2] Above, p. 43.

order that an aesthetic *object* may exist, a perceived entity must be contemplated imaginatively for its own sake, must be *contemplated imaginatively* as an embodiment or expression, and that the embodiment is embodiment of *valuable* meaning. Let us now consider further, still in a provisional way, the three main notions: (1) the *object* apprehended in aesthetic experience, (2) *imaginative contemplation*, (3) embodiment of *value*.

## III. The Aesthetic Object

(1) In aesthetic perception what is the object contemplated? The answer is, a perceived-object—appearing—to—express—or-embody—a-somewhat (to be specified later). The hyphenation is important. The aesthetic object is not a mere perceived object on the one hand, nor is it a disembodied somewhat on the other. It is a union of both: the *what* appears as inseparable from its 'body'. Thus there is a contrast between aesthetic expression and the other 'expressions' of which we have spoken. In these other expressions the body side is cognised as being in external relation to the *what* which is 'expressed'. Sometimes, it is true, there is, in these cases, a very intimate connection between the nature of the body side and the nature of the *what* which is 'expressed'. The instinctive expressions of the emotions of anger or fear, for example, are genuinely revealing manifestations of inner states of body and mind. In this we approximate to the kind of expression which may be called 'functional' expression, which is clearly related to what is often known as 'functional beauty'. To a discussion of this, and of 'natural' expression and so-called 'natural' beauty, we shall return later.[1] Sometimes, on the other hand, there is not much connection between the *what* and its body, or at least not much connection immediately obvious. There is little obvious connection, e.g., between the slapping of her

[1] See below, Chapter VI, and also pp. 387 sqq.

sister and the perplexity of the lady of Bicester, nor is there much between my action of turning the leaves of a dictionary and my mental curiosity. But whether there is intimate connection or not, it cannot truly be said that in the manner in which we ordinarily and in practical frame of mind contemplate such 'expressions', we really imagine and enjoy the *what* as if it were actually *there* in the body. The expressions are ordinarily taken as signs, and as signs only. That is why there is some point in the position which denies the name of true expression to anything but aesthetic expression. For, in aesthetic experience, we do imagine the *what* to be there. Aesthetic experience is experience of an aesthetic object, and the aesthetic object is a true embodied unity, the consideration of which is, as we shall observe later, of importance. The aesthetic object is an imagined unity of a *what*, or content, and a 'body', in the entity we call concretely an 'embodiment'. We simply cannot, as we shall see, regard the *what* apart from the body without changing the nature of the *what*: and for the same reason the embodied *what* did not of course exist before the embodiment.

## IV. IMAGINATIVE CONTEMPLATION

(2) In aesthetic experience the aesthetic object (or what might be called the aesthetic 'unit') is imaginatively contemplated and is enjoyed for its own sake and not for the sake of anything extrinsic. By saying that the aesthetic unit is *imaginatively* contemplated I mean simply, as I have just said, that we apprehend embodiment as embodying in its very qualities and forms valuable meaning. But the point now is that we *contemplate*, and take pleasure in our contemplation. This imaginative contemplation takes us a step higher than the biological level: it may be called 'hyperbiological'. A truly instinctive expression, as of anger or fear, is not 'contemplated' either by the agent or by the animal spectator, e.g. by the victim of the anger. The

victim is afraid: the aggressor acts, spontaneously. But
with human beings a different situation may arise. The small
boy stamps his foot with rage: a little later, perhaps, he
becomes interested in, notices, and enjoys his action; he
contemplates it, finds it an enjoyable expression, and
repeats it—probably with modifications. His expression
begins to aim at higher standards for itself.[1] The first stamp
is instinctive, the second has the seeds of an aesthetic
expression in it. So the instinctive jump for joy may be
repeated deliberately (again probably with modifications),
and may later become the basis of an aesthetic activity,
namely, the dance. Again, man may build, or he may sing,
from instinct or from instinct modified by imaginative
contemplation and enjoyment. Hear Shelley: "A child at
play by itself will express its delight by its voice and motions;
and every inflexion of tone and every gesture will bear
exact relation to a corresponding antitype in the pleasur-
able impressions which awakened it; it will be the reflected
image of that impression; and as the lyre trembles and
sounds after the wind has died away, so the child seeks, by
prolonging in its voice and motions the duration of the
effect, to prolong also a consciousness of the cause. In
relation to the objects which delight a child, these expressions
are what poetry is to higher objects."[2]

The aesthetic unit is contemplated, and is enjoyed for its
own sake. It is felt to be valuable in itself, apart from any
external factors: it is not aesthetically valued (to repeat)
because it increases knowledge or has practical results, or
even because it may communicate valuable experiences
from one person to another—though the latter desire may
often enter into acts of expression, and has indeed been
made by some the central motive of expression.[3]

[1] See below, pp. 160 sqq.
[2] *Defence of Poetry.*
[3] See below, pp. 181 sqq.

## V. "PSYCHICAL DISTANCE"

The fact that the aesthetic object is at once an object of interest and is yet apprehended 'disinterestedly' (as it is sometimes, unfortunately, put) and the importance of a due balancing of these two factors, was epitomised, a good many years ago, by Mr. Edward Bullough, in the term 'psychical distance'. 'Psychical distance' implies a certain 'projection' of the contents of subjective experience [1] into the objective world. The contents are no longer felt as merely part of personal, subjective life, but are contemplated as objective. We become detached, as it were, and in this way are able to appreciate them aesthetically, though, if the detachment be overdone, and the 'distance' be too great, the subject is not able to come in contact with its object and to experience it. For aesthetic experience there is one correct 'distance', and only one, for each person and each thing. To quote Mr. Bullough:[2] "Distance is produced in the first instance by putting the phenomenon, so to speak, out of gear with our practical, actual self; by allowing it to stand outside the context of our personal needs and ends— in short, by looking at it 'objectively', as it has often been called; by permitting only such reactions on our part as emphasise the 'objective' features of the experience, and by interpreting even our 'subjective' affections not as modes of *our* being, but rather as characteristics of the phenomenon." 'Distance', Mr. Bullough thinks, is both a factor in art and an aesthetic principle—indeed, he inclines to regard it as the most important and fundamental principle of aesthetics.

The conception must be acknowledged as valuable and important. It does not seem to me to have the all-importance

[1] The phrase I use is full of confusion, but the context makes clear, I think, what is meant, namely, bodily and mental contents.
[2] *British Journal of Psychology*, V, 94.

which Mr. Bullough gives to it, or to be, in itself, the basis of a comprehensive account of aesthetic experience. And when Mr. Bullough says that there is only *one* correct distance for each person and each thing, and that this occurs where there is "the utmost decrease of Distance without its disappearance",[1] his statement, I think, should be accepted with reservation. It is probable that there is not merely *one* distance which is correct, but that 'correct' distance may lie anywhere between certain limits of nearness and farness. The guess might be hazarded that in what is called 'classical' art and the 'classical' attitude, the distance tends to be greater, whilst in the art—and the attitude— we call 'romantic', it tends to be lesser. It is possible, I think, that Mr. Bullough's account can be made to cover this provision. ("There is one correct distance *for each person and each thing.*") But it seems wise to state the theory in relative rather than in absolute terms. It is perfectly safe to say that aesthetic experience ceases when the distance is either *too* great or *too* small. If we content ourselves with this, the metaphor of distance is useful and helpful.[2]

[1] *British Journal of Psychology*, V, 94.
[2] The extreme difficulty of achieving the 'right' psychical distance is illustrated in experimental work by Bullough and others on 'types' of apprehension. Four 'types' are distinguished. They are (i) the "objective" type; (ii) the "physiological" or, better, the "intra-subjective" type; (iii) the "associative" type; and (iv) the "character" type. These were discovered by Bullough through experiments on the appreciation of simple colours and colour combinations, and were confirmed in two sets of experiments, one by C. S. Myers and C. W. Valentine on individual attitudes towards tones,* the other, by Myers, on individual differences in listening to music.† The classification, of its kind, seems to be fairly fundamental. The objective type (i) involves an impersonal, intellectual, critical attitude towards the object, and bases appreciation upon, e.g., the purity, saturation, luminosity, etc., of colours, the roundness or the blending properties of tones, or the technical devices and qualities of music. The physiological or intra-subjective type (ii) bases appreciation upon the personal mood and the organic modifications involved. The associative type (iii) emphasises the power of the object to call up

* *British Journal of Psychology*, VII, 68 sq.    † Ibid., XIII, 52 sq.

## VI. The Difficulty of 'Distancing' some Bodily Sensa

Let me illustrate the importance of recognising 'distance' as a factor in aesthetic experience by citing a criticism which Mr. W. T. Stace makes, in a book entitled *The Meaning*

associations or memory-images of past experiences. The character type (iv) predicates moods or characters, e.g. cheerfulness or sadness, of the object (as opposed to the physiological type, which thinks of colours and tones as 'cheering' or 'saddening').

Only one of these types is, according to Bullough, properly aesthetic at all, in the sense of being properly 'distanced'. This is the 'character' type. Bullough ranges the types according to their aesthetic importance as follows, dividing the 'associative' type into two sub-classes: (*a*) character, (*b*) fused* association, (*c*) objective, (*d*) non-fused association, (*e*) physiological or intra-subjective type. In this classification (*b*) may in fact often be identical with (*a*), as, e.g., when yellow-green associated with envy comes to *mean* envy. But it is very difficult to range the others in order, for they are not types of aesthetic apprehension at all, and are chiefly useful in showing what aesthetic apprehension is *not*. If we confine ourselves here to the single characteristic of 'distance', (*c*) is far *too* distant, and (*e*) is not distant enough; (*d*) is outside the pale of consideration. (But again see footnote below*.)

Such experiments are, of course, full of snares. The above may represent types of apprehension, but they do not stand necessarily for types of persons, 'aesthetic' and 'non-aesthetic'. Types (*c*) to (*e*) may represent stages on the road to aesthetic apprehension. Or they may represent temporary moods. Or the subject's report may be misleading and for more reasons than one. To be more specific, the intra-subjective type may really be simply an earlier stage of the character type: e.g. we feel cheerful or sad, but have not reached the stage of projecting our mood into the object. Or perhaps, not being in aesthetic frame of mind, we simply recognise the cheerfulness or sadness as being *caused* by the object. Or our reason may step in and restrain us from the palpable absurdity of saying that inanimate things possess moods. It was found in the experiments that the physiological type did, in fact, approach to the character type, and that the subject sometimes found it difficult to say *ex post facto* whether the colour was 'cheering' or 'cheerful'. His judgment might depend upon whether he, the subject (and he might be, on general grounds, an 'aesthetic' person), was thinking truly 'aesthetically' or was trying to justify his experience intellectually. In aesthetic experience the object may, without raising problems to us, appear

---

* For a discussion of fusion, see below, pp. 97 sqq.

*of Beauty*,[1] upon theories like Professor Alexander's,[2] which base art upon an instinct. Alexander argues that the exercise and enjoyment of the instinct of construction for its own sake, is aesthetic. Mr. Stace disputes the contention that exercise and enjoyment, for its own sake, of an instinctive activity can constitute the differentia of the aesthetic. He cites the instance of the exercise, for its own sake, of the sexual instinct, especially when employing methods of contraception. He argues that such activity is not, in itself, aesthetic. Neither, it may be inferred, is construction exercised and enjoyed for its own sake necessarily aesthetic.

But sexual activity[3] at any rate (I shall not discuss construction here) might fail to be aesthetically expressive in part at least because one important condition is not fulfilled, the condition, namely, that the perceived object must be contemplated as an object, so that its objective characteristics are apprehended by the imaginative mind as expressive. This condition it might not be easy to fulfil in the case of an activity such as that of sex, regarded as an activity yielding simply sense-satisfaction. And what is true of sex would be true in general of those other bodily sensa (such as those of toothache or of smelling) which are so 'near' to the experiencing of them that it is only by a determined effort that we distinguish between our experiencing and its con-

---

literally to have the most curious qualities; but it is difficult sometimes to make this sound rational afterwards. Finally, the most aesthetic persons, e.g. artists, are interested in technical questions, in the relative 'values' of colour, in composition, execution, etc. Myers indeed found* that the most musical persons were also the most critical, making many technical observations. This is perfectly natural, and does not in the least imply that such persons are non-'aesthetic'. All these things show that the usefulness of such classifications is strictly limited.

[1] Op. cit., p. 35.　　　　　　　　　　　　[2] In *Art and Instinct*.
[3] This is, of course, very different from active *sex-love*, which involves a very complex attitude to the body-and-mind of a *person*, in which the sensuous sex-element is fused with a much larger whole of non-sensuous content.

---

* *British Journal of Psychology*, XIII, 58.

tent. It may be difficult in such cases to escape from the defects of membership of the 'intra-subjective'[1] type. In addition to this, such sensa may possess, even when, with some effort, they are contemplated, extremely little structure or form which can be contemplated as expressive. It would, however, be the former reason rather than the latter which would tend to cut them out from the realm of possible aesthetic objects. It is important to say this because some writers[2] do tend to exclude from aesthetic experience, because they are 'formless', all sensa, those in terms of which we perceive the world external to the body as well as those in terms of which we are aware of our own bodies. They say that only forms, and not sensa, such as colours and sounds, can be apprehended aesthetically. But it seems to be the case, first, that completely formless sensa are non-existent, and second (what is more important), that the sensuous aspect of objects may in itself yield distinct aesthetic experience, though in the higher types form is probably always the more important factor. The reason, therefore, that sexual and certain other sensa are difficult to conceive of as aesthetic objects is their lack of psychical distance rather than their relative 'formlessness'.

These statements about sex in particular need not, however, be taken as denying that sex may yield aesthetic experience. In the first place, though the term 'sensa' has been used, our sense experiences are of course always at least perceptual, and never merely sensational. This being granted, it may be possible—if we accept the testimony of writers like D. H. Lawrence—for the sex experience to be expressive of complex, even if only of physical, values. But it would be monstrous to restrict sex-data to the expressiveness merely of physical values. Sex, as we know, may be a main integrating factor in the highest and the most spiritual experiences of which mankind is capable. There is no intrinsic reason why the experience of sex should not

[1] See above, footnote, pp. 56-58.          [2] See below, pp. 68 sqq.

be, on one side of it, the experience of these values of human personality, fused, as always, with a perceptual object. There is no intrinsic reason why this should not happen. There are only the same difficulties which were referred to in the previous paragraph.

## VII. Embodiment of Value

(3) The aesthetic unit is an embodiment of *value*. There is an obvious and verbal sense in which it is 'embodiment of value'. I.e., it is embodiment which is *of* value, which possesses value (of some kind) for us. But the aesthetic object is an embodiment of value in a much more significant sense, a consideration of which raises important aesthetic problems, though in a simple form. The embodiment of value in the aesthetic object is of such a nature that the value 'embodied' in the perceived object or 'body' is *not literally* situated in 'the body'. The 'joy' expressed in music is not *literally in* the succession of sounds. The perceived object *appears* to imaginative mind to express values, so that values *seem* to emanate from the perceived object which somehow appears to contain them. The music *appears* in itself to contain joy. To imagination there is fusion of value-meanings with a perceived object, and if fusion breaks down, the aesthetic object or embodiment disintegrates. But the value-meanings, once again, are not literally in the perceived object, so that in *some* sense the values must be conceivable as distinct from their body. E.g., a dancer may experience the values of a particular joy, or tenderness, or conflict, and may then be said (in some crude, inaccurate sense) to express or embody such joy or tenderness or conflict in a dance. Our problem in the chapters which follow will be to hold these two sides of the situation together, to discover what is meant by saying (inaccurately and incompletely) that a distinct or independent or 'free' value is embodied, whilst keeping in mind that freedom and embodiment are antithetical notions.

## VIII. Forecast of the Theory of Value to be Adopted

The *what* which is imaginatively fused into embodiment is, we have been saying, a value or values. I do not at this point propose to discuss the general nature of value that is embodied: this will form the main topic of Chapter V.[1] But it may possibly save misunderstanding if I state quite baldly, and without defence or justification, that the theory of value which is implied here is one which makes value in its essential nature quite objective to experiencing mind, to cognition, to desire, to enjoyment. In aesthetic experience we are in *fact* always concerned with the experience-of-value, and not with conceivable values out of all relation to appreciating mind. But cognition, desire, and feeling must be regarded as falling on the side of valuation, and not of value. The view of value itself which I shall adopt will be the view that value is the fulfilment or the frustration of tendency (one of the most important kinds of which is teleological tendency), fulfilment being positive, frustration negative, value. I shall treat mainly, unless otherwise stated, of positive value, and shall, if the context requires it, indicate its nature symbolically, thus; 'TF', 'TF' standing for tendency fulfilment. Teleology will be regarded as something which does not in its essence imply consciousness, at any rate finite consciousness. And two exemplifications of teleology (and therefore of value) which will be found to be of great, though not of exclusive, importance in human life and aesthetic experience, will be the values (*a*) of our own bodies and (*b*) of our minds. Finally, it may be noted that the fulfilments and frustrations of our bodies and our minds take place always in a larger world, whose tendency-fulfilling—or frustrating—*objects* are often unreflectively, and mistakenly, confused with our bodily and mental values. To

[1] Some readers may prefer at this juncture to read the parts of Chapter V concerned with the definition of value.

put it otherwise, teleological tendencies frequently (though not always) require definite and clear-cut objects in order that they may be fulfilled. Tendency to eat requires food, tendency to maintain normal temperature of the body requires warmth and exercise, tendency to think requires problems, and so on. These I shall call the 'terminal objects' (symbolised by 'O')[1] of value. And 'terminal objects' of values are often wrongly taken to be values in themselves. We think, for example, of the food or warmth as being good, instead of our bodily fulfilments.

## IX. Problems of the succeeding Chapters. A Warning

Having touched upon the three important notions (cited on p. 52), we may now pass on to state the problem of the next chapters. We have taken it that, broadly speaking, any object perceived 'imaginatively' is an aesthetic object. This, though true as far as it goes, is not a complete statement. For not *every* existing perceived object is, as it stands, fully aesthetically *satisfying* or beautiful. It may require alterations —omissions, selections, additions, unification—before it can satisfy the critical aesthetic percipient. This question, that of the construction cf beautiful wholes, we shall return to in Chapter VII. Leaving it on one side for the time being, let us now concentrate on the other question (raised on p. 51), the question, How do perceived objects come at all to appear to convey to mind meanings which they do not themselves literally possess? This general question will include problems of the expressiveness of sense data and of forms, and of the direct and indirect ways through which the expressiveness may take place. Our general question then is (to repeat), *How* do perceived characters come to *appear* to possess, for aesthetic imagination, qualities which

[1] To use the symbol T O would involve confusion with the 'T' of TF.

as bare perceived facts they do not possess? How does body, a non-mental object, come to 'embody' or 'express', for our aesthetic imagination, values which it does not literally contain? Why should colours and shapes and patterns, sounds and harmonies and rhythms, come to *mean* so very much more than they *are*?

In this chapter we have confined ourselves as far as was possible, and for reasons stated, to the consideration of examples of those perceived objects which are 'expressions' (in the ordinary, accepted, more general sense), in the material of our own bodies, to bodily manifestations of the emotions, to gestures, to facial expression, and so on. But it would not fairly present our problem were we to confine ourselves to these. For they form rather a special case, and the question, How does 'body' come to 'embody'? can be met by a special answer, the answer, namely, that our bodies express *functionally* our inner states of body and mind. As Darwin showed, the external manifestations of emotion have an intimate biological relation to the needs of the organism in certain situations. So that, when we apprehend aesthetically a gesture or a facial expression of anger, we are apprehending something in which the value-content is in actual fact in a most special relation to the 'body'. Our aesthetic experience is not made any the less 'aesthetic' thereby, for if we imaginatively apprehend the content as 'in' the body, its being already 'there' (in some merely approximate sense) does not detract from the aesthetic quality of our *experience* of it. Yet this is but one special case, and we must cast our net more widely. We must consider cases in which there is no such functional relation of body to content, cases like the colours and sounds and the patterns of these which are perceived as existing in a world external to living and functioning bodies. These things form a large part of the materials of the 'arts'.

In making this exploration it will be convenient to distinguish between two aspects of perceived objects, (*a*) their

sensuous aspects (e.g. colours, sounds, smells), and (*b*) their formal aspects (e.g. lines, volumes, melodies, harmonies). We shall, further, consider two main ways in which (*a*) and (*b*) come to appear as expressive, (1) by their direct effects upon us, and (2) by the effects of association. (1) (*a*) and (*b*) will form the main subject of the next chapter, and (2) (*a*) and (*b*) of the chapter which follows.

This is the plan we shall adopt. But it is necessary to issue a warning. When this part of the plan is complete, we shall only have been discussing some of the principles involved in the simplest sorts of aesthetic apprehension which in themselves do not possess a very high significance. There may be aesthetic quality in a curve or an autumn colour, or even in the sweetness of a St. Martin's wind. But, generally speaking, it is only when such data form part of more complex unities (as in a landscape or a work of art) that they become really important. The supplement to the next two chapters, therefore, can only be found in the later part of the book. And it will be necessary to remember that when sense data or forms do become parts of larger complexes their meaning becomes transformed thereby. Although, then, we must, of necessity, take our investigation step by step, let us not assume that a full and complete understanding of aesthetic principles is possible without an understanding of aesthetic objects and aesthetic experience in their fullness and their completeness.

# CHAPTER III

# 'DIRECT' AESTHETIC EXPRESSION

We have, so far, considered some main general principles of aesthetic expression. Our aim in this chapter will be to try to understand one way in which the two aspects of all perceived objects, namely, their sensuous, and their formal, characters, can come to appear as aesthetically expressive. There appear to be two important ways in which aesthetic expression may come into being, in which 'body' may come to 'embody' aesthetically valuable meaning. The first, which I have labelled the 'direct' way, we shall consider here. It arises through the 'direct' effect upon us of sensa and forms.

I wish to make it clear that I am using the terms 'expression' and 'expressive' inclusively, to apply both to sensa and to forms, and to modes of expression which arise 'directly', as well as to those which arise 'indirectly' or through association. This is the more necessary because some writers use the term 'expression' in a more, others in a less, inclusive sense. Bosanquet and Croce, so different in many ways, belong, I think, to the former category. Writers whose preoccupation is with the actual processes of art and the production of art forms, writers like Mr. Roger Fry and Mr. Clive Bell, tend sometimes to attach too little importance to the sensuous element[1] and to the effects of association. Their emphasis tends to be upon pure form, and upon what they conceive form in itself immediately expresses to the competent spectator.

Another type of exclusiveness is the common use of the term 'expression' as referring, not to 'direct' formal or sensuous appeal, but to associations, or to the meaning of the subject-matter which a work of art is supposed to be 'about'. Thus, a work of art is said to be 'expressive' if it derives its appeal from extra-aesthetic sources. Mere 'illustrative' painting or mere 'Programme' music would

[1] See below, p. 68.

be examples of this. Mr. Santayana,[1] although he must not be held guilty of the baser crimes involved in this kind of usage, uses the term 'expressive' to apply *only* to the appeal through association. For Mr. Santayana, neither sense data nor forms can be expressive, for 'expression' is wholly a function of association. We get thus in his scheme three distinct *kinds* of beauty: material or sensuous beauty, formal beauty, *and* expressive (associative) beauty. This is partly a matter of words: "It would be pedantic, perhaps, anywhere but in a treatise on aesthetics to deny [to simple sensa and forms] the name of expression; we might commonly say that the circle has one expression and the oval another. But what does the circle express except circularity, and the oval except the nature of the ellipse? Such expression *expresses* nothing: it is really *im*pression."[2] It is, however, as it happens in this case, not *merely* a verbal matter. For it is something of a question whether Santayana does not in part vitiate his treatment of beauty by his separation[3] of the three elements, although he does to some extent provide his own corrective at the end of his book. Again, his limited use of the term 'expression' seems to me to arise from an inadequate analysis of the conception. These criticisms are, of course, mere dogmatism, and to be acceptable would need the proof which I cannot here explicitly offer.

My main point is simply to assert, as against Santayana and any others, an inclusive use of the term 'expression'; to assert, for example, that circles and ovals (as well as colours and sounds, and tunes and harmonies) can in themselves appear as expressive, and that association is only *one* of two main processes which account for expression. If the implications of this be kept in mind, there will be no antithesis between 'formalism' and 'expressionism' as theories. For form as such will be 'expressive'. In actual

[1] In *The Sense of Beauty*.                    [2] Ibid., p. 84.
[3] On this see Mrs. Katharine Gilbert's excellent essay, *Studies in Recent Aesthetic*, p. 116 sq.

practice, no doubt, sensa imply forms and vice versa, and aesthetic effects, again, are complicated, not only by association, but, as we have already said, by relations of parts to the meanings of larger and more complex wholes. With these important facts continually in mind we are now committed to examining the aesthetic values of the parts— or, if preferred, the elements, which themselves are inadequate, imperfect, and not very significant, little wholes. Let us begin with sensa.

## II. WHETHER SENSA CAN EXPRESS AESTHETIC SIGNIFICANCE

We must first be clear that sensa do play a real part in aesthetic experience. This has been denied by 'formalists' like Mr. Fry and Mr. Bell. "Our emotional reactions", says Mr. Fry,[1] "are not, I say, about sensations. This may at first sight appear paradoxical, because the arts seem to be peculiarly preoccupied with agreeable sensations, with relatively pure colours and pure sounds. But it is not difficult to see that, however valuable a predisposing and accompanying condition of aesthetic apprehension such agreeably pure sensations may be, they are not essential, nor have we any difficulty in distinguishing between our response to sensations and our response to works of art." Or again,[2] "in literature there is no immediately sensual pleasure whatever." In Mr. Bell one finds similar attacks on colour.[3] "Colour in itself", he says, "has little or no significance. The mere juxtaposition of tones moves us hardly at all. As colourists themselves are fond of saying, 'It is the quantities that count'. It is not by his mixing and choosing, but by the shapes of his colours, and the combinations of those shapes, that we recognise the colourist. Colour becomes significant only when it becomes form."[4] The same kind of arguments might be applied, *pari passu*, to sounds.

[1] "Some Questions in Aesthetics", in *Transformations*, p. 3. Chatto & Windus.  [2] Ibid., p. 4.
[3] E.g. *Art*, p. 237. Chatto & Windus.  [4] Ibid., p. 236.

Now the school to which these two distinguished writers belong has been remarkable for the way in which it has shown, not only in the theory, but in the practice, of art, how such a sensum as colour can become vitally expressive of plastic form. But Mr. Fry and Mr. Bell do, it seems to me, in their preoccupation with the plastic importance of colour, fall into the mistake of underrating the sensuous, and the aesthetic, value of colour. Mr. Fry, speaking of sounds, says[1] that in most works of art agreeable sensations form the texture of the work, but that it does not follow from this that agreeable sensations are necessary, because, in modern work, sounds harsh and disagreeable in themselves may enter into the texture of what is pronounced aesthetically agreeable as a whole. There are, however, several fallacies here. Mr. Fry's argument is that relations transform the effects of disagreeable sounds and that it is their relations which make them aesthetic. We may agree to the first part, that relations transform the effect of sounds in themselves. And we may agree that the transforming effect of relations gives *new* aesthetic meaning. But we go too far if we suppose that because 'relations' are important the 'terms' have no importance, and therefore that sounds do not really contribute to aesthetic experience. Again, Mr. Fry seems to imply that sensations (or sensa, or sense data, as philosophers say) cannot themselves be aesthetic because *disagreeable* sensations may form the material of works of art. Thus the individual colours which Monet uses to build up his aesthetic effects may be disagreeable, though the whole gives aesthetic satisfaction. Mr. Fry appears to assume that 'disagreeable' and 'aesthetic' are mutually contradictory. This is very questionable; and even if it were true, it would still only show, what we have agreed upon, that relations do transform, and that in *some* cases the whole of the aesthetic effect is due to the relations, and none to the terms. But to this we have, very definitely, not agreed. It is simply impos-

[1] *Transformations*, p. 4.

sible to separate terms and relations in this way, and to say that everything is due to mere relations. If colours and sounds *in relation* can be aesthetic, the colours and sounds are still real factors having real effects, though in relation, and not in themselves. To deny the existence of the effects of sensa in a work of art, as Mr. Fry does when he says that there is no immediate sensual (sensuous) pleasure (aesthetic appeal) in literature, is surely the plainest falsehood. In poetry the speaking of a beautiful voice is not merely "a favourable predisposing condition";[1] it is a real and essential *part* of the effect.

Our concern now is not with sensa as parts of larger wholes, but with sensa regarded as far as possible in themselves: we have merely been trying to remove an a priori objection to their being considered as aesthetic objects at all.

## III. THE RELATIVE AESTHETIC IMPORTANCE OF THE VISUAL AND THE AUDITORY

It is possible to range sensa on a kind of scale, having at one end of it those sensa, such as colours and sounds, which are clearly and indisputably objective to and distinct from the sensing of them, and having at the other end sensa such as organic sensa, which are easily confused with the sensing of them. I am not suggesting that the latter *are* in fact indistinguishable, but only that it is more *difficult* in practice to distinguish, e.g., between the ache of a tooth or a muscle-joint-tendon strain, and the experiencing of it, than it is to distinguish between a colour and the seeing of it. On such a scale sensa such as those of smelling, tasting, and touching would occupy an intermediate and somewhat ambiguous position.

As in developed aesthetic experience the discrimination of form plays such an important part, it is natural and right that the objects of the two 'senses' whose discrimination of

[1] *Transformations*, p. 5.

form is most highly evolved, namely, vision and hearing,[1] should receive in aesthetic practice and aesthetic writings the lion's share of attention. But the aesthetic importance of vision and hearing is due also to another fact, hinted at in the last chapter, the fact that sights and sounds (and their relations) can most readily be *contemplated* as objects. That, we said, is an essential condition of all aesthetic experience. But whilst this is true, and whilst it is the case that visual and auditory sensa are the entities in terms of which visual and auditory *forms* are apprehended, and that visual and auditory forms are of almost supreme importance in art, it does not follow that visual and auditory sensa are the *only* ones which can yield aesthetic experience. It is rather that visual and auditory sensa are much *more* easily contemplated, and that the forms and patterns they assume are far richer, more complex, more subtle, than those, say, of tasting and smelling. It is a matter of degree. Tastes and smells, or organic sensa, are certainly more difficult to contemplate objectively. They may be pleasurable, but it is not easy to apprehend them as expressing meaning. And of course the forms and patterns which they can assume, even to an epicure in sensations, are immeasurably poorer than those of colours and sounds. And so the possibility of their expressing meanings is correspondingly less. With these provisions let us follow common custom, and concentrate on the visual and the auditory.

## IV. THE CORRELATIVITY OF SENSA AND FORMS

We are now concerned with visual and auditory sensa regarded in themselves, and as far as possible uncomplicated by relations to complex aesthetic wholes, or to formal

---

[1] Touch is in a peculiar position. It is immensely important in *coming* to know the external world, and has therefore probably more significance at that stage, e.g. in the case of children or blind persons. Normally it acts more as an adjunct of visual apprehension, through tactual imagery.

factors. This latter state of affairs is, of course, impossible to find in fact because of the correlativity of matter and form. Suppose we take as our sensum a single long-drawn note of a flute, or a single patch of colour. In one sense these are not 'forms', but of course they *have* form. In the first place each is *one*; it has the form of *unity*. Again, the lengthening out of the note in time, is form, and that form may introduce an element of expressiveness distinct from that belonging to the sound itself. Or, penetrating into the quality of the sound itself, we may apprehend form in the timbre of the note, or perhaps in its loudness or its pitch. It is difficult to say how far form can directly be discerned here, for of course we are biased through the possession of extra-aesthetic knowledge of physics. When we allege that the apprehension of a difference, say, between a note of the same pitch played by a flute and by a clarinet, is the apprehension of a difference between the form or structure of the two notes, we may be importing some such extra-aesthetic knowledge into our experience. But probably not, so far as the broader differences are concerned. We seem to *hear* some of their formal differences, e.g. a greater 'reediness' of tone in one as compared with the other. So, again, a loud note appears to have some audible[1] vibratory differences from a soft one, or a low note from a high one. But (to come back) however simple—or complex—it be, the note has always the form of unity.

Perhaps sounds with their timbre, pitch, and volume are more complex than colours. It appears, anyhow, easier to discern formal differences between sounds than is the case with colours. Colours, if they are different, seem to be different in an indefinable qualitative way. Each finest shade of difference is a *colour* difference. These differences may of course be *conditioned* by forms: colours are spread out[2] upon surfaces the variation of which may affect the tone, the

---

[1] Using 'audible' in its comprehensive sense.
[2] I am speaking popularly.

saturation, the intensity. The luminosity and the 'textures' of colours are dependent upon the forms of surfaces. But the sheer indefinable qualitative differences of colours—of violet from orange, of red from green—bulk possibly more largely in the total colour experience than do the sheer indefinable qualitative differences of sounds. This, if it is true, may be due to the biological history of the development of the ear. (Possibly it is not true.)

However these things may be, in both cases there is a residuum of sheer irreducible qualitative differences between different sensa, and it is this with which we are concerned.

## V. The Physiological Effects of Sounds and Colours

The physiological effects of sounds and colours are interesting. I should be guilty of irrelevance were I to enter into a discussion of them—apart from the question of my competence to do so. It is with what sounds and colours may *mean* to us, rather than with their physiological effects and the processes by which they come to be perceived, that we are concerned. But it is interesting, nevertheless, and quite important for aesthetics, to remember that sounds and colours do have physiological effects, and that our aesthetic experience of them is due in part to this.

The organic effect of sound is said to be more remarkable than that of colour: this has been explained in terms of biology, with which, however, we need not concern ourselves. The fact is also cited that the development of the auditory functions was a differentiation out of the primitive 'shake-organ'. These 'shake-organs', whose function was to re-establish equilibrium by means of reflexes, divided later into two organs, the organ of hearing, or the cochlea, and the organ of equilibrium, or the semi-circular canals. What exact inferences are to be drawn from this fact it is not my province to say. We can only note, for present purposes,

the physiological effects of sounds which it is possible to observe in ourselves. When the band goes past with drums beating and trumpets blaring, when the orchestra crashes out the first or the final note, when the door slams suddenly, our hearts beat more quickly, our breath comes and goes, our muscles tighten. Noises and sounds affect not mere audition, but the whole organism, often in a very striking way, and it is little wonder that the emotional effects should be great, even on this account alone. It is not improbable that the statement that the effects of sounds are greater than those of visual stimuli is a true one. Certainly "we dance to sound rather than to the waving of a baton or rhythmical flashes of light."[1] The great emotive effect of sounds may conceivably be the fact upon which the Greeks based the judgment (to us difficult to accept) that their music was the highest of all their arts.

But colours, too, have their direct physiological effects. Some of the stimulating or depressing effects of certain colours may be due to associations, but others are certainly not. Some colours in themselves awaken, as everyone knows, spontaneous signs of interest in the young child, or the young animal. Again, it is not possible to explain the exciting influence of red by reference to association. Valentine[2] cites the case of a man blind from the time of his birth to the time when a cataract was removed. To this man red was immediately pleasing, whilst yellow made him feel exceedingly sick. We must agree that here no association could possibly explain the matter. Again, the stimulating effect of colours on human beings can be tested by such instruments as the pneumograph and the sphygmograph. By means of these and other instruments it is found that, just as a high or a loud note is more stimulating than a low or a soft one, so colours at the 'warm' end of the

[1] Puffer, *Psychology of Beauty*, p. 169.
[2] *Experimental Psychology of Beauty*, p. 12.

spectrum are most stimulating.[1] The undoubted effect of sheer colour, especially on some persons, is proved by the fact that it has been thought worth while to construct an instrument called the 'colour-organ' with a keyboard by means of which 'chords' of colour are 'played' upon a screen consisting of folds of soft material. The effects are said to be impressive. Some of them, no doubt, are due to the forms, the rhythms, the flowing shapes and patterns which the colours assume in being 'played'. But the sheer stimulus of the colours no doubt plays an important part.

## VI. Examples of the Expressiveness of simple Sounds and Colours

The physiological effects of sounds and colours are facts about which the experts can tell us a great many interesting things. Our business, however, is not with these facts as such, but with the further question whether sounds and colours can be apprehended as aesthetically expressive, and if so, how? First, the fact. Do sounds and colours appear as expressive?

It seems quite certain that they do. The apprehension of sounds and colours may be, of course, just the apprehension of facts, as when in our ordinary practical frame of mind we hear the door-bell[2] ring, or see the table as a brown patch against the background of a yellow and red carpet and cream walls. But sometimes the apprehension of sounds and colours involves the apprehension of more than this; it involves the apprehension of values.

Take sounds first. Sounds may appear as 'cheerful', 'melancholy', 'steadfast', 'eerie', 'pathetic', 'sad'. In our experience they do indubitably appear sometimes to 'express' these qualities, which we may summarily designate

[1] *Experimental Psychology of Beauty*, p. 13.
[2] A door-bell *can* be terribly expressive!

as 'values'. They *speak* to us. The trumpet has a martial quality,

> "The trumpet's loud clangour
> Excites us to arms."

The drum has the emotive quality of thunder, the flute—

> "The soft complaining flute
> In dying notes discovers
> The woes of hopeless lovers,
> Whose dirge is whisper'd by the warbling lute."

The notes of the clarinet hesitate with an appealing pathos, the French horn is a buffoon. And so on.

As sounds 'speak', so in their own ways do colours. Orange may appear to express high-spiritedness, good cheer, blatancy; blue, simplicity, restfulness, or reserve; green is fresh and naïvely cheerful; red is alluring. It has been suggested[1] that the peculiar rather unpleasant character which some (certainly not all) pink sometimes appears to possess may be due to its suggestion of pretence. Here is a colour which seems to be *trying* to be pretty, and yet is too feeble to support its claim. Or it may appear feeble because pink is red watered down.

## VII. Two Remarks

About these illustrations of the apparent 'expressiveness' of sounds and colours two remarks may be made. One is that the effects of association will always be present and that they will contribute to the value which the sounds and colours appear to have. In the example of pink this may be very clearly so. We may associate pink with sentimental persons, with pink dresses and pink decorations and pink chocolate boxes. And the very notion of pretence itself is an imported one. Again, as the lines just quoted from Dryden show, the expressive qualities which sounds appear to

[1] By Mrs. K. Gilbert, *Studies in Recent Aesthetic*, p. 164.

possess are normally enriched by a cluster of associations. The trumpet and the drum have martial associations. Yet, though in fact these associations always do come into play in our apprehension of colours and sounds, it is certain that there is a residue of non-associative meaning. It is indeed probable that in many cases the colours and sounds have come to possess the associations through their intrinsic suggestiveness rather than by the reverse process. Their effects cannot be entirely due to association. A certain kind of crude pink comes to have vulgar associations because something in pinkness itself jars upon us, jars probably upon our organisms. The trumpet and the drum come to have martial associations because their quality, as appre- hended through our organisms, suggests in itself 'martial' meaning.

The other remark which may be made is that the values which these entities appear to express cannot properly be described in the crude words we use in pointing them out. The meaning which appears to be expressed must be taken *in its relation to* the sense datum. In relation its character is modified. If pink is 'feeble' or 'vulgar', it is not feebleness or vulgarity in general, but 'pinky-feeble' and 'pinky-vulgar'. Or if violet or blue expresses delicacy or mystery, it is not delicacy or mystery *apart* from blue, but 'blue-mystery' or 'violet-mystery'. Again, the 'martial' value of the trumpet and the drum must be imagined as *embodied* in the sounds.

## VIII. How Expression occurs

The fact that sounds and colours may seem to possess these and other values is, then, an indubitable fact of experience. How does this come about? We know that in themselves the colours and sounds literally possess none of these qualities. How do they come to appear to possess them?

The answer is simple but important. First, when we say that the colours and sounds literally possess none of the

values cited, we are thinking of colours and sounds as bare distinguishable data of cognition. If our minds simply cognised—and did nothing else—it is highly probable that sounds and colours could never come to appear to possess valuable meaning at all. But sounds and colours, though they can be regarded by an abstraction as data of cognition, are really, to our concrete experience, much more. Or, at least, they *can* be more. They can please us, for they can become the terminal objects (O)[1] of values (TF) in our own bodies.[2] A trumpet- or flute-sound, or a powder-blue—these are facts, but just because of their qualities, and the stimulation by their qualities of successful functioning in our organisms, they can become sources, or at least causes, of value-experience. 'Springy' green can act as a tonic. And further, sounds and colours, though they are the data of auditory and visual sense-organs, involve more than auditory and visual process. They involve, as we have seen, other processes and other sensa, kinaesthetic and organic.[3] These other processes likewise may be stimulated and fulfilled (or they may be thwarted). Not only the special sense-organs, but the whole body, may be soothed or stirred. We may experience a general sense of well-being, or of *joie de vivre*. So that what appears at first sight to be the apprehension of a bare sound or colour turns out to be the enjoyment of what is very considerably more, the enjoyment arising from the experience of the sensory and organic processes involved.

The enjoyment arises from the experience of the sensory and organic processes involved. The fulfilment of these processes is, according to the theory I am assuming, the true value (TF), the sounds and colours being merely

[1] See p. 61 above.    [2] But see footnote at the end of this chapter.
[3] At any rate, when they are intense or prolonged, or apprehended with some interest. It may be that there are no kinaesthetic sensations, and perhaps no organic ones, when a colour is flashed for an instant on a screen. But such cases, having little if any aesthetic value, hardly interest us here.

causes, terminal objects (O). But in aesthetic experience we are not, normally, thinking about our bodies, but rather about the sounds and the colours. These are, in perception, taken as existing in the world external to the body. Now, though these objects are, in the sense just stated, but causes of the occurrence in us of values, we do not, aesthetically, regard them as causes, but as themselves 'expressing' values. Our question is, How do the values get there? The only possible answer can be that we put them there—in imagination. They are not, aesthetically, apprehended as belonging to the organism. The focus of interest is in the external object, and to the external object they become imputed. Likewise their hedonic effects upon us, though they belong, analytically and abstractly regarded, to the side of the subject and not of the object, are in aesthetic experience apprehended to some extent *as if* they were hedonic properties of the external thing. In other words, not only qualities of the terminal object, but value itself, appears in aesthetic experience to characterise the object. And not only value, but even some of the qualities of valuation. It is no use saying prosaically that values *cannot* inhere in sound or colour: most philosophers would be ready to admit that. The point is that for aesthetic imagination they certainly do so. For the poet, the flowers *do* "paint the meadows with *delight*". Our moods become objectified. High-spiritedness, good cheer, blatancy, are imputed to the orange colouring; simplicity, restfulness, or perhaps a shrinking reserve, to blue. When our blood is stirred and we feel martial, we call the trumpet's note martial. From the queer shivers it gives us, we say that the flute 'complains'; or that it is unearthly. In cases of simple, even crude, aesthetic experience like those just mentioned, there may be a certain vacillation in the imputation; Bullough's subjects, it may be remembered, sometimes found it difficult to say whether a colour (or a note) was 'cheering' or 'cheerful'. There was a certain instability as between the 'character' and the 'physiological'

types. But in more developed, more complete aesthetic experiences, where the interests are strongly felt, it is probable that the imputation is carried out with less uncertainty. To mature aesthetic imagination a complex of valuable meanings appears without effort as *in* the symphony or as *in* the picture.

In all this it is, no doubt, easy to go too far. Because qualifications of our bodily and mental processes do appear to characterise objects outside the body, and because these external objects are, in such aesthetic experiences as we have been considering, the focus of our attention, we may be led mistakenly into thinking that awareness of our own bodies and minds vanishes, that we, as it were, hurl ourselves by main force (of imagination) at things. But consciousness of ourselves, 'immediate experience', can probably never disappear. It is a matter of degree and focus. We focus upon the external things, but the total content is our-functioning-bodies-and-minds-in-relation-to-these-things. Imputation takes place, but we do not impute everything. We might say, in a metaphor, that things are merely coloured by our relation to them. But to this subject we shall return.

### IX. Forms. Their Correlativity with Qualities; and their Aesthetic Importance

We know that formless sense data are non-existent. In apprehending colours or tones we are always apprehending something which is a unity, which is really a complex of such factors as tint, intensity, saturation, pitch, timbre, volume. Or, again, when we apprehend a patch of colour, say the uniform blue sky, the very fact of its approximately equal stimulation of the different parts of the retina is a fact of form. It is homogeneity. Yet though form is never absent, there remains an irreducible residuum of immediately perceived qualities to which we can attend.

An entirely analogous argument applies to forms. Form,

which is not the form of a matter, has no existence, for form is just arrangement, plan, structure, of something. Yet form, like matter, can be distinguished; we can attend to the arrangement, plan, structure. In practice we can do this best where the sensuous interest is not too insistent. Thus spatial structure can best be apprehended where the colours are not too attractive, whilst structures of sounds are best apprehended when our attention is not diverted by the entrancing qualities of the tones. We apprehend the structure of an organ-fugue better if the 'fancy' stops are avoided. Again, the structure of a pure rhythm may be apprehended perhaps best by the tapping of a stick; here the sounds have a minimum of intrinsic interest.

It is a question whether the expressiveness of forms 'directly' (or apart from association) is more potent than the expressiveness of simple colours and sounds. It is a fact, of course, that in our developed aesthetic experience of the arts, form is very important indeed, and whether or not it exceeds in importance the expressiveness of sense data, it is certainly more easily described. But we have to remember that sometimes the complication of forms involves also a complication and enrichment of sensuous appeal. And further, the expressiveness of forms is, in fact, in a work of art, undoubtedly very much enhanced by acquired meanings through association. Even with some effort, it is difficult to ignore this. If we confine ourselves to the expressiveness of pure forms, it may be that forms have just as little significance as colours or sounds, perhaps less of it. On the other hand, rhythms and the structures of simple tunes probably possess more powerful appeal than the appeal of single sounds. But all this is not very important; it is a matter of experience, rather than of principle.

## X. Reasons for now taking the Expressiveness of Forms together with that of Sensa

I propose now, instead of treating of the expressiveness of pure forms apart from sensuous expressiveness, to treat of the expressiveness of forms together with the expressiveness of the sensa which are bound up with the forms. Logically, perhaps, we ought to follow our previous procedure and to consider first the expressiveness of pure form apart from sensa. But in aesthetic effect this amounts to so very little that it need only be mentioned. It may be possible, for example, on looking at a small object flashed for an instant on a screen to apprehend its shape with a minimum of sensuous experience. But this is, aesthetically, quite an unimportant case. In significant aesthetic experience the apprehension of spatial forms would seem always to involve a considerable complexity of kinaesthetic and organic experience. (It is doubtful, for example, whether the aesthetic value of a very small cameo carved on a ring would be very great if we saw it only for an instant. In the first place, such an object requires attention, and attention takes some time. Secondly, in taking time we explore the detail of the object, probably enlarging it imaginally, or fancying ourselves extremely small, so that we can touch and move over its contours. And in the third place, its value will partly arise, in all probability, from its associative meaning. Its making involves skill and delicacy; it is small, and this arouses a certain tender emotion. And so on. All these factors are additional to the instantaneous visual apprehension of the form.) So again, as regards auditory form, it is hard to conceive of significant aesthetic experience which does not involve sensuous values in the very apprehension of structure. The apprehension of the structures of rhythms and tunes has a sensuous aspect which cannot be ignored.

So, in treating of the aesthetic expressiveness of forms, we shall not exclude sensuous values. (We shall still try to exclude associations as far as possible.) It will also be of additional advantage now to include over again consideration of the expressiveness of sensa, because this will supplement what we had to say about sensuous expressiveness in the previous section. There, having to limit ourselves to the expressiveness of simple colours and sounds, we could not consider their fuller significance. This fuller significance is seen only in the concrete apprehension of forms.

## XI. Examples of Formal Expressiveness

As before, let us begin with the facts. There is little doubt, I suppose, that visual and auditory forms can be expressive, though their 'direct' expressiveness is always hard to name, and it is always impossible to escape from the effects of associations, including infantile ones. Still, it is possible, by an effort of abstraction, to discern some of them. On the visual side we have lines, planes, and solids. Straight lines express the 'values' of directness, unwaveringness, what can only be called, in rather feeble language, rectilinear efficiency. Horizontal lines suggest—and not, I think, through association only—stability and balance; vertical straight lines in a picture or a landscape or a building suggest a different kind of stability. They do not rest upon anything along their length, but rise vigorously, containing the principle of their own stability. (I am thinking here, of course, mainly of lines bounding upstanding solids.)

Curves possess expressiveness, both on account of their curvature, or, if delineated (and we allow 'association' with the activity of delineation), on account of the varying thickness of the lines in which they are drawn. A line graduating from fine to thick may suggest vigour and vitality. Some curves suggest grace, or fluidity, or, again, vigour. Others suggest uncertainty and hesitation. When we

take into account the gesture-significance that lines may sometimes have, it explains some people's dislike of straight lines, whilst it also explains some of the pleasure we may get in curves. Lines appear to flow, and a pleasing trajectory is that of flowing and unstrained gesture.

The significance of lines becomes altered when they are clearly regarded as boundaries of planes and solids. Planes and solids have aesthetic value which is certainly not reducible to the aesthetic value of their boundaries: this is a fact which is sometimes overlooked by some of the 'Empathists'. In plane figures and solids our attention is properly directed upon these more inclusive wholes as wholes. Pure circles, ellipses, squares, rectangles, and the various polygons are not highly interesting forms, but they may certainly be expressive in a simple way. It is difficult, once again, to say *what* a circle or an ellipse expresses. The circle seems perhaps to possess a certain serenity and peace. It is the most perfect and self-contained whole, seeming in its very form to spring forth from its own centre. It is not thrilling, but it is in its limited way satisfying. The ellipse, again, is expressive of the value of a certain order, more interesting than the order of the circle, its circumference being an order of continuous and even-flowing change. More than this it is difficult to say. Again, four-squareness expresses the values of strength, stability, order, self-containedness.

When the square becomes part of a three-dimensional cube we get, especially if it is a large cube, as in a building, a particularly satisfying shape of the simpler sort, returning equal for equal threefold. It has captured the imagination of the writer of Revelation. "And the city lieth foursquare, and the length is as large as the breadth: and he measured the city with the reed, twelve thousand furlongs. The length and the breadth and the height of it are equal."[1] The dimensions, again, of solids are most important material

[1] Rev. xxi. 16.

in the work of the architect. Take away the plinth from your temple and it loses half its dignity of effect. The sheer size of the ancient monuments of Egypt expresses sublimity. The vast heights of the Gothic cathedral, the straight columns, pointed arches, and complicated volumes of dim-lit empty spaces—all these have their meanings to the aesthetic percipient.

There is no need to go over the ground in the case of sound-forms. The simplest cases are perhaps those of rhythms and tunes. Compare the expressiveness of the rhythm of a dead march with that of "The Road to the Isles" or of a jazz tune. And compare "Nellie Bly" with the "Old Hundredth", with "Rule Britannia", with the opening melody in the second movement of Beethoven's "Fifth Symphony". Rhythm, melody, counterpoint, harmony—to the expressiveness of forms of sound it is difficult to set limit.

## XII. How Formal Expression occurs. Brief Statement and Criticism of 'Empathy'

These are the facts: once again we ask, How do these perceived objects come to appear expressive? The general answer we shall expect to be the same as that which was made about the expressiveness of sense data. But the subject has been given so much attention by the exponents of the theory called 'Empathy' that we must devote a short space to considering one or two important aspects of this theory.

The Theory of *Einfühlung* (translated *Empathy* by Professor Titchener) was applied by Lotze and Vischer to general aesthetics and by Lipps to psychology. It is grounded in certain facts, or certain alleged facts, of perception, principally the facts of the motor-processes involved in perception, and of motor and tactual images. A stone or an elephant looks heavy. This fact is due partly to a revival of past motor experience, partly to actual present motor attitudes, and partly to images of ourselves acting. Again, size is

apprehended by movements of the eye, by incipient move-
ments of hand, finger, leg, or the whole body; or by various
images of these. In apprehending rhythm we tend to beat
time, in watching the acrobat sway, we sway ourselves, in
the excitement of watching a football match we may
clutch or kick our inoffensive neighbour. In general, excited
perception involves as a rule both motor imagery and actual
movements, or at least, if not overt movements, dispositions
to move, shiftings of muscular tensions, and so on. That
our motor attitudes do vary in varying circumstances can be
substantiated by self-observation of the different attitudes
we take up before different pictures, when we move about
a picture gallery from picture to picture. Or we may com-
pare our attitudes during different items in a concert, or
as we suddenly shift our attention from, say, classical to
baroque architecture.

These are the facts on which empathy is based. The
theory of empathy is that these activities of ours tend to be
merged with the qualities of the perceived object: they are
'felt into' the object. When we look at the column, and it
appears to 'stand straight up', 'to raise itself', to remain
self-contained in erect tension, this is really a projection of
my own muscular[1] experiences of tense upstanding. Or
when the mountain appears to rise, this is an idea "started
by the awareness of our own lifting or raising of our eyes,
head or neck, and it is an idea containing the awareness of
that lifting or raising".[2] But it is more than this. This is
"merely the nucleus to which gravitates our remembrance
of all similar acts of raising or *rising* which we have ever
accomplished or seen accomplished, *raising* or *rising* not
only of our eyes and head, but of every other part of our
body which we ever perceived to be rising. And not
merely the thought of past *rising* but the thought also of
future rising."[3]

[1] Lipps indeed argued that it is mental ideas, and not muscular sensa,
which are projected. In the above remarks I am indebted to Langfeld,
*The Aesthetic Attitude*, Chapter V sqq.
[2] Vernon Lee, *The Beautiful*, p. 64.                    [3] Ibid.

So again in the apprehension of more complex forms, as, for example, the Gothic cathedral, the complexity of stresses, and weights, and resisting supports, and the systems of line-directions is felt, it is said, because of our past and present motor experiences and images.

On the question whether there is a perception of one's own activities being projected, there appears to be some doubt. Karl Groos speaks as if we were conscious of our "inner mimicry". Lipps, on the other hand, contends that we have no sensation of muscular effort in aesthetic experience itself. On the whole, opinion seems to side with Lipps in this matter. Empathy, it is said, is not sympathy, or 'feeling along with'. When we become *aware* of ourselves having motor and allied experiences, or when we *discern* any process of projection, we have ceased to empathise. To this point we shall return.

If 'empathy' simply means what we have called 'imputation', then it is an acceptable enough theory. But in fact 'empathy' needs to be salted before being taken. It would seem that the theory is too specialised; it lays too much stress on the motor element in perception, and in two ways. In the first place, the empathists appear to assume often that movement is essential in all apprehension of form. But, as has been suggested, there is no sufficient reason for supposing that movement occurs in the instantaneous visual perception of a comparatively small sensum. This objection, however, is not important aesthetically, as we have seen.

But even if it be granted that in *aesthetic* experience movement is always present, and must be always present, surely, in the second place, visual objects are a little solider, a little steadier, than would appear from the writings of, for example, Miss Vernon Lee? Her world is a strange world, and it may be doubted whether her account of it is even authentic. For would not many of these movements of which she speaks contradict one another, making for aesthetic chaos and disunity? Of the far-off mountain we are told

that she sees "a narrow and pointed cone, perhaps a little *toppling* to one side, of uniform hyacinth blue *detaching* itself from the clear evening sky, into which, from the paler misty blue of the plain, it *rises*, a mere bodiless shape. It *rises*. There is at present no doubt about its *rising*. It rises and keeps on rising, never stopping unless *we* stop looking at it. It rises and never *has* risen."[1] The lines *strive*, they *endeavour*, they *arrive*, they *arrest* each other. The whole business is "like the parabola of a steadily spurting fountain". Now there is no doubt that, in some particularly vigorous moods, parts of things may look like this, particularly if we interest ourselves in the direction of lines. But surely not *every* part? For then we should have aesthetic contradictions. And surely not *always*? And surely this is not all? A steadily spurting fountain is sometimes entertaining, but the thing may get tedious, and we turn to other things in art or nature with a sigh of relief. The aesthetic value of the mountain is—is it not?—considerably more complex than would appear in such a description as the above. What are we to say, for example, of the value of its colour? Or of its general associations? The importance of motor elements would, in fact, appear to vary very greatly from time to time. Compare, for example, the difference between our motor attitude to some of the Giotto frescoes in the Arena Chapel at Padua, with Michelangelo's paintings on the roof of the Sistine Chapel, or with the 'Discobolus' of Myron, or with the 'Laocoön'.

Again, although empathists admit the existence of images, they do not always realise two things, first, their importance, and second, the subservience of movements and images of movements to the apprehension of wholes. (1) If, for example, I perceive aesthetically a jar or a circle or a mountain, it is possible that movements or incipient movements or muscular adjustments always take place. But these must be comparatively unimportant compared

[1] Op. cit., pp. 71–72.

with my images—for example, my tactual images of 'feeling' the continuous smooth surface of the vase, of moving my finger or an imaginary pencil round parts of the circumference of the circle, of my imaginary tracing of the curves of the mountain.

(2) But neither movements nor even imagined movements are anything like adequate to account for my experience. For my images do not completely supplement my bare schematic movements. They are themselves bare and schematic. If I introspect my experience of apprehending a vase I cannot discover that I do more than give imaginary little exploring touches or strokes here and there, in order to realise more vividly the shape and surface and texture. Both actual movements and images presuppose my apprehension of the form as a whole, not certainly in all its detail, but still, as a whole. It is an established fact that I can apprehend a visual form flashed instantaneously on a screen, when there is no possibility of eye-movements taking place. Probably also there is no time for other muscular movements or adjustments to occur. Even when such do occur it is no proof that apprehension of form cannot occur without them. Indeed, the burden of proof—and it would appear an impossible burden—really lies with those who believe movements to be essential to the perception of forms. In fact it seems clear that it must be apprehension of the form which determines the movements (and images) and that the reverse cannot possibly be true. As Myers puts it: "There is indeed reason for believing that eye movements are rather the result than the cause of our estimation of small spatial magnitudes, and that the primary basis of such estimation is to be sought in the sensibility of the cerebro-retinal apparatus and not merely in that of the muscular apparatus of the eye."[1] That the mature apprehension of forms undoubtedly involves the assimilation of past apprehensions makes no difference, for the very

[1] *Experimental Psychology*, p. 53.

recognition of forms implies that it is *this* form rather than *that* which is already perceived.[1] It is the jar, then, or the mountain or the circle, as units, which we apprehend, and the kinaesthetic and other sensa which are involved in the enjoyable exploration of these are supplementary, are logically secondary, and have their meaning only as filling up the detail of generally apprehended wholes. My enjoyment of my imaginary tactual exploration of the surface of the vase—an exploration which normally would always be partial and incomplete—is supplementary, is an important supplement to my seeing of the vase as a single continuous whole. It is only the presupposition of the singleness and continuity which integrates my tactual and other sensa, which otherwise would be detached and unrelated.

Recognition of these facts makes us independent of certain criticisms regarding eye-movements which are rather damaging to a consistent theory of motor empathy. It used to be thought that the beauty of some shapes could be partly accounted for by the fact that in looking at them the eye moves in continuous and pleasing curves. Now we know that in such cases the eye often, if not always, moves in jerks. For a theory which puts its trust in the pleasure of 'empathised' muscular sensations in the eye this is a serious objection. And it is hardly comforting to point out that the jerkiness or otherwise of eye-movements is of little importance because there are no joint sensations in eye-movements and its rolling tactual sensations are comparatively slight. For this is just equivalent to saying that eye-movements— of whatever kind—matter very little at all. But if we alter our tune altogether and say that eye-movements are instrumental to the more detailed apprehension of form (by bringing images of different areas of the object on to the fovea) we put eye-movements (and other movements) in their proper and useful place. Eye-movements, tactual movements, muscular movements, and organic sensa, real

[1] On this see also Stout's *Manual*, Third Ed., p. 165.

and imaginary, are, to repeat, rough and schematic, are subservient to the apprehension of a given whole and are throughout controlled and unified by the apprehension of the whole. The enjoyment of these bodily processes forms part of and enriches a larger whole of experience which is vivid mental awareness and enjoyment of objects. I am not, then, arguing that empathy of bodily states and of images is not important in aesthetic experience, for it is. But it is, logically speaking, subservient and of secondary importance.

Empathy, I suggest, is satisfactory up to a point. But owing to its association with a somewhat limited and narrow interpretation of aesthetic and ordinary perception, it is better, I think, to avoid the term. The word 'imputation' is on the whole preferable. In using it we are bound by no tradition to concentrate too exclusively on bodily—or even mental—factors. Anything appropriate to the aesthetic whole can be imputed, associated images of any kind, ideas, meanings—things which far transcend bodily or mental states. Again, 'feeling into' is a muddled conception, whereas 'thinking into' is certainly very much less so. 'Feeling into' suggests that only our own states can be imputed, which is an unjustified assumption. Again, *how* can we 'feel into'? I cannot really 'feel' a movement or anything else *into* a mountain or a vase, though I can quite well *think* it there when it is not; and this is really what is meant by 'thinking into'. We must not, of course, interpret 'puto' as if it meant *self-conscious* thinking, and here the term 'feeling' has perhaps some faint advantage. But thinking need not mean conscious cogitation. Thinking may mean 'taking as'. It is not stretching words to say that some drunkards *think* they see pink rats. Thinking 'rising' into a pillar is in the same case, though with obvious differences which need not be pointed out.

XIII. Problem of the Awareness of our own States in
Aesthetic Experience

A further word may be added here regarding the question,
already raised, how far we are in aesthetic experience *con-
scious* of our own processes, including that of imputation. It
is not at all clear that it is so necessary as some empathists
think, to say that we are unconscious of our organisms in
aesthetic experience. In the controversy between complete
'projection' and 'inner mimicry' we are not really obliged
to take one side or the other. In aesthetic experience the
focus of attention is upon the object, and our experiences
of such movements and enjoyed organic processes as we
have, do tend to become imputed to the object of interest.
But there is no reason, as I have already suggested, for
saying that we must be entirely oblivious of everything
except that which is in the focus of attention, that we must,
in particular, be entirely oblivious of our own bodies as such.
Our experience of our bodies may be marginal, but that
it does enter as object into genuine aesthetic experience
seems to be testified to by introspection. I can quite well
be aware marginally of my own slight movements and of
the images of finger and hand movements when I am
aesthetically apprehending the jar. Or I can enjoy the
music *and* 'feel' it, though marginally, in my organism.
It *may* be that in some intense aesthetic experiences our
interest in the object is so held and fixed that conscious-
ness of our organisms disappears. It is rather questionable.
But in any case it is not so always, and not so for everyone.
For most persons a measure of conscious organic excitement is
present, and I do not think we have any right to say that
this is an anti-aesthetic symptom. We *can* be aware of more
than one thing at a time. All that is required is that, as
Bosanquet puts it, our 'feelings' shall be *relevant* to a per-
ceived object.[1] Or, once again, they 'colour' what we

[1] *Three Lectures on Aesthetic*, pp. 4–5.

perceive. They colour without disappearing as feelings. The *meadows* are painted with delight, and *we* may well delight in our own delight in the delight of the meadows.

## XIV. A CONSIDERATION OF SOME OF THE TERMS THAT HAVE BEEN USED

In describing aesthetic expression we have happened on a number of terms which have slightly different, but converging, meanings. It may be useful to compare, in a few sentences, the meanings of such terms and phrases as *Empathy, Distance, Projection, Imputation, Imagination, object-appearing-to-express-value*. There is, again, Santayana's *pleasure-objectified*[1] (or *Pleasure as the quality of a thing*). And there is Bosanquet's question,[2] 'How can a feeling get into an object?'

In general, these words and phrases refer to the same sort of thing. One might divide them into two classes perhaps, though the division is not quite perfect. One class would contain those words and phrases which describe or question about the *process* by which an aesthetic experience is produced, and the other would contain those which describe more or less the plain fact of aesthetic experience. In the latter class we might put *Imagination* and *the-object-appearing-to-express-value*. All the rest would belong (more or less) to the first class.

The term 'Empathy' we have criticised principally on account of its limited meanings and the obscurity of the phrase 'feeling into' as a description. Bosanquet's question, *How can a feeling get into an object?* is legitimate because it is a question, and not an answer. Bosanquet is asking for an explanation of something which in fast appears to occur in aesthetic experience. The music does seem to express 'feeling', and, if it does, theing feel must appear *in* the object.

[1] *The Sense of Beauty*, p. 44 sq.
[2] *Three Lectures*, p. 74.

But to ask how this happens is very different from offering 'feeling into' as an explanation.

As we have seen, 'Imputation', if interpreted properly, is a sounder term to use than Empathy. It is, again, a better term than 'Projection', which is more metaphorical. 'Imputation', too, more readily contains the idea of imaginative fusion than does 'projection'. The term 'Distance' is, again, metaphorical, but its meaning has been explained so clearly that this disadvantage vanishes: and Distance does symbolise a fact of great importance in aesthetic experience. Interpreted broadly it may be said to include the idea of Imputation, and almost the idea of Expression. But it does not, I think, replace *Expression*; there is much more in Expression than is meant by the term 'Distance'. Imagination and Expression are terms which alone seem able to contain the richness of meaning which any adequate account of aesthetic experience should include.

The phrase 'Pleasure-objectified' is good as far as it goes. But it is bad in so far as it suggests to superficial observation, first, that aesthetic experience is a matter of mere pleasure, and, second, in that it prejudges the question whether pain or unpleasure may not be involved in aesthetic experience. Again, 'Pleasure-objectified' is in itself a phrase to which it is extraordinarily difficult to attach a meaning. Put as a question, on the model of Bosanquet's question, it is permissible; as an answer, hardly. But 'Pleasure-objectified' is good in so far as it stresses the value-aspect of aesthetic expression (though it is far better to say that the object appears to express *value* than that it appears to express *pleasure*). A limitation of most of the phrases, except the two just mentioned, is that they do not suggest that it is values which are expressed.

## XV. Transition

We have now concluded our slight sketch of the principles
of the 'direct' expressiveness of sense data and forms, that is,
expressiveness considered as far as possible as distinct from
association. But this distinctness has been most difficult to
maintain, for the simple reason that in the world we know
our experience is one and continuous, and it is therefore
impossible to stop short with bodily[1] meanings. The ex-
periences of our bodies, or, if preferred, the bodily meanings,
which are imputed to objects, are fused and intermingled
with a tissue of associated meanings, to whose boundaries
and implications it is impossible to set limits. We are not
bodies only, nor are bodily things our only objects. We are
bodies-and-minds; and, because minds are the minds of
bodies, and bodies the bodies of minds, the things of the
body and the things perceived through the body are charged
with significance, with valuable significance, with a whole
world of valuable meanings. These are nothing less than the
whole inheritance of life. To the consideration of some
problems concerning these wider valuable meanings we may
now turn.

---

[1] The body has been stressed in this chapter. But of course *mental* values
may enter 'directly' into aesthetic objects. The instances given on
pp. 75–76 and 83–85 could be taken as revealing the fulfilment of such
*mental* tendencies as pugnacity, tenderness, sympathy, aspiration, sex,
curiosity, and many other deeper mental longings. These, however,
tend to be revealed more explicitly in more complex objects, such as
works of art. In relation to the very simplest objects, and particularly
to sensa, the body bulks largely. But not exclusively. Let the 'bodily'
or 'organic' factors in direct expression, then, be taken to mean '*mainly*
bodily', '*mainly* organic'.

# CHAPTER IV

# 'INDIRECT' AESTHETIC EXPRESSION

# I. Two Remarks on Association

In the present chapter we shall make much use of the concept of 'association'. Before beginning the discussion, let me make two general remarks.

(1) I intend that the term 'association' shall be used here in the widest possible sense. It will be taken to include associations 'tied' and 'free', by contiguity in time and in place, by similarity, by contrast (or by 'continuity' in Ward's sense[1]). It will include associations common to many persons and associations personal and private, associations natural (as 'grass' and 'green') and associations artificial (as many word- or colour-symbols with their meanings), or associations now become conventional by use (as the Cross, the Lamb, the Fish). Several of these classes, of course, overlap. I am not trying to classify them, but am trying simply to indicate that no possible mode of association (not even personal and private ones)[2] is to be excluded without reason from the class of 'associations'.

(2) 'Association' is a term used in psychology; it should hardly be necessary to point out, however, that *what* is associated is not therefore mental. The mind possesses the power of retentiveness, synthesis, and so on, but its contents fall on the objective side. The objects may be mental (as when one fear suggests another), but they need not be.

# II. Fusion, and Aesthetic Fusion

The contents of the associative process in aesthetic experience must, as has been said, be 'relevant' (in the described sense) to the object in the focus of attention. It might perhaps be thought correct to say that the contents must be 'fused' with the focal object, i.e. relevance might be taken as meaning the same thing as what in psychology is called 'fusion'. If green, for example, appears to *be* cheerful,

[1] *Psychological Principles*, p. 193.　　　　[2] See below, p. 102.

it is because cheerful associations have become fused with the present percept. We saw, indeed, how Myers,[1] Bullough,[2] and others also emphasise the aesthetic importance of fusion, meaning by fusion, fusion in the ordinary accepted sense.

Now this may be, up to a point, all very well when we are dealing with simple entities like colours and sounds. With some possible qualifications[3] it may be said that there is not much restriction of the things to which, under some circumstances, a simple colour or sound may be aesthetically relevant. In such simple cases almost anything can be relevant to anything, and there is little or no aesthetic determination or exclusion. In *this* case fusion and aesthetic relevance are one, because anything, or almost anything, is relevant. When, however, we come to consider more complex objects (like works of art), we find ourselves compelled to distinguish between psychological fusion and aesthetic fusion (or aesthetic relevance) because associations which are perfectly and completely fused in the psychological sense may jar upon a delicately constructed system of aesthetic meanings. They may make for ugliness and *not* beauty. Although to speak here of the work of art, its unity and its beauty, is to anticipate future discussions, the distinction is so important that it cannot be avoided in any treatment of 'indirect' expressiveness.

Fused associations in the ordinary psychological sense are associations of whose source we are not explicitly conscious. They are assimilated associations (though in saying these things it must be kept in mind that there are degrees of fusion and assimilation). Fusion and assimilation are illustrated in the process known as apperception. When, for example, the snow 'looks' colds or soft, the associated cutaneous images of 'cold' and 'soft' are fused, in a process technically sometimes known as 'complication', with the

[1] "Individual Differences in Listening to Music", *British Journal of Psychology*, Vol. XIII.                    [2] Op. cit.
[3] For a fuller discussion of this subject, see p. 103.

present visual experience of the snow. So that its coldness and its softness are perceived by common sense as characterising the snow just as certainly as its 'visual' quality of whiteness is perceived as characterising it.

The fact of the enormous importance of apperception in ordinary experience, is enough to absolve us from any possible criticisms in the future of exaggerating its place in the special case of aesthetic experience. What we actually sense is a minute proportion of what we apperceive. This is illustrated, if illustration be necessary, by the case of reading. "Erdman and Dodge proved that the eyes in reading do not move constantly and smoothly over the line, but go by a series of short movements with rests between." The individual letters are discernible only when the eyes are at rest. "It is quite easy to determine from the length of the line and the number of rests, the number of letters which are read at a single glance. It was found that this was considerably greater than the number that could fall at one time on the area of the retina sensitive enough to permit them to be read. The other letters must, it is evident, be supplied by association from the material gathered in earlier experiences."[1]

Aesthetic fusion, on the other hand, as its name implies, is fusion determined primarily by aesthetic needs, and not primarily by cognitive and practical ones—though these may, of course, be implied and contained in aesthetic experience. Where the aesthetic focal object is to any degree complex, the total object becomes a unity, an organisation, a system, of embodied valuable meanings, which prescribes what shall, and what shall not, enter into it. A simple colour or sound may, as we said, fuse aesthetically with almost anything; not so a picture or a poem or a sonata. Aesthetic fusion is determined by a norm, the norm of aesthetic satisfaction, the norm of what objectively we call beauty, and before an idea can be accepted

[1] Stout, *Manual*, Third Ed., p. 148.

in an aesthetic system, it must fit in with the system, it must not distract, it must be aesthetically harmonious, it must be truly relevant. If we were seeking for defined *laws* in aesthetics, we might say here that there is a close analogy (though only an analogy) between the organisation of the aesthetic object and the organisation of a sentiment which, in Shand's words, "tends to include in its system all those emotions that are of service to its ends, and to exclude all those which are useless or antagonistic".[1]

Fusion in the general psychological sense (which I will call for short 'psychological fusion') is thus quite distinct from aesthetic fusion or aesthetic relevance. The two may, or may not, go together. Thus an aesthetically relevant or aesthetically fused association may occur, and it may qualify the focal object in such a way that we are not explicitly conscious of the source of the association. There is here 'fusion' in both senses. Or there might be psychological without aesthetic fusion. Or it might be that an association which is aesthetically fused or aesthetically relevant is not psychologically fused. This is notably the case in an art like poetry. Poetry is expressed in words and words suggest images and ideas, and in poetry we may be explicitly conscious of both the words and the ideas or images with which they are associated. The two must be aesthetically relevant. They must form parts of a single harmonious system. As A. C. Bradley has it, "The meaning and the sounds are one; there is, if I may put it so, a resonant meaning or a meaning resonance."[2] But they need not be psychologically fused.

Very generally speaking, then, psychological fusion may or may not occur, but aesthetic fusion must, or the object thus far fails as an aesthetic object. Once again, to say these things here is really to anticipate, but anticipation is hardly avoidable.

[1] *The Foundations of Character*, Second Ed., p. 62.
[2] "Poetry for Poetry's Sake", *Oxford Lectures*.

## III. Examples of Associations of Sights and Sounds

We have seen, in discussing the expressiveness of sense data and forms, how associations tend to come crowding in. In aesthetic experience, as has now been repeatedly said, they need not be discerned *as* associations, but analysis can discover some of them. In the visual sphere colours and shapes suggest many values ; green suggests fresh 'springiness', or the owner of a green dress, or safety, or the coldness of ice, or "green-eyed Jealousy". Blue may suggest the sea, or the midday or the midnight skies. Perhaps if blue appears 'cold', 'reserved', 'distant' this is in part due to the coldness and the distance of the sky. Yellow may suggest sunshine, or daffodils, or primroses, or jaundice. Such meanings depend partly upon individual history, partly upon associations common to all, and partly (always) upon context. The *textures* of visual appearances again have their associations ; velvet is 'soft', 'sensuous', 'delicate' ; steel means 'hardness'. It is 'icy', and 'glittering', 'unsympathetic', 'impersonal'. Lines and shapes have meanings : vertical lines and shapes are like tall upstanding sentinels, dignified, self-contained, asking nothing, taking nothing. The tall trees look down upon one with lofty disdain. Horizontal lines are associated with rest, with sleep, with width, calmness, peace. Curves are like persons, 'shallow' or 'reserved', 'feeble' and 'meaningless', 'rich', 'round', 'voluptuous'. For a concrete instance let us take one of Jensen's delightful creations, a large, shallow-bowled spoon with sinuous handle. The lines are smooth, easy, liquid, flowing; the handle is deliciously curved, like the tail of a leopard. And strangely, without contradiction, the leopard's tail is finished with little raised nodules like small grapes. It is a queer mixture of a leaf and a leopard. The texture is grey and dull like river mist, and it is lit with soft lights shining out of it like the moon out of a misty sky. The sheen is like white-grey satin : the

bowl is delicately shaped with over-turning fastidiously pointed fronds; it is restrained and shallow, yet large enough to be generous. The lines are fine and sharp with clean edges. Thus described, such a concatenation of qualities may sound absurd and incongruous. But if you hold the spoon in your hand, you feel it as a kind of poem which in a strange way unites all these, and many other, values into a single whole. You feel as you see it that you are living in a gracious world, full of loveliness and delight.

I will not go on, tediously, to try to give examples of associations which sounds may have. As a matter of fact it is very much more difficult to do so. Sounds have an immense direct emotional effect (for whatever reasons) and it has been suggested that perhaps their direct organic effects are greater than those which the eye mediates. It can be said, in very general terms, that the harmonious bodily processes set up by sounds affect the whole tone and level, not only of physical, but of psycho-physical life. And conversely we may say with confidence—again, for the present using very general terms—that music may be the expression of profound human experience. But it is astonishingly difficult to say, in non-musical terms, *why* or *how* Beethoven's Seventh Symphony comes to be humanly great.

In giving examples of associations I have not attempted to mark off private and subjective associations—such as the association of a colour with a certain person or political party—from associations which are relatively more common to all of us (such as the sky with blue, or the primrose with yellow). A 'general' or 'objective' or 'common' association has no intrinsic aesthetic advantage over a subjective or individual one. If *everyone* sees in blue patches something of the qualities of the heavens, that is not to say that it is more aesthetic to see sky-value in blue than it is to fuse with blue some pleasant private association of a blue dress, or to see a sort of painfulness in it (due to, say, associations

with a surgeon's eyes). The sense datum is equally 'expressive' whether it expresses a valuable experience which is shared by almost everyone, or whether it expresses a valuable experience which is quite private and individual. On the other hand. the objective or general association may have a greater social value when it is employed in a work of *art*. A work of art may be, primarily and fundamentally, expression; but in most if not all cases it also involves communication; and if the artist is to communicate, the data which he chooses must be so arranged that the associated meanings to be called up are as common and universal as possible. Of course no rules can be laid down as to how far an artist may objectify his own particular and private experiences, for the charm of his work may consist in its individuality and even in its idiosyncrasy, but he must make as plain and clear as possible the meaning of his idiosyncrasy, otherwise he is not speaking of his peculiar experiences in a common language which can be understood. He fails to convince.

## IV. Problems of the Working of Aesthetic Fusion

We said above[1] that "with some possible qualifications it may be said that there is not much restriction of the things to which under some circumstances a simple colour or sound may be aesthetically relevant." Consequently, in such cases psychological fusion amounts in practice to very much[2] the same thing as aesthetic fusion. What are the possible qualifications? It may be perhaps that there are none; but a reference here to what at first sight looks like an exception to the statement made above brings out extremely well an interesting point. Take colours. Is it possible, e.g., to fuse aesthetically a drab brown, or a

[1] P. 98.
[2] Not precisely, for aesthetic fusion may occur without psychological fusion, as we have seen.

sickly pink, or a dirty yellow-green, with the value of clean clear freshness? The answer, I imagine, would be 'No', or 'Probably No'. Have we not, then, an exception here?

The exception is, I think, more apparent than real. Aesthetic fusion is difficult, or impossible, because in such cases the colours are not really simple colours at all. It is not *merely* brown, or pink, or yellow-green, which will not fuse with certain 'cheerful' associations. It is brown already expressive (perhaps in ways both 'direct' and 'indirect') of drabness, pink of sickliness, yellow-green of dirtiness. These systems of embodied values, and not merely simple colours, are given to start with, and it is because of the domination of these systems that the contrary values are refused entrance into the aesthetic wholes. It might be that there would be little or perhaps no restriction of the values which could be made aesthetically relevant to a simple colour or sound, provided the values with which we were dealing were taken singly, pairing one at a time with the given sound or colour.

The domination of a system of embodied values will determine aesthetically the inclusion or the exclusion of associations. If, in the above cases, drabness (etc.) is not dominant, and associations of cheerfulness are stronger, the cheerful associations will, of course, oust aesthetically the content of drabness. In this case the colours will no longer appear 'drab', 'sickly', 'dirty'. They will appear cheerful. If they are 'represented' in a picture, they will probably be so transformed both in their actual texture, and in the luminosity of their colouring and through their context, that instead of appearing depressing (or depressed) they will appear radiant. They will, in fact, look different colours. This difference in the 'look' of perceived objects due to association is not in the least unusual or exceptional, as is seen in the analogous case of the 'staircase' diagram. The same picture now looks a staircase, now an overhanging cornice with an entirely different 'feel' and meaning in each case.

And presumably if one wanted to draw the diagram as definitely *either* one or the other one would alter it slightly.

The importance of the predominance of one or another system of values, and of its effect upon the 'seeing' of objects, will be illustrated if we take some perceived object which possesses sentimental associations. Here is a memento. It is an old Victorian sugar-bowl which belonged to my grandmother, of whom I was fond. It would usually be judged to be ugly, clumsy, vulgar, fat, ornate, and it is associated with a period which some think to be preoccupied with false sentiments. But for me it is associated with my grandmother, with old tea-parties and white-capped old ladies and firelight of long ago. These are pleasant memories. But this association of the sugar bowl with them is not, of course, as such, aesthetic. It is not 'relevant', yet, to the form of the bowl. Now suppose I cease to think of the associations and concentrate on the bowl. The memories are out of the focus of my present consciousness (though they *tend* to be called up), but their effect is there, for I find myself loving the 'ugly' old thing. Indeed, as now I see it, it is no longer ugly, but beautiful—at least to some extent. How can this be? It is, I think, as before, simply the *effect* upon present perception of meanings experienced in the past. I *see* the thing differently, the curves now seem delicious and cosily luxurious, the ornament lavish; I love it because it embodies these values. Its reflected lights are pleasantly ghostly, its capaciousness is generous with the generosity of the past. I do not necessarily *think* these things as I look, though they may enter the fringe of my consciousness. It is the *object* with its shape and lights which I contemplate. But the object is transformed. And—what is very pertinent— if I could paint it, following my selective vision, it would appear to others no longer as a Victorian horror, but as a thing of charm and beauty. So, in like manner, may the very wrinkles of an old coat or dress, or the bruises and scorings on old furniture, speaking of its history, become

transformed even in their very shapes, as they are seen imaginatively.

## V. SANTAYANA ON THE IMPORTANCE OF ASSOCIATIONS ON THE 'FRINGE'

The aesthetic importance of the dominance of objects on the 'fringe' of consciousness has been very clearly put by Mr. Santayana. His language is, I think, sometimes unfortunate, owing to his limitation of the term 'expression' to associative expression: for Mr. Santayana associative expression is an 'embellishment' of sense data and forms, which are not themselves expressive. But, ignoring this possible mistake, we may agree with him when, speaking of Homer, he says:[1] "That the noble associations of any object should embellish that object is very comprehensible. Homer furnishes us with a good illustration of the constant employment of this effect. . . . There is no dearth of the tragic in Homer. But the tendency of his poetry is nevertheless to fill the outskirts of our consciousness with the trooping images of things no less fair and noble than the verse itself. The heroes are virtuous. There is none of importance who is not admirable in his way. The palaces, the arms, the horses, the sacrifices, are always excellent. The women are always stately and beautiful. The ancestry and the history of every one are honourable and good. The whole Homeric world is clean, clear, beautiful, and providential, and no small part of the perennial charm of the poet is that he thus immerses us in an atmosphere of beauty; a beauty not concentrated and reserved for some extraordinary sentiment, action, or person, but permeating the whole and colouring the common world of soldiers and sailors, war and craft, with a marvellous freshness and inward glow." In another interesting passage, speaking of the way in which rarity and price add an expression of distinction to the

[1] *The Sense of Beauty*, p. 205.

sensuous beauty of gems, he writes:[1] "I believe economists count among the elements of the value of an object the rarity of its material, the labour of its manufacture, and the distance from which it is brought. Now all these qualities, if attended to in themselves, appeal greatly to the imagination. We have a natural interest in what is rare and affects us with unusual sensations. What comes from a far country carries our thoughts there, and gains by the wealth and picturesqueness of its associations. And that on which human labour has been spent, especially if it was a labour of love, and is apparent in the product, has one of the deepest possible claims to admiration. So that the standard of cost, the most vulgar of all standards, is such only when it remains empty and abstract. Let the thoughts wander back and consider the elements of value, and our appreciation, from being verbal and commercial, becomes poetic and real." Again, he speaks[2] of the expressiveness of "moonlight and castle moats, minarets and cypresses, camels filing through the desert—such images get their character from the strong but misty atmosphere of sentiment and adventure which clings about them. The profit of travel, and the extraordinary charm of all visible relics of antiquity, consists in the acquisition of images in which to focus a mass of discursive knowledge, not otherwise felt together. Such images are concrete symbols of much latent experience, and the deep roots of association give them the same hold upon our attention which might be secured by a fortunate form or splendid material."

In aesthetic experience there is always both a focus *and* a margin. This is perfectly obvious to the merest beginner in psychology, for in this respect aesthetic experience is like any other. But it has not always been realised by the purists and formalists, by those for whom all associated meanings are anathema. The trouble is that such purists take 'association'

---

[1] *The Sense of Beauty*, p. 213.
[2] Ibid., p. 211.

to mean aesthetically *un*-fused, or irrelevant, association, and in their very right desire to avoid admitting these into aesthetic experience they deny the effect of association altogether, and in so doing denude their focal objects of a very large part (though not all) of their aesthetic meaning.

## VI. The Aesthetic Expressiveness of Words

In most of the cases we have considered, the focus of attention is upon the perceived object, and the fringe or margin is occupied by images. This is not always so, however. It is not always so in the case of an art like poetry, as has been already said. In poetry our attention may be directed to the meanings (images, etc.) of the words, whilst the words themselves fall into the background, or form a complement of sound. We may now briefly consider the aesthetic relation of words to their meanings.

The aesthetic expressiveness of words may be said to be derived in several ways. It may be derived (1) directly, or through the direct effects of their sensuous and formal qualities; (2) (*a*) indirectly, through associations (psychologically fused or not) suggested by their sensuous and formal qualities; (2) (*b*) indirectly, through their (psychologically) fused association by convention with fixed and definite meanings; (2) (*c*) indirectly, through (psychologically) unfused association by convention with fixed and definite meanings. In all these cases, in order that aesthetic expressiveness should occur, it is of course necessary (whether or not psychological fusion occurs) that there should be aesthetic fusion. Take (2) (*c*), for example. Words as *mere* pointers are not aesthetic entities. They are only a special instance of symbols of which mathematical symbols are another instance. If in ordinary speech we use the phrase 'asleep on a chair', we are merely referring to a group of facts, and the words have no interest in themselves, being purely instrumental to the indication of the facts. But when

we read Mr. Yeats' *The Ballad of Father Gilligan*, how delicately beautiful, how poignantly expressive the very sounds become! They become fused, aesthetically, with their meanings.

> "He who hath made the night of stars
> For souls, who tire and bleed,
> Sent one of His great angels down
> To help me in my need.

> "He who is wrapped in purple robes
> With planets in his care,
> Had pity on the least of things
> Asleep upon a chair."

Examples of (1) would be any words we delight in as sounds and forms of sounds. It is certain that the aesthetic value of words is never *merely* their sound value, but these values can be sufficiently striking to enable us to put in a separate class words in which intrinsic forms and sound-values are marked. In this class would come words, spoken expressively, like *Acroceraunian, Chorasmian, Kubla Khan, plangent, tinsel-slipper'd feet, amaranth.* The purest—but not necessarily the most striking—examples would probably be those taken from some unknown foreign language, for there conventional associations would be at their minimum.

(2) (*a*). Here it is relevant associations—whether completely psychologically fused or not—of the sounds and forms of words which give them their enhanced value. One invariable value associated with the spoken word is the value of the human voice, which in *its* turn embodies a complex of the values of human personality and character. The music of the orchestra may have more variety of resource; the organic thrill which it produces is probably greater; but the speaking human voice may move us in a way in which the orchestra cannot do. And in this respect, too, the spoken word may have an advantage even over song. The direct musical values of song are, of course, greater and more various than those of the music of words, but

what is gained in musical value is very often lost in human expressiveness. Consider phrases like "O my son Absalom, my son, my son Absalom! would God I had died for thee, O Absalom, my son, my son!" and

> "O Cromwell, Cromwell,
> Had I but serv'd my God with half the zeal
> I serv'd my king, he would not in mine age
> Have left me naked to mine enemies."

Or

> "Avenge, O Lord, thy slaughtered saints, whose bones
> Lie scattered on the Alpine mountains cold."

Or

> "O Lord, how great are thy works! and thy thoughts are very deep.
> A brutish man knoweth not: neither doth a fool understand this."

Here the aesthetic value lies very largely in the associative expressiveness of the depths of human experience through the human voice. Anguish, sorrow, vengeance, inspired contempt—all can be impressed into the music almost of monotone. Nothing can be more poignant in this way than the spoken word.

Again, the sounds of words may embody through association the values (other than those just mentioned) of the things which the sounds suggest. The phrase "The unplumb'd, salt, estranging sea" suggests in the very resonance and length and fullness and contrasts of its sounds —as distinct from the conventional meanings of the words— the qualities of mystery and distance and depth and estrangement. Words like 'desolate', 'spindrift', 'gruesome', 'awful', 'delicately', 'swift', 'sharp', 'mystery', 'eternity' possess each in themselves qualities which not only give organic pleasure, but which attract and fuse together aesthetically appropriate images. 'Gruesome' is a hollow,

menacing sound, 'swift' in its passage from the 's' to the 'w', its long-drawn-out 'f', and its explosive 't' suggests a projectile approaching, smoothly and swiftly passing—then gone. The sounds inevitably express meanings.

(2) (*b*) and (2) (*c*). About these little need be said. Words are, logically, pointers. They point, by convention and agreement, to meanings. But in poetry (and elsewhere) they may cease to be mere pointers and may themselves, as noises, become fused aesthetically, and often psychologically, with their meanings, so that they appear to embody their meanings. Words such as 'death', 'fire', 'marigold', 'daffodil', 'love', tend in time to evoke in themselves the emotive apprehension of their meanings. The sounds do not in themselves, originally, tend to evoke these meanings. But having been by convention associated as pointer to object, sound and meaning become fused in one or in both senses. As a proof that this can take place we may cite the familiar case of dislike of a proper name because of its association with a person long forgotten.

In poetry, the art in which the expressive use of words is most typical, it is probably impossible to discover cases in which expressiveness in all the ways mentioned is not to some extent present. If words are not used aesthetically, but are *mere* 'pointers', it is obvious that we *can* discover instances in which expressiveness in none of these ways is present. But this is mere tautology, for the aesthetic use is definitely specified. Yet there is an approach to this even in poetry, as when words are used as conventional symbols pointing to an object (an image) which is interesting for its own sake. In such a case words become, as Shelley has it, a sort of 'transparent medium'. Through words we see, in imagination, beautiful things. When Matthew Arnold writes

> "And as afield the reapers cut a swath
> Down through the middle of a rich man's corn,
> And on each side are squares of standing corn,
> And in the midst a stubble, short and bare—"

Or Wordsworth,

> "Let . . .
> The swan on still St. Mary's Lake
> Float double, swan and shadow!"

we see a picture clearly before our mind's eye: the sound-value of the words is not of very great importance, nor are the associations, derived from the suggestiveness of the sounds themselves or from convention. The words, indeed, become relatively unimportant. Yet even here they cannot be excluded. Words are the fundamental medium of poetry, and even although images may sometimes occupy the focus of our attention, the word-sounds, with all their expressiveness, must at least be harmonised with the images. It is impossible to think of any single instance of a description in poetry where the beauty is *wholly* due to the objects described. If the image is beautiful, the poet, it would seem, naturally tends to use fitting words. Even when we take an instance where the poetic value is low—

> "His jacket was red, and his breeches were blue,
> And there was a hole where the tail came through"

—the lilt of the words is expressive of the joke. Our statement, then, that there is an approach in poetry to the use of words as pointers, must be taken literally; it is *only* an approach.

In most cases the variety of associative sources is seen very clearly. Onomatopoeic words, for example, are words whose actual sounds suggest the objects they now symbolise by convention. Thus 'whistle', 'thunder', 'bark', "its melancholy, long, withdrawing roar" suggest their associated objects through their sounds. But [(1) above] they also possess direct sound-values. And [(2) (b) and (2) (c)] their agreed and conventional meanings come in. Take, as another example, so-called 'nonsense' rhymes. Here we

have (1) the direct values of the sounds (e.g. 'runcible', 'gimble', 'borogove'); (2) (*a*) associations arising out of sound values (e.g. 'slithy', 'jabberwock'). And we have [(2) (*b*) and (2) (*c*)] conventional suggestions (e.g. 'brillig'—broiling, brilliant; 'slithy'—shiny, lithe; 'gimble'—gimlet, gambol, nimble; 'mimsy'—flimsy, miserable).

## VII. SURVEY AND PLAN

In this chapter and in the last we have discussed the chief factors in aesthetic expressiveness. We have seen that through the instrumentality of our minds and bodies a great complexity of values is gathered together relevantly to perceived objects. But the objects which we have considered have been objects of a very simple and abstract sort, colours, sounds, simple forms, words. These are, as we know, aesthetic factors if to imagination they appear to embody value. But, being entities which have been chosen rather on account of their lack of complications than for any other reason, they do not in themselves, as we said at the outset, yield aesthetic experience of a very significant or important kind. In actual fact these comparatively simple entities are not really aesthetically satisfying. When we are in aesthetic mood our excitement tends to elaboration and complication and completion of what is partial and imperfect, and to supplementation of one perfection by its opposite, uniting them in turn in a larger, more complex whole which has more meaning. Aesthetic experience is really a process of growing life which only reaches rest and satisfaction in an object sufficiently complex to be interesting to a vital mind-and-body, an object which is yet unified. Although the entities we have considered are always form and matter, and never mere matter, they may be matter in relation to larger and more complex wholes. These larger, more complex, more significant, wholes, are the things we call works of art, and it is partly from the imaginary dissection of works of

art that we have obtained our material for discussion. (It has been insisted, *ad nauseam*, that elements taken by force out of their context cannot possess the same meaning as elements in their context.) But now, having seen what expressiveness means in simple, limited, and not very important aesthetic objects, it will be our duty and our pleasure to discuss some problems of the aesthetic objects which really matter, the problems, i.e., which arise out of consideration of works of art.

In the work of art there will appear as important one fundamental principle which as yet has been but scantily mentioned. I mean the principle of unity. The entities we have considered have each their unity-of-complexity, it is true. The direct and indirect values expressed in any single word must be very considerable in numbers, and they are not a mere aggregation. They are a harmonious system which forms, together of course with the word-sound in which they are embodied, a single unit of content. But this principle of the unity of complexity—which need not assume great importance in dealing with entities like colours or sounds (or words)—becomes extremely important when we come to consider the work of art. In the work of art we have presented to us a vast complexity of separate items which are yet somehow united to constitute a single unified whole which makes direct appeal. This unification is so important that the principle of variety-in-unity (or unified variety) has often been made the central doctrine of aesthetics. If we are right, this claim to first place cannot be ceded, for in speaking of first principles we have put 'expression' in the premier position. But unity-of-variety must find a place in the theory of art, and in the theory we are developing its place and relation to expression must be determined. This question cannot properly be decided, however, until we have said something of the work of art itself.

To the problem of the nature of the work of art we shall

turn our attention in Chapter VI. The next chapter will be concerned with a brief statement regarding the nature of value, its apprehension, and its bearing on the aesthetic problem. I have suggested that in the aesthetic object there is expressed value. It now remains to give an account of what we mean by value and its appreciation, in order that we may be able to see better how far the meanings (and the unified meaning which is 'beauty') which are revealed in aesthetic experience are *objective*—if objective they can in any sense be said to be.

# CHAPTER V

# VALUE, VALUATION, AND BEAUTY

## I. Alternative Views of the Status of Value

In the present chapter I do not propose to attempt to discuss the problem of value in its detail. Full discussion would entail a book and not a chapter, for there is a very large literature on the subject. I shall chiefly try to state, in the earlier part of the chapter, one point of view[1] as shortly and clearly as possible, in order that our main discussion on the specifically aesthetic problem may be resumed with as little interruption as may be. For these reasons only a few proper names will appear. In the latter part of the chapter I shall discuss some applications to aesthetics of the conclusions arrived at in the first part.

There are three possible views of the status of value. One is that value is essentially a quality of things belonging to them independently of all relation to experiencing mind. Another is that value is mental, and is a quality of mind or mental states only. The third is that value consists in a relation between mind and non-mental objects. Examples of all these three views can easily be found, but the second of them is nowadays not very fashionable, so that the real living issue lies between the first and the third.

The first is, roughly speaking, a view which is assumed by common sense, and which is held to-day by philosophers like Professor Moore, Professor Laird, and, more recently, by Dr. Olaf Stapledon in his book, *A Modern Theory of Ethics*. I say 'roughly speaking' because the common-sense assumption that value is in things (e.g. that value is *in* the food or the beautiful sky) cannot be said to be identical at least with the views of Mr. Laird or Mr. Stapledon: nor are the views of the three philosophers I have mentioned identical. But they all do have the one important element in common. The third view has been held in recent times

[1] The view which has been so far assumed, and which was outlined above, pp. 61–62.

by such thinkers as von Ehrenfels and Meinong, Alexander, Hobhouse, R. B. Perry, and very many others. Here again there is a good deal of variety of opinion regarding the particular aspect of mind involved. Sometimes it is said to be desire, sometimes it is feeling, sometimes it is mental dispositions, or 'presumptions', or 'assumptions'; sometimes it is called 'interest'. But all the thinkers who hold the third view are agreed that value *cannot* belong to an object in itself: value is object-in-relation-to-mind, or, it may be, a mental process awakened by some object.

In discussing our problem we must begin by admitting that some values may be indubitably mental. Whether or not value is in essence dependent on or independent of cognising mind, will not affect the question: this will become clearer later. Of mental values, the values of knowledge, of volition, of friendship and love are obvious examples— though, of course, all these mental values require objects. It may in fact be that the highest values which we know are mental, and that the *Summum Bonum* consists of mental activities or of some organisation of mental activities. Whether this is really so or not we need not discuss, for our problem, quite definitely, is not, What is the *supreme* value or good? Nor is it, What are the characteristics of *mental* values? Our main problem is, What is the essential nature of value—*any* value? Does value essentially depend for its existence upon a mind? Or can an object, or an objective process, be said to possess value entirely on its own account, independently of any experiencing mind or minds?

## II. Values as essentially related to Mind

Let us take a simple instance. It is a cold day and I come shivering into a room where burns a bright warm fire. I spontaneously say, 'Good!' 'How lovely!' 'What genial warmth!' and I spread my hands and body luxuriously

before it. Here is a simple value-experience.[1] Wherein inheres the value which is the object of my value-experience?

Unreflective common sense may say that the geniality, the 'goodness' of the warmth is *in* the fire, just as unreflective common sense may think of gold or diamonds as intrinsically precious. But the slightest reflection, even of unreflective common sense, casts doubt upon this assumption. It is equally difficult to think of the fire's 'goodness' as existing all by itself, as to think of gold and diamonds as being precious apart from someone's use of them. Common-sense reflection—and philosophic reflection—is inclined to conclude, then, that the value or 'goodness' of the warmth arises through some relation of the fire's warmth to us. But such a conclusion is only a beginning. For what *kind* of relation to us? And to what *part* of us? Is the relation of the heat of the fire to our experiencing mind? To our desire? To our pleasure? Or is the relation to our organism? An answer which is very often given by philosophers is that already referred to, that value somehow arises in relation, and only in relation, to our *mental* processes. If I do not experience the heat in any way, if I do not cognise it or desire it, or feel it as pleasant, its peculiar quality of value seems to vanish into nothing.

We are, then, very easily led to the conclusion that experiencing in some sense constitutes value. The conclusion seems so natural and inevitable, that even the argument that in knowing value we cannot 'make' it, because in knowing it it must already be *given* for us to know, does not succeed in convincing us that value is not, somehow or other, connected with mentality. But we adopt a new procedure and make a new variation. We now say, not that mind's cognition, desire (etc.) constitutes the value of its object, but that value belongs, not to the object, but to the complex 'mind-in-relation-to-object'. So that any difficulty of mind's 'making'

[1] The value here is positive. For brevity's sake I shall take 'value' as meaning *positive* value, unless the context indicates otherwise.

the thing it cognises is partly overcome. The value belongs to the whole. The whole, and nothing less, possesses value. And if we say this, we are of course obliged to say, too, that when we think we are valuing anything which is completely independent of mind, we are in error. What we value is not the warmth (nor is it simply our own enjoyment of it). The true—though concealed or 'recessive'—object of our valuation is our-experience-of-the-warmth, or the warmth-as-experienced. And this total object is truly independent of our valuation. Expressed symbolically we get

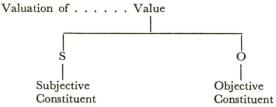

In this case, then, the mind's relation to an object (O) constitutes a value, but it does not constitute O as valuable. For mind's process itself is a part of what is valuable. And the whole, S—O, is a true object of valuation, a true value.

### III. Criticism of this View: Valuation and Value

This account may be consistent as far as it goes. But is it the true analysis? Consider the case more closely. Is it the heat of the fire in relation to our experiencing which we value? Is its relation to our experiencing an essential factor? Surely it is not. What we really value is neither the heat of the fire in itself nor our cognition (nor our desire or enjoyment) of the heat of the fire, but, simply, a process of our organism caused by the fire. It is not the fire in relation to mind which is significant, in this case, from the point of view of the problem of value, but fire in relation to organism.

I am, as they say, 'frozen stiff': my body needs warmth
for the fulfilment of its functions. And my desire for warmth,
and my cognition of and pleasure in warmth are experiences
of bodily process. As the warmth 'gratefully' penetrates my
cold fingers and limbs I experience the restoration of my
bodily functions. This is what I really cognise, want, desire,
enjoy (though I may unreflectively think it is the fire itself,
the cause); and the value consists, it would seem, in this
process of organic fulfilment. My enjoyment, it is true, is
always present when I am aware of this positive value, but
this is no more than saying that when I am aware of value
I am aware of it, or that I cannot be pleasantly conscious
of value without pleasant-consciousness occurring. It is in
no wise implied that this book which I see has a mental
constituent because in order that it shall be an object of
my awareness I must be aware of it. This is the essence,
I think, of an argument of Dr. Moore in *Principia Ethica*.

An even more convincing instance, perhaps, is that of
definite relief from some bodily tension, as that, for example,
of a distended boil. What is wanted in such a case, what
is adjudged good, is just bodily relief and nothing else.
It is not enjoyment of relief or even absence of (mental[1])
unpleasure; what is wanted is something entirely non-
mental, belonging to the body, localised relief. Feeling
supervenes. As Mr. Laird says;[2] "When human beings think
about their values, to be sure, they naturally consult their
feelings—naturally but not, perhaps, wisely. If they cherish
vipers, it is surely the character of what they favour, rather
than their amiable frame of mind, that really does concern
them." Pleasure and unpleasure, then, fall on the subject—
and not on the object—side, on the side of valuation, and
not on the side of value.

Valuation implies pleasure or unpleasure (let us ignore
unpleasure, as agreed). But valuation is, of course, not mere

[1] We must not, of course, confuse the organic 'pain' of tension (which is
a sensum) with mental experience.          [2] *The Idea of Value*, p. 107.

pleasure, for such cannot exist by itself. The pleasure is part
of a psychosis, and valuation is a psychosis involving cogni-
tion as well as conation and hedonic tone. Indeed, valuations
may be divided into two grades, according to the level of
complexity or otherwise of the cognitive aspects. If, on the
one hand, the cognitive aspect is confined to a relatively
simple state of awareness, with prominence of hedonic tone,
there is one level of valuation. If, on the other hand, cogni-
tion is highly critical and discriminative, as, say, when we
analyse the different elements of value in an experience of
music, there is valuation on a different level. The former is
direct intuitive appreciation, the latter involves a *rationale*
of appreciation. We cannot, of course, draw a hard-and-
fast line between the first and the second, for the simplest
cognition we know is to some extent discriminative, whilst
critical analytical judgments are just a turning over, an
examining and a discriminative retasting, of the intuitive
experience.

IV. Positive Value as Fulfilment of Tendency

The theory that positive value consists in the fulfilment of
needs of living organisms (or of higher entities, such as
minds) has recently been ably expounded and defended by
Dr. Olaf Stapledon in *A Modern Theory of Ethics*. My previous
analysis is strongly influenced by the ideas in that work,
with which I am in substantial agreement. Dr. Stapledon's
view clearly has its precedents in Greek Ethics, but it is
also very much coloured by the light of modern knowledge.
He holds that the affective aspect of an act of valuation is
logically posterior to the cognitive and conative aspects
of valuation. "Pleasure is consequent on conation. And
conation (by which I mean a *conscious* activity), is consequent
on a cognitive act of valuation which cognises the relation
of the object to some behaviour-tendency. And the behaviour
tendency is itself essentially objective to any act of 'espousing'

it, or desiring its fulfilment."[1] This theory is based upon the 'hormic' psychology. The organism is conceived as a teleological system and its teleological structure is the presupposition of conation. "The presupposition of every act of conation, whether 'blind' impulse or desire or fully self-conscious will, is a teleological activity or tendency distinct from the purely conative act itself. At the lowest level the activity is purely physiological; the impulse, in so far as it is mental at all, is an acceptance of, or active espousal of, some activity of the body itself. Desire may set as its goal the realisation of some such purely physical teleological activity of the body. At higher levels the teleological activity may be psychical. The goal of desire, or of considered will, may be the fulfilment of some psychical capacity. But in this case, no less than in the others, the activity of tendency whose fulfilment is desired or willed is strictly objective to, and logically prior to, the mental act of willing its fulfilment. For there to be any conscious conation at all there must be awareness of a hormic drive or tendency, awareness vague or precise, true or erroneous. For there to be not merely 'blind' impulse but explicit desire or will, there must be prevision, true or false, of the supposed goal of the activity—prevision sometimes of an immediate goal, at other times of a goal more remote."[2] Again, "Every conative act, then, consists in the acceptance or espousal of some cognised hormic activity or tendency; every case of feeling (pleasant or unpleasant) is consequent on the cognised success or failure of espoused hormic tendency.

"We may conclude this psychological description by saying that: we feel because we 'espouse a cause'; we espouse the cause because we cognise it *as* a 'cause', i.e. as a teleological process of something within our ken; and finally we cognise the teleological process *as* a teleological process because (apart from errors of cognition) it really is so."[3]

[1] *A Modern Theory of Ethics*, p. 51.    [2] Ibid., pp. 87–88.
[3] Ibid., p. 88.

It is important to note that the description of teleology which Mr. Stapledon accepts, the description, namely, of Mr. Broad, does not contain the term 'mind'. Broad defines a teleological system as one which acts "as if it were designed for a purpose",[1] but it still "remains a question of fact whether the system was actually the result of a design in someone's mind". Artificial machines imply design, but organisms are teleological systems which seem to arise without design. The machine is a case of 'external' teleology, the organism of 'internal' teleology.[2] Stapledon himself, defines teleological activity as activity "which [*whether or not it violates physical law*] is as a matter of fact regulated in reference to a future state. In teleological activity events occur because they will produce or maintain a certain result."[3]

The typical case of value within our experience, then, occurs when some hormic tendency of the organism is fulfilled or thwarted. This is an entirely non-mental process and itself constitutes positive or negative value. This bodily process is what we cognise, conate, or espouse and feel to be pleasant or unpleasant, as the case may be. It is likewise with the case of mind. We know that mind has tendencies and needs and that the fulfilment or thwarting of these brings pleasure or unpleasure. So too there are mental values, and mental values, though mental, are just as objective to the act of their valuation. We can rejoice in our own intellectual or moral fulfilment. And as well as rejoicing in them, we can value them intellectually. We can think of them and judge of them and form philosophies about them. We may go even farther and value our valuation of values.

## V. PROFESSOR LAIRD'S VIEW

If value is not in *essence* mental, is not necessarily inclusive of a mental factor (though sometimes it may include it),

[1] *The Mind and its Place in Nature*, p. 61 sq.    [2] Ibid.    [3] Op. cit., p. 83.

we shall be tempted to go farther than we have gone, and to try out a generalisation which will include all physical, and not only organically physical, things. Such a generalisation would be exemplified in the notion of "Natural Election", of which Professor Laird makes a good deal in his recent book, *The Idea of Value*. "Natural Election", says Mr. Laird, following a hint in Montaigne, "is the principle of Non-indifference in nature. I take it to be evident that if two things in nature are utterly indifferent to one another, neither, in relation to the other, has any value at all. If, on the other hand, they are *not* indifferent to one another, it is likely, if not absolutely certain, that a value exists for one or the other or for both of them, at least of a relative kind."[1] By "indifference" Mr. Laird does not mean anything peculiarly psychological, nor anything peculiarly biological, although both of these may be included in the general notion of natural election. The general idea which Mr. Laird has in mind is something like that of 'attraction' in physics, or 'affinity' between chemical bodies. The attraction of iron filings by magnets is one of his favourite illustrations. But the principle of natural election is wide enough to be inclusive of all things, inanimate, animate, mental. It includes not man only, but cats, and, "if cats, why not beetles, and, if beetles, why not potatoes, and, if potatoes, why not magnets and filings. Magnets do concern filings; and, if it does not matter whether or not we are aware of our likings, why should it matter whether or not there are any likings at all? If things are concerned with, and take account of, one another, is not that enough? So far as I can see, it is a mere dogma that values are peculiarly characteristic either of men or of cats."[2] Discussing the views of D. W. Prall[3] and R. B. Perry,[4] he urges that, if "biology is admitted to

[1] *The Idea of Value*, pp. 92–93.   [2] Ibid., p. 107.
[3] In *A Study in the Theory of Value*, University of California Publications in Philosophy, Vol. iii, No. 2, 1921, pp. 215, 227.
[4] In *The General Theory of Value*.

'provide the context' for psychological interest", if "natural election provides the context for biology", "we should not stop short at life any more than we should stop short at mind".

Very likely Mr. Laird is right. There is no general or logical reason why we should stop short at living organisms. Physical 'affinities' and 'attractions' (as Mr. Laird very well knows and would agree) are of course dangerous and obscure notions, and we are apt to run off the rails if we think too naïvely of 'affinities' between iron filings and magnets, or 'attractions' between stones and the earth. But there is a growing open-mindedness to such notions (vide modern physics, and philosophies like Whitehead's or Lloyd Morgan's). We certainly cannot dismiss them. Natural election in a plain, straightforward sense certainly exists and is but another name for natural law. We cannot, therefore, gainsay its truth.

The question, however, is not of the first importance here, for in aesthetic experience we are concerned with values which can be appreciated. And though sub-organic[1] natural laws, affinities, and attractions certainly exist and are to some degree known for what they are, they cannot be appreciated affectively by us in a *direct* way, though we may by means of anthropomorphic metaphors, and bodily analogies, and sympathy, appreciate aesthetically something which we take for them. The prime values for us, on which our appreciation not only of sub-organic entities, but of other organisms and of other minds, is based, are the values of our own bodies and minds, whose processes we immediately[2] experience. Certainly we know, and can in varying degrees appreciate, more than these. But we do it *through* our immediate experience of our organic and mental

[1] I mean, of course, 'organic' in the more usual, and not in Whitehead's, sense.
[2] For a discussion of Immediate Experience compare a paper by the writer—*Mind N.S.* Vol. xxix, No. 154.

processes and their values, which we know in a peculiarly intimate way.

The values which we know through, and by means of, our own, are chiefly the values of other human beings, animals, and plants. By means of a very little sympathy and imagination and power of analogy we may indirectly appreciate the intrinsic values of other human organisms and minds; with a little more, the mental and organic values of animals, and with a very great deal more, just possibly, the organic values of plants. Beyond that there is no intrinsic value which can be appreciated in anything approaching an adequate or literal way, if at all. If tendency-fulfilment of inanimate nature can be said to be appreciated at all, it is only through the use of the most imperfect analogies. We have, as has been said, no real notion of the 'affinities' of magnets for iron, of positive for negative poles, of stones for planets. Still less can we 'feel' them. Of course these are movements, and we know what movements in our own bodies 'feel' like. But there must be more in physical 'affinities' than that. And the more we cannot feel. We can and do, on the other hand, impute much which is not there. When we rejoice in "The keen unpassioned beauty of a great machine", or in the tumbling water-falls, or in the trickling, babbling streams, or in the terrible expressiveness of thunder and lightning, or in the peaceful sunset sky, we are imputing values to these things which are derived from other more direct experiences of our own values and those of other living beings. Certainly we rejoice in the waterfall or in the thunder; but it is their fused suggestion which is really significant for us. They do not in literal fact (or at least as far as we know) *possess* the values we apprehend 'in' them. If it is aesthetic enjoyment we are seeking, good and well. If scientific truth, no.

## VI. Beauty, Value, and the Mind

If the account we have given is correct, the several values which appear to be imaginatively embodied or 'expressed' in an aesthetic object, as when we see a picture or hear music or read a page, will be objective to the experiencing of them. What then of the beautiful object as a unified whole of expressed value, and what of its objectivity?

Let us define beauty provisionally as the character in an aesthetic object of satisfying, complete, self-sufficient expressiveness. The concrete meaning of this profound unity and satisfaction can only be understood of course through experience of the serious work of art. But the definition is good enough, as a definition.

What, then, of the status of beauty? Is it something which is as entirely objective to mind as are the values which are imaginatively embodied in the beautiful object and are its 'parts'? The answer is on the whole 'yes'. This does not of course mean that mental entities may not be imagined as part of the beautiful object. For mental values may be embodied, and are certainly as important as, if not more important than, non-mental organic values. Nor does it mean, on the other hand, that beauty can be existent apart from all mind, for the values which are imaginatively embodied in the object cannot appear *as parts* of the object without the causal agency of mind. For (*a*) if the mind imagines or 'imputes' values to the picture or the symphony which are not *literally* in it, then it is clear that mental agency or causality is involved. Imputation is a mental process; it is 'thinking into' or 'imagining into' the object. And further, (*b*) the several contents of imputation, i.e. what the object is going to appear to reveal, cannot appear as fused *together* in one object, here and now, apart from the mind's power of fusion, of association, of assimilation, and so on. Values may exist apart from the consciousness of them, but the object

cannot appear to fuse them together, without the gift of (mental) imaginativeness. The values are still objective, but they are imagined together, and imagination is mental activity or agency. Or, in other words, what is true of the embodied values which are imputed to the object is true of the aesthetic whole which is beautiful. The aesthetic unity has objective meaning which is due to the objective relations, or system, of its objective parts. But such a whole needs imagination, creative imagination, in order to be created or realised as a whole. We may conclude, then, that beauty, with all its contents, is objective, entirely objective, but is dependent on mind, as the cause of its existence as a systematic whole of parts apprehended 'in' a perceived object.

We shall be in error, of course, if we suppose mind to be a sort of external causal agency, sticking ready-presented objects together on a work of art, like enamels on a mosaic. For the 'objects' are not mere inert pieces, stuck together by mental cement. The objects are, to change the metaphor, molten objects, not joined superficially by an applied cement, but adhering and fusing and running together, taking on marvellous new fluid patterns as they touch. It is true that they do not do so literally. The metaphor is of limited value. The colours, sounds, forms, organic and ideal contents with which the artist deals, are, in themselves, distinct entities incapable of thus inter-acting. Imagination is certainly needed. But imagination is really dealing, not with inert fact-objects, but with innumerable tendencies and their ends, with a thousand active impulses or needs of body-and-mind, impulses and needs which, being alive, demand fulfilment, which restlessly stretch out hungry tentacles to all possible—and often to impossible[1]—objects of fulfilment. And, whilst the process of artistic production is going on, one fulfilment (say, through the production of a line or a musical phrase) leads to other needs whose fulfilment

[1] The artist rejects no less than he selects. Artists "often add, but oftener take away".

in turn leads to further needs, till at last we come to rest in a self-complete system of balanced fulfilments, a rest which can only be attained through the production of, or at least the participation in, such a perceived aesthetic whole. The aesthetic imagination implies a body-and-mind sensitive— even irritable—to the suggestiveness of perceptual data. Colour, sounds, and their forms awaken needs which (unlike, say, the eating of sweets) can only to a slight degree be fulfilled by the same aforesaid colours, sounds, and forms. For the larger part, *demands* are created for *fulfilments* of profounder needs. These needs are met through the marshalling together of a great complex of other fulfilling objects, the perception and imagining of which as a complex whole afford us mental satisfaction with its accompanying pleasure.

Mind, then, in one sense, is the cause of the aesthetic object and its beauty. But it is so only because it is sensitive to, and has the power of apprehending bodily and mental needs objective to itself, whose fulfilment demands the production or construction or apprehension[1] of a considerably complex perceived object.

## VII. BEAUTY, SATISFACTION, AND PLEASURE

Satisfaction, pleasant feelings, pleasant psychoses, perhaps pleasurable[2] emotions—these all bulk largely as the final-efficient causes of aesthetic activity, as we view this activity introspectively. They are perhaps the most important factors immediately present in consciousness. It looks as though we construct aesthetic objects for the sheer pleasure of it, and for no other reason. Although, however, the assertion here has truth, the negation is false. On the one hand, pleasure appears a genuine motive to aesthetic endeavour. Pleasure,

---

[1] Here taken as roughly equivalent.   But see below, pp. 157, 175–176.
[2] I ignore the negative-tone aspect for brevity's sake. But I am thinking of hedonic factors generally.

it is true, may fall on the subjective side, on the side of valuation (though its existence is a *sign* of the presence of objective value), but, as we have seen, it is also true that valuations of value enter into aesthetic activity, and not simply bare values. And in the total-valuation of a (positive) value there is contained pleasure. Pleasure is thus a component part of what is desired. Desire for pleasure is part of the motive of aesthetic construction. On the other hand, desire for pleasure is never the complete motive. 'Pure' pleasure, as we know, is an abstraction. Actually, we construct aesthetic objects partly because this constructing is a fulfilment (which is also in fact pleasurable), and partly because the contemplation of the construction is also in itself the fulfilment of various needs. In the end, it is tendency-fulfilment, or value, which is the ultimate final-efficient cause of aesthetic processes or products, though conscious enjoyment of this value is an essential part of all aesthetic *experience*. And, without this conscious aesthetic experience, as we have repeatedly said, the aesthetic object could not exist at all, for the aesthetic object is dependent upon imaginative mind as its cause in the sense we have described. Pleasure and joy, then, which are in some cases the immediately apparent causes, may be called integral, though secondary, parts of the final-efficient cause of aesthetic activity.

We have, in our investigation so far, been taking it that the aesthetic object is always an embodiment of values. The significance of this will be seen perhaps even more clearly, in the light of our fuller understanding of value, if we now contrast it with the belief, often held, that the aesthetic object embodies mere[1] facts.

---

[1] By 'mere' and 'bare' facts I mean simply facts which are not values.

## VIII. Criticism of the View that the Aesthetic Object expresses Concepts

A great deal of very serious mischief has been caused by the popular supposition that art is nothing but the 'expression' of facts, that painting just imitates, that poetry just tells stories. Hardly less confusion has been caused by some forms of the theory—sometimes more vague and poetic, sometimes more precise and philosophic—that in aesthetic expression are embodied fact-Universals, that art is a revelation of reality or truth.[1] A philosophic statement of such a view is seen in the aesthetic theory of Hegel.

The latest modification of this tradition is to be found in Mr. W. T. Stace's recent work.[2] Mr. Stace holds an interesting theory, namely, that beauty (for us it is sufficient to say here the 'aesthetic object') consists in the fusion of an intellectual content, which he calls "empirical non-perceptual concepts", "with a perceptual field, in such manner that the intellectual content and the perceptual field are indistinguishable from one another; and in such manner as to constitute the revelation of an aspect of reality."[3]

Empirical non-perceptual concepts, it may be explained, are concepts which lie between universal and abstract categories (e.g. unity, existence, quality) and, at the other end of the scale, what Mr. Stace calls 'perceptual concepts', concepts which have percepts corresponding to them (e.g. house, jealousy, roughness, hitting, to the left of). Empirical non-perceptual concepts, which form the content of the beautiful, are more universal than perceptual concepts (because they are abstractions which cannot be grasped together in any single act of perception) but are less universal than the categories. Empirical non-perceptual concepts are not found in ordinary perception at all, but are the result

[1] But see Chapter X.
[2] *The Meaning of Beauty*. Grant Richards.     [3] Op. cit., p. 43.

of intellectual reflection: but as free concepts they enter into the special kind of perception which is aesthetic. Examples of them are evolution, progress, harmony, goodness, civilisation, law, order, peace, gravitation, spirituality. To these no single percepts correspond. But the fusion of any of them with a perceptual field constitutes aesthetic perception.

It is, of course, impossible to do justice to Mr. Stace's interesting book in the course of a page or two, but the type of thesis which Mr. Stace advances prompts one to ask generally whether any principles of conceptual classification are adequate to determine what shall, and what shall not, enter into an aesthetic object. If the categories and "perceptual concepts" are excluded, why not empirical non-perceptual concepts also? Or, to put it in the opposite way, why not include all? In a rough sense it would seem that some at least of the concepts from any of Mr. Stace's three classes might be embodied. In a rough sense some works of art may be said to embody 'unity', or 'jealousy', or 'love' just as much as 'progress' or 'gravitation'. It is, indeed, difficult to see why 'unity', for example, should be placed (for *aesthetic* purposes) in a different class from 'harmony' or 'law' or 'order'.

If we are right, it is the principle of value, and not Mr. Stace's, or any other possible principle of the classification of concepts, which decides what can be embodied in an aesthetic object. No concept as such, of whatever kind, is by its own right worthy to enter in. It is as 'terminal objects' (O) of fulfilment that concepts are embodied, or (as, e.g., in the case of 'goodness' or 'love') as values (T F) themselves. We make an artificial abstraction if we leave out of consideration the relation of concepts to value. Value (T F) is the central explaining principle of embodiment. The concepts as such are not values, but they must be related to particular values before they can be embodied.

Not only have mere concepts as such no right to enter

into the aesthetic object, but they could not possibly do so. They could not possibly get fused. Concepts are static, inert, abiding eternally in 'the place of the Forms'. And the conceiving of them could never bring them into relation with individual aesthetic objects. They must get into this relation not through conceiving, but through our desires, through all forms of our interests, these being based in their turn upon our tendencies, upon our hormic 'drives'. Hormic drive is the true motivation of aesthetic construction; without it there would be the completest aesthetic sterility.

On the question whether there are some concepts which can, and some which cannot, be embodied, it seems unsafe to dogmatise. The question involved is whether any concept whatever can be related to values. It might be said that such a category as 'existence' or 'quality' or such a perceptual concept as 'to the left of' is unlikely to be appreciated as a terminal object or as a value (T F). Yet what of the composition of pictures? And it is perhaps not too fantastic to suppose sheer 'existence', or any of the Platonic Forms, as appearing to a metaphysically minded artist as supremely satisfying objects (O). And if 'existence', why not 'house', or 'roughness'?

## IX. A NOTE ON 'AESTHETIC EMOTION'

We have said that "Pleasant feelings, pleasant psychoses, and, perhaps, pleasurable emotions" occur as final-efficient causes of aesthetic production. Of feelings we have spoken. But what of emotion? Is there a special kind of aesthetic emotion? Are there special emotions at all? To both of these questions the answer 'Yes' is often given. We have, it is often said, emotions corresponding to every instinct, and we are told[1] that there is a special aesthetic emotion. Other people argue that there is no such thing.[2] That there

[1] E.g. by Mr. Clive Bell in *Art*, Phoenix Library, p. 6.
[2] E.g. Mr. I. A. Richards in *Principles of Literary Criticism*, p. 11 sq.

are 'special' emotions is either untrue or it is obvious. It is untrue if it is meant that each emotion is in some obscure way unique, *sui generis*, containing nothing in common with any other emotion. It is obvious if it is meant that each emotion, being a psychosis, is therefore concretely different from every other psychosis; and that some are very *like* others. The obvious seems to me the only really tenable view. If we adopt it we need not trouble ourselves very much about whether there is a special aesthetic emotion or not. Of course there isn't and of course there is. There isn't, in that to have aesthetic experience is not to cast off human nature, and there is, in that aesthetic experiences as a class are noticeably different in many ways from any others. Emotion is a psychosis in which, through organic and conative-affective disturbance in relation to a particular object, there is experienced a certain degree of excitement. The concrete character of any emotion depends upon each of these factors and upon their relations to one another. If this is true, every single emotion will be concretely different from every other, though some emotions, resembling others, may be classified roughly in certain groups.

As regards aesthetic emotion, we may say in the first place that there is such a thing, since aesthetic experience often, and perhaps always, involves sufficient excitement to be called emotion-psychosis. And aesthetic emotions which are, thus, just aesthetic experiences with stress laid on their *excitement*-aspect, are different as a class from other emotions, in the same degree and to the same extent as aesthetic experience is different from non-aesthetic experience. Also, for reasons given, each aesthetic emotion is different in some ways from every other. But to say this is not to say anything in the least remarkable, and one sometimes wonders at the stress which has been laid upon emotional excitement, which, after all, is but a symptom.

## APPENDIX TO CHAPTER V

### (a) Variations of Stress upon O and T F in the Value-Situation

Having discussed value and its embodiment, it may perhaps be helpful to add here in an appendix a brief formal analysis of the value situation and of its various manifestations in aesthetic objects.

We have said that what is embodied is primarily, though by no means exclusively, the values of our own bodies and minds. (Let us as before concentrate on positive values, taking the term 'value' as here meaning positive value.) The values of our bodies and minds are fulfilments of needs or tendencies. Now, sometimes, the need is for some specific and definitely recognised object or thing which is outside or extrinsic to our own processes, as, when hungry or thirsty, my organism needs, and I cognise, the object food or the object drink, and I behave in a manner conducive to the obtaining of it. Sometimes, on the other hand, there is no such specific or definite extrinsic object or thing clearly recognised. The need may be simply for the continuance or completion of the process, and this may be all that is wanted. Thus exercise of the body is, under some conditions, a value, and my organism's activity of exercise, or continued exercise, may be all that I consciously desire. In the one case a terminal object or thing, which is extrinsic to the process itself, is consciously recognised. In the other case, if a terminal object is thought of at all, it will not be thought of as an external thing, but simply as the exercise, or the continued exercise, or the completion of our own activity.

These distinctions, though in a way obvious, may seem a little arbitrary. It may be said that organisms and minds always have needs or objects outside themselves; by themselves they cannot live. The need for physical exercise and

for rest is the need for replenishment and repair of tissues, and this is possible only through the existence of chemical substances distinct from the body itself. So, I suppose, with digestion. Mental fulfilments, too, imply the presence of a world of objects independent of them.

All this is perfectly true, and, if we were considering mindless organisms merely, it would be unimportant, and perhaps false, to say that sometimes the terminal object is prominent and sometimes it is not. For all there would really be (on the above hypothesis) would be mindless organisms with needs and tendencies, in an environment more or less fitted to fulfil these needs and tendencies. Mindless organisms would not 'seek' objects, as the mind seeks the things it desires, and the idea of prominence before consciousness, would be, of course, irrelevant.

But in aesthetics we are not dealing primarily with mindless organisms, but with mindful ones, and with mind which consciously 'espouses' (to use Mr. Stapledon's happy jargon) its own tendencies and those of its organism. And where mind enters in, 'objects' of consciousness enter in too, and the question of the relative 'prominence' of a terminal object or of a process is no longer irrelevant.

In a conscious organism, four possible kinds of value-situation may occur. Let us represent those aspects of any situation of which the mind is unconscious or is not prominently, definitely, or clearly conscious, by putting them in round brackets, and let r stand for 'in relation to'. We then get:

$$(1) \ (T \, F \, r \, O)$$
$$(2) \ T \, F \, (r \, O)$$
$$(3) \ T \, F \, r \, O$$
$$(4) \ (T \, F \, r) \, O$$

(1) This is exemplified by some such process as digestion, or circulation, of which we are, or may be, quite unconscious.

(2) This would include any tendencies of our bodies or

minds of which we are conscious, and which are moving smoothly on and so fulfilling themselves, and where there is no *extrinsic* object bulking largely before our minds. Thus we may enjoy the activity of thinking, or of exercise like swimming or walking. True, such activities are all, in reality, intercourse with an environment, and are not mere mind- or leg-wagging. But in the case I am considering the external environment is not prominently before consciousness.

(3) Here we are conscious both of a tendency being fulfilled and of a terminal object extrinsic to it, which is what we desire, and which is a cause of the fulfilment. Examples of this would be the enjoyment of eating *food* when we are hungry, when the interest in the food and the interest of our being satisfied are about equal. Other examples would be, getting warm before a blaze (where the blaze is an object of some attention) and mental exercise with the desire to solve a special and interesting problem.

(4) Here the interest is so 'objective' that we cease, or almost cease, to be aware of our own processes in our interest in the object which compels our attention. Thus some sudden disaster may awaken, and so hold our attention, that our eyes, symbolically, almost start from our head. (The tendency here might be one derived from the instincts of curiosity and fear and sympathy.) Or the boxer's attention is wholly fixed on the body of his opponent, especially on the place where he hopes to deliver his next blow. So, mentally, our attention is focused upon the fascinating problem. Or the desire of the lover is for his beloved.

## (b) How these are exhibited in the Aesthetic Object

These are the ways in which the two aspects of the value-situation may be stressed. We may proceed to apply it to the aesthetic embodiment. Before doing this, however, it may simply be remarked that the aesthetic object, perceived or

imaged, is itself always a terminal object of value, or, perhaps better, it is a complex of terminal objects. This is shown by the mere fact that we are interested in it. We are interested in it because the contemplation of it, for various reasons, fulfils awakened tendencies in us.

The formally possible ways in which (in the light of the above analysis) the value-situation may appear in the aesthetic object, are as follows:

    (i.) $[(T\ F\ r\ O)]$ embodied by ways direct.
    (ii.) $[(T\ F\ r\ O)]$ embodied by ways indirect.
    (iii.) $T\ F\ (r\ O)$ embodied by ways 'direct'.
    (iv.) $T\ F\ (r\ O)$ embodied by ways 'indirect'.
    (v.) $T\ F\ r\ O$ embodied by ways 'direct'.
    (vi.) $T\ F\ r\ O$ embodied by ways 'indirect'.
    (vii.) $(T\ F\ r)\ O$ embodied by ways 'direct'.
    (viii.) $(T\ F\ r)\ O$ embodied by ways 'indirect'.

(i.) and (ii.). These are, formally, possible. But they are not important for our present analysis, and are therefore enclosed in square brackets. Organic and mental processes of which we are wholly unconscious may be part of the necessary conditions for our having aesthetic experience at all: and their existence may colour the content of present experience. My digestive and circulatory processes, for example, are necessary if my organism is to continue to exist; they are therefore necessary if I am to appreciate a picture or a poem. And the state of my digestion or circulation may easily colour what I cognise. So, if there are mental processes of which I am totally unconscious,[1] these may likewise affect cognised content, either 'directly' or 'indirectly' through fusion with some content with which they may have been associated. But then so may many other things affect cognised content—race, heredity, tradition,

[1] I am not concerned to say that there are, or, if there are, what is their nature. But see below, pp. 184–186.

education, class, prejudice. With these, however, we are not concerned here, for we are dealing with the cognised content of what is embodied in the aesthetic object. Physical or mental processes, of which we are totally unconscious, have importance for us here only in a roundabout way. Our interest is in content of which we *are* in some degree conscious.

Of course if we *are* in some degree conscious of the organic or mental processes, they become part of the content. But in this case they come under later headings.

Examples of (iii.) would be the 'rising' pillar, the 'flowing' circle. The 'rising' and the 'flowing' are derived from our organisms, and are processes enjoyed for their own sakes without any explicit consciousness necessarily occurring of an external terminal object which is (for example) literally 'rising' or 'flowing'. Other examples would be the 'dignity' or 'vigour' imputed to music, or the 'courage' and 'energy' imputed to a statue like the *Colleoni* in Venice. These, as values vividly experienced, all arise 'directly' out of our organic and mental dispositions which become imputed.

Examples of (iv.) would be similar values, only awakened through association. The sound of the horn might awaken, through association, imaginary experiences of the value of the exercise of hunting. Or the drum might suggest courage and other warfare-values.

(v.) would be exemplified by representations of organic and mental process with definite relation to some object. The quest of the Grail—good in the seeking and good in the finding; the Madonna suckling her infant, Niobe mourning for her children, Demeter seeking for Persephone, Apollo for Daphne, all these would be illustrations—though in several the value is negative rather than positive.

(vi.) Here, if the associations are psychologically unfused, we might select as example any image of T F r O called up explicitly before the mind through association. (It would

have to be, of course, aesthetically fused, or relevant.) If, on the other hand, the associations are psychologically fused, it is not so easy to give examples. For if an association is fused, it is not present before the mind in a clear-cut way. Now T F r O is a considerably complex object, and the realisation that O is the cause of the fulfilment of T F, and that T F is in relation to O, involves a fairly high degree of abstractly discriminative synthesis. Whilst this synthesis may easily be possible in an aesthetic experience when directly apprehended, it could hardly exist so definitely in a psychologically fused experience. A T F r O in the past, fused with a present content, will affect it, certainly. But T F r O will not appear explicitly in the present aesthetic experience so that it can be pointed at.

(vii.) Here colours, figures, sounds, combinations of sounds, ideas, all *things* or objects which are directly apprehended as interesting in the aesthetic object, are represented by the symbols (T F r) O. The apprehension of these Os fulfils needs in us.

(viii.) Here the *suggestion* of all interesting things or objects—psychologically fused, it may be, in varying degrees—enters in as a qualification of the focal object. In Mr. Masefield's

> "Quinquireme of Nineveh from distant Ophir
> Rowing home to haven in sunny Palestine,
>     With a cargo of ivory,
>     And apes and peacocks,
> Sandalwood, cedarwood, and sweet white wine.
>
> Stately Spanish galleon coming from the Isthmus,
> Dipping, through the Tropics by the palm-green shores,
>     With a cargo of diamonds,
>     Emeralds, amethysts,
> Topazes, and cinnamon, and gold moidores"

the charm lies not merely in the delightful objects named [which would be further examples of (vii.)], but in the

qualities of the many more romantic things which they suggest. Or take the suggestiveness of a name like Samarcand. Perhaps some of the best examples of the suggestion of delightful objects, of exotic and fascinating things, are to be found in *Kubla Khan*.

### (c) 'IMPUTATION' AND 'RELEVANCE'

A further note on the word 'imputation' may be in place here, even at the cost of some repetition, for the matter is important.

In the first place, the imputation of the T Fs unbracketed must be accepted with reservations. We may in one sense impute vigour to the bronze forms of the equestrian statue: we do seem to see 'vigour' in the statue of General Colleoni. But we enjoy it through immediate experience of our own organisms. If the T F appears in the object, it is *also* experienced in us. We think vigour, for example, into the object, for we are interested in and are attending to it. But our experience is of a larger complex whole, including our own processes and states, even if only marginally, together with the object. This is the total objective in the aesthetic situation. The term 'relevant' is therefore, as previously suggested, the safest and most comprehensive word to use. We experience T Fs relevant to the aesthetic object, and a whole complex situation, including our own states, is cognised by us.

In the second place, the T Fs in brackets exist, of course, in us, and as forming part of aesthetic experience are relevant to the aesthetic object. But, as is symbolised by the brackets, they are not attended to or made prominent in any way.

The value-situation, then, is exhibited in these various ways, and with these stresses and emphases, in the aesthetic object. But it would be tedious and far too complicated to state every time under which form the value situation is being revealed. We may, therefore, for purposes of simplicity,

speak in general of *value* being embodied when we mean either that T F (r O) or T F r O, or (T F r) O, is embodied. This is strictly speaking inaccurate, for only T F is really 'value'. But if we do clearly realise the inaccuracy, we may be forgiven for using 'value' in this inclusive way. We shall have avoided the fault of pedantry—in this matter, at any rate.

# CHAPTER VI

# EFFICIENCY AND BEAUTY

# I. The Aesthetic Problem raised by Functional Fulfilment

In Chapter IV we discussed at length the aesthetic expressiveness which occurs by the way of association, or, 'indirectly'. The term 'association', it will be remembered, was deliberately used in a very wide sense. Employed in this way it might, of course, be taken to include the association which a perceived function-fulfilling object naturally has with the idea of its function. If, for example, the shape of a bread-knife or an arm-chair or a racing motor-car at once suggests ideas respectively of cutting bread, of sitting comfortably, of speeding along, the suggestion, to our minds, by one thing of the other is of course a form of 'association' in our sense. I have, however, postponed until now the discussion of problems raised by functional suggestion. This has been necessary mainly because functional suggestion raises certain questions of value of which it would have been premature to treat before the last chapter on 'value'.

The problem, however, deserves separate attention. For one thing, what is sometimes called 'functional beauty', or the 'beauty of efficiency', is regarded to-day as of great importance. For another, the association determined by the relation of object to function appears, at least at first sight, to form an exception to the rule exhibited in the instances which were discussed in the first four chapters. In these instances, the work of imagination was found to be a necessary condition for the existence of the aesthetic object. If a yellow patch aesthetically suggests qualities of sunshine, or of jaundice, or of a certain person, the fusion of yellow with the suggested quality is dependent causally, we have agreed, upon the imaginative mind. The conjunction of the body and the content could not possibly occur without the mind's presence. But with function-fulfilment it is—at any rate it looks—different. The relationship between the thing and its function is 'there' already. True, we may know

it, but it does not look as though aesthetic imagination were necessary. The knife does cut, the motor-car does speed; we are apprehending, not a mere construction of our imagination, but a fitness which is fact as surely as anything could be. The question, then, is, Are we right in supposing that in such a case imagination is a superfluity, is inert, that it does nothing? Is 'functional beauty' just the bare fact of fitness, which only needs eyes, and no aesthetic synthetic imagination, to see it for what it is?

Let us take the term 'functional' broadly. Let us take it to include both the artificial and the natural, a steam-engine or a sailing-ship or a coal-scuttle,[1] as well as the sheath of the lily, the form of a tree, the curving body of a sea-gull in flight, or the movements of a race-horse or an athlete. We might perhaps include also under 'functional' revelation any revelation of natural states and processes through their appearances, such as the revelation of wakening life in the sounds and smells and fresh green colours of spring, or of the revelation of a state general well-being in growing things through their colours and shapes. But the clearest cases of functional revelation belong perhaps to the types first mentioned.

## II. THE KNOWLEDGE OF FUNCTIONAL FULFILMENT

The knowledge of function is, in the first place, knowledge of fact. When we apprehend, say, the fitness of the shapes of a schooner for its function, we are apprehending an unquestionable fact. Here is a direct revelation of a reality which exists entirely independently of our cognisance of it. (It is true that when we know it, it becomes related to mind.)

Our cognition may be a cognition either of something which is obvious on the face of it to every adult human

---

[1] Conceptual entities, like mathematical objects, are excluded by agreement, though these, as we have seen, may possibly possess a kind of functional beauty.

being, or a cognition of something which cannot be cognised without a process of arduous learning. An example of the former would be the shape of the arrow or of the torpedo. Anyone can see that such things look as though they were made for movement. Likewise, negatively, I can see, without much difficulty, that a beer-barrel is a system of tensions in equilibrium in which the springiness and compressibility of the wood play an integral part. So when I notice, hanging above the doors of certain public-houses, a beer-barrel constructed out of red *glass*, I can apprehend at once the contradiction of function, and can almost hear, in painful anticipation, the splintering crack which would occur were the thing not a fraud. Functional revelation, on the other hand, may not be so immediately obvious. Anyone can see how the bellying sails, the leaning, straining masts, and the tautened sheets of the sailing-ship are fulfilling their functions. The steam or motor liner, however, demands more knowledge and a greater resource of imaging the hidden source of power. Only to the initiated, again, can the shapes of a very complex machine reveal its functions. A dredger or a tank or a grain-chute, when unfamiliar, may appear meaningless and ugly, though revealing economy and perfection to the expert eye.

Yet, though cognition must always be present, and is less, or more, complex, we are, in these cases, in contact with indubitable facts. Are these facts which we know in themselves aesthetic facts? And is aesthetic imagination unnecessary?

## III. The Efficient Thing versus the Aesthetic Object

I suggest that it is not so, in spite of an extremely common idea which is current, that beauty is simply efficiency, and that the efficient is always *per se* beautiful. It is popularly thought, and often said, that the thing which does its job well is the model of everything it aesthetically ought to be.

Steam-engines, Schneider Trophy winners, or racing motor-cars thus become the aesthetic idols of the day. Pictures and statues and 'works of art' are, for such opinion, rather out of date. This has its counterpart in the moral sphere, in the shallow but equally self-assured philosophy, that goodness and beauty mean merely the same thing, being identical with nothing more than 'doing your work well'. In a very right reaction against the ornate, there is a tendency to go to the opposite extreme and to become mawkish about efficiency. As against this view one would urge that 'functional beauty', or the 'beauty of efficiency', must be imagined aesthetically, like any other aesthetic object, and that function-fulfilment, or efficiency, is never identical with beauty. Further, *aesthetic* expression of function is, it would appear, merely one among a number of possible expressions, and it demands supplementation frequently, though perhaps not always.

## IV. THE AESTHETIC APPREHENSION OF FUNCTIONAL FULFILMENT

Functional beauty must be imagined like any other aesthetic object. When I apprehend the bare fact that this sailing-ship, shaped thus, fulfils its function, I am in possession of an ordinary piece of knowledge, expressible in a proposition which has a universal for its predicate. This is not an aesthetic experience. When functional fulfilment is experienced aesthetically, what we are experiencing is not merely the fact that this-body-is-fulfilling-(or can-fulfil-) its-function. What we are experiencing is, to start with, the functional fulfilment as-revealed-in-the-form-of-the-body. The content, functional fulfilment, is imaginatively fused with the body, is aesthetically fused. And what we are experiencing is, to go on with, not merely this, but the complex as exhibiting a kind of joy. In Mr. Santayana's phraseology, there is 'pleasure objectified'. We apprehend then, not the meaning of a proposition in which a logical

idea of functional fulfilment is related to a particular body, nor even the revelation of a bare fulfilment *in* the body: what we apprehend is *delightful* fulfilment, fulfilment full of delight, embodied in the body. If, for the poet, the meadows are painted 'with delight', so the movement of the ship,

"Leaning across the bosom of the urgent West,"

is a thing in itself full of subtle joy. Or consider these wonderful rapid motion-pictures of the growth of flowers. Not only do we enjoy such fulfilments, but there appears to be a joy in the movements themselves.

In the case of an object like a ship we know there is, literally speaking, no joy existing in the relation of the shape to its function; there is even, so far as the *ship* is concerned, no fulfilment. There is cause and effect. How then do fulfilment, and joy, 'get into' the object? The fulfilment 'gets' there, in the first place, because it *is* there, in the sense that the ship's forms were designed for its purpose (analogously, an organism *looks* as though it were designed for its purpose). In the second place, the ship's fulfilment 'gets there' aesthetically, as we said, through the agency of aesthetic imagination. So also its joy. Its joy 'gets into' the movement, through the instrumentality of our bodies-and-minds. Part of the fulfilment that 'gets into' the object is, not the ship's fulfilment, but ours. Part of the imputed fulfilment is, not the fact for which the ship was designed, but the fulfilment of our own being, which is made 'relevant' to the appearance of the ship. When, in looking at a Greek Temple, we vividly apprehend the forces at work in the entablature supported by columns, we do to some extent, as we have seen, project our own tensions, feelings, images, into the object. Or at least sometimes we do, and so far the empathists are right. Likewise in seeing the ship we do in some sense enjoy organic (and mental) fulfilments 'in' the object. We enjoy them: and joy enters, as it were,

into the object. In a sense, we *are* the ship, we *are* the sea-gull. This is all familiar. As the muscular and other factors are projected, so is the accompanying joy projected. The 'joy' is of course mainly the positive hedonic tone which accompanies our 'direct'[1] fulfilments. As was said in the last chapter, we immediately experience and enjoy our own states; and hence arises appreciative enjoyment of things which lie beyond our organisms.

On the whole, then, we may say that, although we are apprehending a real functional fulfilment which is a fact (expressible in a proposition), we are bringing to our cognitive apprehension of it an imagination, a sympathy, and an empathy with their hedonic accompaniments, which not only unite the idea of the function to the appearance of the object, but which to some extent unite our fulfilments, and even our enjoyments, to that appearance. The object apprehended in the aesthetic experience is thus something much more than the fact of the function-fulfilment. And it is something obviously dependent upon the presence of mind as its cause. The functional fulfilment of the ship may be a fact independent of my mental processes. So may some fulfilments of my organism. But 'the-appearance-of-the-ship-united-to-the-idea-of-the-function-united-to-my-body-and-mind-fulfilling-itself' as a whole, depends upon my synthetic imagination for its very existence. If, then, yellow-which-has-the-quality-of-jaundice-in-it is a complex due to imagination, so is the ship-aesthetically-seen. Functional expression, as an aesthetic object, is causally related to mind as are the other cases we have examined. And fusion of several entities is equally necessary.

---

[1] Of course in apprehending functional beauty, association may contribute much. And other values may enter in. The curves of the ship's sails may have a general aesthetic value. But of this I have not been thinking at the moment.

## V. The Irregular Correlation between Efficiency and Beauty

Efficiency, then, as a mere fact, has no aesthetic value; for this it demands the presence of a body-and-mind. And for the body-and-mind it is not always easy, or possible, to apprehend efficiency aesthetically. For one thing, much efficiency goes by unnoticed, and much efficiency is in itself uninteresting, just because it is efficiency, and we take it for granted. But it would be hard to refute the view that any relatively *simple* piece of efficiency might, so far as it could be embodied in a perceived or imaged object, be apprehended with some degree of aesthetic satisfaction, might be, in this sense, beautiful. But even if this is so, it does not follow that efficient *complex* objects, composed of parts each of which is efficient and aesthetically satisfactory, will always, as wholes, be aesthetically satisfactory. A factory (or a warehouse, or a piece of office furniture, or a dredger) may be a congeries of efficient units, each unit playing a part in the efficiency of a larger system, and each unit being, perhaps, aesthetically satisfactory. And yet the whole factory (etc.) may fail in aesthetic value. An aesthetic object is always an imaginative organisation of parts, and its organisation is not identical in type with the organisation of efficiencies which constitutes the complex efficiency of, say, a factory. The organisation of the aesthetic object is one which must make itself apparent in a single percept or image.[1] And the complex efficiency of a great factory may simply not be aesthetically organised at all. If we try to perceive or image it aesthetically it may appear 'ugly'.

It may be, as a complete *whole*, aesthetically ugly. And again, it may appear, however efficient it be in part and

---

[1] If concepts and systems of them can be true aesthetic objects, it might be argued that the complex conception of an efficient factory is an aesthetic object. But this is doubtful, and we may leave it here.

whole, ugly also in some of its *aspects*.[1] There is absolutely no necessary relation between a thing's being completely efficient in part and whole, and its being aesthetically pleasing in every aspect. Its efficiency-aspects *may* be aesthetically pleasing, but it has aspects *other* than these, which may be the reverse of pleasing. I am sure that, even though the Corporation rubbish-cart may be an entirely efficient machine, it is, in its shape and colours, ugly. So office and domestic furniture may fulfil their functions perfectly, in every part, and yet remain monstrously ugly in *some* of their appearances.

## VI. The Relation of Functional Beauty to Beauty in General

Sometimes a system which is efficient in all its aspects and as a whole, happens to be aesthetically pleasing in most, or all, of its non-efficiency aspects. A schooner or a suspension-bridge (or the Forth Bridge) is aesthetically pleasing both on account of its functional revelation *and* of its general proportions. Sometimes, in efficient objects, these proportions are lacking, and have to be provided by a conscious act of design. The architect, planning warehouses or banks, does, in fact, consider very carefully indeed the general aesthetic values of proportion, of relations of lines and planes and volumes. It is merely nonsense, and sentimental nonsense, to suppose (as is very often indeed supposed) that because a factory is built efficiently for its purpose, it must therefore be all beautiful, or, conversely, to argue that because this window appears disproportionately placed to the rest, therefore the factory is inefficient at this point. If beauty were identical with efficiency, this would certainly follow. Every deckhouse on a liner no doubt has its function, and is

[1] I am, of course, anticipating later discussions in speaking of beauty and ugliness at this stage. Let them be taken as short for 'aesthetically satisfying' and 'aesthetically dissatisfying'.

placed where it is for a purpose. But its fitness for this purpose has little if anything to do with the beauty of the lines of the ship. It may involve real ugliness as a whole. Conversely, 'good' proportions may make in some cases for inefficiency.

The artistic designer takes into account not only function, but the general aesthetic values of proportion. He may do more even than this. There are cases where functional beauty is not only harmonised, in a creative act, with a general beauty of proportion, but naturally and rightly blossoms into suitable ornament. When we speak of functional beauty we think often of craftsmen and their work rather than of machinery; we think of hand-constructed chairs, hand-beaten spoons, bowls, candle-sticks, fire-irons, and so on. Now these no doubt fulfil their function well, or we should condemn them. And their beauty cannot adequately be judged apart from their fulfilment of function. But it is the variation and individuality which gives them the special beauty which thrills us, which thrills us as sheer efficiency scarcely does. You get a certain kind of utensil which is best made by machinery, which has its own plain, honest, though limited, functional beauty. But in the craftsman's work there is more. The craftsman making his candle-stick makes an efficient article, and he adjusts his proportions carefully. But there is more even than this. He goes on to embellish—and how spontaneously and with what delight he does it! It goes without saying that in his delight lurks a danger, that he may let himself be led away to excess. We have the warning of the inveterate wood-carver before us. But true ornament is possible and legitimate, and is seen in the best craftsmanship. It is, at its best, a natural outgrowth of functional expressiveness, though it is distinct from it.

Functional fulfilment, then, has its place as a datum for aesthetic experience, but only a place. There are two different senses in which it might be said that functional

fulfilment enters into *all* aesthetic experience. The first is hardly appropriate. It might be said that all aesthetic experience involves immediate appreciation of mental and bodily functions, therefore functional expressiveness always enters in. This is really invalid, however, because the functional expressiveness we are considering is the expressiveness, not primarily of our own states, but of an object apprehended as distinct from the body. It is the efficiency of the ship, and not of our organisms, which is referred to when we talk about the 'functional beauty' of the ship. The other sense has more meaning. It may be said, for example, that functional beauty enters into all the beauty of art. The picture or the poem or the symphony is a unity, is a perfection in which part fits in with part, in which the complex and difficult is unified in complex simplicity. All these are cases of functional fulfilment and efficiency. In this there is probably truth. The value of efficiency or functional fulfilment is *one* of the values which may be (and perhaps always is) fused into aesthetic objects like works of art. But it would, even in this case, be misleading and confusing to speak of all beauty *as* functional beauty, for 'functional beauty' still has its specialised meaning.

# CHAPTER VII

# THE WORK OF ART

# I. 'AESTHETIC', 'ART', 'WORK OF ART'

Thus far we have been dealing largely, though not exclusively, with the aesthetic expressiveness of relatively simple perceptual data, and we have often found ourselves definitely hampered through not being able to speak more fully of aesthetic objects in their more developed and complex forms—in a word, of works of art. From now onwards we shall be concerned mainly with problems of the work of art.

The work of art is a more developed, more complex entity than the entities we have mainly been discussing, and it has its own very definite problems. But it should not be thought that in beginning to discuss the work of art we are approaching anything which is fundamentally and essentially new in aesthetic principle. The making of the work of art does, as I shall try to show, involve activities which are not present in the aesthetic appreciation of an aesthetic object which is given.[1] But it is, on the other hand, really the fulfilment to the point of completion, by means of construction, of the simpler expressions or embodiments of which we have spoken. An odd colour or sound or form may appear to imagination to express value, but such simple objects are unlikely to be completely satisfying to the vigorous aesthetic imagination. In fact, as we have already suggested, they may, if we are of certain dispositions, stir in us appetites which cannot be satisfied by anything less than a very complex process of construction, of modification and supplementation, which stops only at complete satisfaction. Such a construction possesses unity; it has no 'ragged edges'; in it we can rest, and we are not tempted to stray out beyond its boundaries. The genesis and building up of this unity, which possesses the quality of 'beauty', is now our problem.

A word about terminology. The general term 'art' is ambiguous. It may apply: (1) to the comparatively simple

[1] See below, pp. 175–176.

activity of producing comparatively simple aesthetic objects
(such as expressive gestures, shouts, or splashes of sound or
colour); (2) to the product of (1); (3) to the production
of more complex, unified, aesthetic objects, like pictures or
poems; and (4) to the product of (3). Here the term 'art'
will include all four senses, except that (4) will usually
be called the '*work* of art'. And (4) only. Here I follow
common custom in terminology. Shouting may (sometimes)
be 'art'; so is producing a picture 'art'. And the produced
shout might be called 'art'. On the other hand we should
usually speak of the picture as a *work* of art, whilst we should
not so name the produced shout. If this sounds arbitrary,
it is convenient. And it has an importance beyond con-
venience, because strange conclusions are sometimes arrived
at through muddling art in the widest sense with the produc-
tion of *works* of art, or through failing to realise the relation
of the two.

One more remark on a matter which is closely allied.
We are calling every kind of artistic activity 'art'. But not
every kind of *aesthetic* activity. The term 'aesthetic activity'
includes the purely mental work of the contemplative
imagination, and this would not ordinarily be called 'art'.
It is true that some writers do make 'art' and the 'aesthetic'
coterminous. But this, I believe, is erroneous as well as
confusing, as I shall try to show. I shall argue for the view
that the aesthetic includes art, that art is *one* form of general
aesthetic activity, namely *productive* aesthetic activity.[1]

## II. THEORIES OF ARTISTIC MOTIVATION

The awakening of desire for further aesthetic satisfaction by
apprehension of some simple and aesthetically incomplete
object is, we have said,[2] one way in which artistic production
may start. But it is only one way; or, perhaps better, to
describe artistic process thus motivated is to describe only

[1] See below, pp. 175–176.                    [2] Above, pp. 129–130.

one aspect of what may in fact be a much larger and more complicated affair. For the work of art may be, it would appear, the result of various motives. It is thought, for example, that art is, at least very often, the elucidation of a subject-matter. The poet tells stories, or he sings of love, of nature, or even of rather general ideas like duty or immortality. Painters represent landscapes and human beings. And it is said that these or other things are the 'inspiration' of art, that art must be 'inspired' by subject-matter and (perhaps) that art is a kind of imitation. Again, it is alleged that the artist constructs his work of art because he desires to communicate something to others, or because he desires to make something permanent, or because he wants to 'express himself'. Or it is said that art finds its real motive in some instinct—in play, or construction, or sex—or, again, that art springs 'from the unconscious'. What we have to do now is to try to state what seems to be the truth about the central principle of art-construction, and to consider how the theories cited—or such of them as seem of importance—fall into place or fail to do so.

### III. 'INSPIRATION'

Perhaps the notion about art which is most common to all theories, and which is most generally accepted, is that it must have 'inspiration'. The notion is evidently an important one, and for this reason and because inspiration is usually rather vaguely conceived, it will be useful to begin with a brief consideration of what it may mean.

The ancient sense of the word 'inspiration' is well known. It is, of course, that the artist produces his work through the agency of some Being superior to himself, say, a God (or Goddess), a Muse, or perhaps an Angel. Inspiration means 'breathing into'; it was the Muse or other Being, t was thought, who breathed the music or the poem, or whatever it was, into the artist's soul for his transcription.

Though this notion no longer has the potency it had, we still speak of a person's being 'inspired' when he appears to utter things which seem to come not from himself, but from some agency or power beyond him. We speak of 'inspired' speech or 'inspired' action. Artists have often testified to the feeling that their best work seems to come from a source 'outside' themselves. And in the sphere of religion the idea still has some importance.

But what is, more prosaically, often meant by 'inspiration' to-day is illustrated by quite a different interpretation of the metaphor of 'inspiration' or 'breathing into'. We say that Arnold was inspired, not by an Angel or a Muse, but by Oxford or by Rugby Chapel. We mean that these perceived objects stirred and stimulated Arnold into production. In terms of the metaphor, it is not another animate Being who breathes into the poet, but he himself, who breathes. *What* he experiences is like a fine mountain air, intoxicating him into song.

On this interpretation, the term 'inspiration' means the conscious apprehension of some object[1] which is such that an artistic process is set going. Inspiration is thus a kind of motivation. But it is only one kind. Motivation is a wider concept than inspiration, and we must consider it generally, keeping in mind the special question, Do the immediate conditions of artistic production include, as essential, the conscious apprehension of some 'inspiring' object? Arts like painting and poetry are commonly supposed to be inspired by an object; but others certainly do not seem to be so inspired. Or at least it is difficult to discover definite inspiring objects, definite 'subject-matter' (outside the art itself) of a good deal of music and dancing, or of arabesque or architecture. Let us turn, then, to the general question and hope for light by the way on the special one.

[1] Including persons and events.

IV. ARTISTIC MOTIVATION THROUGH PERCEPTION, AND
OTHER SOURCES

What sets the artist going? In one sense everything. The cause of the artist's production includes a vast conglomeration of circumstances. It includes all the conditions of his past life, his state of body at the time, and his state of mind at the time, conscious or dispositional. It includes all the circumstances giving rise to an inspiring object, which, strictly speaking, may imply the whole history of the universe up to the time of the event. Most of these things, however, are not in the least interesting for the theory of art. We may let them alone. The things we are interested in are the *immediate* conditions which set the artist going and the conditions which keep him going once he has started.

The basic fact about the aesthetically equipped person, which differentiates him from all other highly developed human beings, is a great sensitivity to the suggestiveness of the material which he perceives. This material is always tending to set his imagination working. The moralist may have a keen sense of moral values, the religious mystic of a Presence behind all phenomena; but for the artist, who is the type of the aesthetic person, it is values *as embodied* in perceived stuff which matter. To the artist, then, whose organism is disposed to be keenly alive to sensuous impressions, who is keenly discriminative of them, and whose mind is quick to apprehend the valuable meanings with which, to his imagination, the material appears to be charged, the material is a stimulant. It stimulates into activity needs which are experienced as 'desires'. The needs demand fulfilment (and the 'desires', satisfaction) and they find it partially in the apprehension of the stimulating material. Thus the sound of 'tuning up', or of a few odd notes of his theme played by a violinist before he begins his recital, both whets an appetite to hear a more satisfying sequence of

sounds, and, at the same time, partially fulfils this need. That fulfilment does, so far, occur, is indicated by the fact that we enjoy the notes which we hear. But if the preliminary skirmish whets and satisfies it whets more than it satisfies. Or it whets in satisfying. It whets desire for a fuller fulfilment and a fuller enjoyment. If the notes happen to be the notes of the first few bars of a trio, the notes played will demand the next phrase, and the next, and the next, and so on, stopping nowhere short of the end. Whilst the music is in progress we are at every moment becoming satisfied by what is given. But the very thing which satisfies us is itself a demand for more. Its expressiveness satisfies, but it is an expressiveness of instability, of the instability of experience, of life itself. Instability demands stability, but this is not found before the end. And when the end is reached, we see that it is not, paradoxically, the end, but the process of reaching it—in other words, the lived aesthetic whole, which is satisfying. Aesthetic experience is not the stopping or ending of a process, but a life of appetite and satisfaction more intense than ordinary earthly life and rounded to unearthly perfection.

The tendencies which are stirred, fulfilled, and stirred again by the apprehension of this phrase or that, are of course tendencies both of the organism and of the mind. The values, i.e., are both organic and mental. And further, there is, as well as the direct production of these values, 'indirect' production, by the process of association.

The same general statements are of course true of the arts other than music. They are true of painting, for example. The perception of a shape—say the shape of a cedar tree— stirs and partially fulfils certain bodily and mental needs. Its structure, its colour, its grace, its dignity, are pleasing. We may draw it, stressing this and eliminating that, the drawing making for a more vivid realisation of the values, and selectiveness making for their purification from irrelevancies. But the isolated tree, though satisfying, is inadequate,

unstable; it must spring from its earth, it must grow in a setting. To show up the beauty of its volumes, its planes and its lines, we may, in our drawing, set it forward against the background of an old house. To emphasise its black-blue-green foliage, we make it stand out against the white-washed walls of the house; to emphasise the severe grace of its form, we introduce other, more delicate, foliage in contrast. To balance the shadows of the house, we introduce an old wall in this corner or that. And so the picture grows from one fascinating instability to another, till it is complete. The whole is a unified embodiment of many values, which as a whole does possess stability and which is something in which we can remain, without temptation to wander outside its boundaries.

This is the schema of how a work of art may arise, starting off with the perception of some stimulating material. But the initial process may be reversed. Instead of the need being wakened by the perception of material, artistic construction may be started in other ways. It may be started by an idea, or by some other object or event which is not material. Anything which stirs what we call 'an emotion' may set the artistic process going. It may be a vague feeling of mortality, or of spring, or of the sublime, or of a general *joie de vivre*, or it may be some purely fortuitous circumstance, such as a fit of irritation. But very commonly the initiating agents are 'inspirations', involving the apprehension of interesting objects. The 'inspiration' might be an example of a work of art in the artist's own medium. More probably it would be something else. The painter need not be motivated in the first instance by seeing paintings, or even natural objects. He *might* be stimulated by music, by poetry, by ideas, by persons, or by natural objects of a non-visual kind. So the musician need not be stimulated to compose only through auditory suggestion. Debussy has said, I believe, that "it is more profitable for a musician to watch a fine sunset than to listen to the Pastoral Symphony". The musician may

thus be stimulated through vision. Or he may be stimulated through the medium of friendship (e.g. Elgar's *Enigma* variations), through ideas, or indeed through anything which interests and stirs him. Such interests may be very vague and undefined or they may be definite.

We commonly say that such inspiring objects, whether vague or definite, 'arouse emotion', and that emotion is the 'dynamic' of artistic construction. Superficially, as we saw, this is true, but only superficially. If the 'hormic' psychology is true, then what is awakened or stirred by the inspiring object is not *primarily* feeling or emotion, but need or tendency. Tendency is experienced as vague unrest, as desire which demands fulfilment and satisfaction. Fulfilment and satisfaction in *this* case can only be obtained through the production in some medium or other of a system of perceived objects which (through all the complicated processes involved in 'expression') is found to fulfil and satisfy, in the very contemplation of it, the awakened needs. Thus sunset[1] colours and forms waken in a Turner needs which can only be fulfilled by means of selective painting. In a Swinburne they stir the need to make a system of harmonious, satisfying words which to the poet's imaginative mind somehow fulfil the needs awakened by the very different visual material of the sunset. In a Debussy the appetites whetted by perception of the sunset can, perhaps, be fully satisfied only through the production of a system of harmonious (and disharmonious) sounds. The apprehension of the completed music, and that only, can for the musician fulfil and satisfy with full enjoyment the needs awakened by the self-same sunset, which is (approximately) common to all three artists, the painter, the poet, and the musician.

[1] No doubt we are all tired of the illustration. Yet sunsets do in fact appear to have stimulated real artists—sometimes.

## V. Why there are different Arts: Artists, and Varying Materials

*Why* should the same object initiate such very different processes? Why should a sunset stir painting impulses in one man, verbal impulses in another, and sound-producing impulses in a third? One possible answer to such a question —if it is an answer—is that the several artists are so *made* that this happens. The painter is so made that, when his needs are awakened, their fulfilment tends to flow out along the channels of his interests in colours and shapes, of his painting activity. Inspire the poet and he breaks into words; harass the musician or fill him with woe and sorrow and tragedy, or with rapturous joy, and he will, under certain conditions, so arrange sounds that they express the profoundest values of his being. He may produce a symphony which stirs and satisfies and gives a special kind of pleasure, 'musical' pleasure, to his—and our—hungry soul. The artist is *made* in that way. And each artist is made in his own particular way. What interests the painter, as such, may leave the poet cold. And vice versa. You can see it in their very bodies. Or you can, anyhow, see it in the body of the plastic artist. As Mr. C. R. W. Nevinson (with a natural prejudice in favour of his kind) has rather violently and pungently put it, "Very few literary men have a visual sense, or any response between their hand and brain. I am always able to know a literary man by his hands, which hang by his side for all the world like hibernating slugs. An artist [a plastic artist] can always be recognised by the movements of his hands, which are forming and drawing the ideas of his brain".[1] Mr. Nevinson is a little biased, of course, and the external evidence, too, points in favour of the plastic artist. Perhaps if Mr. Nevinson could get inside the *glottis* of the painter he would see, if not "hibernating slugs", a depressing limpness like the limpness of deflated toy balloons.

[1] Letter to the *New Statesman*, March 29, 1930.

"Artists are *made* in that way." To say this is to say no more than to say that with which we started, namely that the basic fact about the artist is that his body-and-mind is peculiarly sensitive to such and such material, and to its suggestiveness. The artist's vocation is to be specially aware, not of values in general, but of values embodied and (to him) embedded in material X or Y or Z.

Another side of the same thing may be noted. It is the fact, not so much that special organisms have special capacities for special materials, but rather that special materials make their own demands, and set their own marks and limits, upon aesthetic expression. It is vividly expressed in the following passage by Bosanquet. "Why", he asks, "do artists make different patterns, or treat the same pattern differently, in wood-carving, say, and clay-modelling, and wrought-iron work? If you can answer this question thoroughly, then, I am convinced, you have the secret of the classification of the arts and of the passage of feeling into its aesthetic embodiment; that is, in a word, the secret of beauty.

"Why, then, in general does a worker in clay make different decorative patterns from a worker in wrought-iron?" He goes on ". . . in general there can surely be no doubt of the answer. You cannot make the same things in clay as you can in wrought-iron, except by a *tour de force*. The feeling of the work is, I suppose, altogether different. The metal challenges you, coaxes you, as William Morris said of the molten glass, to do a particular kind of thing with it, where its tenacity and ductility make themselves felt. The clay, again, is delightful, I take it, to handle, to those who have a talent for it; but it is delightful of course in quite different manipulations from those of the wrought-iron. I suppose its facility of surface, how it lends itself to modelling or to throwing on the wheel, must be its great charm. Now the decorative patterns which are carried out in one or the other may, of course, be suggested *ab extra* by a draughtsman, and have all sorts of properties and

interests in themselves as mere lines on paper. But when you come to carry them out in the medium, then, if they are appropriate, or if you succeed in adapting them, they become each a special phase of the embodiment of your whole delight and interest of "body-and-mind" in handling the clay or metal or wood or molten glass. It is alive in your hands, and its life grows or rather magically springs into shapes which it, and you in it, seem to desire and feel inevitable. The feeling for the medium, the sense of what can rightly be done in it only or better than in anything else, and the charm and fascination of doing it so—these, I take it, are the real clue to the fundamental question of aesthetics."[1]

## VI. Croce's Views on Material and Technique

The material, then, is of central importance. It is the more necessary to stress this, even to harp on it a little, in that some of the writings of Croce[2] have given rise to a wide-spread, and unfortunate, impression that material is *not*, aesthetically, of the first importance. This impression is certainly widespread. I do not think it is altogether justified, as I shall show. But it certainly exists. Its popularity is perhaps partly due to the fact that the apparent 'spirituality' of such a doctrine is always likely to appeal, through its emotive associations, to dabblers in philosophy and art. But the impression that, for Croce, material embodiment is unessential, is not confined to popular opinion.[3] It is the interpretation of first-rate experts like Bosanquet.[4] Perhaps because this matter is, though controversial, so important, I may be allowed to quote still further from Bosanquet. Bosanquet alleges[5] that Croce is so possessed by the idea that beauty is for and in the mind, that he forgets that

[1] *Three Lectures on Aesthetic*, p. 58 sq.
[2] When this section was written, I had not read Croce's article in the *New Encyclopaedia Britannica*.
[3] Limited popular opinion, of course.
[4] Cf. also Alexander, *Art and the Material*, pp. 10, 16, and 17.
[5] Op. cit., p. 67 sq.

"though feeling is necessary to its embodiment, yet also the embodiment is necessary to feeling. To say that because beauty implies a mind, therefore it is an internal state, and its physical embodiment is something secondary and incidental, and merely brought into being for the sake of permanence and communication—this seems to me a profound error of principle, a false idealism. It meets us, however, throughout Croce's system, according to which 'intuition'—the inward vision of the artist—is the only true expression. External media, he holds, are, strictly speaking, superfluous, so that there is no meaning in distinguishing between one mode of expression and another (as between paint and musical sound and language). Therefore there can be no classification of the arts, and no fruitful discussion of what can better be done by one art than by another. And aesthetic—the philosophy of expression—is set down as all one with linguistic—the philosophy of speech. For there is no meaning in distinguishing between language in the sense of speech, and other modes of expression. Of course, if he had said that speech is not the only form of language, but that every art speaks to us in a language of its own, that would have had much to be said for it. But I do not gather that that is his intention." He goes on to say that Croce's notion is "deeply rooted in a philosophical blunder". The blunder is "to think that you can have them (things) completely before your mind without having their bodily presence at all. And because of this blunder, it seems fine and 'ideal' to say that the artist operates in the bodiless medium of pure thought or fancy, and that the things of the bodily world are merely physical causes of sensation, which do not themselves enter into the effects he uses".[1]

I have cited Bosanquet and referred to Alexander[2] to show that the impression which Croce has left on distinguished minds is a very clear and definite one. No doubt other examples might be found of its incidence. Personally I

[1] Bosanquet, ibid., p. 69.  [2] Footnote, p. 166.

believe that it is extremely doubtful whether Croce really means a great deal of what he says, particularly in his earlier work, the *Aesthetic*. Croce is, of course, an idealist, and holds a special view of the ontological status of material and of its relation to minds. But apart from this it does not appear that Croce, *on the whole*, intends to deny the importance of embodiment in material as much as he seems to do in certain places. There are many passages which point in the opposite direction.

It is true that Croce continually ignores the dependence of imagining upon perceiving, that he forgets,[1] in speaking of Leonardo's painting with his mind, that Leonardo's visual images could exist only in so far as constructed out of perceptual data. He fails to see that this is true of the images of words, or statues, or music, and that without the fact of what he cavalierly dismisses[2] as mere "willing" (to "utter by word of mouth", to "take up the . . . chisel", to "stretch out our hands to touch the notes of the piano") the word or the statue or the musical motif "within us" could have no existence at all. In other words, *what* is imagined is the 'material': and imagination of the material is based on perception of the material.

Nevertheless, if we may pass over what appears to be, in Bosanquet's terms, a "sheer blunder", we shall find that Croce does continually insist on the necessity of embodiment —in his own sense. This is much more clearly and unambiguously expressed in the *Brevario*[3] than in the earlier work. It is illustrated in the following extracts. "The content is formed and the form filled",[4] the "feeling is figured feeling and the figure a figure that is felt".[5] Again, "a musical image exists for us only when it becomes concrete in sounds; a pictorial image only when it is coloured". It need not be actually declaimed or performed or painted, but "the words

---

[1] *Aesthetic* (Ainslie's Trans.), p. 10.    [2] Ibid., p. 50.
[3] Translated by Ainslie under the title of *The Essence of Aesthetic*.
[4] Op. cit., p. 40.    [5] Ibid.

run through our whole organism, soliciting the muscles of our mouth and ringing internally in our ears; when music is truly music, it trills in the throat and shivers in the fingers that touch ideal notes".[1] "If we take from a poem its metre, its rhythm, and its words, poetical thought does not, as some opine, remain behind: there remains nothing. Poetry is born as those words, that rhythm, and that metre."[2] Again, "How little . . . does a painter possess of the intuitions of a poet! And how little does one painter possess those of another painter!".[3] Again, "Artistic imagination is always corporeal."[4] It is a pity that such unexceptionable statements should be negatived in other parts of his writings by confusions and ambiguities arising from what certainly will appear to many present-day thinkers to be a false view of knowledge.

The idea that 'real' embodiment is an aesthetically irrelevant circumstance[5] is seen perhaps with most force in Croce's views of artistic production. The making of the work is a practical, and not an aesthetic, activity; it is a "translation of the aesthetic fact into physical phenomena (sounds, tones, movements, combinations of lines and colours, etc.)".[6] The translation exists merely for the purpose of making permanent the product of the artist's spiritual labour, and for the sake of communicating it to others. "The artist . . . is a whole man, and therefore also a practical man, and as such takes measures against losing the result of his spiritual labour, and in favour of rendering possible or easy, for himself and for others, the *reproduction* of his images; hence he engages in practical acts which assist that work of reproduction."[7] These practical acts he calls "technical".

I have said enough to show that, aesthetically, actual embodiment is absolutely essential, and is not a mere means to communication, reproduction, translation. If this is

---

[1] *The Essence of Aesthetic*, p. 43.     [2] Ibid., p. 44.     [3] *Aesthetic*, p. 11.
[4] *The Essence of Aesthetic*, p. 49.     [5] *Aesthetic*, p. 51.     [6] Ibid., p. 96.
[7] *The Essence of Aesthetic*, p. 45.

true, then technique, which is a means to aesthetic embodi-
ment, will not exist primarily for the sake of 'translation',
'communication', 'reproduction', but for embodiment.
These other factors may also enter in as ends, and I shall
return to the subject shortly. But meanwhile, aesthetic
embodiment is the prime aim of technique, and aesthetic
embodiment is, aesthetically, an end in itself.

## VII. Technique and Aesthetic Values

And here there arises a question of some interest. Is technique
itself *merely* a means to embodiment, or may it have in itself
an aesthetic value? Again, does technical knowledge and skill
affect or influence our appreciation of art, and, if so, how far?
And how far and in what ways do technical knowledge and
skill affect the work of the artist? Let us take these questions
in turn.

In the meaning of the term 'technique' I include all the
practical activity, involving various degrees of skill, which can
be said to have any significant bearing upon the making of
a work of art. The first question is, Is such technique *merely*
a means to actual aesthetic embodiment, or can it possess
in itself an aesthetic value? Can we say, as is said by a recent
writer,[1] that in artistic production the artist does "not have
an aesthetic experience at all", because he is not "content to
remain absorbed in rapt contemplation of the beautiful
object"? Is the completed beautiful object the only aesthetic
object? May not the process of making be an aesthetic object
of its kind?

It is, of course, perfectly plain that the object which we
contemplate in the finished work is distinct from the object
we contemplate in the process of making. I.e., in the latter
case the object is just the process of making itself. And it is
also necessary to recognise further two things. The first is that
both are contemplative activities, that the process of making

[1] A. C. A. Rainer, "The Field of Aesthetics", *Mind*, Vol. XXXVIII,
No. 150, p. 165.

is contemplated just as much, though in a different way, as the finished work. And second, we must remember that contemplation itself is not an inert or inactive state of mind but is discriminative, synthetic, actively imaginative. In the one case this mental activity is directed towards a finished, or partially[1] finished, product; in the other case it is directed towards a practical process of production.

We have, then, two kinds of objects of possible aesthetic contemplation: (1) a finished or partially finished product, (2) a practical process of producing. In the latter class it is useful, I think, to distinguish further between (a) that producing activity or technical process which *immediately* leads to the finished production, and (b) the technical process or processes more *remotely* connected with the finished production. Examples of the former would be the actual process of laying on the paint, or of touching the notes of the keyboard, or of bowing in violin-playing. Examples of the latter would be the mixing of the pigments, or the preparing of the canvas, or the practice of mechanical exercises producing dexterity. Between (a) and (b) there can of course be drawn no hard-and-fast line.

We have, then, (1) and (2) (a) and (b) as possible aesthetic objects. Are they ever actually aesthetic objects? As regards (1) there is no question. What, then, of (2) (a) and (b)? I think we may say with absolute certainty (a) that to the working artist the technical process *immediately* leading to the production of the finished object, or of a stage of it, *may* sometimes be an aesthetic object. Whether it is so or not would appear to depend partly upon the stage of production of the art, and perhaps upon the art. The actual playing of passages, the actual drawing or painting of important parts of the picture, are very likely to yield aesthetic pleasure. The roughing out or laying of a wash does not seem so necessarily to involve this. It is probably the case that the more immediately dependent upon technical excellence is

[1] For the artist may stop to contemplate his work as far as it has gone.

the aesthetic value of the actual finished work, the more inevitably will the technique itself tend to be aesthetically enjoyed. In playing or in painting the most important and interesting parts of the work, it is unlikely that the artist could produce the right effect without some aesthetic excitement, some enjoyment of his movements as expressive of grace and beauty. It is quite clear of course, as has been said, that the technical 'object' is different from the completed object, and the aesthetic pleasure gained is rather analogous to the movements in dancing. I do not suggest that the focus of the artist's attention is upon these things: they must indeed be extra-focal, because it is not (as in dancing) they which are the final object, but a product which is different from them. But they probably do, I think, enter into the content immediately before his mind. Would his work be vital if his immediate experience of producing of it were lifeless and cold and aesthetically neutral?

(2) (b) As regards that part of technique *remotely* connected with the finished product, we can only say that it may sometimes yield aesthetic pleasure, and sometimes it may not. There is no tendency to inevitability here. If there is aesthetic experience, it is possible that the values realised will be fused into (2) (a) and even into (1), so that to the experienced artist the enjoyment of his own picture, and even of another's, will contain the fused values not only of actual painting activity, but of the general daily work and smells of the studio.

It may be said that this is irrelevant to the finished work of art, and that what we contemplate in the painting or the sonata is just the colours on the canvas, and the music, and not any of the values we have included under heading (2). But it depends. It is true that we do normally think of the painting or the sonata as the unit, and do not include the painter or the pianist in their efforts. But we *may* do so, and in the case of the pianist at least I think we frequently do. It is possible, that is to say, to get a *different* aesthetic experience in watching *and* listening to Schnabel playing,

than it is from listening to him with closed eyes. This may cause distraction from the music, upsetting our aesthetic stability, but it need not do so necessarily—though the dangers are great. Fusion is possible. If we do contemplate the two things fused together, our art-object will be more complex, i.e. Schnabel-sitting-at-his-Bechstein-playing-the *Hammerklavier*-Sonata, and not just the *Hammerklavier* Sonata. And, if we have sufficient technical knowledge, if, for example, we are pianists, the quality of the music itself may be enriched by watching. The *mere* vision of the player is of course in itself irrelevant to the music.

I conclude, then, that technique *may*, under certain conditions, yield aesthetic experience in itself, both to artist and to spectators of the artist, and that the aesthetic values of technique may in some cases become united to those of the finished product.

The next question was, whether, and how far, technical insight and skill may help to enrich our experience as spectators of the finished work of art.

That it does enrich our experience is highly probable. What applies to the drawing of a map of Sicily[1] applies to the aesthetic apprehension of works of art. If it is difficult to have an accurate apprehension of the contour of a region when we are not able to draw it, so it is difficult for us to appreciate the full value of the expressiveness of a material unless we ourselves have made some aesthetic experiments in the handling of it. In technical experimentation we discover.[2] We discover what the materials and its aesthetic possibilities really are. It would be going much too far to say that without it there could be no aesthetic experience. But it remains true that technical experimentation tends to increase discrimination, and through it (other things being equal) aesthetic experience.

The final question was, How far does technical skill and

[1] Croce, *Aesthetic*, pp. 8, 9.
[2] See Alexander, *Art and the Material*, p. 12 and passim.

insight affect the quality of the artist's work? In the first place it is quite clear that if he has poor technique his powers of communication and his chances of practical success as an artist will be impaired. But, what is more important, it is also probable (I suggest with some hesitation) that his power of imagining a finished product will be limited. If his hands are inflexible, it is unlikely that he will be able to visualise so perfectly, out of his *own* direct technical experience, how a rapid passage ought to be played. He may learn from listening to other players, but that is a different matter. If his workmanship as a painter is poor, he will tend to fail (again, so far as he is dependent on his own private experience) to visualise precisely how his picture should be painted.

But the question how far technical powers condition the artist's aesthetic vision is difficult, and I can only ventilate it. We certainly could not go so far as to say that poverty of artistic imagination runs parallel with poverty of technique. The case of Blake or of any of the great Italian primitives makes this clear. It is difficult to say what vision and depth and greatness of vision really mean. I shall return to the subject later.[1] But they do mean something, and whatever they do mean, limitation of technique does not in itself appear to imply a definitely corresponding limitation of greatness or depth or intensity of vision. The depth and intensity and sincerity of Blake or (in a very different way) of Giotto are plain enough. And it is impossible to say that Blake or Giotto, given a more perfect technique, would therefore have been better artists. They might have been; but also they might have ceased to possess the special charms of Blake and Giotto. Very often, as we know, with the greater technical competence of a later age aesthetic vision diminishes. On the other hand, it would seem as though, other things being equal, lack of technique is an aesthetic defect and must limit vision. Would not Rembrandt, bereft

[1] In Chapter IX, p. 237 sq.

**Genus**

General aesthetic activity or 'aesthetic imagination'. (This never of course exists by itself, but only in relation to objects, as opposite.)

in relation to

**Species**

(1). A given perceptual object which is:

(a) aesthetically *incomplete*, i.e. which fails to yield complete aesthetic satisfaction, and which therefore calls out some *selective* activity (etc.) in the 'seeing'. E.g. an odd bit of natural landscape which contains many aesthetic 'accidents'.

(b) aesthetically *complete*, e.g. a work of art by a master. This calls out imaginative activity, but is purely or mainly *appreciative of* a given whole and may involve little or no selective activity.

(2). *Imaginary* manipulative or productive artistic construction.

(3). *Actual* manipulative or productive artistic construction.

(1) (a) and (b) may be called generally '*Contemplative* aesthetic activity'.

(2) and (3) may be called '*Productive* aesthetic activity', or '*Artistic* production'. This has 'Contemplative aesthetic activity' as its 'final cause'.

of his amazing technique, have been lesser, not only as technician, but as artist of vision?

## VIII. CLASSIFICATION OF AESTHETIC EXPERIENCE

In concluding this section of the discussion it will be useful, I think, if we distinguish the kinds or classes of aesthetic experience. I have tabulated them on p. 175.

All four processes mentioned are aesthetic processes; and the term 'aesthetic' should not be confined to (1) (*a*) and (*b*) [or to (1) (*a*), (*b*), and (2)] exclusively of (2) and (3) [or of (3) alone]. Again, the quality of aesthetic experience in (1) (*a*) and (*b*) and (2) is probably to *some* extent dependent on experience of (3). Finally, (1) (*a*) and (*b*) should not be called 'art'.

## IX. OTHER THEORIES OF MOTIVATION: DESIRE FOR PERMANENCE

We have been discussing, so far, the central motives and process of artistic production, and have seen how essential is the notion of the material. It will now be in place to review very briefly several of the different ideas already alluded to which have sometimes been offered as accounts of the motivation of artistic production.

Our view has been, roughly, that in artistic production the artist desires to produce a complex self-contained unity which will 'embody' values, and in the perception of which a great complexity of awakened needs will be fulfilled. Such an account is at first sight, at least, something like that which gives prominence to the desire for *permanence*. The artist, it is sometimes said, desires to capture and enshrine the value of the fleeting moment and to enhance it. Shelley's words express this idea: "Poetry is the record of the best and happiest moments of the happiest and best minds. . . . Poetry . . . makes immortal all that is best and most beautiful in the world; it arrests the vanishing apparitions which

haunt the interlunations of life, and veiling them, or in language or in form, sends them forth among mankind. . . . Poetry redeems from decay the visitations of the divinity in man."[1]

This is probably true in some sense of all art: there is desire, it may be feverish desire, to capture something for the artist, and perhaps all the world, to dwell upon. The artist desires to build tabernacles on his mountain of transfiguration. Yet such an idea rather presupposes that there is already something which *can* be preserved, that the best and happiest moments which art expresses exist *before* expression, that expression is but translation into more solid material of something already given. But the work of art is not translation, it is construction: and it is creative construction in the sense that in the completed whole there is contained more than existed before the construction. The best and happiest moments, so far as art is concerned, do not exist until the last word is said or the last bar played. Of course there *are* "best and happiest moments" before the work is created. But it is not precisely *they* which are 'captured' but something different. The process of art, then, if it can be said to be motivated by desire to capture something, must be said to be so in the sense that it captures or discovers something which is not given to begin with, but which is found and grasped only after complicated artistic effort.

## X. IMITATION

The fact that what it is desired to make permanent is not fully discovered until the completion of the work, may seem to be negatived by the fact that artists appear to imitate things and so to make permanent for themselves and others what they imitate. As *imitation* is even now sometimes thought to be a central motive of art, it will be worth while to ask and to consider very briefly what its place may be.

[1] *Defence of Poetry.*

In the first place, complete imitation is in any case impossible. To imitate a tree completely would be to produce another tree of wood and sap and leaves exactly like the first. One might approximately 'imitate' a drawing, or a piece of furniture, or a dress; hardly a tree. But because by imitation we usually mean representation in some medium, say colour spread upon a flat surface, the limitations imposed are obvious. We cannot put in all the details; the larger ones are represented and the smaller ones are more or less vaguely indicated or left out. Again, selection is determined by the interests of the painter, interests which it is impossible to exclude, however much he will. Even slavish copying reveals that the painter is not interested in everything indiscriminately. The true artist, on the contrary, gets meaning into his picture by virtue of his skill in selecting and inventing and constructing what is expressive aesthetically. Imitation is never thoroughgoing in true art. Imitation may be, sometimes, a part of the process, but is never its essential principle.

"Imitation is *sometimes* a part of the process." It is difficult to make imitation, even aesthetically selective imitation, an essential principle of all art, for the reason that some arts, e.g. music, seem to contain very little of it, and others, e.g. architecture, if they contain any, contain hardly any at all. Yet imitation does *sometimes* play a part in artistic production. It appears to play some part in arts like painting and sculpture. And it is pertinent to ask, What exactly is its interest and importance? What is its *rationale*?

There is unquestionably a sheer joy in imitation. There is joy in imitating any object as accurately as possible, quite apart from its intrinsic interest or beauty. Such imitation yields the pleasure of clear and accurate knowledge; for indubitably imitation helps accuracy of apprehension of an object. The achievement of accurate imitation again gives sense of efficiency and power, to which, in some cases, may even be added a rather spurious delight in the deception which an illusory appearance gives. There must be a naïve

pleasure in being able to paint 'real' pictures of curtains, or dishes of fruit, and thus to deceive naïve-minded persons like the kings in story-books. There certainly *is* such a delight, otherwise pictures that 'look so real you could walk into them' would not arouse the perpetual interest which they do.

This delight has in itself, as we have said, nothing to do with aesthetic experience. But when the things which are 'imitated' are themselves to some degree aesthetic objects, when they are, i.e., perceived objects which up to a point are *aesthetically* pleasing, then imitation may form part of an aesthetic process. Suppose it is an attractive piece of landscape, or a character to be drawn by a novelist. The painter desires to apprehend the landscape more clearly and vividly because, as it stands, it is up to a certain point an expressive object to him. In order to apprehend it more clearly and vividly he begins to imitate it. But the landscape is only *up to a point* an expressive object, and in order to achieve something which is completely satisfying he has in his imitation to select—to eliminate, to stress, to add, to construct—a process which only properly ends, as we have seen, in the completion of a work of art. His 'imitation' is a qualified one, though it is still so much of an imitation that his painted trees for example can (at least sometimes) be recognised *as* being drawn 'from' real trees.

The same is true of the novel. The novelist is fascinated —or many novelists are—by real people. They are his models, they have their limited and qualified and imperfect beauty, and he desires to represent them as he *sees* them. His 'seeing' may be already so selective that he only has to draw[1] or imitate what he sees. Or he may more consciously select and construct. But his selection is determined, if he

---

[1] I am at the moment only considering him as a kind of imaginary draughtsman. It is of course true that his medium is words, and that the sensuous value of words and of their relation to the novelist's images have their own problems.

is an artist, by the principles of aesthetic experience. And the 'final cause' of his selective imitation is desire for complete aesthetic experience 'in' an object.

The problem of imitation does not arise in music in quite the same form. When imitation does occur in good music it either tends to be incidental, a diversion, and so to be of questionable value; or it becomes transformed and fused with the rest, and is made an expressive part of the whole. Aesthetic expressiveness is thus, once more, the aesthetic justification for the existence of any imitation at all. This is true of the imitations which may occur in programme music. But programme music, of course, need not contain imitations in the crude sense of sound-imitations of sounds, say pastoral sounds or storms at sea. It may believe itself to be 'imitative' in a much more subtle sense. It may be 'inspired' by very many objects, and it may purport to 'express' these, to express, e.g., persons, or scenes, or a philosophy of life. Of the first, Elgar's *Enigma* variations contain some of the best instances. Elgar warns his hearers that they are to listen to the music as music and not as programme, but the variations do, as is well known, depict personalities. The theory of what happens here is the same as before. The musician may, by touches of imitation here and there, suggest characteristics of his human subjects, but the essence of the process consists, not in any imitative reproduction of these, but in the production of musical forms which, by the process of aesthetic embodiment, completely fulfil for the time being the needs awakened through personal contact with the inspiring human beings. The hearer, in hearing, experiences roughly similar musically *embodied* values, but not the original objects of inspiration. This is true, generally, of all programme music which *is* music. The programme may be of love, of country scenes, of 'Fate knocking at the door'[1] or of "Fate, the power that thwarts our aspirations towards

[1] Beethoven, opening bars of *Fifth Symphony*. On *one* account. Another, I believe, contains reference to the notes of a blackbird—or is it a thrush?

happiness, that jealously watches lest happiness should get the upper hand . . . a power which, like a sword of Damocles, continually hangs over our heads . . ."[1] But these are (if we are to believe what we are told) the inspiring objects and no more. The values *we* get are embodied in the music and are untranslatable.

## XI. DESIRE FOR COMMUNICATION

Another motive which is often, very often, alleged to be of central importance in art-constructing, is the impulse to *communicate*. Within recent years Mr. Lascelles Abercrombie[2] and Mr. I. A. Richards have made it an important part of their aesthetic theories. Mr. Richards, for example, says, "The arts are the supreme form of the communicative activity", though he adds that the artist is not as a rule consciously concerned with communication, but with the business of embodiment. Nevertheless, the artist's "denial that he is at all influenced in his work by a desire to affect other people, is no evidence that communication is not actually his principal object."[3] For Croce, on the other hand, art, being intuition, is in essence incommunicable.

We may admit that, in a very strict sense, communication of aesthetic experience, and indeed of any experience, is impossible, without denying the force of the communication theory. Experience, and aesthetic experience, is no doubt personal and private, and no personal and private experience can ever literally be communicated to anyone else. It makes no difference to say that one part of the total aesthetic situation is a perceived object which can be perceived by others. For the mere perceived object (even presuming that it is neutral as between different subjects and exists inde-

[1] Tschaikowsky, Introduction to *Fourth Symphony*. Letter to Frau von Meck of February 17, 1878.
[2] *The Theory of Poetry* and other works.
[3] *Principles of Literary Criticism*, pp. 26, 27.

pendently of them) is not, as such, the aesthetic object; activity of the imagination is necessary. Yet there are such things as analogy and sympathy. In one sense each mind lives within its own cell, but there is also a very evident sense in which minds do communicate, sympathise with, 'enter into' one another's experiences. Accepting this common evidence, without going into the difficult question of the nature of communication, we may say that in some plain, rough-and-ready sense, we have things in common and that we do communicate with one another on many occasions. One of these occasions arises through the medium of art. If I am a competent listener, I can have experiences which are approximately similar to the experiences of the conposer, or to the experiences of other competent listeners. It is not meaningless to hold that we can compare our several experiences. The same is true of poetry, painting, and the other arts. Because (I am assuming) many people have approximately similar bodies and minds, and an approximately similar store of experiences, the perceived work awakens approximately similar responses. It is of course true that the similarity is only rough and approximate. Mr. Richards has himself urged this in his analysis of the definition of a poem[1] where he distinguishes four things which 'the' poem may mean. And he has shown even more clearly in his later work[2] how amazingly uncertain the interpretations even of educated persons may be.

Communication is, approximately, possible. Yet, though possible, is it essential? We may admit that artists possess, like all other human beings, social impulses. It is true that artists are sometimes unsocial or even anti-social, and that the idea of public approval, even of discriminating public approval, does not always count for very much with them. Doubtless, even, there are artists who destroy their works upon completion of them. On the other hand, it is unlikely

[1] Op. cit., chap. xxx.
[2] *Practical Criticism.*

that artistic production often, if ever, takes place which does not contain *some* presupposition of *some* kind of audience, even if an ideal imaginary one. The artist who is contemptuous of the public may have anything but contempt for some imaginary soul-companion who, he believes, really can appreciate the greatness of his work. The repudiation of desire for sympathy and appreciation is no sign of indifference to it. It may even be the defence-reaction against indifference, and reveal a profound hunger for appreciation. We should almost certainly be wrong if we were to say dogmatically that in any single instance the social factor is wanting. It need not be, as Mr. Richards says, in the focus of the artist's consciousness.

But though the impulse to communicate, to share, to be appreciated, may always be present, this is not to say that it is an essential motive or the essential motive of art. (Some arts, like acting, involve an audience, but this is another matter.) Rather does it appear to be of the nature of an inseparable accident. The impulse to communicate (etc.) may bulk more largely in art than in some other desires of human beings, e.g. the desire to acquire wealth, or the desire to outdo a rival. And desire to communicate may in most cases be a strong incentive to clarify and perfect expression as far as possible. In some instances the desire to communicate may even be a sufficient initiating cause of artistic effort. But it does not account for the central and intrinsic process of art itself. Theoretically it is even conceivable that an artist completely devoid of social impulses might create a perfect work of art. Communication would then become what I believe Mr. Drinkwater has called 'self-communication'. It is not to be doubted that such hermit—and hermetic—art might greatly lack in the richness of content which comes from social intercourse. It might be insignificant, though perfect. I am only concerned to show that the conception is not self-contradictory.

It may be said, If communication is so unessential, why

should the artist employ a medium which is a 'public' one? Why should he not be content with his own private imagined aesthetic experiences? The answer to such a question has already been given. The artist needs to produce an arrangement of perceived materials, we have said, in order to satisfy himself fully. Even if he imagines, his imagination must be based on perceptual experience. The fact that his material is a public one is *aesthetically* a mere accident, though to say this is not to deny that the artist's life as a man is indefinitely enriched by all social contacts.

## XII. Instinct, 'The Unconscious', Play', Self-Realisation

Other motives have been assigned as of central importance in artistic production. But they need not detain us. Among them may be cited self-realisation, and various instincts (other than those discussed) such as play, construction, sex. Or art may be ascribed to the action of the unconscious, individual or collective.

Of the theories which ascribe art to the 'unconscious' I shall say very little here, for the problem is a large and difficult one. But it is perfectly clear that, although in this matter enthusiasm has sometimes led to excess, there has opened out in recent times a vast new field of investigation. Many hasty assumptions will no doubt have to be given up. Pictures of mind as a partly submerged iceberg, or as an underground chamber of horrors, reductions of all human motivation to repressed sexual impulses and complexes— these things will pass away in the natural progress of events. But normal and abnormal psychology is, mainly through the instrumentality of the psychotherapists, possessed of new implements for investigation of a new world. We may not yet have the technique, or the psychology, to proceed as quickly as we should like, but the principle of analysis and of its allied methods is of course perfectly sound.

Nevertheless, if we are to admit, as we must, the application of the principle to works of art, and the creation of works of art, we ought to give our terms a very wide meaning. If we use the word 'repression' it should be taken, not in a strict Freudian sense, but to cover any great and widely rooted tendency or system of tendencies which is not cognised, or is not clearly cognised, by the subject, because it cannot by ordinary ways be harmonised with the system of conscious personality and conscious interest. We can say this without committing ourselves to the very doubtful notion of 'the Unconscious', or even of 'the Subconscious'. The notion will work perfectly well, I think, if we stick to the well-tried image of focus fading into a margin of whose contents we are but dimly aware.[1]

Sometimes the 'repressed' tendency or system of tendencies may be primitive, and (justly or unjustly) tabooed. Sometimes it may be something too subtle and highly complex for the subject to understand its nature, so that through lack of understanding, or through fears perhaps of violating some private or some social code of belief and behaviour, he ignores it as much as he can. Or, if he cannot ignore it, he misinterprets it as evil, or at least as awkward or embarrassing or foolish. On this view the unconscious (for us the 'marginally' conscious) includes impulses not only of sex, but of our deepest religious nature, that nature which may perhaps connect us with the larger Cosmos in ways of which we have no understanding.

Obscure tendencies and interests exist, and we have enough evidence to show us that art in a very real sense may be an expression of them.[2] Certainly the highest art affords fulfilment, which is symbolic fulfilment—in the very special sense

[1] On this point see Dr. Broad's admirable treatment of the subject in Section C of *The Mind and its Place in Nature*.
[2] See, for example, Dr. Ernest Jones' *Analysis of Hamlet*, or Professor Livingstone Lowes' *Study of Coleridge*, or in general Mr. W. M. Thorburn's *Art and the Unconscious*.

in which aesthetic expression is symbolic expression—of tendencies, of yearnings and hungerings in our nature which we cannot fulfil by any deliberate policy. We cannot fulfil them by any deliberate policy partly because, as we have said, they are difficult to harmonise, but partly also because we have not yet discovered what they are, and can perhaps only discover them progressively as we advance in wisdom— helped in our advancement through the influence of works of art.

To say that art expresses powerful, profound, and subtle impulses of our nature of which we are as yet not fully aware, and perhaps never will be aware, is to say something of importance. But it is not to enunciate any new aesthetic principle. For these fulfilled tendencies which become embodied are, once again, just values. And what the psychology of the so-called 'unconscious' can do is to provide increasing evidence of what some of these values are. This of course is a matter of detail, upon which it is not our task to enter.

Of the theory of *instinct* as the motivation of human life I need, for just these reasons, say nothing. The increased knowledge of the instincts has greatly altered our perspective of human life, and if art is (as it is) a perspective of life, then knowledge of instinct will of course throw its own light upon art. It is needless perhaps to repeat pious warnings of the dangers of excess here as in the theory of the unconscious. Highly specialised explanations of life or of art alike are to be distrusted.

The theory which makes art an outcome of the special impulse of play, for example, has been often enough dealt with by other writers. It is certainly not compatible with what we have said, except in so far as the need for play (and this applies to any other need whatever) may enter as an item to be fulfilled through artistic production. As for 'self-realisation', if this be taken as the outcome of the instinct of 'self-display', the same remarks apply as apply to the

instincts generally and as applied in particular in our account of communication. It is highly probable that some desire for self-realisation is always involved. The production of art is difficult, and to achieve it is satisfying both because it raises us in our own estimation, and, perhaps, in the estimation of others. Again, each artist has the gift of his special temperament: his creations are an expression of *him* and no one could produce quite the same things as he does. His production is not only creditable to him as a workman: it is beautiful; and his association with it enhances his personality. He may feel that he is worthy of honour, and perhaps that he deserves to be honoured. It is also true of course that too much reflection upon this kind of thing may adversely affect his art.

## XIII. Unity and Art

The work of art, we have said, involves the development of an aesthetic object to the point at which it possesses self-subsistent unity. *Any* perceived object which can be contemplated imaginatively is in one sense an aesthetic object. But it may, whilst possessing suggestiveness on account of some of its perceived qualities, fail to carry out its suggestions in other parts. It may promise and break its promise, it may let us down with a crash. We therefore have to idealise it in seeing it. If we are artists, we may represent it with modification and supplementations, such modifications and supplementations leading to the construction of a unified whole, an object which is completely satisfying, which possesses beauty. In practice only the artist primarily, and the technical critic secondarily, are able to say what modifications and supplementations should occur, what constructions are necessary in order that this particular whole shall grow on to completeness. In practice, abstract general principles are no necessary part of the contents of the artist's mind. But we have a right, in a theoretical investigation, to

ask what the unity of the work of art really means. This is our business now.

Generally speaking, unity is a category which applies to anything whatever. The possession of unity is therefore no criterion of the aesthetic. A flash of light, a fragment of stone or of sound, is, in the most general sense, as much a unity, as much *one*, as a mountain or a triangle or a rose or a symphony. But the unity which is relevant to our problems is of course not this bare unity, but something more organically related to its content; it is what is sometimes called the 'unity of complexity', or the 'unity of variety'. Here, again, however, the possession of unity is not an aesthetic criterion, for many things possess unity-of-variety which are not, in any sense we have described, aesthetic objects. Thus a human character or a philosophical system or a machine[1] may have unity-of-variety. Anything which is a complete system possesses it, and we have not found the essence of the aesthetic to lie in system, in unity-of-variety, but rather in expressiveness. It is true, of course, that many aesthetic objects do possess unity-of-variety, and that unity-of-variety is probably always a characteristic of the most highly significant aesthetic objects. I shall argue that this unity is, in the end, just the completeness or perfection of the working out of the expressiveness, so that the expressiveness becomes perfectly organised and self-contained, and without ragged edges. The aesthetic object in its perfection, then, possesses unity, unity-of-variety, but it is *aesthetic* unity which it possesses, and aesthetic unity can only be understood if we have previously understood the meaning of aesthetic expression. We cannot differentiate the aesthetic object merely by saying it possesses (any) unity of variety, for other things also do that.

[1] I am thinking of these as facts. It is conceivable, as we said in Chapter I, that aesthetic experience of these things is possible. I am only contending now that the *fact* of their unity-of-variety is not sufficient to constitute them aesthetic objects.

I do not suggest, in saying these things, that unity is in itself not a value, and an important one, and one whose aesthetic embodiment gives to the aesthetic object a real and striking importance. Unity is a value, desirable both as a means, and intrinsically, as an end in itself. In the first place, it is an aid to other fulfilments of tendency, both bodily and mental. We function best and most easily by means of system. (We shall see in a moment how this is illustrated in the case of perception.) In the second place, the systematic is the complete; it is that whose potentialities are wholly fulfilled. And the contemplation of it satisfies that fundamental urge in us which craves for all completeness and perfection. Unity is one of the most important of intrinsic values we know, and the aesthetic object gets much of its importance from its embodiment of unity. This is all true. But it is also true that the unity of the aesthetic object is aesthetic unity, and that its irreducibly aesthetic character must be recognised.

## XIV. Unity in Perception

The aesthetic experience, with which we are concerned, is ultimately perceptual experience, though of a special kind. The general laws, therefore, which determine for us the unity of the object as ordinarily perceived, may be expected to have a great deal of bearing upon the problem of the unity of the aesthetically perceived object.

The facts about the unity of attention in relation to perceived objects are familiar. Whenever we have to attend to a number of things at once, we must, if our attention is to be efficient, attend to them as a connected whole. When a number of diverse items appear upon the field of perception, we either fail to grasp them all at once, or we grasp them by means of imagining them to form some pattern. Or the many details not grasped at first, may be grasped later through certain groups of them being formed into patterns,

these patterns in turn being formed into larger patterns. This process of apperception may enable us in time to apprehend the most complex objects as single wholes. Thus, though we cannot simultaneously apprehend, so as to be able to count them, more than about five or six momentarily exposed visual entities (dots, for example), and though we cannot apprehend together, without counting, more than about eight sounds succeeding one another at regular intervals of a quarter of a second, much larger groups can be perceived if they are taken as groups of groups (or groups of groups of groups, etc.) of units. Or again, if the points be regarded as salient features of some interesting pattern, such as a picture in the fire, or Orion in his heaven, or if the sounds, say, of the moving train, or the beats of a drum, be given interesting meaning (be made, i.e., into a 'tune'), the same building-up process is possible. Of the psychological processes concerned in such building up of apperception we need not speak. It is sufficient to say that Unification is necessary. When it appears not to occur, as for instance when we talk and play the piano simultaneously, there is probably rapid oscillation of attention from one activity to the other, the process which is not actually being attended to at the moment proceeding automatically. But the fact that such a performance tends to produce restlessness and irritability shows that it is an exception to some normal rule.

## XV. Unifying Devices in Visual Art

In the arts many devices are employed to enable complex data to be apprehended as single and complete units. Perhaps there is to be found some excuse for those who have run to death the idea of unity-of-variety as an aesthetic principle, in the fact that great works of art, such as a drama or a symphony, do manage to integrate data from such an immense variety of sources. It is of course no proof, for the complexities which are united in the arts are certainly no

greater than the complexities unified in living organisms and in minds themselves. But great complexities there are, and the devices for ensuring unity of attention are many. I do not propose to attempt to classify them or to discuss them fully. That indeed would mean a treatise with illustrations on each of the arts, and to write such treatises is, luckily, no part of philosophy. I shall content myself by citing simply one or two illustrations exclusively from painting, where they are most easily grasped.

Devices[1] which may be mentioned are, the interest of a subject, the binding effect of lines, the binding effect of suggested movements, the emphasis, by special treatment, upon the focus of interest, the use of symmetry and composition or complex balance. These are some of the more important. They are not necessarily exclusive of one another, and they are selected at random. Books on pictorial composition will yield many more and with many interesting illustrations.

Interest in the *subject* may be an important unifying factor. We see the colours and shapes related as a single whole because of the subject they depict. A familiar and striking example of this process actually coming into operation is the case of the puzzle picture. 'Puzzle; find the dog in the picture.' Before the puzzle has been solved, the lines may appear to have little meaning or relation. Afterwards it is hardly possible to see them out of relation. So, quite apart from the 'thoughts' which subject-paintings may suggest, nearly all painting—except perhaps some extreme forms of cubism and vorticism, and of course all merely decorative work—gains pictorial unity from subject sources.

The binding effects of *lines* is a vague phrase, which, interpreted literally, denotes a considerable part of pictorial composition. It includes the use of line both on the surface of the picture and as suggesting depth through imaging.

[1] For a fuller general account of these see Langfeld, *The Aesthetic Attitude*, Chapter VIII sq. To this work I am indebted in the following passages.

The very boundaries, again, of the picture itself possess a unifying effect. An example of the binding effect of lines combined with the effect of a circular frame is Raphael's well-known *Madonna della Sedia* in the Pitti Palace, Florence. Again, lines may suggest connections between the parts of a complex picture. In many early Italian pictures of the Coronation of the Virgin, we get simply two pictures, one of earth, the other of heaven. Later, connecting lines are introduced, or the picture is bound together by suggested *movements* or by the *direction of the gaze* of the adoring saints. (These latter really come under a different heading.[1]) Again, architectural backgrounds are frequently used to give unity to the various items of interest in the picture. An example of almost total lack of any unity is the picture, by Pieter Brueghel the elder, of *Christ carrying the Cross*. Here there are dozens of incidents tending to disperse the attention. The happy use of architecture for this purpose of unity is seen in Andrea del Sarto's *Annunciation* in the Pitti Gallery.

Lines frequently suggest movement. Some of the most vivid compositions are those in which movement-suggesting lines give unity to what would otherwise be separated items. A good example of this is Michelangelo's *Creation of Man* in the Sistine Chapel, where the line of the arms of God and of Adam not only joins the two portions of the picture, but suggests movement and by it unity. Another example of the unifying effect of suggested movement is the gestures of the figures at the edge of the picture, towards the figure of Christ, in Leonardo's *Last Supper*. Again, there is Volterra's rather melodramatic *Descent from the Cross* in the Church of Santa Trinita de' Monti, Rome.

A good example of unity obtained by special *emphasis of the object of interest* would be many of the portraits of Rembrandt and of Velasquez, where the head stands out from a darker mass of colour. And in all pictures *composition* is involved, whether it be the more naïve symmetrical com-

[1] See below, this page.

position of so many of the Italian Madonna-and-child paintings (with standing saints) or the more complex and more interesting 'hidden balance' of composition. All these devices and very many more are subject, as everyone knows, not for paragraphs but for large books.

I shall not go on to cite examples of unifying factors in arts other than painting. It is sufficient to point out that they exist, that each art—music, poetry, drama, and so on—has its own ways of securing unity.

## XVI. Form

The unifying devices that have been cited are mainly what would be called 'formal' factors. Formal factors within the work of art may, for the purposes of discussion, quite legitimately be distinguished. The parts of the work have 'form' and the whole has 'form' which is its unity of the parts. There is real significance in such uses of the term 'form', and it may be said that in a sense form is one of the chief factors in art. In a sense it is true that expressions "can only become artistic by the addition of another essential element, not present in play nor in the activity that simulates art of the animals, and this element may be described generally as Order, under which main idea are included such manifestations of the principle as Rhythm, Measure, Proportion, and all those modes of arrangement used by artists that may be summarised as Composition. . . . Schiller uses a good phrase when he asks What is man before . . . the Serene Form tames the wildness of life? It is indeed one of the notable facts of human nature that in art this free pleasurable activity of self-expression obeys a certain inner control, that transforms it from a mere animal effervescence into a rational product of ordered parts in a clearly defined unity."[1]

On the other hand, it would be erroneous to take literally

[1] G. Baldwin Brown, *The Fine Arts*, p. 42.

the idea of the 'imposition' of form. Form and expression are
not related as Procrustes' bed to his victims. The unifying
devices to which we have referred are not merely so many
moulds impressed, as it were, upon a matter which is foreign
to them; they must, if the work in which they occur is to be
art at all, be true fulfilments of the aesthetic expression of
the picture. That, aesthetically speaking, forms are just
manifestations of the expression, and that the Final Form
of the Unity of the whole is just the completion or self-
containedness of the perfection of expression, is a fact which
it is of the first importance to grasp. It is so important, and
form is so often conceived as a kind of imposition, that it is
worth while discussing for a little the general idea of form.

Form, we know, is always literally inseparable from
matter, though distinguishable in thought. A near approxi-
mation to the idea of separation of form and matter occurs
when we think of a thing's shape, e.g. an odd piece of iron,
as distinct from the stuff of which it is made. It is true that
we cannot pull the shape away from the stuff. But the shape
has in such a case no very intimate connection with the
stuff, and does not reveal the nature of the stuff. Yet even
this is only true relatively, for the way in which a piece of
iron or stone will break, or the shape it will in time assume
through weathering, is partly due to its 'stuff'. And if we
look more closely, say through a microscope, we shall discover
that its shapes, more accurately seen, are very much deter-
mined by its stuff. Continue the process to its molecular
structure; this appears even more. And so on. Though the
distinction between 'shape' and 'stuff' is real, the relation,
even as regards physical shape in inorganic matter tends
to be intimate. The intimacy of relation is far more easily
seen, on the other hand, if we take as our example the shape
of an organism—of a flower or an animal. The general
shapes or the forms of these are profoundly significant of the
organism's nature. And if we dissect the flower or the animal
we see that the stuff of the shape is in its turn the form of

a further stuff, which is in turn the form of something else. And so on. This is all, since Aristotle, perfectly familiar, though it is often forgotten. Form and matter, though distinguishable, are always relative to one another, and, sometimes, very significantly so.

'Form' in art may mean several things. Among common meanings are (1) the 'body' as opposed to the *what* or *content* which is 'embodied'. In the case of visual art this would include both shapes *and* colours, as opposed to the meanings which these express. If form thus means body as opposed to content, and if we say that art's form reveals its matter, we are only then saying that in aesthetic embodiment the body is truly expressive of its content. The colours being bright, mean cheerfulness; the arrangement of the volumes is expressive—of whatever it *does* express: solemn moods are embodied in solemn movements or sounds or colours. So we might go on.

(2) 'Form' may mean 'formal' side of 'body' as *opposed* to sensa: e.g. shape as opposed to colour; the rhythm, the tempo, the structure, of a melody as opposed to the sound-values of which it is built up. In the plastic arts generally it will mean the 'shapes' as opposed to the materials or medium (in this restricted sense), and what is true generally of the relation between matter and shape, will be true in a special way of art. If you make the statue in marble, its forms will have to be markedly different from the 'same' statue made in clay or plaster. And this will affect the concrete character of the aesthetic expressiveness.

(3) Or 'Form' may mean something rather more general than this particular form or that within a particular work of art. It may mean a *class* of forms, of which instances are to be found in many works of art. Examples of such are, iambic or trochaic feet, common measure, four-four time in music. Or forms may be the forms of certain classes of works of art as a whole, such as the epic or the sonnet; the fantasia, the suite, the symphony, the fugue, or the sonata.

## XVII. Forms and Expression in Art

But the really important meaning of form in art is contained in the general truth which has been already stated. It is that form or forms, of whatever kind, are, in all genuine art, just the revelation-in-a-body of art's content (or matter). Traditionally we have certain art-forms. In music we have the madrigal, the fantasia, the fugue or the sonata or the symphony. In architecture we have the Classic, the Romanesque, the Gothic, the Baroque; in poetry the sonnet, the Spenserian stanza, the triolet. An artist may set out to construct a work in one or other of the set forms. If he is inexpert, the form may appear to him difficult, even clumsy, fitting ill with the matter of his experience. Suppose he is a poet. It may be that, although he is a craftsman of merit, his experience in the end simply will not find its outlet through any of the set forms. On the other hand, it may. He may discover that in the sonnet or in the Spenserian stanza his aesthetic experience comes to possess an ordered significance which it could not have possessed had he chosen to manufacture some 'freer' form of his own. There may be modification of his first mood, but it is modification which is development and discovery. The reason for this will be, that the ready-made form has not been imposed like a mould and successfully forced upon the matter, but that the matter has, through its relation to the form, *grown* to a new organic completeness. There is a certain analogy, I suppose, between this and the development of a fruit tree, as the result of judicious pruning. The reason why the ready-given form is *able* to condition such fruitful fulfilment of the artist's aesthetic experience, is that, though ready-given, it is form which has been discovered in the course of long experience and experiment, by similar living minds in the past. The forms which have achieved permanence, which have become typical, are just those forms

which aesthetic experience of certain important types has naturally tended to assume. Their crystallisation is of course helped by tradition. And when the poet, in using the form, discovers a new unity in his experience, he is simply sharing in an empirical discovery of other minds in the past. This is perhaps even more vividly illustrated in rhythms and metres, than in types of unity as a whole. The form of the trochee is not something imposed upon a certain type of feeling; it is this feeling's most natural spontaneous embodiment.

In all cases, Form, as described in a general phrase, is of course only a rough approximation to the actual form which any artist uses. The 'sonnet' or the 'Spenserian stanza', or the 'trochaic' or 'iambic' measures, or the 'sonata' or the 'fugue', stand merely as *general* types; they imply a general anatomy of which this or that work is the living embodiment, varying in every case from standard. The standard guides the artist. And it guides the attention of the appreciating mind. But, beyond that, the individual imagination must do its work freely. Expression is the primary notion, not Form.

But though expression, not form, is in *this* sense the primary notion, that is only because we are thinking at the moment of form [in sense (3) above] as if it were external to expression. The true aesthetic form, on the other hand, as we have been arguing, is expressive form, and conversely form is the structure of expression. For aesthetic expression is embodied expression. It is not mere content, but imaginatively apprehended content-in-a-body. It can never be stressed too much that neither body nor meaning is our main concern in aesthetics, but embodied-meaning. This is the aesthetic object, and the unity of the whole is just the complete concrete self-containedness, not of a physical 'picture' or 'symphony' or 'poem' for the organism, nor yet of a set of disembodied contents; but of the contents-embodied, or the embodiment-of-content. And this, which lives before imaginative perception only, is perhaps the greatest perfection that

man knows. It is neither merely sensuous, nor is it other-worldly; it is an ideal world *in* this world of sense. The experience of art is the mysticism of the world of sense. And being such, it awakens neither gross, nor other-worldly longings, but is itself all-sufficient.

## XVIII. 'DISCOVERY' VERSUS 'TRANSLATION' IN ART

The truth of this seems to be overlooked by those who regard art as a translation, for the purposes of communication, of a spiritual experience. If we are right, there is, as we have said, no 'translation' of spiritual experience, or of any inspiration, in art. The point is well brought out by contrasting two points of view on the matter—the point of view, on the one hand, of Professor Lascelles Abercrombie, and, on the other, of Professor Alexander.

Mr. Abercrombie, writing of poetry, says:[1] "This moment of imaginative experience which possesses our minds the instant the poem is finished, possessed the poet's mind the instant the poem began. For as soon as there flashed into complete single existence in his mind this many-coloured experience with all its complex passion, the poem which we know was *conceived*, as an inspiration. Whatever event in the poet's life generated it, this is the first thing we can take hold of in the composition of the poem; and it existed before the verbal art of the poem was commenced, just as it exists in us after the verbal art has finished. . . . So that it is also possible to consider the inspiration of the poem as distinguishable from the verbal art of it: namely, as that which the verbal art exists to convey and which can be distinctly known as such, however impossible it may be to describe it or express it at all in any other words than those of the poet." He goes on to cite four poems, of Drummond, Herrick, Wordsworth, and Whitman, all on the subject of mortality. He contends that, although they have a common subject,

[1] *The Theory of Poetry*, p. 58. Martin Secker.

the inspirations are uniquely different, and each is distinct from its corresponding poem. "In the first place, each inspiration is something self-contained and self-sufficient, a complete and entire whole; and in the second place, each inspiration is something which did not, and could not, originally exist as words."[1] The words are simply translations into external symbols of an inner experience which by itself and before such translation was a perfect and self-complete whole in all its details. "Every inspiration has its own unity, and every poem should have its own form, since the form must be the efficient equivalent of the unity."[2] Mr. Abercrombie makes this the centre of his whole argument.

Professor Alexander holds exactly the opposite view. He says: "I suggest that the artist's work proceeds not from a finished imaginative experience to which the work of art corresponds, but from passionate excitement about the subject-matter; that the poet sings as the bird sings, because he must; that his poem is wrung from him by the subject which excites him, and that he possesses the imaginative experience embodied in his words just in so far as he has spoken them. In no sense is the poem the translation of his state of mind, for he does not know till he has said it, either what he wants to say or how he shall say it—two things which are admittedly one. The imaginative experience supposed to be in his mind does not exist there. What does exist is the subject-matter which detains him and fixes his thoughts and feeds his interest, giving a colour to his excitement which would be different with a different subject-matter."[3] In short, the artistic experience is a discovery or revelation[4] which takes place in and through the act of expression.

There is no doubt truth in both of these statements. But Mr. Alexander, I believe, is far *more* right than Mr. Abercrombie. Putting it dogmatically, Mr. Abercrombie is

[1] *The Theory of Poetry*, p. 62. Martin Secker.          [2] Ibid., p. 74.
[3] *Art and the Material*, pp. 11, 12.                          [4] Ibid., p. 19.

correct enough in saying that 'inspiration' *in his sense* did not "exist in words". "Nor was it in words that the mind of Wordsworth had [in *Lucy*] that entranced experience of becoming one with the unconscious speed of the spinning earth."[1] But then inspiration in his sense is just not *poetic* inspiration; it is an experience *prior* to the existence of poetic inspiration. Poetic inspiration means the inspiration of *poetry*, and implies the formation of images and words and phrases which are the beginning of the poem. If Mr. Abercrombie supposes that poetry is the 'translation' of a complete but *non*-poetic experience, it is not much wonder that he speaks of the shortcomings and 'defects' of language,[2] and implies that poetry's translation is always a little inferior to the real original thing which is unsaid. But the real thing *for poetry* is not unsaid. Poetry is spoken. Mr. Alexander, though he frankly admits that he overstates sometimes,[3] is entirely right. The poet possesses his entire imaginative (poetic) experience so far as he has spoken the words. It does not exist till then. There is no 'inferiority' or 'defect' about language, if it is poetry of which we are thinking. Wordsworth's actual living experience of the spinning earth was personal and private, and we can only understand it, if we do, through sympathy and imagination, aided no doubt by descriptive words. But *this* is certainly *not* what "possesses our minds the instant the poem is finished". Wordsworth's wordless experience may have been the 'subject' of (part of) the poem and its occasion. But what possesses our minds is not this experience of Wordsworth before, perhaps long before, he even thought of the poem, but Wordsworth's experience-in-the-completed-words:

> "No motion has she now, no force;
> She neither hears nor sees:
> Rolled round in earth's diurnal course
> With rocks and stones and trees."

---

[1] *The Theory of Poetry*, p. 63.    [2] Op. cit., p. 90.    [3] Op. cit., p. 15.

Before we decide, then, whether expression in language (or other medium) is a gain or a loss, or whether it is possible to say absolutely that it is either, we must distinguish between an 'inspiring experience' (*a*) in a more general, and (*b*) in a more particular and specifically artistic sense. (*a*) An 'inspiring experience' in the general sense may be perfectly harmonious and satisfying in itself, and, as such, will demand no completion beyond itself. Mystics have claimed that a single moment of mystic rapture is worth the struggles and defeats of a lifetime, and that this is an end in itself. We can each of us recall some experience, religious, aesthetic, or otherwise, when to breathe this finer air so satisfied us that anything beyond the moment (e.g. a verbal description) seemed superfluous and trivial. (*b*) But with certain persons (i.e. artists), at certain times, rapturous experiences do, as we have seen, demand complement, do demand aesthetic expression in one medium or another. The experience is inspiring *to* a certain form of activity, artistic activity.

If we are referring to (*a*), it is true that no artistic embodiment can ever fully convey this kind of inspiration in its private simple directness and in its utter perfection. If we are thinking of (*b*), then not only is a medium such as words *not* 'defective', but it is the only means through which the experience in its fullness can be discovered and possessed.

# CHAPTER VIII

# BEAUTY AND UGLINESS

# I. FACTORS IN THE AESTHETIC OBJECT ANALYSED

We have been working, so far, upon the belief that the aesthetic object is a unity of two factors, the content, or the *what*, which is embodied, and the body *in* which it appears. The whole we have called 'Embodiment'. Aesthetic Embodiment is a fusion by imagination of content with body, and we at once get into difficulties if we try to separate the content from the body, or vice versa. If we do, we get either, or both, of two things which are not aesthetic at all. Yet, on the other hand, it is of paramount importance to realise that the aesthetic object *is* a fusion of two factors. If it is, it will follow that the concrete character, the character as a whole, of the aesthetic embodiment or unit, will vary, (1) with the nature of the parts, (2) with the relative importance given to one part or to another, and perhaps, (3) with the thoroughness or lack of thoroughness of their fusion. These are, formally, three possibilities, not necessarily mutually exclusive.

Let us consider for a moment what these three things mean, taking them according to their formal division, in spite of some obvious overlapping.

(1) The nature of the concrete aesthetic whole will be different as the *nature* of its components varies. On the one hand, (*a*) its *what* or content will contribute to determine the nature of the whole. The subject of the picture or poem, the characters and activities of persons in a drama, are part of the meaning of the whole. One picture or poem or novel or drama obviously differs from another in this respect. Or again, the fact whether the content is trifling or important or profound, or even perhaps whether what is represented is in some way disgusting or repulsive or evil, will affect the meaning of the whole. On the other hand, (*b*) the nature of the material of the 'body' will obviously affect the whole. If words are the material we get one kind of art; if colours, another; if solid forms, a third; if sounds, a fourth, and so on.

On the nature of the material will, to some extent, depend the fact whether or not the art is 'representative'. Thus painting tends to be 'representative', whilst music and architecture do not, the materials of which they are composed helping to determine their characters.

(2) The relative importance given to content, or to body, will affect the kind of aesthetic whole. This will partly depend upon (1), partly upon our interests. The *nature* of the content, or of the body, will sometimes determine whether the content-side or the body-side is likely to be given most attention by the aesthetic percipient. A dramatic subject may suggest dramatic treatment; this tends to direct our interest to content, and this in turn affects the aesthetic whole. Or a revolting subject may attract attention to itself. Or a trifling subject may, indirectly, turn our attention to the cleverness of treatment in the medium—these things, once again, affecting what is to be the total aesthetic object for us. Or take the influence of 'body'. Where the medium is, for example, music, the focus of interest tends to be on the combinations of perceived sounds themselves, rather than upon any meanings[1] suggested. Where the medium is words, on the other hand, the art will tend to be 'representative', with a corresponding increase in the attention to the meanings which the words convey. The same is true, with some modifications, of certain sorts of painting (and sculpture). Neither poetry nor painting is *merely* representative in the sense that it is intended to convey our thoughts away from embodiment to non-aesthetic subject-matter. But the content-side may very well be much more marked, more clear and distinct, than it is, say, in abstract music or in architecture, this determining a difference in the nature of the concrete aesthetic whole.

These are tendencies only, and to all of them there are

---

[1] I do not intend to suggest that music does not possess 'meanings' which can be apprehended. The above are only approximate general statements to which I hope to give point later.

exceptions. Music *may* be representative—to some degree. And words and colours may delight us, compelling interest through the sheer loveliness of their texture.

(3) Of the thoroughness or otherwise of the fusion of body and content I shall say nothing at the moment. Implications of the question will be revealed later in this chapter, and I shall return to the subject in Chapter XII (on "The Competition of Interests in Works of Art"). There I shall ask such questions as, Can there, in Opera, be a real fusion of interests? or, Is Opera to be reckoned a 'composite' art? Must we concentrate *either* on the drama *or* on the music? Or, Can there be, in song, true fusion between the meanings of words, the appeal of word-sounds, and the appeal of the music?

## II. How this Analysis bears upon our Future Problems

These rather abstract distinctions of content and body and their relations are, though in themselves not particularly interesting, of considerable importance in their implications. Most, perhaps all, of the problems which we shall discuss in the next four chapters, would appear to arise out of them. In this chapter we shall find that the notions of 'significance' and 'perfection', as applied to art-theory, are largely, though not merely, applications of the idea of aesthetic fusion [(3) above]. The notion of greatness, on the other hand, appears to arise from the side of content. As for future chapters, under heading (1) above might perhaps be placed some of the general problems of 'kinds' of beauty (Chapter XIII). The nature or kind of *content* will affect the question whether a piece of art is, say, tragic or comic or sublime. Differences of *body* will, obviously enough, determine whether a work of art is to be classed as painting, or music, or poetry, and so on. Again, the questions of the relation of art to moral values (Chapter XI), as well as of the relation of art to what is commonly called the 'true' and

the 'real' (Chapter X), will arise mainly, though again not exclusively, from consideration of the content-side. Or we might place under (2) the problem of the classic and the romantic (Chapter XIII), which is, on one side of it at least, a question of the emphasis on form, or on spirit or content.

These are some of the problems which arise out of (1), (2), and (3). The question under which heading each should go is not of much importance, for the classification is not water-tight: possibly a case might be made out for each problem being placed under every heading in turn. All that is necessary now is that we should be clear that our main concern for some time will be with the nature and the relations of content and of body, and of the effects of these things upon the nature of concrete wholes, the best examples of which are to be found in works of art. In this chapter I shall be concerned with the general ideas of perfection and imperfection (Beauty and Ugliness), and in the next with subject-matter, greatness, and the standards of these. In the following two I shall discuss the relation of art to reality and truth, and to morals. In Chapter XII we shall meet with some concrete problems of apparent conflict between different elements in works of art, whilst in Chapter XIII will be raised the question of 'kinds' of art, with discussion of one or two important 'kinds'.

## III. THE DENIAL THAT THERE IS ANY UGLINESS

Let us begin, then, with the notion of perfection. In order that aesthetic expression shall exist there are required, as we know, three fundamental factors, a 'body' or material, a content (which possesses significance or valuable meaning), and an imaginative mind-with-its-organism (fusing 'content' to 'body' in 'embodiment'). The significance possessed by the content may sometimes, as we saw, be stated in general and abstract terms. Thus the music means 'joy' or 'sorrow' or

'power' or 'tenderness'. But such significance, as we also saw, is never fully the significance embodied, for the significance is not just significance in general, but the significance to imagination of *this* particular body. And when body does, to imagination, completely (i.e. without defect or superfluity) express meaning, we say it expresses perfectly. Body becomes part, i.e., of a total concrete unity of body and meaning. The perfection, the self-complete expressiveness of this complex we call 'beauty'.

The nature of beauty is thus simply described. But there is a certain underlying difficulty, which may now be discussed briefly, before going on to examine more in detail what perfect expressiveness means in simpler and more complex cases.

It may be quite true to say that *if* body appears to imaginative mind completely to express meaning, it expresses perfectly. But *what* body? What *kind* of body? *Any* body? Or are some bodies intrinsically incapable of appearing to any imaginative mind as expressive? Or, Is the burden of aesthetic expressiveness to be thrown wholly on the side of imaginative mind? Can imaginative mind see the most perfect expressiveness in trashy poems, pictures, tunes, in trashy suburban villas? Or, if we have been right in insisting that aesthetic expression always has a 'body' aspect, must we not suppose that the qualities and forms of the body really do determine, at least partly, whether anything can or cannot be called beautiful? If we do not accept this conclusion, does it not at least *look* as if the distinction between beauty and ugliness were like to fade away? If *any* body, however hideous it appears to us, can appear expressive to someone else, how have 'beautiful' and 'ugly' any objective meaning?

It must be confessed that there is a strong tendency to-day among artists and aestheticians to deny—or at least to appear to deny—the distinction between beauty and ugliness. "It is now taken", writes Mrs. Gilbert,[1] "as aesthetic innocence to

[1] *Studies in Recent Aesthetic*, p. 162.

apply the word 'ugly' to the portraits of wrinkled old
women, cacophany in poetry, discords in music, angularity
in drawing, or roughness of dramatic utterance. The
shrinking from complex and uningratiating representation,
if there is something powerful offered, is imputed to the
timidity or intellectual narrowness of the spectator. But the
new attitude", she goes on, "raises a problem. If you extend
the term 'beauty' beyond the merely agreeable so that it
will include everything that is in any sense aesthetically
moving, how much territory do you leave to the ugly?
The tendency is to say, 'nothing'. Just as it is said regarding
morality that 'tout comprendre, c'est tout pardonner,' so it
is said of the world of semblances that to take in any presen-
tation adequately involves giving it a positive worth. This,
Saintsbury says, is the spirit of the new literary criticism.
Your new critic 'must constantly compare books, authors,
literatures indeed, to see in what each differs from each,
but never in order to dislike one because it is not the other.'
And Bosanquet with all his austerity and insistence on
distinctions of value admits that he is much inclined to the
view that there is no such thing as invincible ugliness."
Croce and his followers, again, often appear to deny that
the term 'ugliness' has any real meaning. "This problem"
(that of the ugly in art), writes Croce, "is without meaning
for us who do not recognise any ugliness save the anti-
aesthetic or inexpressive, which can never form *part* of the
aesthetic fact, being, on the contrary, its antithesis."[1]

## IV. ANALYSIS OF THE PROBLEM

These are serious views. We may find in them much to agree
with. I do not wish to discuss them as such at the moment,
but will make one or two comments on the issue which has
been set forth.

The main questions we raised may be classified as follows.

[1] *Aesthetic*, p. 88.

We asked: (*a*) Are some bodies intrinsically incapable of appearing to any imaginative mind as expressive? (*b*) Is the burden of aesthetic expressiveness to be thrown wholly on the side of imaginative mind-and-body? (*c*) Can imaginative mind-and-body do anything aesthetically with such things as trashy poems, pictures, tunes, suburban villas? (*d*) Or, if *any* body can be expressive, what then becomes of the distinction between beauty and ugliness? These four questions refer of course merely to closely related aspects of the same thing, but it will be convenient to try to answer them in order.

(*a*) We certainly cannot say that some bodies are intrinsically incapable of appearing to mind as expressive. We may say that they are now, and perhaps will be always, incapable of appearing as expressive to *us*, to x or to y or to z; and possibly (though with less certainty), to anyone of this time and generation and culture. We can say, and we can give reasons, why this or that body, regarded aesthetically, hopelessly breaks down before our apprehending minds. But we certainly cannot say with complete certainty that the very same body *might* not at *some* time appear to *some* mind as truly and completely expressive. Different minds-and-bodies at different times, owing to different backgrounds and associations, and perhaps owing to differences in mental and organic[1] structure, may get quite different meanings out of perceived forms.

(*b*) From this it does not follow that the burden is all thrown upon imaginative mind-and-body, and that the forms and material of the aesthetic object are indifferent to aesthetic expressiveness. The material with its forms is an essential component, but what it suggests to one mind, by reason of the differences just mentioned, is simply different from what it suggests to another mind. The aesthetic object

[1] It is possible, for example, that differences of pigmentation, of cutaneous structure and the position of the nerve-endings, may affect our aesthetic experiences as compared with those, say, of the yellow or Negro races.

must have a 'body'; aesthetic experience is not a matter of mere mental exercise; but one mind will imagine very different meanings relevant to a given object than will another.

(c) The trashy poem, picture, tune, suburban villa, is genuinely trashy, i.e. aesthetically inferior, for the discriminating minds of *our* generation. These things really are so, for us. They have their meanings, and their breakdowns of meaning, from which they cannot escape—our perceptual systems and associations being what they are. And to find some of the works of Miss Wilcox or Mr. Marcus Stone or Mr. Ethelbert Nevin or Mr. Speculative Builder as perfectly expressive would require a revolution in the associations of our lives—of words, of moral traditions, of sounds, of visual shapes. The change required would be so complete that we certainly cannot imagine it, though we may conceive it as a remote and indefinitely unlikely possibility. If we could come upon these things as visitors from another planet, it is conceivable that we might find some of them expressive, for some of them might happen to be *relevant* to an entirely different system of organic experiences and associations. It would be like finding beauty unexpectedly in some eddy of chance, as when pressing the eye-ball we discover a pretty pattern of colour, or see beauty in a rubbish-heap or a congeries of enamelled advertisements. But much of the 'accidental' material which in this life we happen upon, has more possibility of aesthetic meaning than the sham decorations on a suburban villa or on cheap furniture, because it is often the revelation of the order of some natural process. We talk of the 'accidental' formation of clouds, or of the beauty of petrol in a puddle, or of the forms in a coal-fire. But if these appear beautiful they usually do seem to express (at least) some unity and coherent pattern. They have some 'functional' beauty. The applied carvings on a cheap wardrobe, on the other hand, have no coherent meaning whatsoever, and it is therefore impossible to imagine how any dis-

criminating person could ever find them beautiful as he literally[1] sees them. We must say for accuracy's sake that it is not inconceivable that some different Being might see in them meaning expressed for him. We must say, for accuracy's sake, that it is not inconceivable that there is no such thing as the impossibility of *any*thing's appearing beautiful to *some*one. But that is all, in such cases, we can say. No 'body' can accurately be said to be absolutely incapable of appearing as expressive to anyone. But there are probably many bodies which never will so appear because of their forms.

It is to be observed that the 'seeing' by, say, visitors from Mars, of the works of the authors mentioned as 'beautiful', would not prove their authors to be artists, or their works aesthetically excellent to their authors or to earthly admirers. For their authors are *not* from another planet. They are very like ourselves in some frames of mind, or perhaps at some earlier stage which we should like to forget. We know *The Rosary* is a wretched thing because we can understand the wretched thing so well. We know that imitation-timbering is bad because we know the motives to which it appeals. We find out the defects of these things because of our knowledge of what they try, and fail, to express. It is because our judgment is based on aesthetic *knowledge* that we can say with some confidence that the pleasure some people get out of such objects is other than aesthetic pleasure. For the visitor from Mars it *might* be different.

In all these instances I am assuming the existence of expert aesthetic judgment. Much of course that appears ugly appears so because it is, to begin with at least, too difficult for us, and we wrongly suppose that the artist has failed; whereas it is ourselves. Or perceiving a thing as really expressive, we may condemn it for some non-aesthetic reason, such as that it suggests something unpalatable or unpleasant.

[1] He might idealise—might select, omit, supplement—in seeing, or in painting, but that would be another matter.

(*d*) The distinction between beauty and ugliness does not disappear because beauty and ugliness depend upon meanings imagined by some particular mind with its particular history and experience, and because, therefore, no perceptual object can aesthetically be condemned absolutely. If Beauty is perfection of expressiveness, and Ugliness is failure in expressiveness, then, if any body really appears to any mind to be perfectly expressive of meaning (strictly in the sense of expression which we have defined), then here is *real* beauty, though there be but one mind in the world which sees it so. The same applies, *mutatis mutandis*, to ugliness. Beauty and ugliness are real and objective notions, real and objective qualities, distinct from one another and never identical. The fact that the very same 'body' may appear to X as 'ugly', and to Y as 'beautiful', makes no difference whatever to the real existence of real ugliness and real beauty in the one case and in the other.

To these topics I shall return a little later (pp. 219 sqq.). In order to make the problems and their suggested solutions rather more definite, in order in particular to see more clearly why there is a considerable community of opinion regarding the things we call beautiful and ugly, let us now examine the idea of aesthetic perfection a little more closely.

## V. Greater, and smaller Variations of Aesthetic Meaning in Simple Data and in Works of Art

In any one generation the *variety* of possible interpretations of an aesthetic 'body', the *variety* of meanings which may be got out of it by different minds, is probably very much smaller in the case of some kinds of aesthetic bodies than it is in others. It is probably smaller in the case of very complex works of art, where the aesthetic meaning to the expert is made definite by the coherence and contextuality of the whole. (On the other hand, of course, complexity makes for difficulty, and resulting difference of interpreta-

tion.) And it is probably larger in the very simplest aesthetic bodies, such as sense data or uncomplicated forms. In order to see concretely what expressiveness may mean in these two cases let us discuss them both, beginning with the simpler.

Examples of simple objects are sense data, e.g. simple sounds and colours. Take colours. The meanings which a simple[1] uniform surface of colour may appear, aesthetically, to possess to different minds, and even to the same mind at different times, are very various. Various relatively, I mean, when we consider how poor is the perceived object in its potentiality of suggestiveness. Variations in organic structure and in private associations, particularly the latter, conduce to this result, although once again similarities in organic structure, and community of experience and tradition, must make for limitation of variety, for considerable community of interpretation. But the variety is patent. Yellow may appear 'sunshiny' to A, 'bilious' to B; green may appear 'jealous' to C, 'springy' to D, deep like the sea to E. And so on. Provided the seen colours appear to possess the qualities imputed to them, and if the other conditions of aesthetic experience are present, we cannot but call the colours aesthetically expressive. The variety of individual meanings makes no difference.

There is, then, relatively, a great variety of possible aesthetic meanings to be obtained from the perception of simple sense data by different percipients. It is true that, imagining the imputed values to belong to a sense datum, we instinctively expect others to see them there. We say: "Can't you *see*, how 'cheerful' . . . how 'lugubrious' . . . how 'false', the colour is?" But aesthetically, as we have argued, this desire for community is, strictly speaking, irrelevant. Community, or privacy, it is aesthetically no matter, and the fact that half a dozen or a hundred, or

[1] Reservations as to 'simple' data have already been made (above, pp. 103–104).

ten million people, get the same (or a similar) meaning out of a perceived object, makes it not one whit the more 'aesthetic'—though community may affect the *content* of an aesthetic object.

Such aesthetic meanings may depend upon whim, upon purely individual, private, and subjective experience. This is bound to be less so in complex aesthetic unities like works of art. The work of art is a complex whole in which the meaning of every part is determined in relation to the rest. And it follows that for one race, generation, and culture the aesthetic meanings of the parts must be *relatively*, and in spite of variations of interpretation, more fixed than are the aesthetic meanings of detached sense qualities. Just as, to get definite meaning out of a phrase or a sentence in a philosophical argument, we have to take it in its context, so in art definiteness and contextuality go together. A colour or sound, a word in poetry, a bar in music, may, when detached, suggest to different persons an indefinite variety of meanings; when in the picture or sonata or poem the meaning becomes relatively (though only relatively) fixed. To take but the crudest examples, the meanings of the yellow in the desert-painting, or of the green in the sea-scape, will be limited to values in the picture relevant to these. The words, "*O cursed spite*", in Hamlet's mouth, have an aesthetic significance determined by their context in the play. And, the meanings being relatively fixed, it is obviously more likely that the same meanings will be shared by a number of expert minds—though, because of difficulties arising through complexity, experts will always dispute. Once again, however, this fact of community, though ethically and socially important, is aesthetically irrelevant. The artist, as we saw, *primarily* develops and constructs for his own fulfilment, and in so doing he makes his meanings more definite, more fixed, more unambiguous, more 'objective', less dependent on his passing whim. His sociality may of course encourage and develop this process.

## VI. Perfection, and Degrees of Expression

The perfection of expressiveness of a sense datum is a simple
kind of perfection, because the complexity of the aesthetic
object is slight, and it is not difficult to discern where lie
the elements of aesthetic harmony or (if there is imperfection)
disharmony, of relevance or irrelevance. The perfection of
works of art is exactly the same in principle, except that the
aesthetic object is indefinitely more complex. In the case of
sense data the 'body' side, for example, is simple: in the case
of works of art it is anything but simple. A simple colour,
regarded as colour, has no parts: a picture has. The picture
is a complex with a body in space, the poem or the symphony
are complexes with bodies in time, and perfection of expres-
sion implies that every part contributes in harmony with
the rest and with the whole. But not only the body- but
the content-side of art is extremely complex, vastly more so
than the content-side of simple sense data. And, generally
speaking, where any part of the *total* complex fails to fulfil
what, aesthetically, it ought to fulfil, there is (following the
definition we have assumed) to that extent ugliness or lack
of beauty. Because of the great complexity of works of art,
contradiction of aesthetic significance between part and part
of embodiment can occur, only too easily.

Whilst speaking of degrees of the perfection of expressive-
ness (or, simply, 'degrees of expressiveness') we may refer to
Mr. E. F. Carritt's views. Mr. Carritt, who, in admitting
degrees of expressiveness, disagrees with Croce, distinguishes[1]
three senses in which we might speak of degrees of expression.
The first is a difference of "extension" and is admitted by
Croce (e.g. the difference between a single word and a novel).
The second he calls "degrees of expression" (e.g. Keats'
revised draft of *Hyperion* may be more expressive than the
earlier draft). Thirdly comes "depth", which consists in
the fusion in a whole of "the most elements which, had they

[1] *The Theory of Beauty*, pp. 214 sqq.

existed independently, would have seemed most recalcitrant to expression".

Of the first sense we may say that it implies greater complexity both of body and of content, but not necessarily any difference in degree of expressiveness, although there may in some cases be such. A single word, or, better, a sentence, may be perfectly expressive, may contain a complete meaning, perfectly aesthetically embodied. Such perfection is no less perfection than the possible perfection of a whole poem. In fact a sentence may be *more perfectly* expressive than the whole poem, if our account of perfection has been right. Of course, if the single sentence is imaginatively conceived as *part* of a whole poem, then, as a part, it is in itself incomplete, and in *that* sense, not 'perfect': for only the whole is complete and in *that* sense perfect. But this is only assuming over again that the degree is a degree of complexity (and *not* a degree of "expressiveness"). For the less complex part of a more complex whole, though itself, as a part, less complex (and in that sense—in Croce's and Carritt's term—less "expressive"), may yet attain in itself complete perfection of expression (in our sense). It is very often the case that parts of works of art—selected parts, not pieces hacked out at random—are in themselves perfectly expressive. Milton's address to Light at the beginning of the Third Book of *Paradise Lost* is an example. So are innumerable lyrical passages in Shakespeare. So may be separate movements in musical structures, or parts of groups of sculpture or of architectural wholes. Perfection of expression of parts, taken in themselves, is not in the least incompatible with incompleteness when the parts are taken in relation to a more complex whole. Degrees of "extension", that is to say, have no sort of necessary relation to degrees of perfection of expression.[1] They may, on the other hand,

---

[1] I am not suggesting that Mr. Carritt would necessarily disagree with much of this conclusion.

very well have some sort of relation to 'depth' or 'greatness' of significance. A slow movement, though perfect, *is* more profoundly significant in the context of the whole symphony. But degrees of 'depth' or 'greatness' of significance are, I shall suggest, quite a different matter from degrees of expressiveness.

(2) The instance of the two drafts of *Hyperion* is, it seems to me, a genuine example of degrees of perfection, presuming, of course, that the second is a 'better' draft than the first. I do not think Mr. Carritt is quite accurate in saying that the revised draft is a better expression "of the very same feeling",[1] for the "feeling" is the feeling embodied, and is different in the second case from the first. But letting that pass, we may cordially agree that a work of art may be more or less expressive, in the sense that it may be less or more patchy. It does not, as one would sometimes imagine from reading Croce, completely and absolutely bar itself out from the aesthetic sphere in being here and there less than absolutely perfect or beautiful. The work of art, being, unlike simple expressive sensa, extremely complex, can fail in various degrees. Partial failure does not mean total failure. But so far as it is imperfect, the work is, admittedly, failing in beauty; and it is thus far ugly.

(3) With Mr. Carritt's third heading I shall deal very shortly when I come to discuss the ideas of 'difficulty' and 'greatness'.

## VII. BEAUTY AND UGLINESS

Beauty, according to the assumption we have been making, is just perfection of expression; ugliness is some failure or breakdown or obstruction of expression. And as we have seen, there are, in some sense, degrees in these things.

Ought we to say that there are degrees of beauty? Or degrees of ugliness? Or both? Croce (for his own reasons)

[1] Op. cit., p. 215.

argues[1] that though there may be degrees of ugliness—
"from the rather ugly (or almost beautiful) to the extremely
ugly"—there cannot be degrees of beauty. Croce's view we
have already discussed, and we need not concern ourselves
with it now. But leaving him, what is the right usage?

Strictly speaking, if beauty is perfection of expression,
i.e. complete perfection, there can be no degrees of it.
Perfection is always complete perfection. On the other hand,
there may be degrees of approximation to it, i.e. degrees of
ugliness. But although this is strictly so, it would be pedantic
to insist on it. In common usage, when the object reveals a
relatively high degree of aesthetic expressiveness we say,
'This is more, or less, beautiful than that.' And, where there
is much failure in expressiveness, we say, 'This is more, or
less, ugly than that.' Similarly we often say 'more perfect'
or 'less perfect' or 'more imperfect' or 'less imperfect'. If we
are clear in our mind there need be no difficulty in this.
We may, then, I think, follow common usage here and speak
of degrees of beauty and perfection (when we are thinking
of the ideal which is beauty) or of degrees of ugliness or
imperfection (when we are thinking of failures to reach the
ideal).

Let it be noted, however, that beauty *is* the ideal, and
ugliness failure or obstruction of beauty. Beauty is the
absolute ideal of perfect expressiveness, and ugliness would
have no meaning except in relation to this ideal. It would
not be possible to set up ugliness as another absolute but
negative ideal, for, ugliness being defined in relation to
beauty, there could be no such thing as absolute ugliness.
Absolute ugliness, if it could mean anything, would mean
absolute failure to attain expressiveness at all, and this,
being the non-expressive, would be the non-aesthetic. And,
clearly, the non-aesthetic is not what we mean by the ugly.
'Seven plus five is twelve'; 'my Airedale is fifteen months
old'—these are non-aesthetic facts, but are certainly not

[1] *Aesthetic*, p. 79.

ugly. Ugliness falls within the aesthetic: it involves some degree of aesthetic expressiveness, and, in the sense we have described, some degree, however slight, of beauty. This is probably all very familiar to the reader, for it is no new doctrine.

## VIII. WHETHER ABSOLUTELY UGLY THINGS CAN EXIST

But it is wrong to let enthusiasm for this undoubted truth lead us to jump to the conclusion that nothing ugly exists. Sometimes this is said sincerely, sometimes it is said because it is fashionable to say it. It has, of course, its grain of truth, but taken by itself it is, I think, false. In the first place it is ambiguous. It may mean (*a*) 'nothing relatively ugly exists', or (*b*) 'nothing absolutely ugly exists'. If 'nothing ugly exists' means (*a*), then (if we are right) it is demonstrably false, and we should be chary of being led astray by specious paradox. *Of course Simon Lee* is uglier than *Tintern Abbey*.

If, on the other hand, 'nothing ugly exists' means (*b*), 'nothing absolutely ugly exists', the case is more difficult. It certainly looks as if it followed, from what we have said, that nothing absolutely ugly *can* exist. This is the conclusion that Bosanquet inclines to.[1] Is he right? The question is difficult, and one hesitates to speak dogmatically. Yet, searching our experience, can we not all conceive, or perhaps remember, certain visual objects (for example) which seem to be wholly hideous, "invincibly ugly"? Are not some advertisement hoardings, some pieces of furniture, or architecture, wholly ugly? I certainly seem to remember portions of highways in America and of main roads in this country where could be found what seemed to be ugliness, absolute ugliness, in almost every direction.[2] But how is this

[1] *Three Lectures in Aesthetic*, p. 99.
[2] I do not suggest that an artist painting these things might not by selection make a beautiful picture out of them. But if he took the shapes and colours exactly as he found them, could he find them expressive?

reconciled with the statement that ugliness implies some expressiveness, and therefore some degree of beauty?

It might be reconciled, I think, by distinguishing between beauty actually embodied and beauty which is only imagined or suggested as an ideal, perhaps by contrast, to the mind of the beholder. When I see a hideous horsehair sofa with apparently no relieving features, no portion of expressiveness anywhere, I think of the function of sofas, and of the thing the sofa might be, a thing clean in lines, expressive, simple. So, the machine-made imitation carved wardrobe may actually be, as a whole, entirely hideous, but I have in my mind what a wardrobe *ought* to be like. The object suggests to my mind a possible ideal beauty. If it suggested nothing of the kind it would not even appear ugly. Here perhaps enters the element of expressiveness, of the degree of beauty which is required. There need not necessarily be any *actual* beauty. Similarly, on returning after many years to a spot which used to be rural and lovely, and is now made loathsome by unregulated industrial developments, I cannot help seeing in my mind's eye what *might* have been there, or how development might have been regulated.

This class of case it is convenient, I suggest, to contrast with the class of case (perhaps more frequent) where expressiveness is present here or there, but fails to organise itself completely, or where one kind of beauty, so far complete in itself, jars with another kind in a larger whole. Bosanquet gives as an example of this the hypothetical case of the beautiful silky ear of a dachshund replacing the ear of a beautiful human face.[1] Bosanquet's own view is, by the way, that "the principal region in which to look for insuperable ugliness is that of conscious attempts at beautiful expression—in a word, the region of insincere and affected art. Here you necessarily have the very root of ugliness—the pretension to pure expression, which alone can have a clear and positive failure."[2] With reservations regarding the cases

[1] *Three Lectures in Aesthetic*, p. 102.     [2] Ibid., p. 106.

in which beauty is only present ideally in mental imagery, I am in agreement with this.

We do often, it is true, think of the slum-areas of great industrial cities, with their grime and colourlessness and general dreariness, as examples of the most unrelieved ugliness. There need be no 'pretension' present. It may be, however, that here, too, we think of what, aesthetically, might have been. Or perhaps, on the other hand, we have been misled into confusing the general depression which such scenes cause in our minds-and-bodies with aesthetic ugliness. In some cases these grim and dreary buildings are relatively expressive of what they are, of their own values. It is *what* they express that we cannot abide.

## IX. 'Difficult' Beauty

Genuine ugliness should be distinguished clearly from what Bosanquet calls 'difficult' beauty. This is necessary because it is, I think, a failure to make this distinction which leads some modern thinkers to try to do away with the term 'beauty' on account of its limited meaning. When they do, they usually mean by beauty the easy, the pretty, the pleasant. And when they say that great art is not always 'beautiful', but is often 'ugly', they mean by 'ugliness' what is in fact a kind of beauty not facile or obvious.

Bosanquet has settled this distinction once and for all, and I have to quote him once again at some length. For Bosanquet, easy or facile beauty coincides "with that which, on grounds which cannot be pronounced unaesthetic, is *prima facie* pleasant to practically everyone. A simple tune; a simple spatial rhythm, like that of the tiles in one's fireplace; a rose; a youthful face, or the human form in its prime, all these afford a plain straightforward pleasure to the ordinary 'body-and-mind'. There is no use in lengthening the list."[1]

[1] *Three Lectures in Aesthetic*, p. 85.

It is true that some of the highest types of beauty have simple aspects which have a wide appeal, but Bosanquet is not thinking of this when he speaks of 'easy' beauty. In fact he distinguishes "between the easier types of beauty and what might be called simple victorious or triumphant beauty; between the Venus dei Medici and the Venus of Milo; between the opening of *Marmion* and the first chorus of the Agamemnon".[1]

Of 'difficult' beauty, of that which amounts with some persons to what is repellent, Bosanquet suggests three forms. He calls them (*a*) Intricacy, (*b*) Tension, (*c*) Width.[2]

(*a*) *Intricacy* is self-explanatory. It is easy to explain the revulsion awakened by first acquaintance with a pattern too difficult for us. We can apprehend pieces here and there, but the whole we cannot as yet grasp. It is thus natural that we should give vent to the erroneous judgment, 'bad'. Of course so far as our interpretation of it goes, it *is* bad, for we do not grasp its expressiveness. But the point is that in criticism it is our business to enter into the artist's point of view as far as we can.

(*b*) *Tension*. This means high tension of feeling for which human nature is inclined to lack the capacity, or which it is inclined to shirk. Aristotle speaks of "the weakness of the spectators" which shrinks from the essence of tragedy. The common mind "resents any great effort or concentration, and for the same reason resents the simple and severe forms which are often the only fitting embodiment of such a concentration—forms which promise, as Pater says, a great expressiveness, but only on condition of being received with a great attentiveness. The kind of effort required is not exactly an intellectual effort; it is something more, it is an imaginative effort, that is to say, as we saw, one in which the body-and-mind, without resting upon a fixed system like that of accepted conventional knowledge, has to frame for itself as a whole an experience in which it can 'live' the embodiment

[1] *Three Lectures in Aesthetic*, p. 86.    [2] Ibid., p. 87.

before it. When King John says to Hubert the single word
'death', the word is, in a sense, easily apprehended; but the
state of the whole man behind the broken utterance may
take some complete transformation of mental attitude to
enter into. And such a transformation may not be at all
easy or comfortable; it may be even terrible, so that in
Aristotle's phrase the weakness of the spectator shrinks
from it. And this is very apt to apply, on one ground or
another, to all great art, or indeed to all that is great of any
kind. There is no doubt a resentment against what is great,
if we cannot rise to it."[1]

(c) *Width.* There are genuine lovers of beauty, says
Bosanquet, well equipped in scholarship, who cannot really
enjoy Aristophanes or Rabelais or the Falstaff scenes of
Shakespeare. This again, he thinks, is a weakness of the
spectator. For with strong humour the conventional world
is destroyed; the comic spirit enjoys itself at the expense
of everything. "The gods are starved out and brought to
terms by the birds' command of the air, cutting off the
vapour of sacrifice on which they lived; Titania falls in
love with Bottom the weaver; Falstaff makes a fool of the
Lord Chief Justice of England.

"All this demands a peculiar strength to encompass with
sympathy its whole width. You must feel a liberation in it
all; it is partly like a holiday in the mountains or a voyage
at sea; the customary scale of everything is changed, and
you yourself perhaps are revealed to yourself as a trifling
insect or a moral prig. . . . Comedy always shocks many
people."[2]

[1] *Three Lectures in Aesthetic*, p. 90.          [2] Ibid., p. 92.

# CHAPTER IX

# SUBJECT-MATTER, GREATNESS, AND THE PROBLEM OF STANDARDS

## I. Greatness: the Perilousness of the Quest

We have now spoken at some length of expressiveness and of its degrees, or, what is the same thing, of degrees of perfection of expressiveness, or degrees of beauty (or degrees of imperfection of expressiveness or degrees of ugliness). In common usage the term 'perfection' has a fairly definite meaning, and it is a meaning which is quite distinct from the meaning of the term 'greatness'. We talk of a perfect lyric, and we mean something different from what we mean when we say, 'This is a great poem (or drama or symphony)'. The two terms are not incompatible, for what is perfect may be great, and vice versa. We should all probably agree that a work of art may be great without being perfect (e.g. a good many of Shakespeare's plays), or perfect without being great (e.g. a large number of the seventeenth-century lyrics).

What is it that constitutes greatness? This is an extraordinarily difficult question to answer accurately, and a very dangerous one to ask. I propose in what follows to defend the view that greatness comes from the *content* side of art, and that, roughly, art is 'great' in so far as it is expressive of the 'great' values of life. But even to say this is to steer suddenly into violent, treacherous, and narrow waters between rock-bound coasts. We shall have to have all our wits about us. For although, in taking up this view, we may be able to avoid the Scylla of abstraction—of cutting art away from its relation to life—we shall certainly, on the other hand, run risk of foundering on the equally deadly Charybdis of mere moralism, of mere artistic realism, of judging art by standards external to it.

## II. Art and Life: Various Views

That the waters are indeed dangerous may be shown merely by referring to the differences of some distinguished con-

2226     A STUDY IN AESTHETICS

temporary writers on this matter. They fall mainly on two sides. On the one side we may cite Mr. I. A. Richards, in *The Principles of Literary Criticism*. I shall take him second. On the other side, which is larger, is to be found Mr. A. C. Bradley, with whom we may begin.

Speaking of poetry, Mr. Bradley writes:[1] "First, this experience is an end in itself, is worth having on its own account, has an intrinsic value. Next, its poetic value is this intrinsic worth alone . . . its nature is to be not a part, nor yet a copy of the real world (as we commonly understand that phrase), but to be a world by itself, independent, complete, autonomous." Now hear Mr. Roger Fry and Mr. Clive Bell. Mr. Fry writes:[2] "Mr. Bell's sharp challenge to the usually accepted view of art as expressing the emotions of life has been of great value. It has led to an attempt to isolate the purely aesthetic feeling from the whole complex of feelings which may and generally do accompany the aesthetic feeling when we regard a work of art." And, again: "I hope to show certain reasons why we should regard our responses to works of art as distinct from our responses to other situations."[3] Mr. Bell says:[4] "The representative element in a work of art may or may not be harmful; always it is irrelevant. For to appreciate a work of art we need bring with us nothing from life, no knowledge of its ideas or affairs, no familiarity with its emotions. Art transports us from the world of man's activity to a world of aesthetic exaltation. For a moment we are shut off from human interests." "He who contemplates a work of art, inhabit[s] a world with an intense and peculiar significance of its own; that significance is unrelated to the significance of life. In this world the emotions of life find no place. It is a world with emotions of its own."[5] And he speaks with

[1] *Oxford Lectures on Poet y*, p. 5.
[2] *Vision and Design*, p. 296. Phoenix Library.
[3] *Transformations*, p. 2. Chatto & Windus.
[4] *Art*, p. 25. Phoenix Library.
[5] Ibid., pp. 26 and 27.

eloquence of "the austere and thrilling raptures of those who have climbed the cold, white peaks of art".[1]

Leaving the pure critics, and coming to Croce and his followers, one finds a certain difficulty in representing them fairly. On one side of him Croce holds precisely the opposite point of view from that just quoted, for he says[2] that one of the principal reasons which have prevented aesthetic from revealing the real roots of art in human nature "has been its separation from the general spiritual life, the having made of it a sort of special function or aristocratic club". Yet—though for entirely different reasons from those of Fry and Bell—he also supports the view that the "content" of art is of no aesthetic importance. "The impossibility of choice of content completes the theorem of the *independence of art,* and is also the only legitimate meaning of the expression: *art for art's sake.* Art is independent both of science and of the useful and the moral."[3] Beauty is "expression and nothing more".[4] Mr. Collingwood writes:[5] "Every work of art is a monad. . . . Nothing can go into it or come out of it; whatever is in it must have arisen from the creative act which constitutes it."

Mr. Richards is all against the aristocratic and esoteric view of art, and urges that its content is a part of and is continuous with life. "When we look at a picture, or read a poem, or listen to music, we are not doing something quite unlike what we were doing on our way to the Gallery or when we dressed in the morning."[6] Again, the gulf between a poem and ordinary life "is no greater than that between the impulses which direct the pen and those which conduct the pipe of a man who is smoking and writing at once."[7] And he speaks[8] of "the myth of a 'transmutation' or 'poetisation' of experience and that other myth of the 'contemplative' or 'aesthetic' attitude." Whether Mr.

[1] *Art*, p. 33. Phoenix Library.   [2] *Aesthetic*, p. 14.   [3] Ibid. p. 52.
[4] Ibid., p. 79.   [5] *Outlines of a Philosophy of Art*, p. 24.
[6] *Principles of Literary Criticism*, p. 16.   [7] Ibid., p. 78.   [8] Ibid., p. 79.

Richards is right or not, he truly points out,[1] "the 'moral' theory of art (it would be better to call it the 'ordinary values' theory) has the most great minds behind it. Until Whistler came to start the critical movements of the last half-century, few poets, artists or critics had ever doubted that the value of art experiences was to be judged as other values are."

Quotations are seldom quite fair. Those which I have given do seem to me to represent extracts of two radically opposed views. But there are, of course, individual variations in the background. I have referred to the difficulty of representing Croce. Among the critics, Mr. Bell is perhaps the most consistently downright and is therefore the easier to quote. Mr. Bradley is judicial, particularly if his work is taken as a whole, and one of the many charms of Mr. Fry's writing is his willingness to modify or change his views in the light of concrete experience. In view of this, and in view of trends in the remarkable first essay in his *Transformations*, I feel that Mr. Fry is ready to be persuaded that the significance of content or subject-matter is more important than he sometimes says it is. He wrote, for example, in an early essay (1904) on Beardsley's drawings:[2] "The finest qualities of design can never be appropriated to the expression of such perverted and morbid ideals; nobility and geniality of design are attained only by those who, whatever their actual temperament, cherish these qualities in their imagination." I believe that there are grounds at least for an armistice between the opposing armies, if not for permanent peace. In this statement perhaps we must except Croce, whose view of expression is more radical.

But if future agreement is possible, it is because both sides are so indubitably right in so much of what they assert. Their mistakes appear to consist chiefly in over-statements. As against Mr. Richards, surely we may urge that the significance and the value of art are to be judged "from

[1] *Principles of Literary Criticism*, p. 71.    [2] *Vision and Design*, p. 236.

within", and not by standards imported bodily from life. Is not the "finer organisation of ordinary experiences",[1] which he admits, just the "new and different kind of thing"[1] which he denies? How can he maintain that in a poetic unity values do not become "poetised"? (And this without postulating any isolated "aesthetic faculty" on the subjective side.) And yet, on the other hand, as against Mr. Bell's point of view, how can we step suddenly out of life and cut ourselves off from it? Surely here are avoidable misunderstandings? Surely the exploration of what Mr. Bradley calls "the underground connection" between art and life will afford some clue to the mystery?

### III. 'SUBJECT-MATTER' IN ART

I have said that I propose to defend the view that the greatness of art comes from the content side, that there *is* some "underground connection" between art and life. As the term 'content' is in ordinary usage taken to be very much the same thing as 'subject-matter', and as the idea of 'subject-matter' is apt to be full of confusion, I shall try to analyse it first, before going on to the question of greatness.

The term 'subject-matter' (of a work of art) may mean five distinct things, the majority of which are best illustrated —perhaps can only be illustrated—by the 'representative' arts. In the first place, (i) there are the external objects[2] or events, the ideas, or even the mental states, regarded as independent, ontological facts, and thought of as being entirely distinct from all knowledge of them (though they are not of course unknowable). These may be called the *ontological* subject-matter. Regarded thus as independent and distinct, they are not strictly '*subject*-matter' at all, for this term seems to involve the idea of relation to some one's attitude or treatment. But for simplicity's sake let the word pass. The other 'subject-matters' which we shall discuss are,

[1] *Principles of Literary Criticism*, p. 16.      [2] Including persons.

in their turn, not literally different subject-*matters* from this, but are this ontological 'subject-matter' viewed by different minds and bodies, in different perspectives, and with different interests in view, the different perspectives and interests determining difference in what is immediately apprehended.

(ii) The first of these perspectives is an ontological entity as viewed ordinarily by Tom, Dick, or Harry, and known to be the sort of thing which artists do take as their 'subject-matter'. Artists paint 'landscapes', they write about' women' or about 'duty' or about 'the desire for immortality'. Any intelligent person knows what these things mean, and any intelligent person can see what is meant by saying that a picture or a poem is 'of' or 'about' this or that. The things 'about' which pictures and poems are made are in this sense 'common' to all of us, and we do not need to be in the least 'aesthetic' to recognise the objects which have happened to interest artists, or to know the fact that artists have been interested in them. Anyone above an idiot can see Helvellyn, and can know that Wordsworth wrote a poem about it. This subject-matter, aesthetically indifferent, approximately 'common' to everyone, I will call *neutral* subject-matter.

Ontological entities in relation to the *artist, in his ordinary everyday life*—and not in relation to any and every Tom, Dick, or Harry—I will call (iii) *primary* subject-matter. The landscape, as seen ordinarily and without aesthetic interest by the painter, is the primary subject-matter of his picture. Lucy's death, as Wordsworth primarily experienced it, was the primary subject-matter of Wordsworth's poem, *Lucy*; his general idea of Duty the primary subject-matter of his *Ode*. A cognised mental state, in an artist, of *joie-de-vivre* or of sadness, may be the primary subject-matter of a lyric or a piece of music. By primary subject-matter I mean just facts cognised by the artist, regarded as independent of all aesthetic interest (though not as independent of other, perhaps very profound, interests), which do nevertheless *occasion* aesthetic feeling and aesthetic expression, and which the artist, later,

tries to represent. It may be that such facts as those of which we have spoken have *never* been regarded entirely without aesthetic interest by the artist. It may be that the painter always saw the landscape which he subsequently paints, with his 'painter's eye'. In such a case there would be no primary subject-matter, properly speaking.[1] But it is extremely likely that often there is such primary subject-matter. And the fact that many things and events which do seem to have no aesthetic significance at the time are *possible* 'subjects' for art makes it the more probable. Even, however, if primary subject-matter did not exist in an absolutely pure form, the distinction would be useful as marking out a stage in artistic experience.

The term 'primary' here has, of course, no connection with 'primary' in the phrase 'primary qualities'. It is not the bare physical world independent of the conscious organism which is primary subject-matter (though this might be 'ontological' subject-matter), but the concrete world of which the artist is ordinarily aware and in which he is interested, although he is not at the instant *aesthetically* interested in it. Anything which is going to interest an artist aesthetically, and which, during the time it is interesting to him, or when it has interested him, in a quite non-aesthetic way, can be thought of as the independent occasion of a later aesthetic interest, is primary subject-matter. It is called 'subject-matter' because he will, in some way, try to represent it in the subsequent work of art. But our interest in it is interest rather in history or in biography than in aesthetic fact. For this reason primary subject-matter is not of central interest in aesthetics, though, as I shall show, it is important to distinguish it just because it is liable to be confused with what *is* of central importance.

Because primary subject-matter is historical or biographical it is not possible to discover it *in* the work of art, though

[1] There would only be the 'ontological' landscape viewed in such a way, as to give what I am going to call in a moment 'secondary' subject-matter.

examination of the work may in many cases give us a good idea of what it was. In 'representative' arts, like painting or sculpture or poetry, if a landscape or a person is 'represented' in visual form or by means of words, we suppose that facts in *some* degree similar were what stimulated the artist. In so supposing we leave behind for the time being our aesthetic experience. In less 'representative' arts like music and architecture, on the other hand, the primary subject-matter is often quite impossible to determine. And there is no need to suppose that primary subject-matter existed at all. It may have, and it may not. Often all that we are given is the unique and complete aesthetic fact of the music or the architecture, which suggests no hint at all of a subject outside itself. Even the artist himself may find it impossible to tell what it was. We need not, however, conclude from this that primary subject-matter was necessarily non-existent, though it may have been.

Primary subject-matter is called 'subject'-matter, we said, because it does awaken aesthetic interest, and is afterwards 'represented', though it is defined as being unqualified by aesthetic interest. As soon as aesthetic interest is awakened, the object of interest loses its aesthetic neutrality and becomes aesthetically qualified. The object so qualified I will call (iv) *secondary* subject-matter.

By 'aesthetically qualified' I mean simply that the artist begins to regard the object with a view to 'representing'[1] it artistically in this or that medium. If he is a poet, then, as he contemplates his subject-matter, words and rhythms and appropriate images come crowding into his mind. If he is a painter, he begins to 'see' imaginatively, to select and modify, perhaps to set in hand the work of blocking out a picture. The secondary subject-matter is the subject-matter aesthetically regarded at the beginning of the production of a work of art.

(v) What I am going to call the *tertiary* subject-matter is

[1] On reservations regarding 'representation', cf. p. 234 sq. below.

the subject-matter as it finally appears when the whole embodiment is complete. Tertiary subject-matter is simply the content side of the work of art. It is subject-matter imaginatively experienced in the work of art, still distinguishable but now inseparable from its 'body'.

Secondary and tertiary subject-matter mark respectively the limits of a continuous and progressive aesthetic process. A simple illustration might be given of the different 'subject-matters', and their relations. Suppose the subject-matter in general is a mountain to be painted. The 'ontological' subject-matter will be the physical mountain with all its qualities. The 'neutral' subject-matter will be some rough idea or image or perception of the mountain sufficient to distinguish it from other things. The primary subject-matter may approximate to the neutral subject-matter, or it may be qualified by particular, but non-aesthetic, interests in the painter. The secondary subject-matter will be the mountain as the painter begins to see it imaginatively, as he selects and begins to paint it in his mind. The tertiary subject-matter will be the perspective of the mountain as revealed in his completed painting as the artist sees it.

So much for the distinction between ontological, neutral, primary, secondary, and tertiary 'subject-matter' of the work of art. The distinctions are simple, but, I believe, important. If we do not know precisely what we mean by 'subject' when, e.g., we talk of the relation which the 'subject' of a picture or a poem has to the work as a whole or to the artist, we shall arrive nowhere. Examples make it clear that 'subject' in ordinary usage may refer to several, or to one or two only, of the meanings. The 'subject' of a portrait may mean the sitter as he is, or as anyone may see him or her, or as a friend of the artist's, or it may mean the sitter-aesthetically-seen before painting, or the content-of-the-work. When we talk of the 'subject' in music, we mean normally the aesthetic subject, the content-aspect of the completed work. When we say, "Music has *no* subject-

matter", we refer to ontological or to neutral, or to primary subject-matter.

It is important again to be clear about the nature of subject-matter when we dispute about the possibility of 'translation' from one medium, or from one language, into another. Strictly speaking, translation is utterly impossible, because the same tertiary subject-matter can never exist related to different 'bodies'. It is only when 'subject-matter' is interpreted *non*-aesthetically (i.e. as ontological, or neutral, or primary subject-matter) that 'translation' appears in the least plausible. In reality, 'translation' of art is completely self-contradictory, and belief in it the result of false abstraction.

## IV. TERTIARY SUBJECT-MATTER, AND 'CONTENT'

It will be apparent that the difference between the more 'representative' arts, such as painting, and the less 'representative' ones, such as music, makes it convenient now to use the term (tertiary) 'subject-matter' and now to use the term 'content'.

The terms are different, and what term we use is partly a matter of convenience. But the terminology is not unsuggestive of ideas which are of the most vital importance. The term 'subject-matter', even when guarded by the adjective 'tertiary', does suggest an element of representation, something distinct from the 'body', and even *tending* to separate itself off from the body. 'Content', on the other hand, suggests what is 'contained' rather than what is 'represented'.

The naming or the verbal description of subject-matter is always, of course, as we have already pointed out, but a rough approximation. This may, as, for example, in the case of a picture, be suggested by its title. Nevertheless, in 'representative' arts like painting and sculpture, drama, and sometimes poetry, there does exist a subject aspect which is very clearly distinct from the body aspect, and which can

indeed be made the focus of attention—though it must always be taken in its aesthetic context. Thus Leonardo certainly does depict the Last Supper, Myron does depict the Disc-Thrower, Shakespeare does depict in Hamlet a very real character; and it is possible to concentrate our attention on the subject without overlooking its aesthetic context.

On the other hand, arts like music and architecture cannot be said normally to have 'a subject' in this sense. All that such arts can be said to possess is a content which is just one aspect of the embodiment. The content of music or of architecture is just the complex of values, direct or indirect, of which the body is expressive. The complex values in these cases are not unified for us by the giving of a name, by the calling up to mind of some definite, already integrated subject-matter. The unity or integration, or systematisation of value-meanings, is achieved by means of the structure of the body itself, so that the content seems to be *in* the body in an even more intimate way than it is in the case of the representative arts. It is so bound up with it that it is only with difficulty that the content-aspect is distinguished and focused at all.

But although this is true, the other side is also true. We shall err if we think of the integration of a piece of 'representative' art as being achieved merely by the subject-matter, say 'The Last Supper' or 'a Disc-Thrower'. If it were so, we should not have art but mere reproduction. The genius of the representative artist is revealed by the way in which he can blend and fuse the integrating interest of his subject-matter with the integrating interest of his body-forms. Thus in Verocchio's *Colleoni* statue there is the integrating interest in the terrifically vigorous personality of a general on a spirited horse. But there is also the integrative interest of the composition, of the arched neck of the horse, of his taut, muscular legs, of his rigid tail, of the fierce posture of the rider with his magnificent, barbaric head. You can easily distinguish 'subject' aspect from 'body' aspect, but you can

hardly think of them apart, for the 'body' integrates the value-meanings. So in any great work. The ideal for representative art is, that subject-matter should be as expressively fused with its body-forms as the content of music or architecture is fused with its body. Pater was right when he said that all art constantly aspires to the condition of music,[1] for here is found a perfect unity of meaning and form. This ought not to mean, as it is sometimes taken to imply, that all values brought from outside sources in representative art should be set aside, for to do that would be to impoverish the art. To say, wisely, that all art should aspire to the condition of music, is only to emphasise the vital necessity of fusion. We must not attempt to cut off any of the sources of the supply of value which come from subject-sources in real life. Much 'from outside' does enter art. It is the nature of representative art, not only that subject should be distinguishable, but that it should enrich—though, once again, its enrichment must be aesthetically achieved.

The realisation that 'subject-matter' must become 'content', and also that the content of arts like music and architecture is simply the values which they embody, will help us to realise afresh and in a new light another truth about art which is familiar to us. This is that art is not, intrinsically, a representation of subject-matter at all (though it may involve some imitation sometimes), but is, through its forms, an imaginative embodiment of *values*. It is the old story. The painter may (with reservations) imitate what he sees, but he imitates what he sees because what he sees fulfils and satisfies his needs. It is values, not bare facts, which appear in the arts.

The danger in representative art, we have said, is that in distinguishing subject from body, in naming it, and in focusing our attention upon it, we are apt to regard it for its own sake and to separate it from its body in embodiment. The danger in non-representative arts like music, on the

---

[1] *The Renaissance,* Essay on "The School of Giorgione".

other hand, is that we may forget, in our enthusiasm for their forms, that these forms are expressive of content. We may become mere formalists, and find that gradually the stem that joins the flowers of art with its roots in the earth, the earth of common experience, is being shrivelled away. In representative arts the danger is of forgetting art altogether through too great interest in life: in the other case we forget life. It is difficult to say which of the two evils is worse. Is it better, or is it worse, to degenerate into thick-skinned, thick-fingered, un-sensitive realism? Or into the over-fastidious, over-delicate un-vital life of the hot-house?

The relation between the terms 'tertiary subject-matter' and 'content' should now be clear. It is more appropriate to apply the term 'tertiary subject-matter' to the 'representative' arts where a subject-matter can readily be distinguished. The term 'content', on the other hand, applies more appropriately to 'non-representative' arts like architecture and music. But in principle the two are the same, tertiary subject-matter "aspiring to the condition" of content.

Keeping all this in mind, we may return to our original proposition that greatness comes from the side of tertiary subject-matter, or from the content-side of art.

## V. GREATNESS

What do we mean by greatness? Greatness is difficult to define, though as to what it is in actuality, there is a certain body of agreement. We all recognise to some degree the distinction between the great and the trifling, in art. We recognise that the passage where Samson cries,

"O dark, dark, dark, amid the blaze of noon",

is 'greater' than the last lyric of Comus, that Beethoven's *Hammerklavier* Sonata is 'greater' than his first, that the reclining *Theseus* of Pheidias on the Parthenon is 'greater' than the Hermes of Praxiteles, that Shakespeare's *Macbeth* is

'greater' than his *A Midsummer Night's Dream*, or any lyric in it.

But can we say what we mean by the comparative 'greater'? In the first place, we seem to mean *at least* expressiveness of the 'great' values of life. As the question of greatness is easier to discuss in the case of an art like poetry, where ideas are more readily discernible, I shall select my examples mainly from poetry. This does not mean that, if true, our answers should not apply to arts like music and architecture. Certainly they ought. But for general reasons already made clear, the elements of greatness are always far harder to analyse in these cases.

It is very difficult, as has been said, and dangerous, to try to define greatness, to say exactly *why* what we call the 'great' values of life are called 'great', and what precisely constitutes their greatness. We do naturally assume that some values are 'greater' than others. They are, I suppose, generally speaking, those values which, positively regarded, are the fulfilments of tendencies which are not only marked and strong, but profound and lofty and broad and far-reaching in the complexity of their implications. Great values are, probably, the fulfilments of those tendencies which are most important on the highest emergent plane with which we are acquainted,[1] the intricate life of man. Animal passions are strong, and strength is one character of greatness. But more than strength is needed. Greatness cannot be conceived without also thinking of the wide system of implications, seen or hidden, of the fine organisation of a questing spirit, which reveals the universality of man's nature, which marks him off from the local animal, which reveals "the piece of work" that he is when he is most man. It must be, approximately, for these reasons that the

[1] It does not follow that there may not exist in the universe values higher and greater than these, or that the values cognised for example in great tragedy or through religion are not superhuman values. We are concerned with 'greater' and not with 'greatest'.

spectacles of human love, hate, mortality, courage, romance, religious experience, or of the strife of man with himself, or his fellows, or nature, are spectacles which, as we say, penetrate to 'the roots of our being'.

That greatness in art consists at least in expression of the great values of life, is seen in the odd examples we mentioned; it is seen in extracts from larger works, as well as in whole and complete works. This quality of greatness may even be realised in the very simplest cases: we may realise something of it in viewing the massive pylons, crude and yet imposing, of an ancient Egyptian Temple. We may get it even in the contemplation of some simple sense datum, such as a patch of colour. It may be that a patch of grey-white may express death to me, carrying with it the flavour of all mortality. Or a patch of blue may express the infinite distances of blue skies, of cosmic sublimity. It may be that even in the apprehension of such extremely simple objects as these there is satisfied in some measure that longing for greatness of which Longinus speaks. "Nature . . . from the first implanted in our souls an invincible yearning for all that is great, all that is diviner than ourselves. . . . And that is why nature prompts us to admire, not the clearness and usefulness of a little stream, but the Nile, the Danube, the Rhine, and, far beyond all, the Ocean." Our minds yearn for these 'Ocean'-experiences, and we are glad when we get them.

But though greatness, in the sense of expression of what we call the great values of life, can certainly be found in extremely simple aesthetic objects, and although such expression technically satisfies the conditions of aesthetic expressiveness, this is certainly not all, or even most, of what we mean when we speak of artistic 'greatness'. For one thing, as we know, the expressiveness of such simple data is relatively 'subjective' and private, and lacking in community. Again, an *extract* from a work of art may exhibit greatness of quality, but to say, "This extract has 'greatness'

*in* it" is very different from saying, 'This is a great work of art.' Mr. Lascelles Abercrombie has this in mind when he distinguishes between great "moments" of poetry, or "great poetry"; and *a* "great poem".[1] In *moments* of poetic experience we get "the accent or tone of greatness: it is matter so concentrated and organised as to effect an unusual richness and intensity of impression". In the great poem, on the other hand, there is more than this. "When we have some notable range and variety of richly compacted experience brought wholly into the final harmony of complex impression given us by a completed poem, with its perfect system of significances uniting into one significance, then we may expect to feel ourselves in the presence of great poetry; and the greater the range, the richer the harmony of its total significance, and the more evident our sense of its greatness. A similar effect may be given by a *series* of poems, when some connection of theme, in idea or mood, some relatedness in the kind of harmony effected over things, enables our minds to fuse the several impressions into one inclusive impression; but the effect can hardly be so decisive as when our minds are, without interruption, dominated by the single form of *one* poem."[2]

In the extract from the poem or in the simple sense datum which appears to express something great, or profound, or mysterious, or momentous, there is, as has been said, complexity of implication. Nevertheless, in such cases, their complexity and the depth of their penetration are rather implicit than explicit. It is not ex licit in the body nor is it worked out in any detail. No one would dream of calling 'great' a simple patch of colour—to take an extreme example which verges on absurdity—even though it appeared genuinely expressive to him of great value. And the extract contains suggestions and possibilities, rather than anything else. But we want more than this in art; we want more than a flavour; we want a greatness made explicit,

---

[1] *The Idea of Great Poetry*, p. 60.          [2] Ibid., p. 72.

expressed, embodied in a body, and worked out in some detail.

A considerable complexity of embodiment is, then, required in works of art which are to be called 'great'. The great works of the great poets, Sophocles, Dante, Milton, Shakespeare, are organised embodiments of a large variety of human experience. And, being organisations of considerable complexity of human experience, they require for their development a certain space of 'canvas', a certain length. Perhaps I may be allowed once more to quote a short passage from Mr. Abercrombie, for he puts the matter, as usual, with charming concreteness.

"Length", he says,[1] "in itself is nothing; but the plain fact is that a long poem, if it really is a poem (as for example *The Iliad* or *The Divine Comedy*, *Paradise Lost* or *Hamlet*, are poems), enables a remarkable range, not merely of experiences, but of *kinds* of experience, to be collected into single finality of harmonious impression: a vast plenty of things has been accepted as a single version of the ideal world, as a unity of significance. As far as unity is concerned, no less than as far as splendour of imagination is concerned, a sonnet by Wordsworth may be just as unmistakably an aspect of the ideal world; and it is a marvel, the range of matter in, for example, the sonnet to Toussaint l'Ouverture. But as for greatness, think for an instant of *The Iliad* as a whole, or *The Divine Comedy*. The thing simply is, that Homer and Dante can achieve an inclusive moment of final unity out of a whole series of moments as remarkable as that single one of Wordsworth's: obviously, then, irrespective of poetic quality as such, that final intricate harmony of theirs will be far richer, and so greater, than his—though by means of a unity far less direct than his, and a form less immediately impressive and therefore, no doubt, less lovely."

The character of complexity, of width and comprehensive-

[1] *The Idea of Great Poetry*, pp. 72–74.

ness, is a character of greatness which is of course not confined
to the arts. In the realm of thought, we call him great who
has the grasp of a wide and complex field of knowledge, and
who has so organised his knowledge that any particular
proposition readily falls into place in the system of the whole.
Of the man of affairs who, in his realm, is also called great,
the same is true: he too has capacity for comprehension of
the complex, and he too has insight into the bearing of the
whole upon this or that problem of practice. All real great-
ness seems to imply this grasp of the complex, with a sense
of proportion and relevance.

The difference between thought and practice, on the one
hand, and art on the other, is the difference between
thought-and-practice-ends, and art-ends. The special situa-
tion upon which the complex system of knowledge must
converge is a *knowledge*-situation, a problem, say, to be
solved and understood. So knowledge of the system of
practice converges upon some problem of *practice*. The
situation upon which the systematised aesthetic complex
must converge, on the other hand, is an embodied *value*-
situation. It is an embodied value to be savoured and enjoyed.

And further, in 'great' art, the embodied value to be
savoured is what we have called a 'great' value, or group of
great values. The thinker, or the man of affairs, must in one
sense possess 'a sense of values', for he has, as we have said,
a sense of proportion; and what is that but a sense of values?
But it is a sense of values relevant to facts to be *understood*,
or *acted* upon, whereas in the case of the work of art the
complexity apprehended is relevant to enjoyment or *appre-
ciation* of value. In great art it is relevant to enjoyment or
appreciation of great value or values. So that, whilst great-
ness of intellect, or of practicality, implies only great power
of grasping the complex, with a sense of proportion and
relevance, and has in itself nothing to do with capacity to
discern and to savour and enjoy and appreciate what we
have called the 'great' values as such, the greatness of the

great artist does involve possession of *both* these powers. What, for example, has a great physicist or a great mathematician or a great strategist to do with the appreciation of mortality or love or mystic rapture? (The physicist, or mathematician, or strategist, *qua* these things, I mean, not *qua* human beings or as possible artists.) The answer is, He has nothing to do with them. But appreciation of these values is just the artist's very province, so far as they are embodied. The function of art is expression of content in a body. The content, we have seen, is a content of values, and the content of great art, of great values. We may conclude then, that when great value or values are embodied in and through the complex whole of a work of art, then the work is great. And the greater the values, and the more of great values we have, provided they are united into one coherent meaning, the greater is the work.

This account, if at all true, ought to hold good of all art. It is far more difficult, as has been said, to work out and to illustrate in such cases as music and architecture; and to prove that it really works in these cases we should require to refer to a long series of experiments which have not, as far as I know, been made. We have therefore to fall back on a certain dogmatism, on a certain body of educated opinion, which says that in art these things are so. In some of Bach's Chorales and in some of his great Passion music, as well as in some of Beethoven's later work (to cite but two names), our intuition tells us that there is embodied this range and comprehensiveness of experience convergent upon, and making vivid and real, some of the profoundest values of human life. We cannot prove it; we can only say that our intuitions, our deepest feelings, our whole *being* of body-and-mind, tell us that it is so. If anyone says us nay, we have no very clear answer to give in reply. But lack of science need not unduly depress us here. Our present impotence at least does not *prove* us wrong. And we have on our side the prestige of the greatest and most distinguished minds.

We have now discussed, *inter alia*, the ideas of perfection and imperfection of expression (beauty and ugliness) and of greatness. Perfection of expressiveness, or beauty, is an end which art should always achieve—or lose something—though failure here and there does not mean total failure, and we may have to choose between less beauty and more greatness. But degrees of greatness may vary indefinitely and we cannot say that art should always be great. We do not always desire greatness as we always desire perfection. There is a place for the slight, for the fanciful, for the whimsical, in art. But there is no place for genuine ugliness, for final, unresolved self-contradiction or incoherence, in a work of art as a whole.

## VI. STANDARDS, IDIOM, CRITICISM, AND TRADITION

Perfection, Imperfection, Beauty, Ugliness, Greatness—all these ideas are themselves norms or standards, or imply them. At the beginning of the last chapter I made some remarks about the difficulties of establishing standards, and concluded in effect that, although for philosophical aesthetics such notions as beauty and ugliness are perfectly definite, objective, unchángeable, particular examples are relative to particular minds. We can therefore say, 'There is definite beauty, and definite ugliness', but not, 'This perceptual object is, and will always remain, beautiful (or ugly) to anyone who perceives it.' For though expert and critical minds of one place and generation may agree substantially about what is beautiful, expert minds brought up in a different tradition, with a different background, and, perhaps, even possessing a different sort of organism, may genuinely fail to agree about the very same objects. Because, in art, the 'greatness' of values must be *embodied*, the same general statements are true of greatness.

For these reasons it is only half true to say, as is often said, that 'Time will show', or 'The true critical test is the

test of time.' What time does show is the lasting power and the importance of that art which is of such a nature that it can be widely 'communicated'. But it is not, of course, the wideness—or the length—of its appeal which in itself constitutes the test, but the particular nature or kind of the experience which (in this case) is widely felt. The true test of objective aesthetic worth, in other words, is only to be found through intensive analysis, never through extensive reference. Of course, if many experts, each competent in the discrimination of true aesthetic experience, are agreed, so much greater is the probability that the private analysis of each has been a true one.

Let us now return to the question of the influence of tradition upon art.

How tradition affects embodiment might be endlessly illustrated. We see it in the artistic *idiom* of a period, in, for example, the elongated oval faces of early Italian Madonnas, in the height of the bodies in proportion to the size of the head, in the conventional figures, facial expressions, and haloes of angels, in the definite and constricted form of the altar-piece. We see it in the figures of the early Greek mythology, in the influence of the allegorical symbolism of the Romance of the Rose, or of the literature of the troubadour, in the classical background in Milton, in the Vice and the Fool in drama, in the established and conventionalised forms of music from time to time. Unless we can understand and sympathetically enter into these conventions, they will tend to appear to us crude or affected or obscure, and impossible of comprehension. It is extremely difficult, for example, for anyone who does not understand the kind of thing which Cézanne was trying to do, who does not know his background, or that against which he reacted, to appreciate the aesthetic expressiveness of his work. Again, it is the fact of being brought up in a certain tradition, with a certain background of interest and technique, which accounts for the difficulty which an older generation

may experience in adapting itself to new forms of art. The older generation has become used to certain conventions, certain idioms, which it takes for granted. The new idioms come strangely to the old, but they do not come strangely to the young who have grown up with them, and have no need to learn them painfully and consciously.

Changes or developments of aesthetic idiom are signs of vitality, of the very life, not only of art, but of a generation. Theoretically, and from the point of view of 'pure' aesthetic experience, there are no objections to change, however frequent, however sudden, however apparently whimsical and subjective it may be. If, that is to say, an artist living by himself, out of touch with his society, discovers and uses unheard-of idioms whose meaning is known only to himself, there is, from his point of view, theoretically no objection. His experience is an aesthetic one, though no one shares it with him. But, in the first place, though his expression may be perfect, his content will be impoverished. For a full experience is, as we have urged, always and largely social. And, in the second place, not only content will be affected, but control of the medium and the quality of his idiom itself. For artistic sociality is a part of the larger human sociality, and the (hypothetical) artist who turns a blind eye to all artistic traditions impoverishes his manner as well as his matter. In the third place, though art is not primarily and in essence social, it is nearly always to some degree social in its effects. In some arts it is much more so than in others. A poet or a musician or a painter of pictures might conceivably express to himself, for himself only, in his own aesthetic language. But in an art, for example, like architecture, which is social art if anything ever was, sudden transitions in idiom may prove very undesirable. As it is often said, bad architecture is bad manners. We may modify this, and say that architecture totally incomprehensible because subjective in idiom, would be bad manners, for our

hypothetical[1] architect has no business to flaunt before us his stuffy private individuality. If the 'subjective' poet bores us, we can fling the book away. Not so with architecture. In architecture of all arts there are the strongest reasons for a certain continuity in tradition, though this is perfectly consonant with experiment, novelty, vitality. Here let me quote the words of an architect[2] on this matter of the importance of tradition.

"All that we know of the development of architecture combines to refute the contention that recent discoveries in material make anachronistic the continued use of detail motives which have hitherto been associated with stone, brick, or wood. The lithic architecture of ancient Egypt is characterised to the very end by the use of shapes and profiles that were unquestionably derived from mud and reed construction. If, as would not seem probable, the Greek Doric order owed less to wooden prototypes than was once supposed, the evidence for the timber origin of the forms of the Ionic temples of Asia Minor is increased rather than diminished. And Roman Imperial architecture, which developed so largely the use of concrete and brick, perpetuated the practice of the Greeks in much of the detailed articulation of its conceptions. For the truth is that the elements of architectural form are not always governed by construction to such an extent that a change in material is instantly echoed by a change in form. The response is often far from being so immediate; sometimes it is only partial; sometimes it never takes place at all; whenever it does occur it is always gradual, an affair of imperceptible modifications. If it were not so, the formal vocabularies of the various languages of architecture would always have been in such

[1] He *is* hypothetical. It would be extremely difficult for any real working architect so to develop the worst vices of the recluse. He can hardly escape from tradition, even if he would.
[2] Lionel B. Budden, "An Introduction to the Theory of Architecture", *Journal of the Royal Institute of British Architects*, Third Series, vol. xxx, No. 8, p. 247.

a state of flux, so much at the mercy of every shift and change and discovery in materials and construction, that no coherent utterance would have been possible in any of them. The stylistic conventions, Classic, Byzantine, Mediaeval, Renaissance, would, as we know them, never have matured."

In all these things, then, once again, the philosophy of beauty has to do with the definite, the unchanging, with, in Plato's language, 'the eternal'. Philosophy may fail to grasp truly the nature of beauty, or ugliness, or greatness, or the rest, but these things are what they are, and remain so. The task of criticism, on the other hand, is to grasp this or that manifestation of beauty. Its task is beset with difficulties. For though Beauty is One and Eternal, beauties are many and come into being and pass away with the turning of a head or the twinkling of an eye. And criticism, to be successful, must know what is in the head, and what thoughts and desires and experiences lie behind the eye that twinkles. Criticism may fail at any instant through breakdown in sympathy or knowledge or breadth of experience. It may miss the significance of an idiom, it may misjudge the difficult as ugly, it may confuse the morally evil with the aesthetically bad.

Of the former two errors we have said enough. As for the last, it involves certain problems which will be briefly dealt with in the next chapter but one. In the meantime I wish to ask what is meant when it is said, as it is often said, that art is 'true' or 'real'.

# CHAPTER X

# ART, TRUTH, AND REALITY

## I. The Claim that Art is in some Sense 'True': Its Various Meanings

There is a deep-seated conviction among lovers of art in its various forms that art may be said to be in some sense 'true'. This is particularly the case with the more 'representative' forms of art. Drama—for example tragedy—has, since Aristotle, constantly been made the subject of such a claim. "Some other forms of art may be merely beautiful; by Tragedy, I think, we imply also something fundamentally true to life. It need not be the whole truth, but it must be true."[1] But not only representative arts, but even arts like music, may lay claim to a kind of knowledge, or truth. There are Browning's lines in *Abt Vogler* about "we musicians" *knowing*.

What is meant by art's being 'true' is not commonly stated, and this is the more confusing because there are certainly a number of distinct senses in which the word may be interpreted, as is shown in diverse instances in which it is used. Sometimes truth has meant simply *correspondence* with fact. It appears to mean this to the 'holding-the-mirror-up-to-nature-school'.[2] Sometimes it has meant the mirroring of some ideal; sometimes it has meant the efficient translation into an external medium of an inner and spiritual vision. In these three cases truth may at least be supposed to consist in *some* kind of correspondence of a work of art with an entity or entities other than itself. Sometimes, on the other hand, 'truth' in art may be taken to mean the internal *coherence* of art, and falsity its incoherence. When used thus, 'truth' and 'falsity' become synonymous with 'beauty' and 'ugliness'. Thus a 'false' note is a note which does not fit

[1] F. L. Lucas, *Tragedy*, p. 53. Hogarth Press.
[2] It means this in *theory*. But in fact even such a 'photographic' picture as Millais' *Christ in the House of His Parents* shows much selection and emphasis. And the same Ruskin who applies his magnifying-glass with approval to Turner's pictures admits that the artist's painting must be guided by love of what he sees.

into the expressive whole, it is a note which jars upon us, which is ugly. A 'false' character in a play is, not merely a character which does not correspond to real life, but a character who is falsely drawn in the sense that it is not consistently worked out. Sentimentality may enter; what ought to be tragedy may be given a 'happy' but incongruous ending. If this is 'falsity', 'truth' will be the harmonious tension of mutually fulfilling parts; it will be expressiveness, beauty. Again, 'truth' and 'falsity' may refer to what is called the 'sincerity' or the 'insincerity' revealed (or said to be revealed) in a work. Or 'truth' may be used to denote 'deep significance', or greatness. We say, How true! meaning simply, How great! The 'truest' work of art in this sense is that which is most profound, in the experience of which as a whole we are aware of a deep sense of 'reality' (as the saying is). And often it will happen that in this harmonious satisfaction of our profoundest impulses we feel a tremendous conviction of knowledge, which is accompanied sometimes by a sense of the superiority of such knowledge to other forms of it. Our conviction is closely akin to the conviction of the mystic. "My soul swims in the Being of God as a fish in water." 'Here is knowledge indeed!' It is the mood of Browning's musician. In such moments the riddle of existence seems to be solved; we experience the perfect moment; we *'feel'* intensely 'real'; and, feeling so, we feel also that we are intuiting objective reality, as it were from the inside. If knowledge can be in any sense true,[1] and the experience of art is the occasion of a knowledge-claim such as this, then, on account of its prestige and authority, it would seem as though there were some kind of *prima facie* justification for saying that art is true.

All these uses of the term 'truth' may be countered by the philosopher who urges that art is not true, but simply valuable, that only propositions can be true, and that to

[1] And the philosopher, I am assuming at the moment, would normally distinguish knowledge from truth. See below, p. 264.

say otherwise is to make confusion. Personally I think that the philosophers are probably verbally right, but that their conviction about the correct use of words very often misleads them into overlooking an important truth in the claims that are made to the contrary. Such claims, sustained by great minds in the past, are not lightly to be set aside. Whether art can be said literally and in strict terminology to be true, or not, it unquestionably *seems* in some sense true and real, and there must be some strong motive for the use of such terms as 'true' and 'real', a use which is a kind of claim for the importance of art in the scheme of human experience. It is therefore vital for any theory of art that it should take these claims very seriously indeed, and that it should attempt to sift the grain from the chaff. This I propose tentatively to try to do, expecting to find more grain than chaff in the 'truth' and 'reality' claims.

Let us begin by asking what the terms 'truth' and 'falsity' ought to mean in their admittedly legitimate sphere, the sphere of propositions. It will be necessary to go into this question in some detail, but the time will not be wasted, as it is perfectly useless to talk glibly of the 'truth of art' and to go on asserting art to be true, when we have no clear idea of what we mean by the truth of a simple proposition.

## II. Propositions, and their Truth and Falsity

The currently accepted theories of the truth and falsity of propositions really reduce themselves to two in number, the 'correspondence' view and the 'coherence' view. The coherence view I believe to be thoroughly unsatisfactory, whilst the correspondence theory, in some of its forms, involves certain dangers. I shall try to state a view which might perhaps be said to be a form of the correspondence one, though the term 'correspondence' is rather unhappy. It is necessary first to say a few words on correspondence and coherence.

We may begin with coherence, for the sake of dismissing it from our minds. We must dismiss it, not in the least because it ˛is insignificant or unimportant, but because (unless we intend to come down in favour of it) it is too large a subject. The doctrine is an integral part of the philosophy of Absolute Idealism, which cannot be stated or evaluated in a few sentences. It is the view that Truth is coherence, unity, system, or, even, the unity of the self-transcending immediate experience of the Absolute. Obviously these statements involve a whole metaphysics. We may content ourselves here by saying, rather obviously, and without proof, that while all true propositions may possibly form a coherent system, 'truth' does not *consist* in coherence. Again, art may possess internal coherence, but it does not therefore follow that it is rightly called 'true'.

Correspondence is a less esoteric doctrine. Probably everyone on first reflection accepts some form of it. The crudest form of 'correspondence' is the theory that truth is some kind of *copying* of reality. But as it is almost impossible to give a satisfactory account of *what* 'copies' reality,[1] I will only refer to correspondence in the form in which it does not mean this. In the correspondence theory, generally speaking, truth is thought to consist in a relation between propositions and an independent reality to which they refer, whereas on the coherence theory truth consisted of a self-contained system (or super-system) which refers to no reality beyond itself, but in the end *is* Reality. Correspondence implies reference beyond, coherence implies self-completion.

Correspondence, it has just been said, is a theory which is the outcome of a common-sense view. The man in the street may have no theory of truth, but, if questioned, he would probably be quite ready to agree that when, in the

[1] The most intelligible account of the copy-theory which I know is to be found in Mr. Bertrand Russell's *Analysis of Mind*. For a critical account of this, compare my *Knowledge and Truth*, pp. 94 sqq., and especially 110 sqq.

witness-box, he says that he met the prisoner at 5 p.m. with a bottle labelled 'arsenic' in his hand, the truth of his statement means that his statement *corresponds* with the facts. The idea of a reference between one entity and another entity, and a relation between the two is clearly involved. It is, however, when we begin to ask what correspondence really means that the difficulty shows itself. If we reject the crude copy-theory, the relation, it would seem, must be correspondence between a symbolic entity (a statement or proposition) on the one hand, and a portion of reality on the other. But the terms 'symbolic entity', 'statement', 'proposition', are ambiguous. If the proposition is one made in words, the correspondence might be between the *words*, and reality, or between the *meaning* or *meanings* which the words symbolise, and reality. Obviously the former alternative cannot hold good, for no one supposes the verbal noises of propositions to correspond with the facts, and even if they did, their correspondence would be totally irrelevant to the problem. On the other hand, if it is the meaning or meanings which correspond, we are faced with the difficulty that what we 'mean' in propositions, what we refer to when we make statements, *is* reality. We do not have before our minds meanings which *correspond* to real facts, in the sense of some *tertium quid*. We are dealing directly with real facts from first to last. If it is still insisted that we have before our mind something other than real facts, we may well ask whether it is possible to give a coherent account of what the something is. And how can we know *when* correspondence does, and when it does not, take place, unless we know the facts *also*? And if we know the facts also, why not first as well as last? And if first as well as last, why correspondence in this sense?

On the other hand, correspondence in some form has this apparent advantage that, if it could be made plausible, it would seem to account for error, and it is difficult to account for error except on some sort of correspondence

assumption. For if I say that, when I make a proposition, I am referring to and am thinking of reality and not of anything 'correspondent' with it, how am I to explain error? If the witness says that he met the prisoner with the arsenic bottle in his hand, and the witness did nothing of the kind, surely what is before the witness's mind is in some sense *not* real? It is not 'real', it is not a fact, that he so met the prisoner. It seems much more plausible to say that he has before his mind something distinct from the fact, and which is not 'correspondent' with the fact. This question of the status of error is of course a very old difficulty, and dates back farther than Plato.

This, then, is the position. Let us now try to construct a positive theory. In order to construct this theory it is necessary to define our terms and conceptions rather carefully.

In the following pages I shall have in mind our knowledge of, and our judgments and propositions about, the external world which we know in perception. What is the case about truth in this sphere generally I shall assume is the case in spheres other than that of perception. Further, I shall here discuss categorical propositions only, assuming without any proof that the theory of truth which I shall defend holds good, *mutatis mutandis*, of other types of proposition.

(1) Let us begin by taking it for granted that there exists a world of fact, existentially independent of the mind, though capable of being cognised by it. The world of fact, of course, consists of many facts, of substances and qualities related to one another in various ways by relations (e.g. the relation of cause and effect) which are as much facts (though they may be a different kind of fact) as the terms which they relate. This world may here be called indifferently 'fact' or 'facts', or 'existence' or 'reality' or 'the real world', or 'the independent world' or 'the outside world'. It is to be noted that in the world of perceived fact, as such, although there may be many kinds of relations, there exists no *assertiveness*.

The world which can be perceived *is* what it is, and, though we can interpret it *as* being so and so, or say, 'This *is* so and so' (e.g. 'grass is green'), there is no assertiveness in the objects we perceive. We cannot possibly *express* its existence without saying 'It is', but perceived reality never says that it is. It simply *is*. 'Green-grass', and not, 'grass (taken) as green' or 'grass is green', is the nearest way in which we can express this ineffable factuality of reality. Let us symbolise this by the letter F.

(2) We cannot of course sense, or perceive, or think of, or in any way apprehend, this world of fact without being in a cognitive relation to it. If 'r' symbolises relation and M symbolises the apprehending mind, then what exists in any cognitive situation is never F only, but F (r M) : 'r M' is bracketed because it is F in which we are normally interested. M falls into the background. Our minds are not identical with cognised fact, they are in *some* sense in external relation to it. Further, being finite, they are in *some* sense localised, so that we apprehend fact in a place from our place (or, more generally, "in-a-place-from-a-place"). In other words, what exists in a cognitive situation, being not bare fact, but fact in relation to some localised finite mind, may be called a *perspective* of fact, or fact-in-perspective. I am here using the term 'perspective' in a very wide sense, to include not only the perspective of perception, but any fact as apprehended by any (finite) mind. And it is of course in no wise implied that because all facts whatever are viewed in perspective (in this very wide sense), they are therefore never known as they *are*. 'True' knowledge is not a *being* of its object as it is, but it is a *knowing* of it as it is. Sometimes facts in perspective are apprehended as they are; sometimes, as, e.g., in some cases of erroneous perception, they are apprehended as they are not.

(3) It is a matter of some dispute whether F (r M), whether Fact in relation to cognitive mind, always involves some *interpretation* on the part of cognitive mind. In other

words, Is there such a thing as sheer acquaintance?[1] I am inclined to believe that there is, that, for example, there exist states between sleeping and waking when we are simply aware without interpreting at all. These states may not be relatively very numerous, and it is probably true that during by far the larger part of our experience we are making active interpretations, but such states do seem to occur. And further, whether acquaintance exists by itself or not, acquaintance may be said to be present *in* all knowledge and to be presupposed in it. This latter, however, is rather a different point, and might be admitted by those who deny that sheer acquaintance is found by itself.

It is not, for present purposes, necessary to decide this question one way or the other. For in considering truth and error we are concerned not with any possible acquaintance, but with interpretation. This, it is generally agreed, is taking place (at least) most of the time. Interpretation implies at least[2] a 'taking-as', and is thus contrasted with factuality (as also with acquaintance, if there is such a thing). Factuality is represented by 'green-grass'. The interpretation of a perspective is represented (at least) by grass-taken-as-green, so that, symbolically, F (r M) amounts actually to F (r M) taken as X or Y or Z . . . There is, in other words, always at least an assumption or presumption or implicit judgment regarding fact. For example, when I walk across the room or drive a car, I make such assumptions or presumptions or implicit judgments about the geography of the perceived world, as my actions show. I am not necessarily conscious of so doing and certainly I do not necessarily make explicit propositions. But I do take the room or the road *as* being, e.g., of such and such a shape.

(4) Yet the implicit process is always on the point of

[1] To which, incidentally, the adjectives 'true' or 'false' could not with significance be applied.
[2] In its later development it implies 'isness' or assertion, as we shall see.

wakening to explicitness. When it does so we get the making of symbolic propositions. The proposition is a direct expression of the mind when it becomes aware of objects to the extent, not merely of taking them *as* so and so, but of *asserting* that they *are* so and so. We get, not F (r M) taken *as* X or Y but F (r M) asserted to be X or Y. Proposition-making is merely the explicit expression of an interpretation which exists before it is made explicit. It is the development of an interpretation to its completion.

Our four stages, then, have been F; F r M; F (r M) taken as X or Y . . .; F (r M) asserted to be X or Y . . .

The proposition itself may be analysed as follows. It is (*a*) the outcome of a proposing or asserting activity of mind. (*b*) This activity of mind is always activity in relation to a content. The content is identical with the content of some perspective so far as it is interpreted and is not merely 'taken as', but contains an explicit assertion of the form 'F is X or Y . . .' The content of the proposing or asserting activity is a perspective viewed assertively, or, if preferred, it is perspective analysed and synthesised in an assertion. Thus the fact 'this green-grass', is apprehended analytically, as, 'this grass' (particular)[1] and 'green' (universal); and it is synthesised as 'grass is green'. Following a usage not my own, I will call *what* is asserted, or the content of the assertion, the *assertum* or *propositum*.

(*c*) The assertum or propositum is expressed in symbols of which, for present purposes, I will take words as typical. Words are noises or marks which by convention refer to items in proposita or asserta. What the word-symbols refer to may be called the 'referents' of the symbols, one referent corresponding to each symbol. Thus in the propositions 'this grass is green', or, 'the door is to the left of the window',

[1] If these terms raise difficulties in the mind of the reader, let them pass, for they may do so without substantially affecting the main argument here. It does imply, of course, that interpreting always takes us beyond sensing. An interpreted perspective implies more than a physical looking.

'grass' and 'green' and 'door' and 'window' and 'to the left of' are noises or marks which by convention refer to their various referents, which are perspected[1] facts.

The only exception to this account is the word 'is'. Since 'is' in the proposition stands for assertiveness, and assertiveness is due to mind, and assertiveness is not to be discovered in the facts perspected, it will follow that the noise 'is' does not refer to a *part* of the proposition in the same sense as the other symbols refer to parts of it. I am not of course suggesting that 'is' refers to a merely mental entity, in the sense of a purely subjective state. 'Is' is what binds subject to predicate in the propositum, and the propositum which contains 'is' is an integral part of it, is an object of mind. Being an integral part of such an objective propositum, 'is' is to that extent objective. Yet, though 'is' 'binds' subject to predicate, it does not 'bind' in the same sense as other relations 'bind', which are parts of proposita. It does not bind as 'to the left of' binds, or as causal relations between the substance grass and the colour green bind these two things together. For though these latter relations can be supposed to exist or subsist apart from all mind, 'is' symbolises assertion, and assertion cannot be conceived apart from the active thinking together, the living active synthesising of a mind. There is no assertiveness, as we said, in bare Fact. So that, whilst the word 'is' certainly does not refer to a mere subjective process going on inside the mind as it were, it does not, on the other hand, refer to a fact which could conceivably exist apart from mind. We must take both things together. The only possible way of grasping the real meaning of 'is' is to intuit the synthetic activity of a mind uniting in thought that which transcends it, namely, its objects. The mind, in making a proposition, contemplates

[1] It has to be kept in mind that 'perspective' is being used in a wide sense which includes conceiving as well as perceiving. Thus 'to the left of' is perspected in a different sense from which 'door' and 'window' are perspected.

a propositum whose unity is the product of its own com-
bining activity. Of that activity it is not itself necessarily
aware: its interest is in *what* is united. The activity is not
its object as that which it unites is its object. But when, in
the theory of knowledge, we ask how the unification sym-
bolised by 'is' comes to take place, we must always go back
to the active asserting mind which is its sustaining cause.

The verbal proposition, then, is composed of symbols
which (with reservations in the case of the copula) refer to
referrents which are always 'real' terms and relations as
viewed by mind. It is not unimportant to add (or to realise)
that they are 'viewed by mind'. *What* is viewed is 'real'
facts, and what we are interested in, in making propositions,
is facts. We are not concerned with our viewing or with our
activity of synthesising. And, as regards the constituent
items of the proposition in themselves, it is not specially
important to remember that they are *viewed* facts (though
it is the case that they are). For the meaning of the con-
stituent items is, in proposition-making, taken for granted,
and what matters is the meaning of the proposition as a
whole. But when we come to this latter, the 'viewing' factor
begins to matter seriously, as we very soon find out in the
case of error. If, i.e., proposita were mere facts, error would
be as 'real' as truth. But if they are viewed facts, it is possible
that error arises in the 'viewing', as we shall see.

The propositum, then, is composed of real (viewed) refer-
rents, which are asserted[1] to be related to one another in a
certain way. Thus, the door is asserted as being related to
the window in a relation of 'to the left of' in a certain 'sense'.[2]
'Grass' is asserted to be in the relation of possessing greenness
as a quality. For brevity's sake we may say that the proposi-
tum or assertum is 'asserted', though strictly speaking it is
not the whole assertum which is asserted; rather its parts are
asserted to have certain relations to one another.

[1] I am only considering assertion here, but the theory can easily be
worked out in the case of negative propositions.
[2] I.e. the door, not the window, is 'to the left of'.

Truth and error may now be defined. If the terms and relations which, asserted, form the complex propositum, are related in real fact (independently of relation to mind) as the proposition asserts them to be, then the proposition is true. If the terms and relations which, asserted, form the complex propositum, are not related in real fact, as the proposition asserts them to be, then the proposition is false. If, for example, I say 'grass is green', and 'grass' and 'green' are in fact related as they are stated to be, the proposition is true. If, the facts being the same, I say, 'grass is red', the proposition is false, for there is no such relation of 'grass' and 'red' in real fact. The complex propositum in the case of a true proposition is an undistorted perspective (taken assertively) of a complex fact or reality; the complex propositum, in the case of a false proposition, is a distorted perspective (taken assertively) of a complex fact or reality. In Professor Alexander's happy metaphor, in error, we *squint*. We squint at the real. Only we squint actively, aggressively, assertively. The terms and relations which we apprehend both in true and in false proposition-making are real terms and relations (apprehended, of course). 'Grass', 'red', 'green', 'possessing', are all equally real. But the erroneous proposition as a whole is expressive of what we see when we squint, when we apprehend real things in the wrong places and in the wrong relations, asserting them to *be* so. The fact that error is possible, that this mixing-up, this fictitiousness, can occur, is simply of course the outcome of the mind's power of analysis and synthesis of real contents, of interpretation, of taking as, and of asserting. And thus the difficulty of error being in a sense non-existent and in a sense existent is solved. As a *complex unity*, the erroneous proposition is unreal; that is, it is a distorted perspective (taken assertively) and therefore is not, *as a whole*, a perspective of a single complex of fact or reality. Yet on the other hand it is in every part a perspective of facts or realities, but a distorted one.

The difficulties of a certain type of correspondence, too, are avoided. The proposition which is true or false is, on the view that is being put forward, the direct expression of an act of interpretative apprehension of reality by a living mind. The propositum is not a *tertium quid*, or a *Zwischending*, which comes between us and reality; it simply is reality itself, viewed, analysed, and interpreted in assertion. If I look down an avenue of trees and see the lines appearing to converge towards a point in the distance, what I see is the reality (of an avenue consisting of two lines of trees which are parallel) in perspective.[1] Not the bare fact, but certainly the fact viewed from-a-place-to-a-place. If I get above the avenue in an aeroplane and see that the lines are parallel, it is still not bare fact, but fact-viewed. Only in this case there is but negligible distortion, whilst in the other case my point of view materially affects what I see. However this be, in both cases it is the real thing which we apprehend in perspective. It is not something which corresponds, or does not correspond, with reality. And so it is, I believe, with knowledge in general. If this be kept in mind, as also the fact that the proposition is the expression of a living act of knowledge, it will be seen that this kind of correspondence is a vicious, though seductive, metaphor, involving all the diseases of "representative perception".

On the other hand, the view we have put forward might quite well be expressed in terms of a different sort of correspondence. For in truth the asserted *unity* of the proposition corresponds with the unity of the bare fact or reality. In error it does not. But correspondence is so dangerous a term that it is perhaps better to avoid it. Knowledge may in one aspect exhibit correspondence as a symptom. But knowledge itself is just knowledge, and it is inexpressible in terms of

---

[1] There are many problems, fascinating ones, about the relation of the content to the physical objects. I hope I may be praised, rather than forgiven, for avoiding them here.

any metaphor. We interpret, sometimes rightly, and some-
times wrongly. And that is all.

Our view is based, as was said, on the assumption that
perspectives do not necessarily involve distortion. If they
did do so, then knowledge would be impossible, since the
knowledge with which we are concerned[1] is, in a very wide
sense of the term, knowledge in perspective. But though
human minds must know from a point of view, this need
not prevent there being, in some cases, quite true knowledge
of things as they are. In the realm of perception a single
perspective taken by itself will very often yield distorted
knowledge of 'real' shapes as, e.g., when I look along the
avenue of trees. But it need not always be so, as when I look
down on a circular penny from above. So, again, our
heredity and our environment and education tend to bias
us on intellectual and especially on moral questions, but
only sometimes and to some extent. It seems to me that I
can apprehend a simple proposition in Euclid, or the proposi-
tion that $2 + 2 = 4$, or the Law of Contradiction, in a
perfectly clear and undistorted way. I cannot of course ever
be absolutely certain that what I apprehend may not partly
be an illusion owing to some trick of my finiteness: that we
can know things as they are is always in the last resort an
assumption which cannot strictly be proved.

On the other hand, although knowledge is knowledge in
perspective, we should of course be very much mistaken if
we conceived all knowledge on the model of a single
perspective in perception, as if we were, so to speak, tied to
one point in space with our eyes fixed in one direction. If
knowledge is knowledge in perspective, perspective may
be perspective of perspectives. Just as, in the physical
world, we can walk round an object and get different views

[1] There is another kind of knowledge, 'immediate' knowledge, which is
not knowledge (of objects ontologically independent) *in* perspective, but
rather knowledge *of* perspectives. With this immediate knowledge,
however, we need not concern ourselves further here.

of it, thus transcending any single perspective and building up by means of comparison and construction a knowledge of the solid object as it is, so in all knowledge. We do not, in knowledge, trust to single perspectives or propositions; and we know that feeling of certainty is no criterion of undistortedness of vision. This is of course only repeating the familiar truth that knowledge is, as far as we can tell, a system, and that the greater the coherence of propositions in the widest possible sphere of reference, the more likely it is that each of the cohering propositions is true. Thus if mature knowledge is knowledge in perspective, it is an extremely complex perspective, in which a great many individual perspectives have been united, fused, assimilated.

The question arises as to what strictly we ought to call 'true' and 'false'. I have taken it that truth and falsity apply to the proposition, and that a proposition is the expression of the living interpretative apprehension by mind of reality. Can we say that the apprehension is true or false? This is partly a matter of terminology; we have to keep in mind two opposite truths. The first is that interpretative apprehension is only made clear and explicit in propositions, and therefore we can only clearly say that truth or falsity applies if we have a precisely expressed propositum. Truth and falsity therefore most clearly apply to proposita, and truth can only so far be proved by clear comparison (etc.) of clear proposita. On the other hand, propositions are the direct expression of acts of apprehension, and such apprehension is interpretative. So that although we cannot *say* 'true' or 'false', until we have an explicit proposition, the fact that mind, in apprehending, interprets, and is always tending to break into propositions, makes it natural to apply the terms 'true' or 'false' to apprehension. There is no difference between apprehension (which is anything more than acquaintance) and the proposition, except in degree of explicitness, and if truth applies to the proposition which springs from apprehension, then apprehension may be

called true or false, although not yet explicitly so. Really, and in fact, once the stage of proposition-making has been reached, we cannot say that truth and falsity apply *either* to the proposition by itself, or to the act of apprehension by itself. For one is part of, and cannot exist without, the other. If we remember this, then it is indifferent whether we say that the *apprehension* of reality is true or false, or reality apprehended interpretatively in a *propositum* is true or false.

### III. Propositions and Works of Art

We may now consider the question of the truth of art. Can 'truth' be applied to art?

Compare the proposition with the work of art. The proposition, like the work of art, has a 'body' and a meaning, the 'body' being the words, and the meaning being, individually, the referrents, and, as a whole, the propositum. Whereas, however, in the proposition the body is merely symbolic, in the sense of pointing to a meaning outside itself, the words as such having in themselves no importance whatever, in the aesthetic object the body does not merely point to a reality outside itself. It is itself essentially part of the real in which we are interested. Our attention is directed to *it*. It is also true, of course, that our attention is directed to it, not for itself alone, but for the content which it embodies: there is revealed aesthetically a meaning in the body. But the point of course is that in art the meaning just *is* embodied in the embodiment. As regards propositions, there is no such genuine embodiment.

We have, then, in art an embodiment which is the reality in which we are interested, whereas in propositions the reality is only symbolised by the body. But further, the reality symbolised by the body of the proposition, i.e. the propositum, is a perspected reality which is *asserted*, whereas the reality of the work of art, though it is a perspected reality, is not an asserted perspected reality, is not an asserted

perspective. Art is not a proposition, or a system or series of propositions. It is not assertive as a proposition is, though of course works of art like poetry may contain propositions and assertions as well as things that look like them. An essential characteristic of the proposition, however, is the copula, and what can there possibly be corresponding to the copula in a piece of architecture or in a fugue? That such things may contain a kind of assertiveness, a challenging assertiveness, which stirs us to the depths of our being, I do not for one moment doubt. But such metaphorical assertiveness, such synthesis as is found in architecture, and music, is a very different thing from the synthesis of subject and predicate in a proposition.

Again, I am not of course suggesting that the reality which is the work of art can be produced apart from all judgment, or even apart from proposition-making. I am only saying that the work of art is not, as such, logically assertive, as propositions are assertive. Judgment, of course, enters both into the making of the work and into our appreciation of it. The work is a construction involving much selection, and the artist is probably judging implicitly most of the time, and judging explicitly the rest of it. If he is a painter he may say to himself, 'This colour should be laid on, so, here'. 'This mass must be so put to balance that.' Or he may simply do it. If he is a poet he may say to himself, 'That is the right word', or, 'No, that won't quite do.' Or he may just write and score out. Again, when we apprehend the finished work we certainly make implicit, and often explicit, judgments; we are actively discriminating, we are continually analysing and synthesising. And, so far as there is assertiveness both in the artist's case and in our own, there is of course the possibility of truth and error. But this is incidental and by the way. What is essential is not the matter of the truth or error, of propositions that may be made about the reality which is the work of art: what is essential, what is central, is the selection or construction itself, and the kind

of experience it gives us. The construction is an embodiment of value, and what matters is the kind of embodiment of value it is, the kind of thing which we contemplate and appreciate and enjoy.

## IV. ART, TRUTH, AND THE REVELATION OF REALITY

Although, then, the work of art is the product of a mental process which involves judgments both about facts and about values, it is not itself a judgment or proposition or assertion. It is a perspective, a finely organised perspective, in which certain values are brought out in a systematic expressive whole. In experiencing the work of art, we are experiencing a perspective of reality of an interesting and vivid kind. The work of art—not being in essence assertive, or a proposition—is not as such true or false; it *is* reality, or rather it is a revelation of reality, of a very special kind. In the experience of art we experience the knowledge which is vision, only it is vision, as we know, not of facts as facts, but of facts selected with a view to their expressiveness of *value*. To this point, in a new setting, I shall return shortly.

I wish meanwhile to consider a view which is, in some respects at least, the opposite of the one which has been stated. It is the view defended by Mr. I. A. Richards, that in experience of art we do not have real knowledge, or revelation of reality, but just feeling.

Mr. Richards rightly holds (he is, of course, speaking of poetry) that art is not in essence assertive; it has, he says, no reference beyond itself. In Mr. Richards' words:[1] "There is a suppressed conditional clause implicit in all poetry. If things were such and such then . . . and so the response develops. The amplitude and fineness of this response, its sanction and authority, in other words, depend upon this freedom from actual assertion in all cases in which the belief is questionable on any ground whatsoever. For any such

[1] *Principles of Literary Criticism*, p. 276.

assertion involves suppressions, of indefinite extent, which may be fatal to the wholeness, the *integrity* of the experience. And the assertion is almost always unnecessary; if we look closely we find that the greatest poets, as poets, though frequently not as critics, refrain from assertion." Assertion is not essential; art does not refer beyond itself and so cannot be said to be true or false.

What then of the claim that poetry is a revelation? Mr. Richards examines it very carefully, but considers that it cannot be maintained. He finds that the claim arises substantially through the confusion between the feeling of certainty and conviction on the one hand, and the feeling of satisfaction which we experience in apprehending a work of art on the other. The difference between the work of art and the proposition is, he says, that the latter refers outside itself and the former does not. But with regard to the feeling of belief, the proposition and the work of art have such similar effects that we wrongly suppose that the belief-feeling attached to the work of art has an object beyond it, as the proposition has an object beyond it. In believing a proposition, we assent, our impulses are harmoniously organised; likewise, in cognising a work of art, our impulses are harmoniously stimulated so that we receive, we accept, and we feel that we believe. This feeling of belief is especially marked in an art like poetry, which contains propositions, and it is easy to suppose quite wrongly that in assentingly enjoying poetry we are assenting to the truth of the propositions in poetry. But we are wrong, because, though poetry can contain assertions, its assertions do not, if taken aesthetically, point to something which is outside the work of art. They have no such object or reference; but the confusion easily arises. In enjoying Adonais we are left in a strong emotional attitude which feels like belief, when it is only too easy to think that we are "believing in immortality or survival, or in something else capable of statement, and fatally easy also to attribute the value of the poem to the alleged

effect. . . ."[1] These objectless beliefs in poetry (which may be paralleled by the belief-feelings, which will attach themselves to almost any reference, produced by certain doses of alcohol, hashish, and nitrous oxide) are, says Mr. Richards, not difficult to explain. "Some system of impulses not ordinarily in adjustment within itself or adjusted to the world finds something which orders it or gives it fit exercise. Then follows the peculiar sense of ease, of restfulness, of free, unimpeded activity, and the feeling of acceptance, of something more positive than acquiescence. This feeling is the reason why such states may be called beliefs. They share this feeling with, for example, the state which follows the conclusive answering of a question. Most attitude-adjustments which are successful possess it in some degree, but those which are very regular and familiar, such as sitting down to meat or stretching out in bed, naturally tend to lose it. But when the required attitude has been long needed, where its coming is unforeseen and the manner in which it is brought about complicated and inexplicable, where we know no more than that formerly we were unready and that now we are ready for life in some particular phase, the feeling which results may be intense. Such are the occasions upon which the arts seem to lift away the burden of existence, and we seem ourselves to be looking into the heart of things. To be seeing whatever it is as it really is, to be cleared in vision and to be recipients of a revelation."[2]

This is an ingenious explanation. If my statement appears unconvincing, I would refer my readers to Mr. Richards' much fuller and highly suggestive statement. His view is based upon the idea that the function of art is emotive, is to evoke feeling or emotion. "Poetry is the supreme form of *emotive* language."[3] It is for this reason that Mr. Richards emphasises so strongly the feeling of satisfaction, certainty, and conviction.

[1] *Principles of Literary Criticism*, p. 279.
[2] Ibid., p. 283.  [3] Ibid., p. 273.

We may agree with him up to a point. Certainly if we have to choose between taking poetry as a series of propositions true or false by reason of some 'reference beyond' themselves, and the emotive view, the latter is to be preferred. We may sympathise with Mr. Richards' complaint: "The people who say 'How True!' at intervals while reading Shakespeare are misusing his work and, comparatively speaking, wasting their time."[1] But though poetry (and, if not poetry, surely the less so any other art) is not true in any sense which involves a 'pointing' of poetry beyond itself, nor yet true in the sense in which I have tried to describe truth, yet surely and certainly poetry and the other arts are 'real'[2] and are in their own way believed in, and surely in *some* sense they imply what is beyond themselves. They are real in the sense that the perceived body which is an essential part of them is real, and they are real in that the body embodies a meaning and a reality which transcends the body, and which in one sense certainly lies beyond it, though it is fused into it. Mr. Richards is so engaged in refuting the 'pointer-' or the 'mirror-theory' of art that he tends to go to the other extreme. The logical outcome of his view is that art has no objective meaning at all, that the words of poetry are real, perhaps, but that their function is merely to call up certain emotions.

This is altogether too narrow. We may agree that one function of words in poetry (or any other material in any other art) is to call up emotion, and I suppose Mr. Richards would agree that our emotions depend upon the conditions and relations of our impulses. Thus far there is certainly something in common between the effect of words and the production of emotions by the action on the body of such things as alcohol, hashish, or nitrous oxide. These latter

[1] *Principles of Literary Criticism*, p. 273.
[2] The reader will find a summary of four relevant senses of the word 'real' on pp. 272-273. It may, on the other hand, be better, in the meantime, to let the context reveal, if it will, the *kind* of meaning which is intended.

'drugged' emotions, as Mr. Richards reminds us, readily attach themselves to almost any reference beyond themselves. But there is also a vast difference between the two kinds. An 'objectless' emotion can be produced by the action of drugs upon the body, and words and music may so far act as drugs or stimulants. But whereas a genuinely drugged emotion will, as has been said, attach itself to almost any object, the emotions produced by the effects upon us of poetry, music, and other arts, attach themselves properly only to the 'significant forms' of the arts in question. In the nature of aesthetic fact they cannot be objectless, but must be relevant to a special object or reality. In this object, and in this only, can they live. And, further, the reality of the object is more than the reality of a specialised stimulant of organic function. Even if, e.g., music greatly stirs the organism, its stirrings are so subtly arranged by the genius of the musician that they carry with them a world of significant meanings which are not limited to the body, but which are charged with a richness of human experience in the widest sense. In other words, music embodies values, sometimes the greatest values of human experience. Likewise with poetry. Our emotional experience which has its bodily aspect, is (far from being objectless) just our experience of a reality in which the values of life are gathered together, focused, unified in a body. In poetry it may be the values of ideas, perhaps great ideas, which are embodied in a body. Our emotions in poetry are simply the experiences of these things, affectively or subjectively regarded.

Art, then, is a special revelation of reality, whose nature and structure is determined by the principle of value-appreciation. Because of this determination, by the principle of value-appreciation, of the perspective which is selected, it follows that there is always distortion and never a literal mirroring. We never get a literal reflection of reality; we get those aspects of it which reveal value as seen by the artist. The artist squints (and he squints without asserting), but he

squints happily (if the metaphor will pass). If he is a painter, he does not copy (though he may think he does); if he is an architect or a musician, he does not imitate life wholesale, but by his intuition selects and constructs those forms which embody values and which fit into the scheme of a perceived unity. This is, of course, perfectly familiar.

The values embodied, we know also, are of varying importance. They may be extremely light and insignificant, though perhaps charming. "Where the bee sucks, there suck I." The values expressed here are real enough, and our enjoyment of them may be quite vivid. But our natural exclamation is not, How real!' or 'How true!' but rather 'How delightful'. Again, a work as a whole may be a work of pure fancy, as *Alice in Wonderland* or *A Midsummer Night's Dream*. Or it may be a play of Robots. Even in these cases, although the works as a whole are, as we say, 'unreal', the values embodied are real enough of their kind. And their unification in the several works is itself a value. The 'squint' of reality we get is charming, or at least in some way pleasing.

On the other hand, the 'squinting' may reveal a vista of values to which it would be inappropriate to apply the terms 'charming' or even 'pleasing'. It may reveal a vision which profoundly moves and profoundly satisfies us. This 'great' art does. And in proportion as the comment 'How real!' 'How true!' was before inappropriate, so now it is felt to be fitting. In great art the artist 'squints' so as to bring out in a related whole the great values of life. We experience them vividly, intensely, 'really'.

The word 'real' is extremely ambiguous, as the reader will have been appreciating, with cumulative force. The senses of it which are here relevant may be now enumerated.

'Real' and 'reality' may, for present purposes, be considered to have four senses. My use of the term 'real' may include one or more of them. (1) 'Reality' may mean the solid world of facts and values of which we have convincing experience in our ordinary life. This reality is something

which is regarded as opposed to mere fancy or fiction or figment of the imagination. (2) The term 'reality' may include both solid fact *and* fancies, fictions and figments. In this sense everything is as real as everything else. (3) 'Reality' may mean a vividness and intensity and vitality which is experienced directly. Anything experienced very vividly appears very 'real' in this sense. (4) 'Reality' may mean *importance* and *comprehensiveness* in the scheme of existence as apprehended by human experience. If 'great' art is said to be 'real', it is principally this kind of reality which is meant, though the others cannot be excluded.

Values in great art, or in any art, are of course not merely collections of values which are transported from real life. They are, as we saw, unified and given new meaning in an aesthetic context. And further, in some examples of some arts at least[1] the structure of the aesthetic whole is such as to bring out the value of some important aspect of real life as a whole. In such a case life, or some focused image of life, appears revealed in a vision which both expresses the logic—and the psychologic—of real life, and at the same time transcends it in a kind of perfection which is higher than real life, and which avoids its mere contingency.

## V. Art as Revelation of 'The Universal'

This looks, at first sight anyhow, something like those doctrines which, after Aristotle, assert that in art (for example, poetry) we have an imitation of the universal. Poetry imitates the universal, Aristotle thought,[2] not the particular; it imitates the form which an actual thing is tending to be, its ideal form, as it would be when complete and freed from contradictions. The universal, though conceived as distinct from the matter of the thing of sense, is not

[1] As we have seen generally, the following statement is specially hard to demonstrate in the case of an art like music, even if it be true in some cases. See below, p. 279 sq.          [2] *Poetics*, passim.

regarded by Aristotle as separate from its embodiment, as
a thing apart, but rather as in the things. It would appear
best in particulars purified and purged from all that is
irrelevant. It is the universal in the particular, revealing the
true nature of the particular. Again, he thinks that poetry,
the highest form of imitative art, imitates not nature but
human qualities, the dispositions, the emotions, and actions
regarded as an expression of moral will. And the form or
universal being an ideal, that which an actual individual is
tending to be, what is imitated in the case of human
characters, is something finer and better than what we meet
with in our everyday experience. This does not mean that
the dramatic character (for example) is an impossible
paragon of virtue. Aristotle specifically tells us that in
tragedy the character must lie between two extremes,
between "that of a person neither eminently virtuous nor
just, nor yet involved in misfortune by deliberate vice or
villainy, but by some error of human frailty."[1] But the
character must reveal the essential qualities of human
nature, on a big scale, freed from irrelevance. The best, in
other words, is the type of what fundamental human nature
really is. It is not average humanity, nor perfect humanity,
but large humanity. The characters and events in poetry
and drama may never have existed—though it is not
impossible that they should have existed, or might exist—
but they are more 'real' than mere existents. Because art
brings out the essential, it is more real than real life, and
the mere fact of a thing's having occurred or not is immaterial.
Both the epic poet and the tragedian should prefer "plausible
impossibilities to improbable possibilities".[2]

It is no part of my purpose to criticise—and hardly to
expound—Aristotle. But we may at least agree generally
that, in our own terms, reality [chiefly in sense (1) above,
p. 272] in this or that perspective is revealed, and revealed
vividly in some examples of some arts at least, and that the

[1] *Poetics*, chap. xiii.    [2] Ibid., chap. xxiv

perspective of reality revealed has more of essence, and less of accident in it, than the perspectives of everyday experience. And, of course, for us it is the value-aspects of this or that perspective of reality which are principally revealed.

If it sounds timid to say "in *some* examples of *some* arts at least", it is necessary, because restraint is necessary. All good art is 'essential' (and in that sense 'universal') in that it is complex and complete and perfect, without self-contradiction and irrelevance, in that it is, in a word, beautiful. But Aristotle, at least, means much more than this. He speaks of *imitation* of the universal, and the universal of which he is thinking is something which lies, in some sense, in the life beyond art, though of course it enters intimately into art in being treated by the artist. And if we too are referring (as we are) to a reality "in some sense" beyond art, to a perspective of reality which has an 'essential' quality in it, we must be chary of generalising. *All* art does not appear to reveal an 'essential' perspective of reality. Even 'representative' art, if charming and fanciful and light, need not necessarily do this. It may offer us images which are delightful, but which are wholly un-plausible, wholly improbable, wholly impossible. Edward Lear's rhymes, for example. (The individual values embodied are of course 'real', and the thing may as a whole have the kind of reality, the kind of essentiality which is beauty. But that, as has been said, is another matter.) Again, it is always difficult to argue with conviction about non-representative arts like music and architecture. We may *feel* often that they embody stretches of human experience which have a 'universal' and 'essential' quality, but such judgments of feeling are not easy to establish as valid. The kind of case which does seem fairly clear is that which Aristotle takes, the case of great tragedy. No doubt there are others. Some landscape-painting, for example, appears to capture the essentials of natural landscape structures, and to stir in us a delight in their fulfilments.

## VI. The Case of Drama

It may be worth while to consider a very little farther the contrasting cases of tragedy and music, the one being typically 'representative', the other relatively 'non-representative'. As we know, in the representative arts it is easier to name the subject-matter—though this is only possible approximately—because the subject-matter of representative art is arrived at from a treatment of some definite subject-matter in real life which is 'represented'. In non-representative art, as we also know, the subject-matter or content is only distinguishable at all by a very determined effort at analysis, because it really has no existence, in anything like its final form, until it is embodied as a whole. Description of superficial aspects is possible: we can say that music is joyous, or sad or stirring, but musical joy or sadness or stirringness far less approximately resembles the unmusical counterparts of these things than do, say, the qualities of the hero in a good realistic drama resemble the qualities of a person in real life.

In drama, the *individual* values which form part of the whole are more vividly realised than they normally are in real life. Conflict, weakness, determination, courage, love, triumph, despair—these and many other values positive and negative, are, upon the stage, intensified. I do not mean that they are necessarily stronger than as they appear in real life, although for the many who live in a humdrum civilisation it may often be so. But because the values embodied are in the play, they are contemplated and are appreciated as they seldom are appreciated in real life. They are suitably 'distanced'. We stand off from them as spectators, and we appreciate and savour and enjoy them as only spectators can. It is, to repeat an old illustration, like standing on one's head in order to see the colours of nature more vividly. The individual values appear more vividly,

and are in that sense (at least) more 'real', more 'alive', than are the values of everyday life. It should be unnecessary to repeat that they are not merely literal transcriptions, but that they are modified by their context in the aesthetic whole. They are also modified by the nature of the material or medium. The conditions of acting upon a stage, for example, prescribe their own necessities. The actor must get his meaning 'across'; he is limited by time and space, by his stage, his setting, and by the audience in front of him. If the values to be expressed are subtle ones, they may have to be specially treated so as to be apprehended by an audience. Mere translation of what 'might happen' in real life will in many cases not be good enough. Still, we may say broadly that it is the values of real life which are revealed, and vividly so, in this medium of acting. The very aim of the special treatment of 'real' values in acting is to make them appear the more real.

But, in the second place, not only are the individual values of life vividly revealed, but, in great drama, large aspects of human character and human life (sometimes, in the greatest works, very large aspects indeed) may be revealed. We see reality not only more vividly, but more comprehensively. One reason for this is the same as that which conditions vividness. What we see is 'distanced', and, because it is distanced, it appears strange and wonderful. It is seen as a whole, as we are hardly able to see it when immersed in the turmoil of life's affairs. But this appearance is of course also due to the artist's treatment. We see because he has seen; and his perspective, as that of a great dramatic artist, is a perspective which results from a subtle and discriminating selection of what is important for the theme of the drama. The 'subject' of great drama is, normally, a section of real life, and what is important for the theme of the drama is (drama being thus, as is said, 'representative' of life) substantially what is important for real life. The perspectives are identical—subject to reservations about the

modifications which are demanded by aesthetic context and unity. Or, it might perhaps be said, the perspective of such drama is just a perspective of real life, aesthetically selected, the selection in this case being determined both by the important and essential and universal things in real life (with a special view to emphasising their value-aspects) and by the aesthetic need for roundness and completion of vision. The perspective as a whole is of course individual, and the characters are individuals, though purged of the irrelevant. Drama reveals, as we have seen, no mere abstract types, no unearthly and flawless perfections. But we do apprehend in great drama, in the right sense of the words, a purified and essential vision of individual persons and actions; and I do not suppose that anyone who has grasped what Aristotle really means would feel inclined to deny its truth. There are differences, of course, as everyone knows, between Aristotle's view and our views to-day. The type of character selected is different. For Aristotle the highest type of dramatic character is a person of standing. The person "neither eminently virtuous nor just" should "also be someone of high fame and flourishing prosperity. For example, Oedipus, Thyestes, or other illustrious men of such families. . . . These principles are confirmed by experience, for poets, formerly, admitted almost any story into the number of tragic subjects; but now the subjects of the best tragedies are confined to a few families—to Alcmaeon, Oedipus, Orestes, Meleager, Thyestes, Telephus, and others, the sufferers or the authors of some terrible calamity."[1] We to-day are not so inclined thus to limit our selection in drama. The development of the novel, too, has shown that the finest characterisation and drawing of the most moving situations may be applied to people of most ordinary rank. We need only think of Jeanie Deans, of Richard Carson, of Adam Bede, of Hetty, or of Tess.

[1] *Poetics*, chap. xiii.

## VII. The Case of Music

Music is in detail very different, though it appears to be, in certain fundamentals, like drama. The individual values which form parts of a musical whole have 'reality' in several senses. They have it in the trifling sense [sense (2) above] in which everything is 'real'. They have reality in the sense that the proper experience of them is a *vivid* experience [sense (3)], an experience of something which 'feels real'. They do not, however, share with drama, the quality of possessing reality in the sense in which reality means being a fact or value of our ordinary everyday life [sense (1)]. In drama, as we have seen, although the values are modified in some degree by intensification, by the material and by their context in the aesthetic whole, they are substantially the values of real life, love, hate, courage, etc. In music, on the other hand, the nature of the medium is such that it radically transforms the real (extra-musical) values which it embodies. It does not merely modify them as dramatic acting does. They become, in musical embodiment, quite untranslatable except into the crudest language. We feel *in* the music, through our body-and-mind, a series of values which are certainly human values, but resemble little of anything outside music. Were it not for aesthetic construction itself the values of music would have no existence at all, and we should be limited to the expressiveness of natural sounds.

It is not that in the case of drama the material is of no importance, and that in the case of music it is of importance. It is rather that, in music, the material and the constructions of the material are the focus of our attention. Not the mere material or body, of course, but the material as embodying or expressing. In drama, on the other hand, the medium is transparent, as it were: we look through it at life. But, to extend the metaphor, its transparency is the

transparency of a lens which alters, and in its own way perfects, the appearance of what we see. In music, if the metaphor may be pushed to the point of its breaking-down, it is the lens itself which seems to contain and reveal and shape, in its characteristically 'glassy' way, what we see. It is for all the world like the things we see in crystals. But for the danger of such metaphors it might be interesting to compare the various media of the arts to a series of lenses, ranging from the almost flat lenses of some drama, which reveal essences of the values of real life to us, to the spherical crystal of music, which seems, as we experience it, to create its own life. But it creates it in a fluid, progressive way which no comparison with a crystal can express.

As regards the values of the *whole* perspective which is music, can we say that it possesses the 'reality' which is comprehensiveness, the reality in which there is revealed an essential vision of human life, or some vision of reality in its comprehensiveness? This is a difficult question, which has been met in part by the metaphor just given. But one or two comments may be added.

Music, it is often said, has no 'subject-matter' in real life: it represents nothing, in the sense in which drama 'represents'. Yet of course music is significant. Music is, in a special sense which was long ago discussed, an embodiment of the values of life which exist outside music (as well as of the values which come into being only when music has been constructed). And, if individual human values which were originally outside music (and which have become transformed in relation to the sounds) can enter into music, why not a relation of them, why not a 'drama' of them? And this music is: we have not merely 'energy', 'resolution', 'dignity', 'romance', 'solemnity', which may be described, very approximately, as entering into music, but we have the relations of these. We may have all of them and many more, working out in a connected whole which may by analogy be called 'dramatic'. Music may be a

revelation, like drama, of the human values and their working out, but transformed by relation to musical sounds and their construction.

Again, as drama both intensifies and selects what is essential in human experience, so it seems likely that in great music we have both intensification and selection of what is essential. Beethoven in his *Fifth Symphony* speaks for all, and we recognise in the quality of this whole 'drama' a musical embodiment of profound human experience. It is impossible, by ordinary methods anyhow, to pin it down, and it is entirely wrong-headed, as we know, to regard music as a series of pictures or other representations. Music is not thus translatable into general terms, even to the extent that drama is. We could only prove that music is in some ways comparable to drama, by a careful set of experiments upon many individual subjects of discernment and experience. Possibly by some such technique as that of psycho-analysis we might discover[1] just what human values are dramatised in music. But short of this, we can say, in general terms, that music is a revelation, and that we seem, at least in our experience of great music, to have emotional contact with values; these move us in a way which is comparable—with admittedly large differences—to the ways in which we are moved in other great revelatory experiences. In its own special way music *seems* to reveal something which *feels* very like the 'essential' or the 'universal' of great drama. This may be rather a lame conclusion. But there it is.

## VIII. CONCLUSION: POETRY AND PHILOSOPHY

These, then, are some suggestions on the difficult question whether art can be said to be a revelation of reality. Art is not true as propositions are true, but, like the knowledge of

---

[1] It is quite possible that this has been done. A good many of the discussions of these things which I happen to have seen, have appeared to me to be limited by preoccupation with one type of experience.

which propositions are an expression, art is a revelation. The aim of its revelation, however, is not simply knowledge and the assertion of knowledge (though art's revelation implies knowledge and may contain assertions). Its aim is appreciation of value. So that, when propositions occur in an art like poetry, we have to remember that, *as poetry*, they are revelations of value, and are not primarily, and as such, of scientific or philosophic importance. When Robert Bridges writes, in *The Growth of Love*,

> "For beauty being the best of all we know
> Sums up the unsearchable and secret aims
> Of nature, and on joys whose earthly names
> Were never told can form and sense bestow. . ."

he is not merely, or, as poet, primarily, making a philosophical statement about the Universal in beauty. He is, by his words, making us feel the *graciousness* of the truth that is expressed.

Yet a truth is expressed. Or a proposition is made--about something very like Aristotle's doctrine of the Universal. And this proposition is true or claims truth. Propositions in poetry which claim truth indubitably occur. And, a circumstance which is irrelevant to that we have been discussing, appreciation may have something to offer to science and philosophy. Out of the process of poetry, for example, may arise propositions which have their value for discursive knowledge. The propositions in poetry may (used, it is true, in a non-aesthetic way) give us at least "the breath and finer spirit" of *some* knowledge. In poetry—and in their own ways in other 'representative' arts—life is seen from an angle unusual in ordinary experience. In the ecstasy of imagination we see things together as new wholes. From this vision the philosopher and even the scientist may learn much.

Poetry and certain other kinds of arts may provide food for reflection. But it is only *food*. As poetry is not philosophy (or other pure knowledge), so neither can philosophy accept

the criteria of poetry. The criterion of true knowledge is the criterion of coherence.[1] All that poetry can do, because of its unusual point of view, because of its unusual perspective which avoids the usual practical and other prejudices of everyday life, is to present a *prima facie* case to knowledge. Poetry and Philosophy do well to observe the mutual courtesies of respect and esteem. But they meet like compeers, princes, each autonomous within a kingdom which is his own.

[1] This statement does not in the least imply acceptance of what is called the 'coherence-theory' of truth. Truth *is* not coherence, though a *criterion* of truth may be coherence.

# CHAPTER XI

# ART AND MORAL VALUES

# I. The Problem of Art and Morals—and Prejudices about it

In Chapter IX we discussed the general question of the effect of content upon the greatness of the work of art. In the last chapter we spoke of a special instance of the problem of content in art, of art's 'truth' and its 'reality'. In the present chapter I propose to consider yet another aspect of the same general problem.

Our title is, 'Art and Moral Values'. I wish, however, also to discuss certain problems of the relation of art to values, and particularly to negative values, without the qualification 'moral'. Our theme is a well-worn one, but the matter cannot by any means be regarded as settled. I shall mainly confine myself here, as hitherto, to consideration of the representative arts. It is in such arts that the question of the relations between art and morality becomes most urgent. This is not to say that the problem has no existence in the case of an art like music, as can be evidenced from the previous chapter. To dub Wagner's *Venusberg* music plain 'immoral', to say that it should bring blushes to maiden cheeks, may be, possibly, merely silly; but it is not self-evidently absurd to contend that music may express bodily excitements which have a connection not very remote from sexual functions. If music is an expression of values which transcend it, and morality is a general regulation of values, then there must be *some* connection between music and morals, as there is *some* connection between literature and morals.

Or at least this is the supposition. But we ought to begin, perhaps, by putting the general question. It is, Have moral values anything to do with art as such, or is art something which transcends morals, to which moral categories are not applicable?

In one sense the answer is obvious. If morality is, not three-fourths, but the whole of life, art and its production and enjoyment must be part of morality and subject to its

jurisdiction. But this too obvious answer is hardly an answer to a sufficiently significant interpretation of the question. For the serious—and the real—problem still remains, *Is* the production and enjoyment of art, and *is* the content of art which we enjoy, properly subject to ordinary moral judgments? Morality may determine when we ought to begin, and when we ought to leave off, producing and enjoying, in consonance with other duties and other obligations. But once we have begun to produce and to enjoy, do not moral judgments about our activities and their content always fall wide of their mark? Are aesthetic judgments not in themselves perfectly adequate in such regions? On the other hand, do we not experience a vague uneasiness in appearing to set aside so lightly the long and weighty tradition which has intimately joined art and morals?

We should be careful to avoid tempting but shallow prejudice in this matter. A great part of the common objection to allowing morals any intrinsic relation with art is due to the narrow interpretation of the term 'morals'. In this matter I am in hearty agreement with Mr. Richards.[1] Arguing against the separation of morals from art, he says that it is very serious that the indiscretions, vulgarities, and absurdities of those who are supposed competent to deal with the morality which (on the theory he is opposing) is supposed to be outside art, encourage "the view that morals have little or nothing to do with the arts, and the even more unfortunate opinion that the arts have no connection with morality. The ineptitudes of censors, their choice of censorable objects, ignoble blasphemy, such as that which declared *Esther Waters* an impure book, displays of such intelligence as considered *Madame Bovary* an apology for adulterous wrong, innumerable comic, stupefying, enraging interferences fully explain this attitude, but they do not justify it.

"The common avoidance of all discussion of the wider social and moral aspects of the arts by people of steady

[1] Op. cit., chap. v.

judgment and strong heads is a misfortune, for it leaves the field free for folly, and cramps the scope of good critics unduly. So loath have they been to be thought at large with the wild asses that they have virtually shut themselves up in a paddock. If the competent are to refrain because of the antics of the unqualified, an evil and a loss which are neither temporary nor trivial increase continually. It is as though medical men were all to retire because of the impudence of quacks. For the critic is as closely occupied with the health of the mind as the doctor with the health of the body. In a different way, it is true, and with wider and subtler definition of health, by which the healthiest mind is that capable of securing the greatest amount of value."[1]

This is all too true. A large part of the objection to art's having association with 'morals' is due to the perfectly childish and convention-bound ideas of what 'morals' means. Mr. Richards has done a service in reminding his readers of the wisdom of Plato, that morals is concerned with the *health* of the soul.

## II. PLAN OF PROCEDURE

But setting aside prejudice, what is the relation, if any, between aesthetic and certain non-aesthetic values, including moral values?

This question is not altogether easy to answer, and it is at the best a complex one. It will perhaps help matters if we divide the problem into three parts, considering first (1), how the quality of values (e.g. their pleasantness or unpleasantness, or their 'morality') with which the artist has contact before he makes his work of art, affects the artist in the process of his production. We may consider (2), the problem of how the quality of such values affects and qualifies the work itself as an aesthetic whole—if it affects it at all. In the third place (3) we may discuss briefly the

[1] Op. cit., p. 35.

moral and other effects (if any) of art upon the lives of the human beings who experience it. The last question, although interesting, is one rather of ethics than of aesthetics. The first two questions—which, by the way, are so intimately related that their separation is only a matter of convenience—are intrinsically aesthetic ones.

The general statement that art, though a distinct and specialised phase of life, is not something which is isolable from the rest of life, needs scarcely to be repeated here. Though there can be no literal importation of values from the sphere of the moral life outside art into art itself, art is a transformation of life's values. And the quality of life's values which are transformed through expression must surely affect in some way the quality of the work. The general truth, by this time, seems plain.

The special questions which I wish to discuss under the first heading are two. The first, (*a*) is a psychological one: Can the artist come to embody values which are negative in the sense of being unpleasant even to himself? And if so, how? This might otherwise be expressed, How do negative values become embodied in art? (*b*) How does the morality of the values which the artist expresses affect the quality of the artist's vision and his creation? I do not mean merely the morality of the values in general out of their special relation to the artist, as when we say generally, 'cruelty is evil', 'courage is good'. 'Cruelty' or 'courage' in general may be the 'neutral' subject-matter of a work of art. But this is not my point. What we are concerned with is with the effect of the morality of the values of what we have called 'primary' subject-matter. That is, with the values as viewed or seen by the artist in his non-aesthetic moments. The moral quality of what, at such moments, he sees, the moral quality of his primary subject-matter, will depend mainly upon two things, upon the morality of the values which are his 'neutral' subject-matter, and upon his own moral character. Thus, if he is a cruel person, he may regard

cruelty with relish. The moral value which he may express in a work in which 'cruelty' appears will not be 'cruelty' merely, but 'cruelty-relished'. If he is a humane and gentle person, the moral flavour of his expression of 'neutral' subject-matter, cruelty, will be totally different. What we are mainly[1] concerned with under heading (*b*), then, amounts to this: How does the attitude and character of the artist affect his artistic vision? Our interest is not in some general morality, but in morality as it is lived and transformed by the artist's personality, and in the possible effects of this upon him as an artist.

### III. How are Negative Values Embodied?

(1) (*a*) The first question was, Can the artist come to embody values which are negative, which are unpleasant, even to himself? The answer is partly a matter of conjecture, since examination of works of art themselves tells us nothing directly about the artist's experience of the subject-matter which he embodies. But we may conjecture with some chance of being right.

That negative values may characterise ontological or neutral or primary or secondary or tertiary subject-matter is fairly obvious. But it is also not unimportant to recognise that the process of artistic expression may modify the quality of a value in one direction or another. A primary subject-matter, for example, which to an artist in non-aesthetic mood appears revolting, may appear quite otherwise when it becomes secondary subject-matter, i.e. when he begins to look at it and paint it, or write about it. Interest in expression erases the first horror. Similarly, when completely embodied as tertiary subject-matter or content, it may well contain little repulsiveness, if regarded aesthetically. One can at least conceive Rembrandt regarding the dead body

[1] Mainly, for the repercussions upon the other problems raised, are obvious enough.

which he painted in his *Lesson in Anatomy* to begin with as horrible, and as losing this horror when he began and continued to paint. And to us it is not necessarily horrible. Or again, it might happen that something which regarded unaesthetically as tertiary subject-matter, appears interesting or even exciting, seems, when regarded aesthetically, to be disappointing and empty. Or a thing may grow more horrible to the artist as it is expressed. It is possible that De Quincey's experience of horror grew as he wrote his story of the Mail Coach—though it was a horror which fascinated. Or it may be horrible from beginning to end of expression, as for instance Shelley's description of decay in the *Sensitive Plant*:

> "Prickly, and pulpous, and blistering, and blue,
> Livid, and starred with a lurid dew.
>
> .        .        .        .        .
>
> And agarics, and fungi, with mildew and mould.
>
> .        .        .        .        .
>
> Pale, fleshy, as if the decaying dead
> With the spirit of growth had been animated!"

It is very hard to give convincing examples, as we have to depend either upon sympathy and inference, or on the rather scanty evidence of artists' descriptions of their own experiences. But if we have even a little artistic imagination, we may be able to supplement it for ourselves.

Our question is, How do negative values become embodied? How do they affect the artist? How can they become embodied by him if he regards them as repulsive?

The difficulty involved here is really very slight. For an object's possession of negative value is not at all incompatible with its being interesting. It may be, for example, that the object arouses disgust, and interests us in this way, and that the fulfilment of the natural instinctive tendency to withdraw is accompanied by its own peculiar pleasure. This pleasure may, in morbid persons, be cultivated for

its own sake. Again, the attention to an object possessing
negative value may itself possess positive value because it is
the fulfilment of a specific need or tendency to attend to such
objects. The moralist may be interested in vice because of
his intellectual needs. The object may repel him because
of its intrinsic quality, and yet interest him. Or a morbid
person may be interested in sin or in what disgusts him
physically, because of a need which is perhaps born of
starvation and repression. Or, it may be, the need which is
so far fulfilled in the apprehension of what is horrible,
arises through some quite natural process of development.
In adolescence, for example, the needs of the awakening
body-and-mind may lead to experiment in thrills and new
experiences of all kinds. These thrills may have to be
obtained by dwelling on forbidden or gruesome subjects.
Or again, there may be interest in the horrible, not for its
own sake, but for the sake of an ideal or positive value
which it reveals by contrast. But this case, and the cases
where the unpleasant is a fitting part of a larger aesthetic
whole, rather take us beyond our present purpose, which is
consideration of delight in the unpleasant for its own sake.
This delight is clearly possible, and being thus possible, its
aesthetic expression is no more of a problem than the
expression of any positive value. We shall consider briefly
at a later stage[1] the effect of the expression of the unpleasant
upon art.

## IV. DOES THE ARTIST'S MORALITY AFFECT HIS VISION?

(1) (b) Our next question was, How do moral values affect
the quality of artistic vision? This chiefly amounted, as we
saw, to the question, What is the effect of the moral character
of the artist upon his artistic vision? The moral character of
the artist comprises the whole of his moral life: for the
moment, we are concerned with that part of it which lies

[1] See pp. 298 sq. and 302 sq.

outside art. How, then, does the moral character which the artist develops independently of his art affect his vision?

This is a question which we might try to answer in two ways. We might try to answer it by a reference to fact—to the actual lives of artists and to the possible effects of their lives upon their art. Or we might infer generally that because art is of such and such a nature, we should expect such and such a character to affect art in this way or in that.

If we adopt the first method we are very liable to be misled by our prejudices about what is 'moral', by the difficulty of getting real evidence, and of interpreting it with sympathy, understanding, and wisdom (both 'moral' and 'aesthetic') when we have got it.

It is said, in the first place, that artists most certainly have not always been 'good' men. They have the repute, in fact, of being loose, if not evil, livers. There is no need to adduce evidence for this opinion, which is familiar.

The rejoinders to it are fairly trite and obvious. It may be said in the first place that, as the artist is a person of very delicate nervous organisation, his balance is extremely liable to be upset. His true life is a "watch and a vision", and the real inconsequences and accidents of ordinary life may fret him into irritation. Again, the artist is often, by reason of his gifts, impulsive, and impulsiveness may lead him to actions which a more sober view of responsibility could hardly justify. And the combination of sensitiveness and impulsiveness may result in a certain instability in, for example, his sexual life. It has to be kept in mind, too, that it has become, in certain places, something of a tradition and a convention that artists should be 'Bohemian', a fact which almost certainly tends to exaggerate, if it does not create, these tendencies. But it is probable that when we commonly talk of 'morality' and 'immorality' we lay far too much stress upon sexual virtue and vice, as if sex were the chief factor in moral life. Important it obviously is, in its strength and in its personal and social responsibilities;

but we ought, in estimating a person's morality or immorality, to take into account and consider as seriously, if not more seriously, the other vices and virtues which any Christian, and any decent, system of ethics regards as important. I mean of course qualities like the virtue of generosity and the vice of meanness, the virtue of unselfishness and the vice of self-centredness, the virtue of charity and the vice of maliciousness and backbiting, the virtues of sincerity, broadmindedness, toleration, courage, and so on. When we remember that 'morality' contains all these virtues and many others, when we get rid of our too narrow preoccupations with sex, we shall see how foolish it is to jump to conclusions about the morality of artists, and how difficult to generalise about their 'moral' inferiority (or superiority) to other men. Even when we do take a broad and generous view of morality, we know that it is hard enough to estimate morality fairly in our personal friends and acquaintances. If this is so, how much harder is it to estimate that of which we know only at a distance, or by hearsay, or from the reading of biographies which are but the perspectives of the biographers? Are artists, on the whole and in the balance of things, worse, or better, than other men? Or are they very much the same? There appears to be no sufficient evidence to form anything like a stable conclusion. We may have our opinions, based on our personal experience. But this is about the most that can be said.

If we start from general principles about art, we may perhaps arrive at certain general conclusions about the effect of morality upon the artist. But they must be taken with caution.

As we saw in the last two chapters, in some great art, at least, there is revealed a perspective of life and reality in which the great values stand out more vividly and clearly than they do in ordinary experience. If art is but a moment of a larger life, and such great art implies a certain wisdom of vision and insight, and if true morality implies, as it

certainly does, a similar vision and insight to that revealed in some great art, then we should rather expect the vision implied in morality to qualify the vision implied in the art. And again, because art is an expression of a larger life, and the artist, in such great art, employs his human capacities, we should expect, further, that without moral vision artistic vision would be impoverished.

I am inclined to believe that in these matters our expectations are justified, though it is difficult to prove, and almost indefinitely difficult to generalise our conclusions, and to say they must apply to all forms of all the arts. Drama and poetry, if they are great, seem to imply moral wisdom or insight into what is important and into the difference between the important and the trifling. (About arts like music, on the other hand, as we know, it is difficult to be quite certain, although it is not unlikely that the same general principles hold good of great music.) Surely at least the creators of the greatest tragedies may be said to reveal in their work—which is the only medium through which we can intimately know it—that breadth of vision, that sense of the relative values of the great and the small, of the essential and fortuitous, which is also the mark of moral genius.

It is not suggested that because Euripides wrote *Orestes*, or Shakespeare *Lear*, either was necessarily a great moral genius in the sense in which Buddha and Jesus were great moral geniuses. It is only suggested that they were men of 'great' vision, and of the vision which is of the same genus as that which is an essential part of moral equipment. It is suggested simply that the great artist (at any rate, the great dramatic or poetic artists) must be able to *see* greatly, and that this vision is, essentially, moral vision. The translation of what is seen in moral vision into terms of a practical life taking three score years and ten to live, is an entirely different matter—though it is probably true that vision and practice reciprocate, and vision without works is likely to become dim. What we look for in the great poet or dramatist

is sympathy and understanding, sense of proportion and sense of relevance. These are demanded by the art, and they can hardly be present in the art if they are entirely absent in the life outside art. And—because good practice fosters wise vision—if the practical life outside the art is such as to encourage their free and generous development, if, that is to say, the artist's life is lived on a broad basis of wide sympathy and understanding, and with a sense of proportion, then it augurs all the better for his art. If he is narrow or grudging or cruel, if he is cynical or bitter and warped, all the worse for his art. There is, of course, bitterness *and* bitterness, that which is small, and that which is the reverse side of a great idealism. But that is another story. If we may quote again from the *Defence of Poetry*, "a man to be greatly good must imagine intensely and comprehensively; he must put himself in the place of another and of many others; the pains and pleasures of his species must become his own. The great instrument of moral good is the imagination; and poetry administers to the effect by acting upon the cause".

If these things are true of great 'representative' art, and perhaps of great 'non-representative' art, they are much less true of the art which we call perfect but not great. An artist who has little integrity, who has little moral insight into life as a whole, who has some vividness, intensity of experience, but little sense of the large proportions of things, may, it is very likely, produce the perfect and the exquisite in art. Reality is not wholly comprised in the sweep of the starry heavens: it contains also the starry flowers by the wayside. There is fancy as well as imagination, there is the joy of the whimsical and the evanescent, as well as the deeper joys of the serious and the permanent. It is only representative art on the scale of greatness that will at all clearly reveal any sort of positive relation between art and morals. An artist needs a large scope and a long period in which to reveal his true self. This is not necessarily to deny that he **does** reveal himself in small things. It is only to say that it

requires transcendent and perhaps superhuman genius to discern what is hidden in the carving of the cherry-stone.

## V. SINCERITY AND ART

One special moral quality is often supposed to be particularly necessary for the artist. It is the virtue of sincerity. Sincerity may mean (*a*) moral sincerity, or (*b*) aesthetic sincerity.

(*a*) It is not always clear what is meant by moral sincerity in common speech; but one familiar meaning is exemplified when we say that a sincere person is a person who never consciously deceives himself or others. If deception of others is in question, there will be no special reason for taking note of its effects on art. Desire to deceive others may occasionally enter into the creation of a work of art, making it spurious and ugly. And a habit of social insincerity will, no doubt, in time affect the artist's work, as other vices may. But it need not affect it *more* than a number of other vices. An artist's insincerity with himself, on the other hand, is a more serious matter. Insincerity with oneself is a deadly fault which is likely to be a canker at the root of all activities, including artistic ones. The artist who is fundamentally and habitually insincere with himself as a man can hardly be anything but a fraud as an artist.

(Another meaning which can be given to moral 'insincerity' is inconsistency and incoherence which is conscious and is consciously tolerated. The sincere person is steadfast, or endeavours to be so, the insincere are this here and that there, and they have no conscience about it. This sense is not necessarily exclusive of the first, and the similar general remarks apply.)

(*b*) The notion of insincerity as deception, if we mean the deception of others, is not of great aesthetic importance. It has little relevance; for though, as was said, the desire to deceive others may lead to aesthetic falsification, so may the desire not to deceive. Wordsworth at his prosiest suffers

from this terrible desire to be plain with his readers. As if his readers mattered. Aesthetic expression is not, essentially, communication, and social insincerity or sincerity in art is, therefore, very strictly speaking, irrelevant. On the other hand, if aesthetic sincerity means honesty with oneself in aesthetic activity, then sincerity is not *one* of the aesthetic virtues, it is *the* aesthetic virtue. The artist must be true to what he sees, he must express what he feels impelled to express, and he must do it with all the honesty he possesses; or he is no artist. The other side of the same thing (following a rough parallel between this and morals) is that the artist, if he is an artist, must work out his expression as consistently and coherently as he can: his business is to achieve beauty if he has the gift. If he does not, he is guilty of ugliness, whether it be sentimental ugliness or any other sort. When George Eliot gives to *Adam Bede* a happy ending she is insincere, and her insincerity is identical with her failure at that point as an artist.

Sincerity, an affair of the will, is not of course the whole of art. Failure as an artist may be due to artistic incompetence, and incompetence does not in the least imply insincerity. But it may be due also to slackness, to lack of courage and persistence in imagination, which things are conditions of a kind of insincerity. The most positive sort of insincerity, however, is probably due to some external, non-artistic motive, such as the desire to make one's readers feel pleased with themselves, or to make money, or to be famous, or to be a propagandist. It should be added, however, that an extrinsic motive needs to be strong to tempt a true artist from the path of artistic virtue. For, in their own way, and in their own sphere, the real artists are a class of men whose devotion, whose sincerity and integrity, can have little superior elsewhere. Conversely, an artist who deliberately allows an extrinsic motive to interfere with his artistic integrity is unequivocally condemned as an artistic scoundrel. Aesthetically speaking, because sincerity is the

prime condition of the existence of art, its absence is the unforgivable sin. And, morally speaking, and as regards a wider range of life, the gift of artistic vision is so great and so rare that to obscure it (except, just conceivably, for the sake of some even greater obligation) we rightly regard as a major evil.

Our second main question was, How does the quality of the values embodied affect the quality of the work of art in which they are embodied? We may divide it into two parts, corresponding to the two parts of the first. We may consider (a) the effect of unpleasantness upon the quality of art, and (b) the effect upon the art of the 'morality' or the 'immorality' (if such terms can rightly be used) of values embodied. (a) and (b) are not, of course, as was said, completely exclusive of one another, for the immoral may be felt to be unpleasant, and what is unpleasant may be judged to be immoral. Or, both being taken as unpleasant, it may be said that the unpleasantness of the immoral is a more far-reaching kind of unpleasantness than the merely unpleasant. But in any case it is legitimate enough to consider the pleasant and the unpleasant separately from.the moral and the immoral

## VI. Can 'Pleasantness' and 'Unpleasantness', 'Morality' and 'Immorality', really characterise Art?

But before we discuss (a) and (b), there is a very important general question to be settled. It is indeed just a special form of the main problem of this chapter. It is the question, raised in parenthesis in the last paragraph, whether the terms 'pleasant' and 'unpleasant', 'moral' and 'immoral' can be said to apply, as such, to art. It may be argued that at the level of aesthetic expression these terms become inadequate. The unpleasant expressed, it may be said, is delightful. The immoral, expressed, loses its immorality.

Expression, no doubt, transforms *what* is expressed, in the

expressing. But, though transformed, is the whole quality of it lost thereby? Is it really true that the qualities of pleasantness or unpleasantness, of morality or immorality, simply disappear in being expressed?

Surely not. Let us take morality first. We do in fact judge art in moral terms, within the conditions of its perspective; we do judge that Lear's daughters behaved despicably, that Macbeth was a traitor, that Antony in his love for Cleopatra neglected his other duties, that Brutus was an idealist. And, though with less precision, we do apply terms of appraisal that have a moral flavour to painting and sometimes even to music. We speak of 'dignity' and 'breadth' and 'graciousness' and 'peace'. In music, it may be argued, the moral terms we use are only metaphors. But if it be agreed that morality enters into an art like drama, the principle has been admitted of art. And from all we have seen, it is *probable* that the principle, with modifications, applies even to an art like music.

We evaluate morally the individual *parts* in a work of art, though the parts must be taken in their context. We evaluate King John's action in ordering Arthur's eyes to be put out, or Henry V's courage on the eve of Agincourt; we evaluate Wolsey's attitude in defeat. We may also in some sense evaluate morally a work as a *whole*; we may feel that in the whole (which is of course a complex of parts) there is revealed moral worth, perhaps moral greatness.

We evaluate morally at least some works of art as parts and as wholes, but there is a difference between our judgments here and our moral judgments in ordinary life. Moral judgments in ordinary life have a practical bias, they arise out of the practical moral tenets of the society in which we live, and such judgments have some practical intent however indirect, if it only be, 'Let such things be cultivated—or avoided.' But the work of art is a whole which is a complete world in itself; and our moral judgments of the work of art share in this quality of aesthetic isolation. Our indignation

may be aroused by an incident in a play; injustice may have been done and injustice must be set right; we may feel vividly about it. But our feeling is an aesthetic feeling; the injustice must be set right within the play, or be left as it is—as with some kinds of tragedy. The injustice contemplated aesthetically in the play does not stir us to go ourselves to set things right, except perhaps as imaginary actors within the play. Our moral attitude is an attitude of appreciation simply, without any suggestion of external conative activity. Our appreciation of moral quality is of course directly derived from our experience of practical moral life, and the reflections that we bring to bear upon the play are the result perhaps of general reflective thinking about moral questions. But though derived from practical sources, and from reflection, perhaps abstract reflection, moral judgment of an aesthetic object is neither practical nor abstractly reflective: it is an immediate appreciation in which these other factors have become absorbed and assimilated.

## VII. Thought, Practice, and Appreciation

In illustration of the relation of appreciation to practice and to thought, it may be interesting to set out formally the relations between thought, practice, and appreciation.

(1) *Thinking* about morals, carried to its full development, is the activity which produces the system we call ethics. The ideal of ethics is to be scientific, taking the term 'scientific' in a broad sense. But we cannot study ethics without experiencing for ourselves the values of moral conduct in actual practice; we cannot know what ethics is about without trying to live the good life, without indeed experiencing some of the zeal of the reformer. For ethics *practice* is essential. And as ethical thinking implies practice, so, likewise, practice carries along with it an *appreciation*, a savouring, and a tasting of moral quality. (2) Beginning

from the side of *practice*, we may say that to be properly moral implies some degree of *reflection*. Moral conduct which is not the product of reflection lacks full morality. Again, as has just been said, morality implies *appreciation* or tasting of moral quality. (3) Appreciation, in its turn, is the fruit both of some *reflection* and of some *practice*. Thus, to sum up, the *thinking* about moral practice, *practice* itself, and the *appreciation* of moral values, all imply one another, and when we speak of 'ethics', or of 'practice', or of 'appreciation', we are merely emphasising one side or another.

When, in particular, we speak of art, we are speaking of something in which appreciation is predominant, though to define appreciation is not to define aesthetic experience, the latter being a special and self-contained mode of appreciation. But aesthetic experience is primarily appreciative experience. In the last chapter we saw that, although art reveals reality, its primary aim is not knowledge or cognition, but appreciation of the values that cognition reveals. So here, although art (at any rate some art) reveals moral values, the end of art is not alteration of morality or practice, but rather the presentation of moral values to be appreciated and savoured. They are genuinely appreciated, genuinely savoured, as *moral*,[1] but the conditions of aesthetic contemplation, and of autonomy and completeness within art, ensure that this end of appreciation, without practical or cognitive interest in anything which lies outside the work, shall be maintained. Cognitive ends and practical ends alike are assimilated within the work.

If this is true of moral values, it should also be true of the values which would not normally be called moral, e.g. the values of the unpleasantness which we have discussed. Unpleasantness may certainly exist in art, but our reactions to the unpleasantness should not be, as they are in ordinary life, reactions of practical revolt, of turning away

[1] Morality, it has to be remembered, is being interpreted in a generous sense.

from, or of effacing, the unpleasant object. Our reaction must find its place within the aesthetic experience; the flavour of the pleasant or unpleasant must be appreciated within its context. The pleasant, the unpleasant, the moral, and the immoral may enter into art. But our reactions to them are special aesthetic reactions.

Granting, then, that such values *can* enter into art, we may now return to our main question, namely, What are the effects of the qualities of the values embodied upon the art? Let us consider very briefly the special cases, first, of unpleasantness, and, second, of negative moral values.

## VIII. How the Quality of the Values Expressed Affects the Quality of the Art

When we consider the influence of unpleasantness upon art, we must think of what is genuinely unpleasant to a normal, healthy, experienced, sophisticated, and well-developed mind. There is, of course, much variety of opinion about *what* is unpleasant: the capacity for being shocked varies greatly with sophistication and experience. Again, in considering the aesthetic effects of unpleasantness, it is better to take cases in which unpleasantness is expressed for the sake of its unpleasantness, rather than those cases in which unpleasantness has as its aim the revelation of a larger value. Probably the lines quoted above from Shelley's *Sensitive Plant* would fit these requirements. Shelley's expression of the repulsive is doubtless a part of a larger whole, but we do feel that he rather rejoices in the unpleasantness, for its own sake, and that in doing so he is unhealthy. Or we might take a piece of verse like Rupert Brooke's *A Channel Passage*, which is a good deal concerned (again not wholly) with the physical details of sea-sickness. Again, in some sculpture of the 'downward slope', like the Laocoön, or in some periods of painting, there is revealed a certain love of suffering. In our own day there appear from time to time cults of the deformed

and the diseased. These things may be expressed with a certain vigour and much frankness; but do they make for very highly significant art?

The answer seems fairly plain. Our intuitions and our theories coincide. We do not feel that the exploitation of the unpleasant for its own sake *is* particularly significant. It may be the outcome of a protest which is significant. It may arise from a rightful and praiseworthy revolt against prudery and false delicacy of various kinds. As the expression of the desire to look all facts, pleasant or unpleasant, in the face, this merits nothing but commendation. It has its strength, and even its greatness. But if it stops half-way, and fosters artistic expression of mere brooding on the painful or the repulsive, our instincts tell us that this art must be art of an essentially minor sort. We may admire its expressiveness, but it is expression of a barren content. The merely unpleasant is not even interesting, except to the morbid. And it is, on a large view, unimportant. Those physiological details of life, for example, which are unpleasant not merely because we are shocked by them through some artificial system of education, but because there is a good biological reason for it (e.g. the unpleasant details of sea-sickness), are simply not of major importance in the scheme of the values of human life. No amount of attention to them and no aesthetic expression[1] of their values, however vigorous, can make them so. It is true, further, there are probably some things which are so horrible that it would be impossible to have an aesthetic reaction to them. They are too 'near'. What of the representation of a man's foot being cut off by a railway train? Or of some scenes in the Grand Guignol? Surely here our reactions are practical, not aesthetic?

We may conclude, then, that (though there is no objection in aesthetic principle to the aesthetic expression of

[1] And of course they *can* (subject to the provision in the next sentences) be expressed aesthetically, just as well as major values, and they are perfectly legitimate content for art.

unpleasantness as such) artistic treatment in the hands of a sane, normal, and well-balanced artist is likely to devote itself in the main to subject-matter which is more important and significant than that of the merely unpleasant.

The same generally seems to be true of the values we call moral or immoral. It is, as has been said, hard to draw a line between this and the previous case. But we should agree, I suppose, that hideous cruelty, and sexual lust, which are not merely animal but anti-human, are 'immoral' values. How do such values affect the quality of the art which treats of them? Once again let us consider such negative moral values as being expressed for their own sakes, and not for the sake of revealing some positive value.

The answer seems to be similar to the last, namely, that art which *merely* expresses negative moral values is simply not very significant. Or, better, it is significant of something which is poor and barren. Art *can* express moral evil—at least within certain limits—for its own sake, but it will be a small, an empty, and a negligible art, if indeed examples of it exist. Negative moral values demand their positives in art as in life. In 'real' life moral evil may achieve the importance of a focal interest, but only because it is associated with good. It may assume a large importance, for example, because it has to be combated, because it awakens positive combative passions, and because it has to be 'overcome with good'. Again, moral evil is sometimes associated—though not so often as we like to imagine—with an energy and vitality, for which it is impossible not to have some appreciation, even if a sneaking appreciation. There are heroic vices, or vices associated with heroic qualities. But genuine moral evil, in itself—cruelty, anti-human lust, selfishness, meanness, dishonesty—are in and for themselves barren topics, and barren topics for art. To be interesting, they require to be associated with positive values, to which by contrast they may give some flavour. But this is a very different matter from cultivating them for themselves. The 'romantic' vice

we all secretly love is a different matter from the reality of the dreary failure of the human misfit. So in art, mere vice by itself is a tedious business. Or, as with the unpleasant in art, if it is not tedious, it may be so shocking that, if our impulses are not allowed some outlet within the experience of the work (which is excluded by agreement in the case we are now considering) they will give rise to practical and non-aesthetic protest. Once again, the possible limitations of subject-matter are determined not merely by a priori general aesthetic principles, but by the test of aesthetic experience itself.

## IX. PORNOGRAPHY AND ART

We have been considering 'immoral' values as they are aesthetically embodied in art. This problem is of course totally distinct from the problem of any possible immoral effects which such values, apprehended aesthetically in art, may have in the beholder. (That question we shall discuss a little later.) It is also totally distinct from the problem of the 'immorality' of which 'pornography' is an example. Let us discuss pornography for a moment. We are not concerned with the question whether pornography is in fact moral or immoral, but with its relation—or rather its non-relation—to art. Let us assume that the thing called pornography exists, and that it is, as it is alleged to be, in some sense immoral.

The relation between art and pornography is a negative one. Pornography cannot be art, and art cannot be pornography, not because that with which pornography deals is a supposedly 'immoral' passion—for art may express the immoral—but because pornography is, I take it, definable as something which stimulates the sex-instinct of the percipient in a way which makes him subject to practical sexual desire. Pornography does not provide for completion of the impulses awakened as art does. Of course an artist

may be pornographic at times, or he may start with pornographic intention and end by producing a pure work of art. And again, a genuine work of art may be taken pornographically. Pornography, like art itself, is not a quality of the bare object, but implies the interpretation of a mind. But these things do not affect the fact that pornography and art are in essence mutually exclusive, that pornography has a practical aim outside art, or at least a practical effect, whilst art satisfies the impulses it awakens. In this one respect art is like the Absolute which is the lion's den to which all tracks lead, and from which none leads out. Any impulse whatever, or very nearly any impulse,[1] may enter into aesthetic experience. In entering in it becomes transformed by its new context. And one aspect of its transformation is that it becomes part of a perfect and complete whole. A work of art which contained pornographic elements would be, to that extent, ugly.

## X. THE EFFECTS OF ART UPON MORAL LIFE

(3) Our third problem concerns the effect of art upon morals. That this question is strictly speaking irrelevant to aesthetics, is by now obvious. Art has no interest in effects outside itself. "Art for art's sake" is in this sense a commonplace truth which no one but the aesthetically untutored or the morally raw or the intellectually inept would nowadays deny. Yet though consideration of effects lies outside the region of aesthetics, effects must exist, for that art-experience should have absolutely no effects is inconceivable. We cannot possess any experience, much less any intense experience, without its affecting us, and this is true of art. Setting aside such incidental though immediate effects as the nervous reactions produced as the result of apprehending works of art, e.g. the irritability which we may feel upon

[1] The exceptions being those impulses associated with the excessively horrible or immoral, pursued for themselves.

the transition from the perfection of music or poetry to the prosaic world of fact and our next-door neighbour, we may ask, What are the after-effects of experience of certain kinds of embodied values?

By effects I intend the effects of the values taken aesthetically. This means that the values must be taken as parts of an expressive whole, which have their meaning in the whole and are not fully comprehensible apart from it. It is not, therefore, strictly speaking, the separate values which affect us, but the whole. Indeed, we have seen that separate values in a work cannot have effects outside the work, if the work is an aesthetic whole and is taken aesthetically. It is true that we do, when we think of a work's effects, think of the effects of this or that part of it. The work indubitably has parts, and the parts indubitably contribute real effects. But we are making an abstraction, and the parts which are experienced and have the effects are experienced aesthetically in a context from which they derived some of their meaning. What we are essentially concerned with, then, are the extrinsic effects of this aesthetic vision as a whole.

As before, we may keep in our mind's eye the unpleasant and the pleasant on the one hand, and the morally evil and the morally good on the other.

The effects of the unpleasant (taken again as expressed for its own sake) and the pleasant in art are, I suppose, respectively depressing or stimulating in their effects, for unpleasure and pleasure correspond to some thwarting or some fulfilment. If what is unpleasant to me is pleasant to you, then its effects are, I suppose, in some degree stimulating to you. But what is genuinely unpleasant is, even though satisfying as far as its expression goes, something which one would expect would cause a certain depression. And vice versa with pleasure.

It is true, of course, that the unpleasant may shock, and that shock is a stimulus. But if this kind of shock be the

effect of the apprehension of a work of art, it is a fairly clear indication of aesthetic failure somewhere, either in the work or in its apprehension. For it is a practical kind of shock. Works of art apprehended aesthetically as wholes affect rather the general tone or level of subsequent experience. The effect of a pleasant work of art is the effect of a general tonic, not of this or that violent particular pleasure. As we have seen, the pleasure results from the whole work. So an unpleasant work, apprehended aesthetically, depresses rather than shocks.

Probably the same generally is true of negative and positive moral values, except for the fact that, as morality comprehends the whole of the nature of man, the aesthetic expression of evil for its own sake may be expected to produce depression on a larger scale, and the expression of the morally great and noble, exaltation on a larger scale. This does seem to be the case in fact. The moral values revealed in great tragedy do stir and stimulate us profoundly. They do not in themselves, if perceived aesthetically, directly (or even of necessity, indirectly) impel us to "go and do likewise". But it is very improbable that in the end, ultimately, and in the long run, the experience of great art does not affect conduct in one way or another. It is, of course, one thing to possess trained apprehension of what is noble and great, and quite another to possess nobility. Practical moral life implies more than feeling and knowing; it implies development of sentiments and character. But one of the conditions of morality is vision, and anyone familiar and in love with what, for example, is seen in the greatest tragedies, comes to moral life equipped with at least this one qualification. It cannot but affect him.

Yet not only are the effects of this vision not *necessarily* in the end productive of good life (because of the *hiatus* between appreciative knowledge and the volition which is the expression of formed character); they may even be bad rather than good. The vision itself is purifying, but the

effect of it upon some temperaments may be to produce a fastidious aesthetic other-worldliness, which seeks escape in the dreams of art from moral problems and the duties of real life. The experience of great art is a great good for the soul, but the soul may misuse its good, and in this life of care there can be too much of this individual good thing or that, however great.

The effects of art upon character will, in fact, depend upon character. As appreciation of art is dependent upon, among other things, richness of experience outside art, so great art will fail, not only in its aesthetic, but in its non-aesthetic and moral effects upon a mind which is immature, or crude, or ill-balanced in any way. Only those in some degree great can apprehend and assimilate, aesthetically and morally, the great. Tragedy will not affect a shallow mind aesthetically, nor purge it morally. Again, on the negative side, the effects of evil in art will similarly depend upon character.

# CHAPTER XII

# THE COMPETITION OF INTERESTS IN WORKS OF ART, AND THEIR FUSION—WITH SPECIAL REFERENCE TO MR. ROGER FRY'S *TRANS-FORMATIONS*

# I. Competition and its Types

By the competition of interests in the work of art I mean that competition which may tend to arise between interests in several parts or sides or aspects of a work of art. The chief case so far of such competition, or tendency to it, has been the competition, in 'representative' arts like painting or drama, between the interest in subject-matter and the interest in the body-side of embodiment. Theoretically, we have argued, 'subject-matter' *ought* to conform to the type of 'content'. But subject-matter has in fact its natural interest. So has form (or 'material' or 'body'). And it may very easily happen that the two distinct interests may lead to a splitting and breaking-up of an aesthetic experience which should be a whole. The topic which the painting or drama is supposed (on one theory) to 'mirror' may become the exclusive focus of attention. Or, on the other hand, the critic of a great painting, poem, or drama, may treat it merely as a series of interesting experiments in the management of pigment, in the use of metre, or in the manipulation of characters on and off the stage.

This is one kind of instance of possible competition, and we shall discuss problems raised by it, with some illustrations. But there are, of course, even more obvious examples of competition between different interests. Opera is an outstanding example. Here there are many claims upon our attention. There is orchestral music and vocal music, there is dramatic plot, the spectacle of dramatic acting, and perhaps the poetry of words. There is colour and scenery, there is the physical movement of the players (as in dancing). The Ballet is another and less complex instance of competition. It is, I think, a fact that we rarely do find critics who are equally interested in all aspects of these complex arts. The critic tends, almost inevitably, to focus upon one factor or another, upon the music, or upon the acting, or upon the choreography, or even upon single aspects of these. Is this

essential? Are such arts merely compounds? Or is fusion possible? We have been assuming that it is. But the matter is of such vital interest that it is worth going into it in some detail and even at the cost of some repetition.

Because, in these matters, concreteness is important, because it is specially necessary to have examples before our mind, I propose in what follows to refer a great deal to Mr. Roger Fry's *Transformations*,[1] particularly to his first chapter, "Some Questions in Aesthetics". Mr. Fry, as everyone knows, is a distinguished critic and artist whose opinions are always worth the most serious consideration. And Mr. Fry not only discusses at great length this general question of what I have called 'competition', including the cases of opera and song, but he gives us many actual illustrations from the sphere of visual art, to which, as they are accessible in one volume, it will be convenient and profitable to refer. I shall frequently have to criticise Mr. Fry's conclusions, but this in no way conflicts with a deep sense of indebtedness to him.

Mr. Fry, after a preliminary discussion, begins by making a distinction between what he calls 'pure' and 'impure' arts.[2] He says that "it nowise invalidates this conception if such a thing as an absolutely pure work of art has never been created: the contention is that some works approximate much more nearly than others to this ideal construction". I am not absolutely clear what Mr. Fry means by 'pure' and 'impure', for he does not define them specifically. Sometimes it looks as though by 'pure' he means 'without competition of interests' (as in pure music, or pure visual plasticity, versus song or opera or representative painting). At other times it looks as though in using the terms 'pure' and 'impure' he were referring to the perfection, or the failure of perfection, of the aesthetic *unification* or fusion of various competing interests in some (perhaps all) works of art. I am inclined to

[1] Chatto & Windus.
[2] *Transformations*, p. 3.

think that the context shows that this latter sense is the sense of which he is really thinking, though on Mr. Fry's view (he is very emphatic about the difficulty of complete aesthetic fusion in complex arts) the purest arts in the second sense *tend* in fact to approximate to 'pure' art in the first sense. But the second sense is certainly the more important, and its problems occupy the whole of Mr. Fry's first chapter. It is the sense which I wish to discuss.

For convenience' sake we may range the arts roughly in a kind of scale, starting with arts like music and architecture at one end of the scale, and finishing with opera at the other end. The scale will represent a transition from relatively 'unmixed' arts to very 'mixed' ones, and the mixture will be mainly[1] of two kinds, (a) a mixture of the appeals of different sense elements (e.g. of the visual with the auditory in musical dancing), and (b) a mixture of the appeals of 'body' and of subject-matter. It is impossible to make any neat classification on one basis or the other; there is bound to be frequent overlapping. But on the basis of both taken together, we might get first—after pure music and architecture (and perhaps dancing without music)—such arts as drawing, painting, sculpture, acting without words, etc. Here the appeal is mainly through one sense, but the element of representation enters in. (I say "mainly through one sense" because of course in all the cases mentioned imagery of other sensations is involved, and, perhaps, other actual sensations. But in painting, for example, the main focus of attention is upon the visual, and this is what we are at the moment concerned with.) In this class also might be placed poetry read aloud to oneself (as opposed to poetry spoken before us by another, where the visual apprehension of attitude and gesture would enter in along with the auditory

[1] There may be finer gradations of mixture of appeals, as in the competition in painting between the appeal of plasticity and that of colour or of line (see below, p. 326). But we are concerned at the moment with broad divisions.

appeal of words). Here too might come privately read drama, the read novel, etc. In the next division of the scale we might place arts appealing to more senses than one, but which are not essentially representative, for example, some musical dancing (visual and auditory). Here also would come representative arts which appeal to more than one sense, e.g. recited poetry or acted drama (representation and visual and auditory appeal). Lastly might come arts which are mixed almost in the sense of being compound. Compound, that is, of separate arts. Song and opera would be examples. Thus, song, it might be said, is a compound of poetry and music, and opera a compound of many arts. Here again (though it has already been included) might come musical dancing, a combination of music and dancing. I do not think, as I shall show, that to regard one art as a real compound of others which can themselves be pursued as arts, is in the end satisfactory, but it is at any rate a point of view, and is good enough for classification purposes. The present attempt to make out a 'scale' has no motive but the desire to see broadly the extent of a rather far-reaching problem. I have no intention here of trying to deal with the problem as it arises in all the arts mentioned. I shall merely select some instances, and in preference, those which have been discussed by Mr. Fry. Let us begin with our familiar friends, subject-matter and body.

## II. The 'Dramatic' versus the 'Plastic'

Mr. Fry discusses at length in *Transformations* the tension in visual art between psychological or 'dramatic' interest on the one hand, and 'plastic' interest on the other hand. In a somewhat earlier work, *Vision and Design*, containing reprinted essays, he has a footnote to a paper on Giotto, in which he criticises a former assumption of his own, that not only did dramatic ideas inspire Giotto to the creation of his form, but that the value of the form for us is bound up with

recognition of the dramatic idea. He adds:[1] "It now seems to me possible by a more searching analysis of our experience in front of a work of art to disentangle our reaction to pure form from our reaction to implied associated ideas." This "more searching analysis" he makes, with great care, in the first essay in *Transformations*. In this essay he takes a large number of examples, Pieter Brueghel the elder, Daumier, Poussin, Rembrandt, and many others, which he examines in a certain order, putting those in which psychological interest predominates (e.g. Pieter Brueghel's *Christ carrying the Cross*) at one end. As we proceed, the plastic interest increases, till we arrive, in the case of Rembrandt's "Christ before Pilate", at "perhaps as good an instance as one can get of . . . co-operation of the dramatic and plastic experiences in a single picture". Mr. Fry's thesis is that this blend of experiences is rare, and that in most cases there occurs not fusion, but tension of interest between the psychological and the plastic. He says, even of Rembrandt's work, that we are compelled to focus the two elements separately. "Indeed, I cannot see how one is to avoid this. How can we keep the attention equally fixed on the space-less world of psychological entities and relations and upon the apprehension of spatial relations? What, in fact, happens is that we constantly shift our attention backwards and forwards from one to the other. Does the exaltation which gratification in one domain gives increase our vigilance and receptiveness when we turn to the other, as would be implied by true co-operation? In this case I incline to think it does, although I doubt whether this more than compensates for a certain discomfort which the perpetual shifting of focus inevitably involves."[2]

In the case of Rembrandt's picture there is a minimum of this (alleged) discomfort. There are examples of well-known pictures in which it is very considerable. Mr. Fry cites, in *Vision and Design*, the instance of Raphael's *Trans-*

[1] *Vision and Design*, p. 131 (footnote).        [2] *Transformations*, p. 23.

*figuration.* The whole of the essay on this subject makes fascinating reading, and cannot be properly reproduced, except as a whole. But the main points of interest for us now are as follows. There is (1) the appeal of the subject-matter. "To those who are familiar with the Gospel story of Christ it brings together in a single composition two different events which occurred simultaneously at different places, the Transfiguration of Christ and the unsuccessful attempt of the Disciples during His absence to heal the lunatic boy. This at once arouses a number of complex ideas about which the intellect and feelings may occupy themselves."[1] But in the subject-matter regarded as representation there are suggested things which are by no means wholly pleasing. If "our Christian spectator has also a knowledge of human nature he will be struck by the fact that these figures, especially in the lower group, are all extremely incongruous with any idea he is likely to have formed of the people who surrounded Christ in the Gospel narrative. And according to his prepossessions he is likely to be shocked or pleased to find", instead of the poor and unsophisticated peasants who followed Christ, "a number of noble, dignified, and academic gentlemen in improbable garments and purely theatrical poses. Again the representation merely as representation, will set up a number of feelings and perhaps of critical thoughts dependent upon innumerable assoc:ated ideas in the spectator's mind."[2]

In these things our pleasure and displeasure is, of course, affected by our extra-aesthetic knowledge, as well as by our general background of taste, training, and tradition. The pagan spectator will have a different view from the Christian.

(2) There is, secondly, the entirely distinct appeal of form, for those who are sensible to its meanings. "Let us now take for our spectator a person highly endowed with the special sensibility to form", who feels intensely the intervals and relations of forms; let us suppose him either completely

[1] *Vision and Design*, p. 296.    [2] Ibid., p. 297.

ignorant of, or indifferent to, the Gospel story. Such a spectator will be likely to be immensely excited by the extra-ordinary "co-ordination of many complex masses in a single inevitable whole, by the delicate equilibrium of many directions of line. He will at once feel that the apparent division into two parts is only apparent, that they are co-ordinated by a quite peculiar power of grasping the possible correlations. He will almost certainly be immensely excited and moved, but his emotion will have nothing to do with the emotions which we have discussed hitherto, since in this case we have supposed our spectator to have no clue to them."[1]

### III. Is Fusion Possible? Criticisms of Mr. Fry

These are examples. And the problem is, in Mr. Fry's words, "Do these form chemical compounds, as it were, in the case of the normal aesthetically gifted spectator, or are they merely mixtures due to our confused recognition of what goes on in the complex of our emotions?"[2] Mr. Fry inclines to think that fusion "of two states of emotion [is] due to my imperfect analysis of my own mental state".[3] Again, in *Transformations*,[4] he concludes: "Our experiments and in-quiries have then, I hope, given us one result on which we may rely with some confidence: the notion that pictures in which representation subserves poetical or dramatic ends are not simple works of art, but are in fact cases of the mix-ture of two distinct and separate arts; that such pictures imply the mixture of the art of illustration and the art of plas-tic volumes—the art of Art, our horribly incorrect vocabulary almost forces us to say". But he is very tentative, and is careful not to say that co-operation between the psychological and the plastic aspects is impossible or that it never occurs.[5]

[1] *Vision and Design*, p. 298.  [2] Ibid., p. 300.  [3] Ibid., p. 301.
[4] *Transformations*, p. 27.  [5] Ibid., p. 21.

And he is ready to admit (in *Vision and Design*) that perhaps the question is one for the experimental psychologist.

This, then, is our first problem. Is there really true fusion of experiences, or is there only, at the very best, an unfused 'co-operation' of experiences?

In asking whether fusion is possible, we must go back to our early distinction between 'psychological' fusion and 'aesthetic' fusion, or aesthetic relevance. Clearly what is meant in this context is chiefly *aesthetic* fusion. Psychological fusion in various degrees may or may not occur; we may, that is to say, be less, or more, explicitly conscious of the many elements which go to enrich the total significance of an aesthetic complex. But what matters, and what Mr. Fry is I think chiefly interested in, is whether in certain cases a single harmonious (or aesthetically fused) aesthetic experience is possible. I believe, indeed, that Mr. Fry often wrongly identifies the two in his mind, and thinks that because psychological fusion does not, in particular cases, occur, that because we have a number of different objects of interest more or less explicitly before our mind at once, *therefore* aesthetic fusion is impossible. But aesthetic fusion is his, and our, main problem, and, unless specified otherwise, the term 'fusion' will here be taken to mean aesthetic fusion.

In this matter it is only fair to seek out the best examples. It may be that in very many instances of our experience of works of art there is some failure of fusion, some disorganised shifting about of attention from one element to another. Mr. Fry concentrates a great deal of attention on such instances (though he does not deny outright the possibility of fusion). But there is a danger in so doing. We may get the problem out of proportion. Because failure often occurs in the instances we select, we must not conclude that it always does, or even tends to, for our instances may be too specialised; a single instance to the contrary is sufficient to disprove any generalisation. I shall try to show later that it is probable that there are many instances of fusion. But, in

order to find them, we must select; and this is a perfectly fair procedure.

No doubt it is possible to disentangle and analyse elements in our aesthetic experience, and this could be done, even in the hypothetical cases where fusion occurs. Mr. Fry's later point of view when he distinguishes between dramatic and formal appeal[1] is an advance on his earlier. But would it not be possible for him to go back to the earlier position, only at a higher level of synthesis? Is there not a danger of taking the products of our legitimate analysis as separate 'parts' which can only co-operate, but can never fuse? In analysis always there does lurk this danger, and in the analysis of aesthetic experience, where unity is so vitally essential, and at the same time so delicately fabricated, it is an especial danger. Aesthetic experience may contain many different elements, and I have argued that it is a synthesis containing many meanings. But is it not also its essence that the elements and meanings should be made one and inseparable from the aesthetic whole? And do not the 'parts' thus resolve themselves either into abstractions from the given existing aesthetic whole, or into the elements entering into its history or genesis?

Mr. Fry does appear to be taking the products of his analysis of aesthetic experiences as if they were separate parts of a composite whole. He does seem to be reinforcing this error by emphasis upon special examples in which there is at least a great danger of the breakdown of the unity of aesthetic experience. And he does speak constantly as if neutral, or primary, subject-matter could be an object of interest in an aesthetic experience. This can be illustrated in two sentences taken from his first essay in *Transformations*. One sentence occurs where he is speaking of the difference between interest in psychological, and interest in plastic, factors.[2] He says: "These two kinds of representation are, likely enough, governed by different principles, and imply

---

[1] See above, p. 315.          [2] *Transformations*, p. 34.

certain differences of emphasis which explains in part the great difficulty of conciliating them. For instance, where drama is in question minute changes of tone in the face will be likely to have a far greater significance than they would have on plastic grounds, and it is almost inevitable that the dramatic painter should give them ultra-plastic values." The other quotation which I will select is a passage where, speaking of a drawing of Rouault in which there is both plastic and psychological interest, he asks:[1] "Does he, then, provide us with the case of perfect fusion into a single expression of the double experience? Or is there not, after all, a certain tension set up? Different people will answer this question in different ways, according to their ruling preoccupation. Perhaps, as in the case of El Greco, in process of time the psychological elements will, as it were, fade into the second place, and his plastic quality will appear almost alone. I do not profess to give an answer. I may note, however, in passing this phenomenon of evaporation. I believe that in nearly every one, wherever a psychological appeal is possible this is more immediately effective, more poignant than the plastic, but that with prolonged familiarity it tends to evaporate and leave plasticity as a more permanent, less rapidly exhausted, motive force. So that where pictures survive for a long period their plastic appeal tends to count more and more on each succeeding generation."

In both the above quotations it is implied that part of the work of the artists mentioned has been representation, reproduction of extra-aesthetic values. Mr. Fry would be quit of it if he could. He writes: "It is a great simplification to ... look upon both illustration and plastic as having each their proper form, the one psychological, the other spatial."[2] This desire is natural, for it is the outcome of the supposition that the two factors are really at war. But is not the cure worse than the disease? Does it not lead to an artificial idea of art and does it not impoverish art of much of its

[1] *Transformations*, p. 25.　　　　　　[2] Ibid., p. 27.

meaning? Life may be difficult to transform aesthetically, but is it impossible? Must we simply abandon the attempt, choosing art *or* life, but not both?

As regards the first of the above quotations, if the artist is interested *merely* in the 'pure' formal relations of the human face, if he is interested, that is, simply in the general emotional values of plastic forms and their relations, he is not painting a *human* face at all. His subject-matter is merely a general arrangement of plastic forms, which, as it happens, bears some resemblance to a human face. It is not a matter of the psychological factor being "emphasised" less; it is a case of the psychological factor not existing at all for the artist. But it is a strained and unnatural attitude. Of course the painter is interested in the expressiveness of visual *forms*. But he is interested in their *expressiveness*. The forms are 'significant'. And what does a human face express more definitely than human character? Surely the artist has more before him than 'lines, planes, and volumes'. Surely, if he is not ridden by theories, he is interested in character. Not the disembodied, purely mental character which is the object of the psychologist, but, once again, character plastically expressed in a face which interests him. If this interest can in some sense be called dramatic, it will not be true to say that the "dramatic" painter will give emphasis to ultra-plastic values, in the sense of values outside and independent of the plasticity. Rather, psychological values will become apprehended plastically. This continually happens. We do not see a face, *and* its character. We see character *in* the face. There is not a better—or commoner—example of aesthetic expressiveness anywhere than this.

The character transforms the aesthetic expressiveness of the plasticity. It is not that we are interested in two things, side by side. Introspection of art experience makes this fairly clear. When I look aesthetically at Verocchio's *Colleoni* I am not in the least interested in the character which the gentleman on the horse originally possessed. Yet I cannot

but feel braced up and inspired by the intense vigour of character which is embodied in every inch of horse and man. Or when I see the fresco (in the Arena Chapel at Padua) of *Joachim Retiring to the Sheep-fold*, it may be that my first interest is psychological, or it may be that it is plastic (in my own case it was the latter). But in a full appreciation I cannot possibly cut out one or other element. In the whole, each becomes transformed. There is not, to repeat, when the experience is complete and mature, psychological interest *and* plastic interest. There is just the plastic-psychological expressiveness of the forms of the dignified old man with head bent, enwrapt in his mantle, in contrast to the different plastic-psychological expressiveness of the naïve-looking shepherds who come to meet him. Our object is plastic psychology, plastic drama. One does not need to know the original story in order to appreciate the delightful expressiveness of the forms, though doubtless knowledge of the story assimilated into the aesthetic experience would enrich it. Aesthetic assimilation is essential, not only here, but always. *All* representative pictures require external knowledge. Some of it is common to everyone, some of it has to be specially acquired. Who could fully appreciate Leonardo's *Last Supper* without external knowledge? But the knowledge must have become familiar, assimilated. The danger is, always, of its remaining external; for aesthetic assimilation is not easy.

Exactly parallel reasonings hold good of the second quotation. It is only if the psychological interest in paintings is an extrinsic interest, an interest in primary subject-matter, it is only where there are elements of external allusion and mere illustration, that psychological elements will tend to "evaporate". If the artist has imagined his way through to the end, the psychological interest will not evaporate because it will be intrinsic to the painting: the psychology is plastic psychology.

Introspection of actual aesthetic experience certainly does

appear to show that there can be aesthetic fusion. And this
seems to be possible, not only in the relatively simple cases
taken, but in more complex ones. Speaking for myself, I do
not experience the continual "shifting of attention" of which
Mr. Fry speaks, in appreciation of works of art of the type
of Rembrandt's *Christ before Pilate*, or still more of his
drawing of *The Hidden Talent*.[1] There is, of course,
always a stage when we are coming to comprehend the
picture, in which we have to attend to this, and then that,
and then something else. And it is not suggested that it is
easy to attain perfection of apprehension, or that an alterna-
tion of attention can always be overcome. But perfection
can, it is probable, be attained, and it is *always* the ideal of
aesthetic experience. To fall short of it is to fail.

## IV. FUSION IN SIMPLER AND MORE COMPLEX CASES

Mr. Fry, I think, must assume that fusion occurs in the case
of 'pure' form, for he approves, I take it, of Mr. Bell's phrase
"significant form". But whether Mr. Fry does or does not
admit fusion in the case of 'pure' form, we have at least seen
for ourselves[2] that fusion does exist here. There is, strictly
speaking, no such thing, aesthetically, as 'pure' form. In
terms of Bell's phrase, form, even in the most 'abstract' of
art, is always, for aesthetic experience, *significant*, whether of
organic or ideal values, whether of values directly or in-
directly apprehended. These values are aesthetically fused
with the form as we apprehend them aesthetically, or
aesthetic experience does not exist at all.

If fusion of meaning is possible in the case of 'pure' form,
why not in the case of mixed, e.g. 'representative', arts?
Introspection, we have seen, suggests that fusion in such
cases is possible, though it may be difficult. The aesthetic
theory we have been defending—and, I should imagine, any

[1] *Transformations*, (facing) 24.
[2] Chapter IV, p. 101 sq.

aesthetic theory—takes it as absolutely essential that fusion should occur, if they are to be aesthetic experiences at all. Is there any possible theoretical objection to the possibility of its existence in these cases, beyond the admitted fact that it is difficult to achieve?

I cannot see that there is. We must not, of course, allow metaphors to run away with us, and think of aesthetic fusion as if meanings melted together in our minds like bits of lead in a ladle. Neither must we think of aesthetic, as if it were psychological, fusion. Mr. Fry, I think, is sometimes guilty of seeking after a too great simplicity of aesthetic experience. The aesthetic experience is (even when 'pure') a complex experience and, even when much psychological fusion occurs, a complexity of meaning remains. This complexity must be fused and unified aesthetically, but aesthetic fusion does not mean the disappearance of the parts. The aesthetic fusion, or assimilation or unification of parts, must simply be accepted as a fact which is irreducible.

To say all this is not to deny that the emphasis in different works may be on different things, or that in the same work the focus of our interest may shift about. Indubitably the focus does shift. This does not mean the same thing as that of which Mr. Fry is speaking when he speaks of the "shifting of attention". In poetry the images and ideas may be an accompaniment of the delightful words: or the ideas and images may be the focus, and the sound of the words their accompaniment. In representative painting we may now be interested in the character-aspect of the content, and now in the formal aspect of the body-side. But the 'shifting' is not from *mere* 'dramatic', *mere* 'psychological' interest, to *mere* formal interest. It is only, if the experience be an aesthetic one, an emphasis on aspects of a whole, in which one aspect modifies and colours the others. In other words, and to repeat, emphasis upon and attention to this or that, is not incompatible with this aesthetic fusion. But enough.

## V. The Importance, for Fusion, of the Artist's Interests

From the point of view of the artist's creation, it is of course necessary, if fusion is to occur, that all the items of his interest should be imagined in terms of his material. If the artist's choice of subject is a spontaneous one, if, in his restless searching after expression, he comes to a subject naturally, and comes to it aesthetically, seeing (if he is a painter or sculptor) the characters of his subject in plastic terms, then there is for him of course no conscious problem of assimilation, no conscious conflict, between character or dramatic subject, and form. We feel, for example, of Rembrandt's *Hidden Talent* [1] that the subject-interest and the plastic interest must be for the artist one throughout. Indeed, where fusion has finally been successfully accomplished, it is difficult to feel that there ever has been conflict. We feel this spontaneous fusion of interest in many of the paleolithic cave-drawings of animals, in many catacomb paintings, in Giotto, in much Dutch domestic painting—in all subject-work, in fact, which is genuinely good.

In work like Raphael's *Transfiguration*, on the other hand, already discussed, we do not feel nearly so certain. It is good in this or in that aspect, but not as a whole. We feel that the subject or character-side has never interested the painter, and so why should he have painted it? Because of tradition, convention, commissions? Much of the religious painting of the Renaissance must have been carried out without great spontaneous interest in the subject-matter. Similarly, painting of portraits of uninteresting subjects for commissions is often a compromise. Ideally speaking, the subject should choose the artist. If it does, he may be relied on to reveal it plastically. If it does not, and he is compelled, for non-artistic reasons, to paint it, we shall get compromise— for better or for worse.

[1] *Transformations*, plate vi.

We have now discussed at some length the general problem of aesthetic fusion. This has been illustrated by consideration of the question of the competition between the interests of subject-matter and of body. It may be of further use now to discuss briefly, with the help of Mr. Fry, some special kinds of 'competition' which may arise. The first group of cases which I shall select lie within the realm of painting, the competition arising between certain of the visual elements in painting. The second group is the group of the so-called 'compound arts', which includes song, ballet, opera.

## VI. Other 'Competitions'. 'Decorative' and 'Plastic' use of Colour

The first question, that of the competition, or "tension" (as Mr. Fry calls it), between the 'decorative' and the 'plastic' use of colour, can only be suggested. It is a highly technical problem in which only the expert is really entitled to speak. Mr. Fry gives an interesting account of the development of the plastic use of colour,[1] showing how, at the time of Cellini, colour was merely an addition, an ornament, filling in the frame of the drawing. And he shows the way in which, gradually, colour came to be used as expression of form. This, i.e., is a 'tension' which has really been overcome, and which in good painting (which is not merely decorative) must always be overcome. It is but one more example of the necessity that all the components of art should be assimilated to one another. The realisation that the world of three dimensions is visually apprehended in terms of colour,[2] i.e. that colour is not something which is painted upon forms already perceived as such, is at the same time a realisation of the prime condition of painting, that forms seen must be

[1] *Transformations*, pp. 213 sqq.
[2] I am aware that this is not beyond controversy, that it is said that visual space is coloured and not colour that is extended; but to discuss this would be to digress.

painted as they are seen, not as coloured shapes, but as shaping colours. Mr. Fry, here and below, does not argue a fundamental tension, as with subject-matter, but only a difficulty in practice in the use of plastic colour. Two-dimensional colour is the actual material of painting, and it must be transformed so as to be expressive of three dimensions, plus other things.

## VII. LINE AND THREE-DIMENSIONAL VOLUME

The next 'competition' to be mentioned is that of line and three-dimensional volume. Actually, as everyone knows, "there are no lines in nature", there are only shapes apprehended in terms of colour. But line is a characteristic and recognised medium of expression, and we have to consider how far it may be expressive, and more particularly how far, if at all, there may be conflict between the directional character of the line and its character of bounding figures and suggesting volumes. The problem is well put by Mr. Fry in the following passage.[1] "For whatever reasons, the imagination is only strongly affected through vision by the vivid realisation of plastic forms, and the great trouble with the drawn contour is that it tends to check that realisation. For one thing, the drawn line tends to carry the eye along its course; indeed, there here comes in, to conflict with this plastic expression, one of the very beauties of the art of drawing, namely, the interest excited in us by the rhythmic flow of the line as we follow its movement along. For the drawn line is a perfect record of a certain gesture, and all gesture, as we see in the dance and the drama, has a strong evocative power over the imagination. In handwriting, where the lines do not even suggest plastic relief, our whole attention is fixed, in so far as we contemplate it esthetically, on these traces made by gestures, and we deduce from them

[1] *Transformations*, p. 200.

very strong impressions of the character and mood of which these gestures are the outcome.

"This purely abstract rhythmical attraction of the line is still more potent in a drawing, and we may call it, by analogy with handwriting, the calligraphic quality of a drawing. But, as we have seen, this very quality tends to divert our attention from the cross-sections of disappearing planes and fixes it on the continuous movement of their summation in the line. It is one aspect of the eternal conflict in the graphic arts of the organisation on the surface of the picture and its organisation as an ideated three-dimensional space occupied by volumes. The conciliation of these two opposing tendencies, accomplished by innumerable different devices at different periods, may almost be said to be the material of any intimate technical criticism of pictorial art."

Mr. Fry goes on to contrast the "calligraphic"[1] quality of a drawing, which possesses its perfect easy rhythmic continuity and coherence only when we are not fully conscious of it, with another method of drawing which has spontaneity and unconsciousness of a different kind. This other method occurs when before an actual appearance, the artist "becomes so concentrated upon the interpretation of a contour as to be unconscious of what goes on between his hand and the paper. The ideal of such a situation is that he should never actually look at the paper. This, of course, is a counsel of perfection."[2] For, if he never looks at the paper, the proportions are likely to go astray, though the rhythmic quality is likely to be excellent. I suppose that the caricaturist who draws faces inside his pocket would be an instance of the 'intention' of this kind of drawing. Mr. Fry says that the rhythm which it possesses is "due to the concentration on the actual vision."[3] The tendency of "calligraphic" rhythm is, on the whole, to be flowing, and there is a danger of

[1] This has of course no reference here to historical fact, such as that Byzantine art was affected by Arabic calligraphy.
[2] *Transformations*, p. 202.                        [3] Ibid.

achieving a certain easy but too obvious elegance of gesture.

The other kind of drawing tends to be more expressive, and, Mr. Fry thinks, more preoccupied "with the plasticity and varying emphasis of the contour than with its continuity. This may be seen to perfection in Rembrandt's, and very strikingly, too, in Browyer's, drawings (Plates VI and XXXI of *Transformations*) where the volumes are indicated by broken lines which, by their continually varied quality, suggest the variations of contrast which the line is intended to express in various parts of its course. Rembrandt, particularly in his preoccupation with volumes, frequently gives several slightly different versions of the contour for fear of preventing us by any one too precise and over definite statement from realising the movement of the disappearing planes."

All this is another example of the fusion of several interests. Mr. Fry's term "calligraphic" marks out drawing at its simplest and least complex stage. When, on the other hand, the lines have the rhythm due to "concentration on the actual vision", the interests in subject and in three-dimensional plasticity enter in. As regards the latter, although three dimensions has to be expressed in terms of two,[1] and this is a task to be overcome by the artist, there is no essential conflict or competition in drawing between two dimensions and three. If drawing is of the calligraphic sort simply, and avows nothing else (the nearest case would be pure arabesque), the question does not arise. If it is more than calligraphic, there is a problem. But it is a practical one for the artist and—if our general arguments are sound— raises no difficulties of aesthetic principle.

[1] Taking the line not as mere mathematical line (in which case it would be one dimension), but as an area—a special case of colour.

## VIII. Opera, Song, Ballet

We may now consider briefly the case of those arts which may be called 'compound' in the sense that they may be alleged to be composed of 'parts' which are in themselves arts. Examples of such are opera ('composed' of music—orchestral and vocal—acting, poetry, stagecraft), song (a blend of poetry and music), and the ballet (music and dancing).

The problem, particularly as regards opera, is a very real one, and one which has troubled lovers of the arts, philosophic and unphilosophic, perhaps more than any other. Is opera the richest of all the arts, or is opera perfectly impossible, being an evil mixture of essentially incompatible ingredients, something tolerated by one person for the sake of music, by another for the sake of the poetry or the acting, and so on? Similarly, in ballet, can we attend only to the music or to the dancing, one at a time, or can there be a true unity of the two in a third art, which we simply call 'ballet'? It is the same question over again that we have been discussing throughout this chapter, in a fresh form.

As before, we ought to distinguish between the actual and the ideal. If ever aesthetic fusion is difficult, it is so in an art like opera. For the same reason perfect fusion may seldom be found. Our view of opera will therefore depend upon whether we are thinking of opera as it is, or opera as it may be, or opera as it ought to be. If we are empiricists and if we like opera, we shall probably be forced, if we are honest, to conclude from our most frequent experience of the actual, that opera on the whole is just a mixture of several arts, and that it is not a bad thing at that. If we are empiricists and dislike opera, we shall condemn it because it leaves us flustered. If we are idealists in this matter, believing in the possibility of fusion, and dislike opera, we shall condemn it coldly for its many faults, whilst if we are idealists and like it, we shall see in it the noble ideal of the

rich unity which it is striving continually to attain. We shall regard it as fuller of potentiality than any of the other arts.

Mr. Fry might be classed as an idealistic empiricist, with the inclination to believe that fusion is sometimes, but not always, possible. He suggests that where there is emotion at a high pitch of tension, fusion in opera is not possible. Conversely, "conflict was far less in the *Meistersingers* and disappeared altogether in great parts of Mozart's operas, where the tension was lower, and most of all where the treatment was most playful and least intense".[1]

Mr. Fry may be right. But he is, I fancy, jumping to a rather too pessimistic general conclusion when, on the basis of the experience of Handel's opera *Semele* he says: "But there . . . was enough to make one see what Opera may safely be, and what, I rather guess, human limitations being what they are, it can scarcely transcend."[2] He may be right. Personally as a sympathetic *dis*liker of opera with an idealistic strain, I find it very difficult to say. No one is fit to pronounce on opera unless he has sometimes, and often, loved it. It may be that fusion is only possible when the tension of feeling is low. A priori this may be questioned. Certainly there is theoretically no barrier, except the extreme artistic difficulty of managing very complex materials. One would expect the difficulties to be specially great when feeling is at a high tension. But nothing more. If fusion is possible in the simpler cases, it is in theory, and very likely in practice, possible in the more complex ones, for no new principle is introduced. And as we have seen that fusion is possible in the simplest cases, we may conclude that opera is, potentially at least, the richest of all the arts.

If in opera fusion is at least ideally possible, each part will of course no longer be a separately existing entity, but will be transformed by its relation to the other parts in the aesthetic whole. This, in other words, means that it is inaccurate and misleading to speak of 'compound' arts. Mr. Fry

[1] *Transformations*, p. 30.  [2] Ibid., p. 33.

is, I suspect, wrong when, speaking of song, he says: "Is there really any such thing as a true song? That is to say, such a setting of words, in themselves esthetically moving, to music, also in itself esthetically significant, that both are apprehended at once, not only in their full significance, but mutually exalted by the co-operation of the other. It is fairly clear that anything at all like great poetry must be lessened by any other way of pronouncing the words than that of beautiful speech. In that direction, there must be loss of poetical beauty, however the words are set, since the intonation of music must always distort in some way the rhythmic quality of verse and the speech emphasis of words. A probable explanation of the song, then, may be that the words are to some extent sacrificed to the music."[1] Here a slight error in the putting of the question occurs, because of the answer which he knows he is going to give. For the problem is *not*, Can spoken poetry and sung music, each with independent beauty, combine harmoniously with one another? If the question is put in this way the only possible answer is that they cannot, for each is complete. Sung poetry can never be the same as spoken poetry, and poetry is meant to be spoken and not sung. The real problem is, Can words (including their meanings) be beautiful in song? Can music be beautiful in song with words? It *may* happen that beautiful poetry is written down in the same identical words as the words of a song. But the community of the written word should not lead us to suppose that there is necessarily any community of aesthetic standards in judging the value of spoken and sung words. The words as sung have a wholly different aesthetic value, but not necessarily an inferior one, in fact not strictly a comparable one at all. For even if the 'same' words used in song are "spoiled as poetry in the song", it is not because they are spoiled *poetry* that they are bad, but because they do not fit in with the music—are, in fact, bad *song*-words. Song is not 'music' plus 'poetry'; it is

[1] *Transformations*, p. 29.

'words-sung', and its beauty is a new 'emergent'[1] beauty which is judgeable by its own intrinsic standards and not by the standards of music or of poetry as they exist independently. So there is, strictly, no 'sacrifice' of words to music, though song-words may, taken out of their context, appear less 'poetical'. It is, as a rule, when we have known and loved a poem *first*, and *then* hear it as the words of a song, that we regard it as a 'spoilt poem'. Until we forget it as a *poem* we cannot judge the aesthetic value of the words of a song.

Precisely the same things are true of the opera and the ballet. Opera requires many talents to appreciate it, and more to create it, but it does not, if it is good, consist of a number of arts compounded together. Each element is transformed by its relation to a complex aesthetic whole, 'opera'. It is recorded of a distinguished French musical critic[2] that before he was acquainted with the story of Tristan, he understood "nothing at all, nothing, absolutely nothing" of the music. Are we to conclude from this that the music as music is bad, or that the music is simply the illustration and illumination of a verbal story? Surely not. But we may very well say, once again, that opera is an art into which, for full enjoyment, must be fused two different orders of experience. Opera is the concrete fusion. So, likewise, the critics of Stravinsky's ballet music[3] misinterpret the function of ballet as a whole when they criticise his music *as* music, independently of its relation to the ballet.

To say these things is not, once again, to deny that different elements in the (badly named) 'compound' art may have different degrees of importance and prominence in different works. The elements must be judged in relation to the compound art as a whole, but, given this, one or another element may claim the lion's share of interest. In the

---

[1] Professor Lloyd Morgan would admit this term here, Professor Alexander not.
[2] Albert Lavignac—quoted in introduction to *Tristan and Isolde*, by Cleather and Crump. [3] *Transformations*, p. 33.

recitative, the words may be of major, and the music of minor and accompanying, importance. Or the words may be a mere fa-la-la, and the music-interest is the foreground. In ballet the fascination of complex expressive movement may hold us, the music but keeping the rhythm together. Or we may get a complex development, in which each seems equally stressed. Opera is by tradition an art in which music has assumed a large importance. Musical critics write about it, and if we were to take a census of their opinions one would find, I strongly suspect, that they usually either assume, or openly assert, that the drama- and poetry-aspects must always be subservient to the music. It may turn out to be so in fact, for there is no theoretical objection to its happening. But only the actual practice of these things is of importance. Categorical statements—or imperatives—are out of place.

# CHAPTER XIII

# SOME 'KINDS' OF BEAUTY

# I. Justification, and Explanation, of speaking of 'Kinds' of Beauty

In this chapter we shall discuss some of what are ordinarily called 'kinds' of 'artistic beauty'. In the next we shall discuss the 'kind' of beauty which is called natural. But before proceeding to treat of either, it is necessary to settle for ourselves the question whether there can truly be said to be 'kinds' at all. We have, as a matter of fact, in the preceding chapters and particularly in the last, been assuming that there are 'kinds' of beauty. It is, I think, a justifiable assumption. But it seems advisable to raise the general question here, in view of the contention of Croce that all attempts to differentiate kinds and classes of beauty are philosophically futile, however useful they may be for the curators of museums and the directors of art galleries.

Let me say at once that I have no intention of trying to make a catalogue or classification of types of beauty, and of trying to put each kind in its place. This, it is rightly said, is futile—except for the curators and directors of art galleries and museums. Our problem here is the problem whether there can be said to be 'kinds' at all, and if in any sense there are, what the factors are which determine different kinds. If there are kinds, their name will be legion: there will be beauties belonging to the separate arts of painting, sculpture, poetry, music, and so on. There will be the beauties of the particular forms of these arts, of, e.g., the fugue, the sonata, the symphony. In poetry we shall get the different beauties of the lyric, the epic, the sonnet, the triolet. Subject-matter, again, will have its say. There will be religious poetry, and love poetry, and nature poetry; there will be the sublime, the tragic, the comic. And there will be beauties varying with the general attitude of the artist, with his realism or his idealism, with his interest in form or emotion, with his classicism or his romanticism. So one might go on, first enumerating almost at will, then moulding such material

into general schemes to suit the fancy or the interest of the moment.

But the preliminary question is, Are there 'kinds' of beauty at all, such as the sublime, the humorous, the tragic, and so on? Or do these kinds fall outside beauty, giving us beauty *and* these other 'kinds'? Or is beauty something which, as it were, absorbs all these other 'kinds' into its own nature? Is beauty, in Mr. Carritt's words[1] (as he interprets Croce), "a universal which contains individuals, but no species"? The meaning of these questions will appear more clearly if we consider Croce's denial of 'kinds'.

Croce offers us two main reasons for his denial of 'kinds'. One is *per accidens*, and the other follows from the nature of his philosophy. The reason *per accidens* is, in effect, the actual failure in fact, of classifications of the arts. The other, the essential reason, is that of the individuality and indivisibility of intuition.

The first point[2] is not a very telling one. It may be difficult, and perhaps impossible, to make a neat and complete classification of all the arts. And, as has been said, it is not necessary for us to try. But this difficulty, or impossibility, is no indication that there are not real kinds[3] of beauty. (It is rather like saying that because there can be no completely 'objective' classification of books in a library, therefore there are no kinds of books.) And to ask whether there are differences, and what, if there are, may be some of the bases of the differences, is to ask perfectly intelligent and intelligible questions. Mr. Carritt, for example, allows his enthusiasm against classification to carry him too far when he says:[3] "To ask in face of a work of art whether it is a religious painting or a portrait, a problem play or a melodrama, post-cubist or pre-futurist, is as ingenuous a confession of aesthetic bankruptcy as to demand its title or its subject. The true motive of such a quest has always been the

[1] *The Theory of Beauty*, p. 256.
[2] See Croce, *Aesthetic*, chapter xii.          [3] Op. cit., p. 204.

discovery of rules and canons which shall save us the trouble of a candid impression; for without rules there are no kinds and without kinds no rules. The result has always been sterility and dullness." But the question can be rightly, as it can be wrongly, asked. At the very moment of aesthetic experience it is, quite truly, totally irrelevant both to ask whether a work of art is 'this' or 'that', and what is the difference between 'this' and 'that'. But it is not always, and on every occasion, out of place.

The positive philosophic basis of Croce's argument is more important, but we need not delay over it, as the ground has already been covered. The nerve of the argument is that neither content nor physical form[1] (or 'body') is an essential component of the aesthetic fact, of beauty; beauty is simply expression.

*If* this is true, then certainly there can be no kinds. Beauty will be the single indivisible spiritual activity of expression, and talk of 'parts' or 'kinds' or 'classes' will be beside the point. We have, however, been arguing throughout for a very different sort of view, for the reality and importance, in beauty, of both content and physical body properly interpreted. If one view is right, the other is wrong. It is a matter of choosing between one philosophy and another.

On the view which has been defended here, there can be 'kinds' and the 'kinds' will vary with content and body. We ought, however, to be clear about our terminology. Beauty for us, as for Croce, is expression, is perfection of expression, whatever the content and whatever the body. The lyric may be as 'beautiful' as the drama, the symphony as the cathedral. For beauty anywhere, perfection of expression only is demanded. In *this* sense, beauty is forever the same, and there can be no kinds. But this is an abstract sense, and beauty is in this sense regarded as an abstract universal. It is not, however, the abstract universal which

---

[1] *Aesthetic*, 15, 16, 98. The above statement is, of course, subject to the qualifications and reservations discussed in Chapter VII, p. 166 sq.

we apprehend in and by itself when we have an aesthetic experience. What we apprehend is not bare 'expressiveness', but the expression of a *content*-in-a-*body*. Beauty, the universal, is the same everywhere because it is itself nowhere. What we apprehend in actual aesthetic experiences are instances, in a spatio-temporal context. These are 'beauties' or 'beautiful things', or 'beautiful objects', and these are the data for aesthetics. Logically, when we speak of 'kinds of beauty' we are speaking only approximately, for there are no kinds of beauty, but one. But we need hardly apologise—except to logicians—for using language thus approximately. For no one—but the logician—is interested in abstract beauty. Our interest is in the things, the pictures, the poems, the symphonies.

And yet we are half logicians. We are aesthetic logicians. The business of the theory of aesthetics is to be continually in touch with individual beauties, and at the same time— or subsequently—to keep an eye on their general characters and similarities and classes. This we must do now. Keeping in mind, as always, that every instance of 'beauty' is an individual, we must ask (the way to it being clear) what it is which broadly distinguishes some 'kinds' of beautiful objects from others. The differences, as we said, will be dependent always on differences of content and body, with varying emphases. We shall mention in turn the sublime, the tragic, the comic, the humorous and the witty, and the classical and the romantic. Our treatment must obviously be brief and inadequate and will lay claim to little originality. But some reference to these important topics is necessary.

## II. A Note on the Sublime

The concept of sublimity I shall not attempt to analyse in detail. The literature of the subject is large, but not always profitable, for it often concerns itself with disputes about the use of a word. In view of Mr. Carritt's recent analysis in

*The Theory of Beauty* (Chapter IX) it would be wasteful to attempt to examine the history of this term. I shall therefore content myself with the briefest and most dogmatic statement of opinion as to what the word should mean, and principally as to what I shall mean by it.

Sublimity and greatness are closely akin. Sublimity, like greatness, is not primarily an aesthetic concept, but is rather a quality coming largely from the subject-side, which may or may not be embodied in an aesthetic object, and which may characterise objects which are not aesthetic. Thus a poem or a piece of music may be sublime, or not sublime, and sublimity may be a quality of an earthquake, or of ideas like time and infinity and mutability and power, which are not *necessarily* aesthetically embodied.

Sublimity and greatness are closely akin, but they are distinguishable as classes, the first being larger than the second. Greatness we have ascribed to those values (and of course to their related objects) which are the fulfilments of tendencies which are not only marked and strong, but are also profound and lofty and far-reaching in the complexity of their implications. Great values, we said in effect, are those which arise at a level at least as high as the highest emergent plane with which we are acquainted, the intricate life of man. The concept of sublimity, on the other hand, is wider than, and is inclusive of this. The truly great is in some degree sublime, but the sublime need not be great in the sense in which we have used the term. Clearly so, for natural objects—thunder-storms, sea-storms, cataracts, earthquakes, sunrises, the starry heavens—may be apprehended as sublime without any *necessary* imputation of human or superhuman qualities. What we explicitly call the 'brute strength' of the ocean or the lightning or the thunder or the immense machine, may both terrify and inspire us, and yet lack what may roughly be named any 'moral' quality.

Sublimity may then be described as a characteristic of any object, artificial or natural, which inspires us by its greatness,

or by its strength or power, or its size, or its expansiveness, or its suggestion of infinity of smallness or greatness, and the mystery and strangeness arising out of these. It may be added that 'inspiration'—our admiration, respect, uplift, feeling of expansiveness—may, but need not, be preceded or accompanied or followed by negative feelings such as those of terror or repulsion. These latter have sometimes been regarded as an essential element in sublime experience. But it would appear that they are not invariably present in genuine experiences of sublimity. Positive feelings, or 'inspiration', do, on the other hand, appear to be essential.

Once again, in matters of terminology, it is hard to command general agreement. The above summary account does seem to me to express what is most generally meant by sublimity and the experience of it. Some will certainly disagree.

## III. TRAGEDY—SOME 'AD HOC' PSYCHOLOGICAL THEORIES

Great tragedy is one manifestation of sublimity, but tragedy has its peculiar structure which demands attention, and which has always received it. As before, we can do a large subject but scant justice.

We shall be concerned in the main with tragedy as it is seen in drama. Drama, we have agreed, is a specially selected perspective which often gives us (roughly speaking) something approximating to real life, expressed in a 'body'. Tragic drama in particular is a revelation of the real, or it is nothing. Therefore, in dealing with dramatic tragedy, we shall be dealing by implication with the tragedy of 'real' life, with the difference that in dramatic tragedy we see tragedy isolated, and in its most perfect, and essential and least accidental form. 'Perfect' tragedy may occur in real life, and we as spectators may see it in its completeness. But if it does, we tend to call it 'dramatic'; and we tell how we could 'see' the unfolding of the spectacle 'as if on a stage'. The

stuff of tragedy is the stuff of real life, but we shall not do real life much injustice if we confine ourselves mainly to the tragedies seen on stages.

Tragedy is a spectacle which calls out vivid, striking, and complex responses. It is consequently not unnatural, particularly in an age of psychology, that attempts should often be made to understand the nature of the tragic object in terms of the impulses which the contemplation of it satisfies and pleases. And it will not be surprising to find the enjoyment of tragedy reduced to terms of this particular impulse or that. It will perhaps help us to work our way to a positive conclusion if we consider some floating ideas about the nature of tragedy.

It is alleged, for example, that the origin of our love of tragedy is to be found in our *sadistic* tendencies, in a certain rejoicing that we have in the sufferings of others. Tragedy, it is said, is a legitimate outlet for, a canalisation of, a tendency in itself unpleasant to regard. Or, again, it is asserted with equal (if any) cogency that our joy in tragedy is *masochistic*, that in seeing the depicted sufferings of others what we enjoy is the laceration of our own feelings. Yet again, it is said that our pleasure lies neither in the one nor in the other exclusively, but in the fact that we can enjoy the thrills of other people's suffering and of our own, and yet know that we are safe in so doing. 'It's only a play.' There is a little sadism or a little masochism (or both), but the pleasure lies largely, though again not of course exclusively, in the *safety* of the process. We can be a little cruel if we will, and it is not a crime, or we can indulge in a little self-laceration, but it does not hurt *so* badly; it has enough of the flavour of reality to season it, but not too much. Perhaps, again, the pleasure of the knowledge that stage suffering is not 'real' is flavoured by a little altruism, which it is enjoyable to experience, and perhaps our own 'safe' suffering flatters our egoism a little.

But however true the facts of safe detachment may be,

they will not, taken at their plain face-value, at all explain dramatic tragedy. Dramatic characters must be, as we say, 'real'. The essential enjoyment of tragedy cannot come from its *un*reality. One important aesthetic condition of the enjoyment of dramatic tragedy is indeed, as we well know, that we are spectators of it, that we look on, and do not take part in the action, as we might feel compelled to in real life. But that is merely an essential condition for the appreciation of it as a whole. *What* we appreciate is none the less 'real'. It is a play, but it is not *only* a play. Arguments based on unreality will not work.

Neither will the technical terms of the 'new' psychology serve as an explanation of tragedy. It is not disputed that in many phases of human life the pleasures of which we have spoken are frequently enjoyed. Most of us read 'shockers' and tales of adventure. We enjoy vicarious experience and danger; we enjoy being shocked. We need not be *very* unhealthy to enjoy reading about tortures, so long as the thing is not too near to real life. The agonies of Bulldog Drummond are 'enjoyed', and not only by 'low-brows'. Most thrills are up to a point pleasant. Again, although in this case perhaps the 'low-brows' are more in question, there is a certain enjoyment in real disasters; the attitude of attraction-repulsion, sympathy-antipathy, to the street accident, is familiar. And although the more developed mind definitely does arrive at a stage when such happenings are no longer in any way attractively interesting, the stage at which accounts of accidents and divorce court proceedings appear either saddening or as a bore, it may well be that substitutes arise and that scandals of a less unsophisticated kind have their charm.

But if we ask, What is the bearing of these things upon dramatic tragedy? and if we demand a definite positive or negative answer, the answer must be that these things have no bearing on dramatic tragedy. Yet the answer cannot really be made quite so simply. It is as human beings that

we come to the appreciation of tragedy; pity, terror, and the feelings of human relief that this is a spectacle only, may form a kind of basis for our attitude. But it is a basis rather in the sense of a superseded stage, a stage through which we have passed, than something which enters into and is incorporated untransformed into the aesthetic experience. Tragedy demands capacities for a different *kind* of interest, and the stage of any sort of mere sensationalism must be transcended before there is the faintest possibility of our beginning to understand real tragedy. The comment of an old servant after seeing *Lear*, "It was all about a lot of people putting an old man's eyes out", is an illustration in point. The ordinary emotions which we have mentioned are irrelevant to dramatic tragedy, not in the sense that a *kind* of enjoyment in the spectacle of the sufferings of others, a *kind* of enjoyment of our own painful feelings, a *kind* of relief that we are only spectators of a spectacle, are not involved, but in that the emotions we experience in the contemplation of dramatic tragedy are wholly transformed by their relation to their context. In aesthetic relation to their context they form what some might call an 'emergent' whole, possessing qualities in the whole which are different from their qualities outside it, and which are unpredictable from the lower level. If this is the case it rather makes nonsense of the attempt to *reduce* the appreciation of tragedy to terms of this or that element.

## IV. The Two Types of Dramatic Tragedy

In dramatic tragedy the interest is never merely in suffering, misfortune, disaster, though tragedy must include some form of these. Street accidents and murders are not in themselves tragedies, as newspapers would have us to suppose. The mainspring of our interest in tragedy would appear to be not in mere evil, but in some good which must arise in its very essence through evil. This interest in good-through-evil

may occur in two main ways, to which correspond two main types of tragedy. In the first, the interest tends to be centred on man and on his response to evil circumstances. In the second, Circumstance or Fate itself draws the attention and interest. We may consider these briefly in turn.

In the first type of tragedy evil is endured by the sort of character which can at least be called 'strong', and which may be 'great'. The quality of this tragedy is that it seems to reveal the fundamental stamina of humanity, its nobility, the "piece of work" man can be.

In this tragedy, Fate, or character itself in the guise of Fate, may hurt, may crush, may lacerate, but it never quite defeats. No disaster can quench it. Such tragedy is the nearest example we have of irresistible force meeting insurmountable resistance. And its vitality as tragedy arises from recognition by the dramatist of the equal importance of both sides.

Such tragedy consists not in simple events, then, but in a tension of events having a structure. Structure is essential in all full-grown aesthetic forms, but its necessity is almost more patent in this kind of tragedy than anywhere else. Suffering taken out of its context in the whole simply ceases to possess its quality. It may still have the intensest emotional interest, but this is quite distinct from the peculiar appeal of dramatic tragedy. A good instance of this is given by Mr. Fry in his *Transformations*.[1] He describes how he was present at a film which recorded the work of rescue from a ship (a real ship) wrecked off the coast of Portugal. "One saw at a considerable distance the hull of the vessel stranded on a flat shore and in between crest after crest of huge waves. In the foreground men were working desperately pulling at a rope which ever so slowly drew away from the distant ship a small black object which swayed and swung from the guide-rope. Again and again the waves washed over it in its slow progress shorewards. It was not till it was near shore that one realised that this was a basket with a human being in it. When it was

[1] Pp. 9-10.

finally landed the men rushed to it and took out—a man or a corpse, according to the luck of the passage or the resistance of the individual. The fact that one was watching a film cut off all those activities which, in the real situation, might have been a vent and mitigation of one's emotions. One was a pure, helplessly detached spectator, and yet a spectator of a real event with the real, not merely the simulated, issue of life and death.

"For this reason no situation on the stage could be half so poignant, could grip the emotions of pity and terror half so tensely. If to do this were the end and purpose of drama, according to Aristotle's purgation theory, and not a means to some other and different end, then the cinema had surpassed the greatest tragedians. But, in point of fact, the experience, though it was far more acute and poignant, was recognisably distinct and was judged at once as of far less value and significance than the experience of a great tragic drama. And it became evident to me that the essential of great tragedy was not the emotional intensity of the events portrayed, but the vivid sense of the inevitability of their unfolding, the significance of the curve of crescendo and diminuendo which their sequence describes, together with all the myriad subsidiary evocations which, at each point, poetic language can bring in to give fullness and density to the whole organic unity."

This tragedy consists of a peculiar structure in which, through conflict, there is brought out some tremendous and permanent value, which is a defiance to the attacks of time, place, and circumstance. It is an equilibrium. But although this is true, it is of the greatest importance not to mistake the character of the equilibrium. It is very easy to overstress one side or the other, to think too exclusively of the disaster on the one hand, or of the triumph over disaster on the other. The first, of which we have spoken, fails to reach the level of true tragedy at all. The second sentimentalises it. A very reasonable balance between the two extremes is

achieved by Mr. Lascelles Abercrombie in his *The Idea of Great Poetry*.

There are two kinds of poetry, Mr. Abercrombie urges:[1] There is on the one hand what we may call the poetry of refuge, and on the other hand the poetry of interpretation. The poetry of refuge is exemplified in Boccaccio's *Decameron*. Here many painful elements enter, but we escape "from the infected, disordered city, into ten days of delight in quiet gardens—feasting, singing, lute-playing, dancing, strolling and, above all, story-telling: and the world of bitter reality is effectually shut out and forgotten".[2] Another instance of the poetry of refuge is the *Faerie Queen*. The poetry of interpretation is exemplified in *Prometheus Unbound*. "When, by whatever means, some sense of the whole possibility of life—its good and its evil, its joys and its misfortunes—is presented under the condition of poetry, it becomes thereby an interpretation of life."[3] This poetry of interpretation it is which is the truly great poetry.

Tragedy, I suppose Mr. Abercrombie would say, is of the type of the poetry of interpretation. "This is the real problem of tragedy: how do we come to enjoy what seems a version of the mere evil of life? Nay, how is it that tragic art gives us the loftiest, though the severest, delight we can have in poetry? It cannot simply be, because evil has become in it orderly and systematic. There might be a kind of maniacal aesthetic enjoyment in a vision of the world as an affair wholly organised for evil; but that would be nothing like the enduring satisfaction which is the ground of tragic enjoyment. Indeed, there is no surer sign of a healthy mind than the enjoyment of tragedy. There must, then, be good as well as evil in it; and out of the final harmony of the two, here, as elsewhere, will come the sense of the significance of evil overriding its injury—the sense that evil is no longer the intrusion of irresponsible and useless malignity, but the servant of universal law: which is the essence of the tragic

[1] *The Idea of Great Poetry*, p. 75 sq.     [2] Ibid., p. 77.     [3] Ibid., p. 96.

satisfaction. Our aesthetic enjoyment of the spectacle of evil (which is certainly present in tragedy) is always accompanied by implicit assurance that we are not merely assisting at its triumph. But when we ask whence tragic poetry is to provide itself with good to match its evil, the answer can only be, that the good must arise out of the evil. This is what the peculiarity of tragedy comes to: out of things evil it must elicit good."[1]

And to the question, 'From whence is the good elicited in this kind of tragedy?' the answer is, 'In character'. This is the type of Shakespearean tragedy. In much Shakespearean tragedy (though of course not in all dramatic tragedy) character both faces the evil and sets going the events which conspire to it. We may select, with Mr. Abercrombie, the very striking case of Macbeth. Here there is evil, the most devilish evil, prophesied and destined almost from the first line:

> "Fair is foul and foul is fair
> Hover through the fog and filthy air."

Macbeth acts, gets his paltry wishes, sustains his ambition by his crimes, and is damned by the torture of his own sensitive imagination. That is one side, apparently unmitigated evil. But it is only one side, only half the tale. The other side is symbolised in his last address to Macduff:

> "I'll not yield
> . . . . . . . .  before my body
> I throw my warlike shield. Lay on, Macduff:
> And damn'd be him that first cries, 'Hold, enough!' "

It is symbolised, because Macduff, "being of no woman born", is his Fate, a Challenge which is met. Here is Macbeth's gesture, his moral stance, as it were, in face of the infinitely greater evil of his soul's disaster. As Mr. Abercrombie finely puts it, "When Lady Macbeth dies, and he realises that he is alone in the dreadful world he has created for himself,

[1] *The Idea of Great Poetry*, pp. 169–170.

the unspeakable abyss suddenly opens beneath him. He has staked everything and lost; he has damned himself for nothing; his world suddenly turns into a blank of imbecile futility. And he seizes on the appalling moment and masters even this: he masters it by *knowing* it absolutely and completely, and by forcing even this quintessence of all possible evil to live before him with the zest and terrible splendour of his own unquenchable mind:

> "To-morrow, and to-morrow, and to-morrow,
> Creeps on this petty pace from day to day
> To the last syllable of recorded time,
> And all our yesterdays have lighted fools
> The way to dusty death. Out, out, brief candle!
> Life's but a walking shadow, a poor player
> That struts and frets his hour upon the stage
> And then is heard no more: it is a tale
> Told by an idiot, full of sound and fury,
> Signifying nothing."

There is no depth below that; that is the bottom. Tragedy can lay hold of no evil worse than the conviction that life is an affair of absolute inconsequence. There is no meaning anywhere: that is the final disaster; death is nothing after that. And precisely by laying hold of this and relishing its fearfulness to the utmost, Macbeth's personality towers into its loftiest grandeur. Misfortune and personality have been until this a continual discord: but now each has reached its perfection, and they unite. And the whole tragic action which is thus incarnate in the life of Macbeth—what is it but the very polar opposite to the thing he proclaims? For we see not only what he feels, but the personality that feels it; and in the very act of proclaiming that life is "a tale told by an idiot, *signifying nothing*, personal life announces its virtue, and superbly *signifies itself*".[1]

Here is an interpretation of one kind of tragedy which, up to a point, we may accept. But, once again, it is necessary to

[1] *The Idea of Great Poetry*, pp. 176–178.

guard against misunderstanding. There is evil, and there is good, and it is said that good comes out of evil. But this is misleading, for only in a relatively superficial sense is there 'before' and 'after' in tragedy. Things do not come right in the end, evil is still evil, staring us starkly in the face. Otherwise tragedy disappears. Nor is the good *in* the evil, for again, evil is evil. What is in fact true is that the tragedy we are considering, though it takes place in time, is, in another sense, a timeless structure, or, if the phrase be preferred, a time-transcending structure, which is complex, which contains opposing elements that must be apprehended in the grasp of a single vision. Evil is evil, and the value of character is the value of character: in the drama they exist side by side as distinguishable elements in a whole. But not as separate entities. For this particular good in this particular tragedy could never come *out* but for this particular evil. In dramatic tragedy such as *Macbeth* great human quality is revealed through the crushing efficacy of sheer force. Of course the capacities must be in the characters first and of course there must be sheer evil, whether of character itself or in independent circumstance. But such tragedy is the union of the two and our appreciation must contain the apprehension of both in their special relationship. So, if we speak of tragedy as a 'harmony' of good and evil, we must realise that its beauty is not 'easy' beauty, but that it is 'difficult'. It is better, I think, to say that our enjoyment is the enjoyment of a tension, of the meeting of two great forces of the universe. For the same general reasons, if we say with Mr. Abercrombie that Macbeth in a sense "relishes" the final evil which he sees, and that the splendour of his character is shown just in this, we must realise that it is sheer blank evil *to* Macbeth as he faces it first, that there is no goodness in it, that he has to *create* his own fine response to it, and that we, as spectators, apprehending both sides, not only see, but probably get a far greater enjoyment out of this fearful game than Macbeth who sees mainly one side, the evil. I do not

suggest that the tragic character savours *nothing* of its own nobility, but if that savouring goes beyond a certain very definite point (known only to aesthetic and moral imagination) it becomes windy, sententious, sentimental. It is, as we have said, blank unmitigated evil which Macbeth himself sees first, but as he speaks there must be imagined to be present in him a limited and restricted enjoyment of his own response. Yet the tragic figure can hardly apprehend the full significance of tragedy as we can who as spectators discerningly contemplate it in its context in the whole.

But all this represents only one type of tragedy. The positive value in tragedy may also arise, objectively, out of the very objective evil itself, rather than out of the victim's response to it (though there may be nobility in this as well). And such positive value may, though it need not, be savoured by the very victim of the evil himself. Mr. Abercrombie is right, I think, as far as he goes (with the qualifications I have mentioned). But the element of good in tragedy need not appear to be situated in the character of the victim of evil at all: it may seem to characterise the events, fulfilling the qualification that it is the kind of good which could not have appeared but for the very evil. In real life, perhaps this is the most common type of true tragedy, though Macbeth represents another type. One species of it is seen in the bereavement (as for example the loss of a child) which—after the first awful pangs have passed—brings out a beauty in the beloved thing that is lost, which could never have existed but for the losing. This is a special case of valuing things most when we have them not, or when their possession is threatened, but it must be imagined in its best and most real and most genuine examples. We shall do no justice to this idea if we confuse it with the rather shallow sentimental self-comfort which it may too easily become. Sweetness may enter in, but comfort is not of its essence. And the sweetness is not sweet, but bitter-sweet. It is poignancy, it is almost mystical fixation upon an unattainable and

unearthly beauty which had no existence till the distancing gulf had been fixed. Or if the beauty is *here*, as it is in the play translated as *The Unknown Warrior*, it is made strangely precious by the underlying fear of its disruption.

I will cite but one example of this tragedy of loss, taken from Edith Wharton's novel, *The Children*, a drama which is intensely 'real'. In this book we have the story of a man in late middle life who has fallen in love with a girl whom, with her brothers and sisters, he has been fathering—or 'guardianing'—in a friendly sort of way. His friendship has grown to a hungering love. She has no idea of it and treats him affectionately as a companion.

" 'If things went wrong, and you were very lonely and a fellow asked you to marry him——' 'Who asked me?' He (Boyne) laughed again. 'If I did.' For a moment she (Judith) looked at him perplexedly; then her eyes cleared, and for the first time she joined in his laugh. Hers seemed to bubble up, fresh and limpid from the very depths of her little girlhood. 'Well, that would be funny', she said.

There was a bottomless silence. 'Yes—wouldn't it?' Boyne grinned. He stared at her without speaking; then, like a blind man feeling his way he picked up his hat and mackintosh, said: 'Where's my umbrella? Oh, outside——' and walked out stiffly into the passage."

There follows the story of defeat, lonelinesss, hurt, growing old. Once he is asleep in a chair on board ship, and dreams of her. The steward comes, and wakens him with, " 'Tea, ham sandwiches, Sir.' " Life's futility is scarcely plainer in Macbeth itself. And later still, long after, there is the return from futility. He sees her through the window of a hotel, dancing. She is beautiful, and his, and yet he is a million years away. Such beauty could not be for him, but for his defeat by time. And yet he sees the beauty plainly. It is *there*, and the complete tale is not *simply* the tale of sorrow.

The tragedy here is real enough. But the most 'objective' type of tragedy is perhaps that in which cosmic circumstance

itself, overwhelming human desires, interplaying often with human frailty, is the very source of a difficult good. This is to be found in Greek, rather than in Shakespearean, tragedy, where Fate, as a power or powers over human lives, is the tremendous force determining finite affairs to its inevitable ends. In Greek Tragedy the positive element, the sublimity of feeling which appears even through the feelings of pity and terror, is reinforced by religious sentiment. Fate is not *mere* chance, it is not *merely* blind, and if Fate on the other hand were conceived as merely malign or petty, such tragedy would lose most of its significance. Fate is conceived not simply as terrible, but as awful and majestic. It appears to the spectator to possess positive value. In spite of the havoc it works, it draws out admiration and even worship, though worship from afar, and not the loving worship of a familiar friend. This quality, which, as has just been said, may be called in the widest sense religious, appears in the works themselves, and some religious sentiment determines the proper appreciation of their tragedy.

It is not suggested that we need possess an explicit religion, or a religious philosophy, in order to enjoy such tragedy. And, in particular, Fate must not be conceived as benignity in disguise. The admiration is directed to the inevitability of the workings of cosmic process, and is in the end a free and unreserved acceptance (though in a sense a compelled one) of the cosmos as it is. This attitude is (in *one* aspect) a 'scientific' one, and it is of this which Mr. Whitehead is thinking when he writes: "The pilgrim fathers of the scientific imagination as it exists to-day, are the great tragedians of ancient Athens, Aeschylus, Sophocles, Euripides. Their vision of fate, remorseless and indifferent, urging a tragic incident to its inevitable issue, is the vision possessed by science. Fate in Greek Tragedy becomes the order of nature in modern thought. The absorbing interest in the particular heroic incidents, as an example and a verification of the workings of fate, reappears in our epoch as concentration of

interest on the crucial experiments. It was my good fortune to be present at the meeting of the Royal Society in London when the Astronomer Royal for England announced that the photographic plates of the famous eclipse, as measured by his colleagues in Greenwich Observatory, had verified the prediction of Einstein that rays of light are bent as they pass in the neighbourhood of the sun. The whole atmosphere of tense interest was exactly that of the Greek drama; we were the chorus commenting on the decree of destiny as disclosed in the development of a supreme incident.

". . . Let me here remind you that the essence of dramatic tragedy is not unhappiness. It resides in the solemnity of the remorseless working of things. This inevitableness of destiny can only be illustrated in terms of human life by incidents which in fact involve unhappiness. For it is only by them that the futility of escape can be made evident in the drama. This remorseless inevitableness is what pervades scientific thought. The laws of physics are the decrees of fate."[1]

On the other hand, though such Fate possesses the negative qualities of remorselessness and indifference, this is not the whole story. Nor is the reference to science, with its dispassionate viewpoint, more than an analogy. There is a solemnity, there is a grandeur, there is a sublimity in the unfolding of things, with which science, as such, has no concern. Mr. Whitehead writes here not as scientist, but as aesthetic critic and as philosopher. Science is but a part of life, and the scientific attitude is not in itself sufficient to account for appreciation even of this sternest sort of tragedy. The thing must move us—and move us as having positive value. And, as has been suggested, mere blind chance or law, or, on the other hand, mere malignity, could hardly do this—at least to any human being with blood in his veins. It is therefore difficult to see (though this may be due to prejudice) how any purely naturalistic philosophy based on science could be compatible with or adequate to the

[1] *Science and the Modern World*, p. 13.

acceptance of real tragedy of this kind. If the cosmos is merely blind, merely impersonal, merely natural, then how can it be 'grand', how can it be expressive of these values of which intuition, in its dark ways, tells us that they are great enough even to balance human agony? How could we admire such a cosmos, except as the victims of some illusion, perhaps an aesthetic illusion? An idealist might logically accept *both* the transcendence of human interests by the cosmos, *and* its great and positive good. But how, without sentimentality, could a naturalistic philosopher account for the latter? And how, without it, could this tragedy be other than mere futility? It might be terrible and fearful, but how could it in *any* sense be positively worth while? If the naturalist is right, would it not follow that the only kind of tragedy which could exist would be that of which we spoke earlier, in which the great positive values arise through the struggles, or the acquiescence, of noble human character? (Or, if the world were regarded as an affair mainly organised for evil—a view to which naturalists, in their human disappointment, are on occasion inconsistently led—the only alternative would be struggle against this evil order. Acquiescence, acceptance, enjoyment, would be impossible —or mad. It would be what Mr. Abercrombie calls 'maniacal'.) The naturalist, it would seem, must forget for the time being his naturalism when he enjoys the type of tragedy of which we have been recently speaking. He must admire, he must see good in, he must appreciate as sublime, that inevitable Nature of Things which for him is in strictness neither sublime nor good nor bad, except in some sub-human sense. Leaving theories behind him he may so appreciate it. For the non-naturalist, on the other hand, it is at least an open question whether cosmic values outside human life are or are not higher or lower than human values. He is free to follow his intuitions. He may, if he has the capacity, achieve the supreme faith of religion, "Though He slay me, yet will I trust Him."

In great tragic experience there resides always a paradox. It is to be found in both of the types which we have discussed, for both of them seem to focus, in different ways, a larger meaning which is part of a larger mystery of the Universe. Mr. Bradley, although in the greatest of his essays he deals with one type only—that exemplified in Shakespearean Tragedy—makes very clear that human tragedy is the symbol of a wider cosmic situation. "We seem to have before us a type of the mystery of the whole world, the tragic fact which extends far beyond the limits of tragedy."[1] Sometimes, true, it is the fibre of *human* quality which seems to us all-important. "Sometimes from the very furnace of affliction a conviction seems to come to us that somehow, if we could see it, this agony counts as nothing against the heroism and love which appear in it and thrill our hearts. Sometimes we are driven to cry out that these mighty or heavenly spirits who perish are too great for the little space in which they move, and that they vanish not into nothingness but into freedom. Sometimes from these sources and from others comes a presentiment, formless but haunting and even profound, that all the fury of conflict, with its waste and woe, is less than half the truth, even an illusion, 'such stuff as dreams are made on!' "[2] But even such convictions do not suffice to solve the mystery. ". . . These faint and scattered intimations that the tragic world, being but a fragment of a whole beyond our vision, must needs be a contradiction and no ultimate truth, avail nothing to interpret the mystery. We remain confronted with the inexplicable fact, or the no less inexplicable appearance, of a world travailling for perfection, but bringing to birth, together with glorious good, an evil which it is able to overcome only by self-torture and self-waste. And this fact or appearance is tragedy."[3]

[1] *Shakespearean Tragedy*, p. 23.
[2] Ibid., p. 38–39.     [3] Ibid.

## V. Tragedy and Catharsis

What is the relation of our interpretation of dramatic tragedy to the theory of catharsis or purgation? It is regarded as barely decent to write about tragedy without devoting a certain space to Aristotle, or to developments of his theory of tragedy. In the present case let the space be a small one.

If Aristotle, influenced by his familiarity with the effects of certain kinds of music and dancing upon the emotions, really meant that the *main* function of tragedy was to achieve purgation, analogous to medical purgation, of socially dangerous pity and fear by harmless excitation of them in the theatre, then there is very little to be said in favour of the theory. This is not, as has often been said, why we go to see tragedy: if it were true, it would not sufficiently account for our enjoyment, and it is certainly very doubtful whether mere exercise of the emotions, as such, ever purges us of them. Exercise of the emotions may encourage more exercise; and, further, that is not of course in itself necessarily a bad thing. It is true that some modern psycho-therapists (e.g. William Brown) do advocate the expression of repressed emotions as a means of getting rid of repressions. But it seems to me that on this matter McDougall is right, and that mental equilibrium is restored not by mere 'abreaction' or purgation, but by reassociation of the repressed impulse or impulses with the rest of conscious life. It is of course quite possible to apply this psychological theory to tragedy and to say that in the drama repressed interests do not merely find an outlet in expression but become linked with the rest of conscious life.

This is, I take it, the kind of view taken by Mr. I. A. Richards in his *Principles of Literary Criticism*. "In the full tragic experience", he says,[1] "there is no suppression. The mind does not shy away from anything, it does not protect

[1] Op. cit., p. 246.

itself with any illusion, it stands uncomforted, unintimidated, alone and self-reliant." The test of its success is whether we can respond to it without subterfuges. "Suppressions and sublimations alike are devices by which we endeavour to avoid issues which might bewilder us. The essence of Tragedy is that it forces us to live for a moment without them. When we succeed we find, as usual, that there is no difficulty; the difficulty came from the suppressions and sublimations." True. Tragedy is an extraordinarily *stable* experience, it is "perhaps the most general, all-accepting, all-ordering experience known. It can take anything into its organisation, modifying it so that it finds a place. It is invulnerable. . . ."

All this—if we dissociate it from the behaviouristic type of psychology which Mr. Richards thinks it necessary to drag in[1]—appears to be unquestionably true so far as it goes. If this is to be called 'catharsis' at all it is not of course the original rather negative catharsis with which we began, a mere getting rid of something, but is distinctly a development of it. It is a development of it not merely in the sense that it substitutes reassociation for mere abreaction or purgation, but in that it specifically recognises the ordered or formal or structural character of tragedy. There is also implied, I think, a recognition of the factor of 'psychical distance,' though this has to be searched for in the context of Mr. Richard's writings.

To return to Aristotle. We began by saying that if Aristotle meant mere purgation, there was not much to be said for his theory. But there is no reason for thinking that he did mean merely this. There is no doubt that he was perfectly aware of the *aesthetic* character of tragic appreciation, of its difference from the practical attitude, of the 'distance' of the object and of its organised form.

Take 'distance' first. Aristotle is clearly aware of the importance of 'psychical distance', though he does not use

[1] As when he says: "The joy which is so strangely the heart of the experience is . . . an indication that all is right here and now in the nervous system." The nervous system, perhaps. But how much more?

the term. The tragic character must lie, as we saw in another context, between two extremes; it must be "that of a person neither eminently virtuous or just, nor yet involved in misfortune by deliberate vice or villainy, but by some error of human frailty."[1] His 'distance' from us must not be too great, which would prevent us from feeling with him, but it must not be too small, and for this reason the tragic character should be one of "high fame and flourishing prosperity".

Aristotle again, we have seen, is of course perfectly aware that the happenings in tragedy are not indiscriminate slices from real life, but that tragedy shows us an ideal possessing form and structure which real life does not ordinarily show. Art imitates not the particular and the accidental, but the universal, and Aristotle is continually telling us of the unity and inevitability of the dramatic plot. This is the objective side of his theory which must be put side by side with his psychologism if we are to have the whole picture. If we keep this objective side of his theory in mind, we may be quite certain Aristotle himself did not regard tragedy as a mere getting rid of anything, though this admittedly enters into his ideas. Tragedy was for him also a *positive* purification (as opposed to the 'aperient' sense of purgation) in that it is an elevating and ennobling experience which lifts us out of the world of practice on to another plane of reality. In saying these things we may sustain ourselves by the knowledge that we have the support of the great authority of Butcher. "If", says Butcher,[2] "it is objected that the notion of universalising the emotions and ridding them of an intrusive element that belongs to the sphere of the accidental and individual, is a modern conception, which we have no warrant for attributing to Aristotle, we may reply that if this is not what Aristotle meant, it is at least the natural outcome of his doctrine."

[1] *Poetics*, chap. xiii.
[2] *Aristotle's Theory of Poetry and Fine Art*, pp. 268 and 269.

## VI. The Comic, the Humorous, and the Witty

The ridiculous[1] is usually contrasted with the sublime and the tragic. There are philosophers who, disbelieving in 'kinds' of beauty, would unite the sublime with the ridiculous and would call the synthesis beauty. We, however, are not committed to any such view, and we may consider the concept of the ridiculous in and for itself. It may be that in this life of change the experience of sublimity is often unstable and that, toppling over, we and things become ridiculous. But, though alternations may occur in real life and in drama, and though we, being human, often need relief from high tensions, the moments of the alternations are distinct and each has its own nature. Thus even though it may be found that the ridiculous *implies* the serious, the ridiculous and the serious are still distinct.

The sublime, we said, may possibly exist in forms which are not specifically aesthetic. Sublimity may qualify human character; the mystical experience may possess the uplift and expansiveness which qualifies the sublime experience, without the objects possessing the clear and definite form which is aesthetically expressive. With the tragic, as we saw, this is less easy: the perfect tragic situation has definite structure and is anything but vague. In this respect the comic would seem to resemble the tragic; the comic situation is, in its perfection, clear and un-vague and embodied; it has, when it most pleases us, a neatness and a finish which is so finely organised that the least thing will destroy its stability.

What, then, are the main characteristics of the comic?

The experience of the comic would seem to contain two fundamental elements: (1) a sudden psycho-physical shock, followed by a sudden relief or relaxation by means of the shock from a tension which existed before the shock. (2) This

[1] Or the funny. I am using the terms here in a broad, inclusive, and perhaps inaccurate sense, as including (at least) the comic and the humorous.

is accompanied or followed by actively conscious, perhaps more analytical, appreciation, not only of the shock and the relief, but also of the *situation* which gives rise to these. The shock stirs, and relieves, and both are pleasant, but through cognition we become aware of the significance of the whole situation. We relish the thing discerningly, we turn it over in our minds, as we may relish good food or good drink.

The comic *situation* which we relish seems to involve the juxtaposition of opposites by a sudden transition from one to another. We may for convenience call the opposites the 'first term' and the 'second term' respectively. The first term would appear to be an entity possessing some serious, solemn, dignified, or massive quality, and the comedy occurs when such qualities are suddenly undone, from one cause or another, producing the effects described. To take the crudest type of comedy—on which Bergson in his essay on *Laughter* lays so much stress—there is comedy on the stage when the solemn and dignified fat man suddenly slips and falls. Here is a human being, as Bergson might say, suddenly transformed into a puppet or an automaton.

Our delight in the comic arises from combination of the elements analysed.

It arises partly from the pleasant stimulation which the shock of incongruity gives us, and from the relaxation which follows the shock. Our minds and our bodies are stirred. This in itself is pleasant if it is not too violent. But our pleasure is not pleasure in the comic, unless it is appreciation also of the transition from the solemn, the dignified, the massive, to its opposite, the ordinary, the dear commonplace. Subjectively, a shock and a relief; objectively, appreciation of a transition from first to second terms—these factors are present together. But most important is the objective transition, to the commonplace and the ordinary, to some touch of nature which makes the whole world kin, which shows that this massive and solemn thing can bounce

giddily like an india-rubber ball, that this high personage is but clay like the rest of mankind.

It is essential that in face of the comic situation we should not be too sympathetic with the first term so that we are unable to relish the second, and the transition to the second. If our sympathies are too much with the first term, with, for example, the serious as against any relaxation from it, we shall fail to appreciate the joke, which may then appear as foolish, or as disgusting, or as in bad taste, or as scandalous, or as pathetic, or even as tragic. Stories of lunatics who believe themselves to be poached eggs looking for their pieces of toast seem comic only if our sympathy for the lunatic as a human being is not at the moment very prominent; if it is very prominent we may think of laughter at the joke as in bad taste, and the situation may appear merely pathetic to us. So the antics of drunken men may appear on different occasions as funny or foolish or pathetic or scandalous. It depends upon where our sympathies lie. So to joke about holy things when the cultivation of reverence is regarded as important, becomes profane and sacrilegious, and not funny. And there are probably things which are so serious that they can never be successfully joked about—for example, suffering or cruelty.

Our appreciation consists, as we have said, in more than an immediate delight in a releasing or relaxing shock. It consists also in a more leisurely and contemplative relishing. We relish the values of the relation and unity and friendliness even of apparent incompatibles. Our sympathies must be properly located, but what we relish is not merely our own states, but the revelation, through the synthesis of opposites, of the values of relations which we do not ordinarily see. Solemnity is a strain, and the commonplace is hum-drum: but comedy weds this queerly assorted couple by its magic. And it is not black, but very white magic. We feel that a world which contains both solemnity and relaxation is a good world, a far better world than one which should

contain only solemnity. 'Laugh and grow fat', the saying is, and we have a deep instinct that a real sense of the comic is a sign of health and sanity and the antidote to priggishness and sententiousness. The man who fancies himself a god becomes intolerable; the tolerable thing is human nature, and human nature has legs that trip and fall. And human nature—in many moods—has the gift even of enjoying this without cruelty and with innocent relish.

There are, of course, types of the comic, but it would take far too much space to go on to enumerate them. We may content ourselves by saying very generally that the types will tend to vary with the relative proportion of factors (1) and (2) (p. 360). In cruder sorts of the comic, the emphasis on (1) is signified on the physical side as a need, in order to get relief, for a larger proportion of loud and explosive laughter. The ponderous fat man bumps down, and there is a delighted roar from the audience. It is largely organic. 'Laugh and grow (physically) fat.' In the subtler sorts of comedy (2) is more prominent. There is drier and more intellectual relish of the complex situation and of its wider significance. This may be signified in a quieter sort of laughter or even in the slow, peaceful smile.

Humour overlaps the comic: the humorous is the comic, with a difference. The difference seems to lie in the presence of a certain degree of kindly feeling of human sympathy. In the comic our attitude is more impersonal; the comic situation is much more a spectacle. Humour, on the other hand, seems to contain an element of kindly humanity; our smiles are softer and more friendly. As we said before, our sympathies with the first term must not be too great, or the comic element will not appear. But some sympathy definitely is present, and this keeps our attitude from being unconsciously cruel, as it may be when we see a thing as merely comic.

Because sympathy is a part of humour, the participants in a humorous situation must be things with which it is possible

to feel sympathy, namely, human beings and animals (or analogues of these). The sight of a very heavy ball rolling ponderously and slowly towards the edge of a plane, and then bouncing off suddenly, might be comic, but could scarcely be humorous. It might be said, in such a case, that even its comic character was dependent on thinking of the ball as, in imagination, a person or an animal. This may be so, though it is very doubtful. But even if it is so, we should hardly feel the kindly sympathy which we should feel were it a real person or animal: it would be, i.e., comic rather than humorous.

The same thing might be expressed in terms of 'psychical distance'. In comedy the distance is greater, in humour it is less. When we apprehend things as comic we are certainly not consciously cruel, as we may be in satire, but the object is at a considerable distance from us. The difficulty of seeing *ourselves* as purely comic is partly the difficulty of distancing ourselves, of regarding ourselves impersonally as objects. It is considerably easier to be humorous about ourselves, to see ourselves (though this is a gift) in a humorous light; our natural kindly disposition towards ourselves does not conflict with it. Yet both comedy and humour do involve, of course, in different degrees, a considerable distancing.

It has been said that in enjoying comedy we show our sanity, and that in comedy there is revealed the happy relation between things which are ordinarily thought of as distinct. It may be urged that there is something of the 'universal' in this, that the humorous and the comic reveal the universal, as tragedy does. This is indeed Butcher's contention. In his "Essay on the Generalising Power of Comedy" he concludes,[1] "Greek tragedy, on the other hand, like all tragedy of the highest order, combines in one harmonious representation the individual and the universal. Whereas comedy tends to merge the individual in the type, tragedy manifests the type through the individual. In brief,

[1] *Aristotle's Theory of Poetry and Fine Art*, p. 387.

it may be said that comedy, in its unmixed sportive form, creates personified ideals, tragedy creates idealised persons."

In this there seems to be great truth. We behave solemnly, seeing ourselves or others as unique and very important individuals. The shock comes, and we are revealed as types, as parts in a very large whole. If our attitude is not just right, we may suffer humiliation. And humiliation may do us good. But comedy is, though never quite positively kind, less unkind, and in its own way just as good if not better for our souls. For, heaven be praised, when we do see ourselves as comic we are not thinking of our souls at all!

The concept of the witty is much less complex than that of comedy or humour. The witty need not be funny, though it may be. If it is funny, its funniness will share in the general characteristics of the comic and the humorous. In the witty there is neatness and there is aptness, quickly seized upon by the witty mind, and there is an element of the unexpected and of surprise. In these things the witty has much in common with the comic. Again, like the comic, the witty depends upon some chance conjunction of entities usually regarded as distinct, and from this it derives meaning. But in the case of wit the chance conjunction seems essentially to lie in some superficial association of words or of ideas. The witty cannot consist, for example, of scenes of clownishness. The witty object is verbal or intellectual or, in some sense, both. Its materials are part-products of mind. Again, the apprehension of the witty demands considerable penetration of intellect. Superficial association of words or of ideas is one part of all wit, but wit demands also a quick insight into the suggested significance of the synthesis which has been effected by superficial association. It is for this reason that punning has been rightly called the 'lowest form' of wit. Indeed punning, being merely a play on verbal associations, is but half-wit. For wit implies a certain genuine construction (though intellect may be pungently seasoned) of connections between groups of ideas not usually thought of

as related. Wit, in the best examples, is discovery of truth through the inspired use of the accidental. Wit, in a word, is the discovery of the profound through the superficial, but always with an approximately equal emphasis on both. Both are seen together in a single vision. The approximately equal emphasis is necessary, and their presence together is necessary, because just as the superficial association by itself is not wit, so neither is profound insight the thing which we usually[1] call wit. Our delight is not in the superficial *nor* in the profound, but simply in the union of the two. Great wit is a kind of paradox, for it is intellectual emancipation through the delightful click and glitter and assonance of the trivial.

In terms of 'distance', the witty is about as 'distant' as anything can be. The comic is distant, but the witty is even more distant, since wit can be enjoyed 'coldly', and involves a minimum of sympathy. The difference of distance between wit and humour on the one hand, and wit and satire on the other, is approximately the same, but for opposite reasons. Whilst both satire and humour are unlike wit (and comedy) in being relatively 'near', the nearness of satire has negative, whereas the nearness of humour has positive value. The element of dislike, and possibly of cruelty, in satire, that is, prevent it from being quite impersonal, just as the sympathy which is a characteristic of humorous appreciation, prevents a complete impersonality in humour.

## VII. Classic and Romantic

In this subject we are again embarrassed by the variety of literature dealing with the question. If we do not ignore it, or rather, take it for granted, we shall quickly lose ourselves. We may be contented, therefore, with a few general statements which for brevity's sake must be put dogmatically.

[1] The word can be used in this way. We speak of 'great wits'. But our concern here is with the witty, or wittiness.

Perhaps the most commonly accepted ideas about the classic and romantic are that the one stands for perfection of design, form, structure, balance, composition, whilst the other stands for an emphasis upon content and upon spirit, upon emotion and inspiration, at some expense, perhaps, of form. Classicism, it is often supposed, is a spirit of order, romanticism of a delightful disorder which is not merely negative, but the symbol of the living spirit of man.

If there is anyone who lightly says that classicism is all for form and romanticism all for content and spirit, he may be lightly ignored. For he is holding something which is obviously false. If classicism were regard for mere form, classicism could have no aesthetic value, for aesthetic value arises, not out of mere form, but out of significant form. And actual experience bears out that the art we call 'classical' never possesses merely formal interest, but is expressive of significant content. Neither, on the other hand, is romanticism interest in mere content or spirit; it must, to be aesthetic, be interest in what has body and form. When it is said, therefore, that classicism stands for form and romanticism for spirit or content, all that can be meant is that this or that side is stressed, or perhaps that the danger of classicism is mere formality, and the danger of romanticism mere content without form. The wind of classicism, it may be said, blows in one direction, the wind of romanticism in another.

These things may be so, but there must be a great deal more than this in the antithesis between classicism and romanticism. Generally speaking, we may venture to speculate that the contrast is not *primarily* one between different stresses on form, or on spirit, but is rather between one kind of spirit expressed and another kind of spirit expressed. The spirit will naturally, of course, affect the form, so that we may expect differences of form in classicism and in romanticism.

What the classical and the romantic 'spirits' are is a

problem of very great difficulty, because of the immense variety of modes in which these two hypothetical 'spirits' manifest themselves. And, as everyone knows, classicism or romanticism are not qualities which can be indiscriminately applied to any school which we label 'classical' or 'romantic', nor can they be applied to any individual artist at all times, nor even to all parts of individual works of art. Classicism and romanticism, it would seem, are moments of aesthetic experience which may, either of them, occur almost anywhere, and it is difficult, if not impossible, to find unbreakable rules for their discovery in this or that period. The romantic wild flower may blossom, with the air of perfect naturalness, in the walled garden of any classical period, and the perfect bloom of classicism may be found in the meadow or on the open hillside. "Homer, who so delighted the Romantics, is, we feel, in some ways less classical than Sophocles and Virgil; there is no greater romance in certain essential qualities of romance than the *Odyssey*; and yet, again, Virgil in the fourth book of the *Aeneid* is more romantic in another way than Homer. Dido is one of the saints of Mediaeval romance. Euripides is more romantic than Sophocles."[1] Of an art like music it is more difficult to speak, because of its elusiveness. But doubtless the same generalisations are true. What of J. S. Bach and Beethoven? Who can say whether they are 'classical' or 'romantic'? For which of the thousand Bachs and Beethovens do we mean? The terms 'classical' and 'romantic' are indeed so full of obscurity that it is little wonder that some would have us abandon them altogether. Yet their continual recurrence is surely a sign that they stand for something fundamental and real, so that discussion, though difficult, cannot be wholly unfruitful.

Mr. Lascelles Abercrombie in his book, *Romanticism*,[2] suggests that the real antithesis is not so much between

[1] H. J. C. Grierson, *Classical and Romantic*, Leslie Stephen Lectures, Cambridge, 1923.  [2] Martin Secker.

romanticism and classicism as between romanticism and realism. "Nothing", he says, "has done more to obscure this question than the common assumption that there is an antithesis between romanticism and classicism. The antithesis is wholly improper, because classicism is of a quite different order of things from romanticism."[1] The true antithesis is between romanticism and realism. Classicism, he says, is the "health" of art, the just proportion, as it were, of the elemental "humours" in it, two important humours being realism and romanticism. As for romanticism, one of its most important characteristics consists in a kind of retreat from the external world to an 'inner' world. Realism "loves to go out into the world, and live confidently and busily in the stirring multitude of external things".[2] Romanticism is at least a withdrawal from these outer things into inner experience. Roughly and approximately it is a transition from "perception" to "conception". (These terms are used advisedly in a loose way.)

How far we may accept this view will be seen in what follows. It may be questioned whether there is not a certain ambiguity of words in saying that romanticism enters into all art, as an element in it; for the word romanticism usually stands for a general tendency of art rather than for an element in it, and it does not in that sense enter into *all* art. There is danger in asserting the close relationship between the classical and the romantic, of overdoing it and of denying their real distinction. But this is a matter we may adjust for ourselves. We shall return to it. A similar slight confusion is seen when Mr. Abercrombie says that classicism is the "health" of art. Classicism may, perhaps, be the health of a *spirit* which is expressed in art. Health, that is, may belong to content. But surely classicism can hardly be the health of *art*, for the health of art is its perfection and its perfection is its beauty, and romanticism has its own proper perfection, or health, or beauty, which is not, as such,

[1] *Romanticism*, p. 31.  [2] Ibid., p. 50.

classicism. Classicism is not just beauty, and beauty is not the same thing as classicism. Classical art may, possibly, be a 'greater' kind of art than romantic art; but this is again a matter of content. We shall find it useful, however, in discussing the classic and the romantic, to follow Mr. Abercrombie in keeping in mind the relation of both to realism.

Mr. Abercrombie is, I think, right when he speaks of the spirit of romance as a retreat from "perception to conception", or, more broadly speaking, from the world outside us to an 'inner' life. Interpreting for ourselves, we may think of the world "outside us" as including society, nature, and the cosmos. But it is essential in speaking of romanticism to think of these in relation to our *retreat* from them. 'Outside' is a relative term, relative to our attitude, to our retreat. It would not be true to say, for example, that nature, or the cosmos, *always* stands for an 'outside' world. For a romantic movement, as we know, may consist in a retreat *to* nature *from* society (e.g. from the life of cities and academies). Or it might be in a kind of mystical retreat, say, from society, to contact with the cosmos, a doing of something with one's own solitariness. Again, the retreat might be, not from society, but from nature itself, to the supernatural, to, e.g., the magical or the religious. Or it might be from a religion become conventional to the freedom of thought, or even from the stern necessity of the cosmos to an assertion of individual independence. The conception of romanticism is thus in a sense[1] a bi-polar one, and the only general statement we can make about the positive[1] pole is that its 'externality' implies something accepted, or established, which is reacted against by the individual. *What* is accepted or established, what is reacted against, may vary greatly: hence the difficulty of *identifying* romanticism with

[1] Romanticism is *in a sense* 'bipolar'. This metaphor, as we shall see, has a limited value, for the 'negative' pole is not merely negative. Romanticism implies faith as well as retreat.

such movements as 'the return to nature', or with its opposite, the cult of fairies.[1]

Romanticism is thus a reaction from something. This reaction is also an individual enterprise, an adventure. The expression of the romantic is,

> "Most roads lead men homewards,
>   My road leads me forth . . ."

or

> "Not for us are content, and quiet, and peace of mind,
>   For we go seeking a city that we shall never find.
>   There is no solace on earth for us—for such as we
>   Who search for a hidden city that we shall never see.
>   Only the road and the dawn, the sun, the wind, and the rain,
>   And the watch-fire under stars, and sleep, and the road again."[2]

Romanticism seems thus to imply a feeling for mystery. This feeling may range from its least developed form, a sheer love of mystery—called 'mystery-mongering' by the unsympathetic—to a more positive seeking for good along mysterious ways. Romanticism in its best forms is a faith, a faith in a world to which we are retreating from the world of established things. The mature romantic—if romantics can ever be called mature—retreats from the known to the relatively unknown, but he is possessed of a "substance of things hoped for", and an "evidence of things not seen". It is half-true to say that for the romantic "to travel hopefully is better than to arrive". The movement of travelling, with its positive joys, may in itself be a 'retreat'. But so may journey's end. The romantic is not, as such, *necessarily* afraid of arriving anywhere.

Of realism, likewise, it is not easy to conceive, except in bi-polar terms. Realism too is a reaction.[3] Realism is not *merely* the habit of mind which lives "confidently and busily in the stirring multitude of external things".[4] Realism is

---

[1] On this, see Mr. Abercrombie, passim.
[2] John Masefield, *Poems and Ballads*.
[3] I do not of course in either case mean 'reactionary'.
[4] Op. cit., p. 50.

something which tends to have the air of a purpose and a mission. In art it has a creed, and the creed is, briefly, belief in "holding the mirror up to nature". Realism in its clearest forms is really a protest, explicit or implicit, against romanticism, a reaction to hard fact, to the solid world of things. Realism tends to despise imagination, and so tends to despise art itself, believing sheer reality more important than human spirit. Selectiveness is a rather cowardly evasion of fact. For sheer realism what matters is just this fact, and not beauty.

There is therefore in truth no such thing as sheer realism of artistic practice, for the artist selects whether he knows it or not, and whatever his theories. Sheer realism is thus the abstract limit of a tendency, and when we say in aesthetic criticism 'such and such is realistic', we do not mean that it is sheerly or completely realistic, but merely that it has some tendency in that direction. On the other hand, when we talk of realism abstractly, as we are, for the large part, doing here, we should think of a realism as near its limits as possible, as all but the extremity of a tendency.

In discussing these questions—which are so exceptionally difficult because in the controversies about them one meaning slides unnoticed into another—it is of vital importance to be clear in our own minds whether we are thinking of a concept like realism in its abstracted purity, or whether we are thinking of a concrete case with a weaker or stronger dash of realism in it. Taken abstractly, such statements as 'there is a realistic romanticism', or, 'there is a realistic classicism' are self-contradictory, for both romanticism and classicism are abstractly, and in relation to the same objects, definable in opposition to realism. Taken concretely they are not nonsense, and may very well be true. For the arts which are *concretely* called 'romantic' and 'classical' are not limits, are not pure and universal concepts. They are slabs of real existence, which may quite easily contain conflicting tendencies. This is why, in artistic

criticism, the labels are so dangerous. It is quite legitimate, on the other hand, to ask (on the evidence of much aesthetic experience itself) what the pure ideas for which these labels stand, really are. This is what we are trying to do here. Hence a rather sharp opposition of terms which would be out of place in concrete aesthetic criticism. On the other hand, we must keep in close touch in our own minds with artistic practice itself.

Classicism, unlike romanticism and realism, is not a reaction. It is neither a reaction from accepted or established things as they are, nor is it a cultivation of facts at the expense of the spirit. The spirit of classicism is a spirit which implies the conviction of the unity of our life with the life of accepted and established things. If true romance has faith in the world to which it retreats from the order of established things, classicism has faith in the order of established things themselves—whether these things be social and traditional, or natural or cosmic.[1] Classicism believes that in losing itself in things the spirit finds itself, that what is, is the source of what is good; it holds, too, that what is demands as its complement the expression of its meaning through our spirit. Classicism has belief in the richness and sufficiency of what is. In relation to a social or artistic heritage it has respect and faith in tradition and in the large potentiality of established forms. In relation to nature, classicism believes that an understanding and a judicious selection of natural forms will reveal there an expressiveness which is amply sufficient to inspire the human spirit. Realism is so preoccupied with the mere facts of nature that it despises selection and therefore misses the expressiveness of the forms of nature when they are distinguished from all accident. Romanticism, on the other hand, may sometimes tend, in its search for new satisfactions, to abstract and distort too much the forms of nature. But classicism brings

[1] On Professor Grierson's emphasis on the social and traditional aspect, see below, p. 375 sq.

out, through a wise and judicious discernment of what essentially they are, and of what essentially they express, the objective values of natural things. So again, in relation to the cosmos, it might be said that whilst realism has little use for the cosmos, and romanticism tends to be over-excited by its escape from a narrower world of fact to that larger world, classicism comes to the cosmos as a wanderer comes home. Like the wanderer, the greatest classicism carries the experience of adventure, and this is part of the half-truth of saying that classicism contains romanticism as an element. Another part of the half-truth is that in classi-cism, as in romanticism, there is an element of great release. But it is the release, not so much of an enterprise and adventure which leads away from something established, as the release of an enterprise which has achieved harmony and perfection at last. Romanticism and realism alike necessarily imply some suppression, and possibly some repression, but in classicism there is neither suppression nor repression, but the peace of a faith which is something almost more than faith, being a faith which is without doubt and without fear.

Another matter of importance arises in discussing the statement that all classicism contains an element of romance. Romanticism is individualistic movement. But in classicism there is no individualism, for the individual is united in sympathy with his time or his tradition, or with nature, or with whatever is his object. On the other hand, although not individualistic, classicism is certainly individual expres-sion and embodies in its own way a spirit of enterprise and adventure. It is not, like realism, merely an echo or a mirror of what is, it is the interpretation by a spirit of what is, and we can never reduce the spirit to a mere social consciousness or a mere objective thing, however much it may express the social consciousness or express the nature of the thing. That is why, in contemplating the figures on the pediment of the Parthenon, or the Parthenon itself, or Bach at his

most classical, or Wordsworth in his complete union with
nature,[1] we feel that here is an enterprise which, though
objective and shareable and public, is also solitary and
private and satisfying to the innermost yearnings of the
individual. Classicism is not, as is so often thought, some-
thing merely or mainly 'formal' and 'cold'; classicism is the
expression of the profoundest passions, only they are
'objective' passions, passions in which 'cosmic' values, or the
'natural' values, or the social or traditional values, have
found issue through some great individual spirit. It is
passion, but calm passion, and no passion of revolt. Romanti-
cism, as we have said, can have, and must have, its beauty
and its greatness. (Sheer realism can hardly be great because
it is not art—though the reality of which it treats may
arouse great emotions.) But perhaps the greatest beauty of
all is the beauty of the classical expression when it has
reached the exact flowering-point of its development.

Romanticism, it has been argued, is (at least) a retreat
from the established. In a sense, classicism, or the classical
spirit, may be said to consist in a harmony between the
individual and what is established. It is, I think, necessary
to interpret, as we have been doing, 'what is established' in
a very broad way. One important kind of entity which is
'established' is the social and aesthetic tradition which, at
certain periods of the world's history, becomes markedly
consolidated. Professor Grierson, in his Leslie Stephen
Lecture, has shown very clearly the connection between
classicism and romanticism and the kind of social environ-
ment of which they tend to be the expression. His view
indeed is that it is difficult to describe classicism or roman-
ticism apart from their social and historical context. He
follows Brunetière's view (with certain important reserva-
tions) that the essential balance which is to be found in
classicism is not entirely a product of individual genius, but

[1] Mr. Abercrombie very rightly insists on Wordsworth's classicism at
such moments. Op. cit., pp. 131–132.

is a product also of social and intellectual conditions which are attained more at some periods of a nation's life than at others. Mr. Grierson believes Brunetière to be right in his description of the main conditions under which classical literature has at different times appeared. "It is the product of a nation and a generation which has consciously achieved a definite advance, moral, political, intellectual; and is filled with the belief that its view of life is more natural, human, universal and wise than that from which it has escaped. It has effected a synthesis which enables it to look round on life with a sense of its wholeness, its unity in variety; and the work of the artist is to give expression to that consciousness, hence the solidity of his work and hence too its definiteness, and in the hands of great artists its beauty. Literature at such a period is not personal—at least in quite the same sense or to the same degree as it is say in Rousseau or Byron or Carlyle, or Ibsen, because there is as it were a common consciousness throbbing in the mind and heart of each individual member of the age, or of the circle for which he writes, for one must admit, and this is significant, that a classical literature has generally been the product of a relatively small society—Athens, Rome, Paris, London. The work of the classical artist is to give individual expression, the beauty of form, to a body of common sentiments and thoughts which he shares with his audience, thoughts and views which have for his generation the validity of universal truths. His preoccupation with form is not, as with those whom Bacon describes, due to disregard of weight of matter and worth of subject, but to the fact that the matter is given to him by his age, has for him the weight and worth it possesses for his audience."[1] Again, "The *differentia* of the true classic, Sophocles, Virgil in all that is greatest in his poem, Racine, Johnson, is that he stands firmly on his own age, is consciously and proudly the mouthpiece of his own age of reason and enlightenment".[2]

[1] Op. cit., p. 19.

[2] Ibid., p. 52.

This is all very true, but it seems to me that perhaps Professor Grierson, in bringing out the bearing of social and intellectual environments, tends to think rather too *exclusively* of social and intellectual tradition as the inspiration of classicism, and as that from which romanticism is a reaction. If we are right, it is not only when he is speaking for his own age of reason and enlightenment that an artist is classical: he may be the mouthpiece of something which his age does not see. He may be the prophet of the natural or the supernatural or the cosmic. Classicism *may* be a voice crying in the wilderness. Whether it may properly be called classical or romantic will really depend upon whether the solitary spirit is able to achieve that spirit of quietness and repose which is the outcome of faith vindicated in the world to which he has turned from the life of society. If he is *mainly* in revolt, if his discovery is not merely individual but individualistic, if he has not yet acquired complete stability in relation to that world of retreat, we should call him romantic. The point is that his classicism and his romanticism are quite as much, in this case, a matter of his relations to the other real world *to* which he retreats, as to the social world *from* which he retreats.

If these general statements are true, it is not difficult to see why the development of the formal side in classicism tends to greater perfection, whilst the forms of romanticism tend to a certain looseness. Classicism in some cases tends to accept the forms which social tradition has given to it, but this cannot be the root explanation. It is rather that the spirit of classicism is the spirit of peace and harmony. Its emotions are ordered, and being ordered, they exhibit themselves in harmonious form. Again, as we said, the classical spirit is different from the realistic spirit in that it is interested in the *forms* which elucidate the expressiveness of things, and in so doing satisfy and nourish the spirit. Romanticism, on the other hand, tends (but only tends) to slackness of form, because it is the expression of a revolt

to freedom which may become licence. More positively, romanticism tends to be so excited by its emotions in its journeyings to new discoveries, that its sure vision, and so its form, tends to be unstable and blurred.

From the nature of romanticism and realism and classicism it can be seen in what direction decay will tend to set in in each. The tendency of romanticism is individualistic. Romanticism, if it is not careful, may die of inanition, of starvation of content, though the signs of its dying may be violent enough in outward form. It is good to live an inner life: it is good to revolt, and the inner life has its positive object of faith. But unless romanticism in its very revolt is seeking out for a new world in which it will some day find peace, unless, in other words, very romanticism itself is a movement to a more stable classicism, it will tend towards subjectivism and starvation. Art is not like the serpent which can feed on its own tail. A danger of romantic retreat is subjectivism. Without some healthy contact with real things, of one sort or another, romance becomes solipsism, decadence.

Realism in its turn dies because it was never properly alive; its life is a theme borrowed not from the spirit of man —although in actual realistic art this spirit can never quite avoid showing itself—but from the nature of things. But things in themselves are not enough, and the mere mirroring of them becomes a tedious and wearisome business.

Classicism does not so much die as fail to sustain itself in equilibrium, being the perfect balance of subject and object. Perfect balance is hard to sustain, for life, though approving of stability, is essentially unstable. Now the balance of classicism, being good, is a thing which inspires imitation, and when imitation occurs we get a mere cultivation of perfect form without that life the expression of which gave rise originally to that perfection of form. Classical art is art with a spirit of assuredness which has been hardly won. If assuredness is imitated, it becomes mere conventionality, it becomes mere correctness and good manners.

True classicism, however, must be the expression of the individual living spirit, for which there can be no substitute. When, therefore, a particular form of classicism has outlived its span of vital days, when it has degenerated into good manners and correctness of behaviour, the only cure for the restless spirit of creative art is a fresh spell of romantic enterprise, romantic enterprise with its admitted dangers. Life being unstable, and being rhythmic, we cannot stay at any stage, however classical, however perfect. The alternatives are to stagnate, or, to live dangerously. And, life being life, the alternative of stagnation is in the long run an unreal one. Perhaps the fineness of the following passage may justify me in quoting Professor Grierson once again:—

"Classical and romantic—these are the systole and diastole of the human heart in history. They represent on the one hand our need of order, of synthesis, of a comprehensive yet definite, therefore *exclusive* as well as inclusive, ordering of thought and feeling and action; and on the other hand the inevitable finiteness of every human synthesis, the inevitable discovery that, in Carlyle's metaphor, our clothes no longer fit us, that the classical has become the conventional, that our spiritual aspirations are being starved, or that our secular impulses are 'cribb'd, cabin'd, and confined'."[1] When this happens, "the heart and imagination bursts its cerements and reaches out" once more to the new life which is the life of the romantic. And once again, we might add, the new life in its good time achieves, for an instant or two, order and stability. Romance, coming home to its reality, becomes classical. But only for a brief moment. It is because of this, because only a millionth part of life can be perfect, and the rest is bursting enterprise, that great romance will always outweigh great classicism in bulk, and that it will always capture our hearts and our imaginations. Perhaps, for most human men, rightly or wrongly, it will continue to outweigh the claims even of the most perfect perfection of the classicist.

[1] Op. cit., pp. 55-56.

# CHAPTER XIV

# THE ENIGMA OF NATURAL BEAUTY

# I. Preliminary

The argument of this chapter will be found to divide itself naturally into three parts. In the first part I shall enumerate some of the attitudes which the aesthetic percipient may take up towards nature. In the second we shall be concerned with certain convictions which the lover of nature may possess about the beauty he believes to exist 'in' nature. In the third we shall try, without attempting to prove these convictions true, to see what some of their implications would be if they were true, and whether the implications lead, or do not lead, to absurdity. The whole subject is full of difficulty, for any such conviction, as, for example, that the beauty of nature exists apart from relation to our minds, is a belief which could not be sustained in regard to the beauty of art. We shall have to leave, with some misgivings, the more certain ground of our own experience and venture into the dark regions of general philosophical speculation. Let us be perfectly clear at the outset that in such realms we shall only be able to move tentatively, and that the chances of being in error here—particularly in a brief discussion—are even greater than is usual in philosophical reasonings.

## II. The Experience of Art contrasted with the Experience of 'Nature'

The natural objects[1] which we perceive—stars, clouds, seagulls, trees, the landscape of mountain or plain—are like the other objects which we perceive, in that to appear in any degree beautiful they must be imaginatively apprehended by mind. In this respect natural objects or scenes are in the same relation to us as art-objects. One difference, however,

[1] The distinction will shortly be made between 'nature' approached casually as when we glance at a landscape, and 'nature' viewed more carefully, as a structure or structures. For the moment the context will show which of these is meant.

between natural and art-objects stands out. The works of art which we apprehend are themselves—at any rate as regards their form—the product of finite minds; their structures which we perceive have been made like that in order that the mind of the artist (and probably other minds) may experience, in and through them, organised valuable meanings. We know this. But of natural objects we do not know it. We have no grounds for believing that nature is a work of art, similar to those for believing that the artist's product is such. We may look at nature imaginatively, and see her as beautiful, but we do not know, *prima facie*, that her beauty does not arise wholly through our 'seeing', as it does not arise through our seeing when we apprehend works of art. It is true, of course, that when we perceive a work of art we have to do our own part in imagining, for unless we imagine, the pigments or the words or the sounds will remain these things and nothing more. But, because of the great community of experience and of symbolic material between the artist and other men, we are able, if we can and do imagine, to enter into an aesthetic experience in the work of art, which is ready given and ready made for us. We must imaginatively apprehend, but imaginative apprehension is discovery of something which is, strictly, in the sense described, there already. Our experience and that of the artist on completion of the work are probably never quite identical, but our appreciation is approximately a discovery and a sharing in already constructed meanings. When we have aesthetic apprehension of natural objects, on the other hand, we certainly possess no ready-made proof that we are so discovering and sharing.

The construct of art is a completed unity. This unity of art is another aspect of the *prima facie* contrast between art as it appears, and a good deal of nature as we casually approach her. Art is artificial, and nature is natural, and one of the most striking differences between appreciation of nature and appreciation of art is the largeness, the stretch-

ing infinity, the cosmical context of the former, as opposed to the exclusiveness, enclosedness, artificiality, of the latter. (Artificiality as here used is of course no term of abuse.) Art reveals reality, but art is specific and enclosed and perfect. It has the completeness of a monad or a microcosm. The nature which we casually approach, on the other hand, being a part of nothing less than the macrocosm, is, for our finiteness, different before each one of us—different at every turn of the head, with every step and every passing mood. Art is a selection, but a definite, chosen, and complete selection; nature, as we come on her casually, appears in perspectives which have ragged edges, which are more diffuse, which melt into a background of indefiniteness. If beauty consists in perfection of expressiveness, then a careless (though imaginative) glance at nature is unlikely to reveal anything like perfect beauty in the whole of any single perspective, though it may possibly reveal much expressiveness here or there. In the careless glance we may have an aesthetic experience, but an imperfect and incomplete one. Nature, casually seen, has no frames; she has no beginning, no middle, and she is endless.

III. Nature as Background; the 'Escape' to Nature

There are, in fact, so many attitudes to nature which may be taken up, and these attitudes are often so delicately and so subtly different from one another that it would be impossible in anything less than a treatise to give an adequate account of them. In the next few pages I propose to consider some of these attitudes, but the suggestions which will be thrown out, though they may provide a convenient perspective for our subsequent treatment, will have no special merit except that of convenience for this special purpose. The expert in the subject will have to supplement from his own reading and his own experience. For the sake of rendering an immense subject manageable in a short

space, I propose to consider attitudes to nature ranging from a stage when nature falls in the background or in the margin, to attitudes in which nature becomes the focus of several different kinds of interest, culminating in that interest in nature which may be called mystical in character.

In literature, perhaps, the most frequent location for nature is in the background. If one confines oneself to English poetry[1] the difficulty is indeed to discover any bulk of poetry[2] which is not coloured by the influence of natural scenery and atmosphere. Chaucer begins straight away: "Whan that Aprille with his shoures soote." Spenser is drenched in pastoral atmosphere; Milton, in his own more indirect way, is so also, especially perhaps in the earlier works. The backgrounds of Shakespeare, with some exceptions, are largely natural, and although in the Romantics of the eighteenth and nineteenth centuries nature comes more into the focus, it is present as background too. Think of the background of the *Cenci*, for example. Indeed, it is impossible to avoid a conviction of absurdity in selecting English poets and poems for examples of the presence or influence of nature. Our national character is so suffused with the atmosphere of the fields and trees and clouds and mountains and rivers and meadow-flowers, and gardens and garden-flowers, that we come almost to cease to notice it, to take it for granted.

But nature may be attended to, and when attended to it may grip the imagination for many reasons. One common cause of its hold upon the imagination is that nature is an escape from the wear and responsibilities of city-life. The contrast of the life of the forest, "exempt from public haunt", is welcome to the jaded nerves of the city-dweller.

[1] The most recent treatment of the general subject will be found in Mr. Edmund Blunden's *Nature in Literature*. (Hogarth Press.)
[2] Periods like certain parts of the eighteenth century excepted.

> "To one who has been long in city pent,
> 'Tis very sweet to look into the fair
> And open face of heaven. . . ."

> "How beautiful is the rain."

Or in a garden, as Marvell sings,

> "Society is all but rude
> To this delicious solitude."

This craving for escape is one source of what has been called traditionally 'pastoral' poetry, and, in more modern times, the source of the poetry of what has been called the 'week-end' tradition. Mr. Gibson, seeing the ice-cart in the streets, sees also Greenland's icy mountains. Mr. Yeats and Mr. W. H. Davies could hardly be labelled week-enders, particularly the latter—but the beauty of the poems of *Innisfree*, or of *Leisure*, is the outcome of this same civilisation-induced craving.

Nature as a background, or as a place of escape, is coloured by human moods. And a good deal else of delight in nature is delight simply in what reflects, or supplements, ourselves —nature being little more to us than a symbol for what we most desire. It is sleep and restfulness when we are jaded, vigour and clean strength when we are cloyed with artificial living, beckoning mystery when some deep voice in us calls to answering deep. Poetry is full of the expression of this. For the most part the poet is unanalytic, ready, like a child, to accept what nature gives to him as her message. But on occasion doubts will arise. The ghosts of some hinting scepticism haunt uneasily the dark corners of the mind. Is the speech of this message of nature an illusion? Are we, all of us, victims of what has been named, with unconscious, but telling, ambiguity, a 'pathetic' fallacy? Coleridge—in some moods—is perhaps one of the most outstanding examples of a poet beset by this awful fear that nature is, after all, but a mere physical thing: the earth a "sterile promontory",

and the golden sky but a "foul and pestilential congregation
of vapours". All that nature says is said by ourselves:

> "O Lady! we receive but what we give
> And in our life alone does nature live. . . .
> Joy is the sweet voice, joy the luminous cloud;
> We in ourselves rejoice!"

## IV. NATURE AS A FIELD FOR ART

The unanalytical attitude of the poet—and of all of us who
'discover' nature's moods in consonance with our own—is a
natural and instinctive attitude which needs no cultivation
and is certainly not cultivated for some conscious artistic
purpose. And, when doubts arise as to whether or no we be
the victims of a fallacy, we feel bereft of a friend, and the
joy goes out of life, as it did for Coleridge in these blankest
moods. There is, however, another attitude to nature which
resembles this one in that it looks at nature as coloured by
human interests, but differs from it in that the interests are
definitely cultivated, and are artistic. The object, in this
case, becomes really art rather than nature, and the sug-
gestion therefore of 'pathetic fallacies' becomes less important,
and hardly matters even if it is suggested, for nature has
already ceased to be a friend. This attitude is best exempli-
fied in the landscape-painter of a certain type, who comes
to nature, not receptively, in order to take what she has to
offer, but who approaches nature mainly as offering a field
of suggestion for his art. This artist is interested in his
pictures, in compositions which will fit harmoniously into
frames. He looks at nature through a post card with a hole
in it. He is interested in making rather than in discovering.
And, often enough, he frankly does not expect to find beauty
in nature as she is. This attitude, in rather an extreme form,
is expressed by Croce in the following passage: "The always
imperfect adaptability, the fugitive nature, the mutability
of 'natural beauties' also justify the inferior place accorded

to them, compared with beauties produced by art. Let us leave it to rhetoricians or the intoxicated to affirm that a beautiful tree, a beautiful river, a sublime mountain, or even a beautiful horse or a beautiful human figure, are superior to the chisel-stroke of Michelangelo or the verse of Dante; but let us say, with greater propriety, that 'nature' is stupid compared with art, and that she is 'mute', if man does not make her speak."[1]

This is half-true, and our painter's attitude to nature is, in its own way, a perfectly legitimate attitude. (And the passage just quoted is the logical outcome of a philosophy of art.) But as an attitude to nature it is 'casual' with a vengeance. It is hardly an attitude to real *nature* at all: it is an attitude, as has been said, to our own 'art'. And the conclusion of Croce's statement just given is inaccurate, for "man" with such an attitude to "nature" could never in this life "make her speak", having no interest in, having no humility to understand, nature, being consciously interested only in himself, his own world, and in his own artistic feelings and doings. And further, no one who makes no attempt at all to apprehend, and to some extent to understand, the objective structures of natural objects, will ever be in the least competent to say whether, as she is, she may not appear *beautiful*—much less "make her speak". Whether or not there is beauty 'in' nature, we must love nature, and with some intelligence, before we can judge whether she has anything to teach us. We have little need to condescend.

## V. A MORE OBJECTIVE ATTITUDE—SYMPATHY AND OBSERVATION

A very different attitude to nature (and to a different 'nature') which is without arrogance and which is more objective and more sympathetic, is typified by such poems as *The Bull*, by Ralph Hodgson, or *The Runnable Stag*, by

[1] *The Essence of Aesthetic*, p. 47.

James Stephens, or by Masefield's *Reynard the Fox*. Here the subject is animate nature, and the main interest lies not in any responsiveness of nature (real or imagined) to our moods, nor in the artistic effects which can be adapted from nature, but rather in the life, the sufferings and the joys of animals with sentience akin to our own. In the poems I have mentioned there is keen objective observation, there is understanding, there is sympathy (and—in Mr. Hodgson's poem anyhow—some sentimentality). And there is also something more, a profounder reflection and questioning of the purposes and plans of nature—with incidental reflections on man's humanity or his inhumanity.

This more 'objective' attitude to nature is perhaps most commonly understood when the concern is with the life and particularly with the feelings of animals. Anyone, or anyone whose imagination has not become blunted or distorted, must be interested in, and must sympathise with, the fox or the bull or the stag. But the objective attitude of appreciation is possible not only towards animals regarded as sentient like ourselves. It is possible to appreciate animals —or human beings—as pieces of structure. The deer, or the tiger, or the turbot (if we could see it in its setting), the bank of moss, the tree, the tulip, reveal intricate functional structures to the intelligently appreciative mind. And not only animate nature, but inanimate nature too—cloud, mountain, plain, rock-crystal, atom. Examples of the expression of interest in the structure and functional activity of animals are to be found here and there in the poems mentioned (in *The Bull*, and *The Runnable Stag*, and *Reynard the Fox*).

> "A chestnut mare with swerves and heaves
> Came plunging, scattering all the crowd,
> She tossed her head and laughed aloud
> And bickered sideways past the meet.
> From pricking ears to mincing feet
> She was all tense with blood and quiver,
> You saw her clipt hide twitch and shiver
> Over her netted cords of veins. . . ."

Or

> "The fox's nose tipped up and round,
> Since smell is a part of sight and sound
> Delicate smells were drifting by,
> The sharp nose flaired them heedfully. . . ."

Or

> "Like a rocket shot to a ship ashore
> The lean red bolt of his body tore
> Like a ripple of wind running swift on grass
> Like . . ."

We get it too in Mr. Blunden's *The Pike*. The structure of the tree is sung in Mr. Aldous Huxley's *Song of Poplars*, or Mr. Masefield's *The Trees*, the poetry of flower structure in Arnold's *The Scholar Gypsy*, or *Thyrsis*, or Bridges' *The Garden in September*, or his poem on a Poppy. These descriptions are not scientific in any strict sense of the word (and they do not follow things in detail or to their conclusion), but they point in that direction in that they are 'objective' rather than 'subjective' in attitude.

This objectivity of attitude is perhaps seen more clearly when the theme is inanimate nature. No one has made clearer than Ruskin the importance of the co-operation of intelligence and aesthetic experience in our attitude to nature. In his account of such phenomena as distance, sky, water, natural topography, Ruskin is a healthy corrective (though he continually says false things) of the over-'artistic' attitude to nature. Ruskin's position is that of the artist, but of the artist ready to learn from nature. Art for him is, though art, the interpretation of natural processes and functions. We get something of the same point of view, with a definitely scientific bias, and in a very different setting, in Hugh Miller's *The Old Red Sandstone*.

The scientific attitude to nature is not, of course, in itself aesthetic. But it may be, and it is this in which we are interested. The scientist as such—and indeed anyone who approaches nature with some degree of understanding—is

interested in the nature of structure. But he may also at any time apprehend natural structures imaginatively, so that they come to appear to express values in their perceived forms. We have spoken, in the chapter on functional beauty, of what is involved in this aesthetic appreciation of function. We saw that the functional value must appear to imagination as *in* the form, and that the appreciation of natural functional beauty involves imputation of our own bodily and mental states; and so on. It is impossible, we said in effect, to *appreciate* directly values other than those of our own bodies and minds, though we can cognise *that* these values are; and *what* they are. We appreciate (by a kind of analogy), *through* our organisms, the functional beauty of the flying seagull or the springing tree or the petals of a flower, and much of our delight in these functional objects is an imputed delight in our own bodies and minds. (There is also of course the imputed delight in colour, balance, composition, and so on.) In aesthetic experience all such factors become relevant to the perceived object, so that it appears to embody, not only value, but the pleasure in value.

These things, which are familiar, are true of any functional object (and indeed of any aesthetic object at all), and not only of those we call natural. The sailing-ship, the racing motor-car, the well-fashioned knife, are not only fitted for a function, but seem, in the aesthetic moment, really to embody a kind of delight. The perfect ship or the perfect motor-car flies 'joyously' along like a living thing, the knife cuts with a will; it is, we may say, a 'self-respecting' knife. So it is also with natural objects like the seagull or the tree or the flower-petal.

## VI. A Conviction arising out of the Love of Nature

But just beyond this point a difference between our experience of the artifact and that of the natural object seems to emerge. In all aesthetic experience it is the case that we

do apprehend values, including mental values, relevantly to the object, as if they were *in* the object. But a moment's reflection shows us that in the case of artifacts our aesthetic conviction is not *literally* true, that in this aesthetic experience there is illusion, the illusion that valuable meaning is literally embodied. An artificial object like a work of art, is, reflection tells us, an appearance made for the purpose (at least) of awakening and satisfying our needs in a certain aesthetic way. Artificial objects like ships and racing motor-cars are not made for this artistic purpose, but they also seem erroneously to have beauty 'in' them. Reflection on the aesthetic experience of natural objects, on the other hand, seems to suggest rather different conclusions, or at least it does not lead so directly and inevitably to the same positive conclusions.

Here is a flower whose perceived detail possesses for the trained eye a functional significance. We can regard this as we should regard an artificial object, aesthetically delighting in the 'functional' expressiveness of its forms, as well as in its colours, its symmetry, and so on. But at this point the difference arises. All aesthetic experience takes the appearance of an object as expressive. Into the aesthetic experience of nature, however, there appears to be fused a kind of conviction not in itself aesthetic and often but vaguely felt, that somehow or other there is expressiveness, not merely in the appearance of the natural object, but in its very *reality*. The real thing, in itself, independently of us, seems, and not only at the aesthetic moment, to be expressively beautiful. This conviction, although it is fused into the aesthetic experience, is not, as I have just said, in itself aesthetic. It is a kind of philosophy which, whether explicit or not, goes along with a certain kind of aesthetic experience of nature, and which is assumed to be true. It is a philosophy which does not, and indeed could not, go along with our aesthetic experience of artificial objects. For artificial objects (e.g. works of art), though made by minds,

are in themselves non-mental bodies, and are external to and independent of the minds which made them. Natural objects, on the other hand, exhibit what has sometimes been called 'internal' teleology. And the internal teleological structure of a plant suggests (whether rightly or wrongly is not the question here) to many observers the presence of purpose and of mind, and of mind in some way immanent in the thing and not merely external to it. It is this kind of suggestion which seems to fuse itself with the aesthetic experience of natural objects. The flower, for some minds in some moods, is assumed to be structure revealing, in some obscure way, not only mental purpose, but beauty which is the literal expression of a spirit or mind immanent somehow in the flower. Sometimes, it is true, the conviction is merely a hint of a Creator beyond, a looking "through nature up to nature's God", a learning of lessons from nature ("One lesson, Nature, let me learn of thee"). But often it is more, and it is the more which is vitally significant for us here in our study of the convictions about natural beauty. In some of the intense experiences of nature it is felt that the beauty we perceive is certainly not merely the function of an imaginative activity of our minds, is certainly not merely a reflection of ourselves, nor even a mere product of, or appearance to, a divine external artist. We 'feel' an aesthetic expression of some spirit really active and immanent in the thing. A delight which is not merely our delight seems, not only to be "painted" *upon* the meadow-flower, but to be resident *in* its very growing tissue. This, I say, is a conviction which certainly occurs.

This conviction is partly supported, as I have said, by an assumed argument from teleology. It is also reinforced by the fact that whilst the aesthetic 'body' of any artifact is, so to speak, a superficies, the beauty-revealing 'bodies' of natural objects are, as it were, many-dimensional, and however far we go in our analysis the possibility of the beauty of structure to be revealed is never exhausted. The

'body' of the picture is a plane surface. Beauty is, in *this* sense, but skin deep. 'The body' of a piece of sculpture is its perceived shape; and if we break it up we are left with lumps of dead matter. But dissect the flower or the tree, and you get layer upon layer of connected structure, and layer upon layer of appearing beauty, each yielding to us the effect of active immanent expressiveness, and each intricately interconnected with the beauties that have gone before. We can dig down to very matter itself and still there is beauty. The only limitation to this process is that beyond a certain point we cannot perceive, but can only conceive, and, perhaps, imagine. There are, too, some limits to our capacities for appreciation. Certain aspects of nature we find it difficult to apprehend as beautiful; for example, the turbot or the embryo, or a pregnant sow. But it is highly improbable that these are real exceptions, and we must not argue from our own limitations. The generalisation is not imperilled. We can say with safety that the wealth of appearances of nature which may appear beautiful is, for our finite experience, all but unlimited.

I am not for one moment suggesting that all these things in fact *prove* that nature at every or any point is the aesthetic expression of spirit. It may be, for example, that at every point, at every perspective, we merely impute meanings, as we do to works of art. It may be that nature, to the nature-lover who reflects, appears to be full of beauty *in* her very body, as art does not appear to be to the art-lover, merely because she has *more* appearances which may appear beautiful to us. The effect is cumulative and the multitude of possible beautiful appearances suggests immanence. Again, arguments from teleology to the presence of mind are very open to dispute. The convictions of nature-lovers are no proof. It is merely pointed out that there *are* such convictions. The nature-lover, in other words, may be more than an aesthetic experient, and the problem of the aesthetic experience of nature may go beyond aesthetics. The lover of

nature is often, in a very broad sense, religious. He has a religion of nature, and his religion carries along with it, temperamentally, certain fundamental assumptions which are theological or philosophical. These assumptions may be right or they may be wrong. Whether they are so, or not, could only be significantly asserted by embarking on a full discussion of pantheism and deism and theism, immanence and transcendence, and the relations of them. This full discussion we cannot possibly enter upon. But we shall have to return again shortly from another angle to these convictions of the nature-lover and their implications.

## VII. THE MORE SENSUOUS APPROACH, AND THE IMPORTANCE OF SENSA

If intelligence, and in particular intelligence assimilated into aesthetic experience, is one instrument of revelation or apparent revelation of 'natural beauty', so, in their own ways, are the senses instruments of revelation. The best example of a sensuous attitude to nature (and to everything else) is perhaps that of Keats, but we get it also, by his own confession, in the "coarser pleasures" and the "glad animal movements" of the earlier Wordsworth, and to a lesser extent in his pleasures "of the eye and ear". But we may perhaps leave the poets alone for a moment and consider directly for ourselves this mainly sensuous approach—for it is a common experience. It is an approach mainly, but not exclusively, sensuous. Experience is not divisible into water-tight compartments, and an aesthetic experience of nature which is mainly sensuous may contain the apprehension and appreciation of natural structures, as well as the effects of many general reflections. And it may be more even than this. The experience, roughly classed as 'sensuous', may range, in fact, from a lower limit where it is little more than sensuous, to an upper level where, mainly through sensuous channels, we come to an awareness which may

be (like that of which we have already spoken) definitely mystical in character. In these things we are speaking of a certain *stress* on one aspect of experience and of nothing more.

The lower limit of this type of experience is little more than sensuous. Think, for example, of lying upon the heather, after bathing, on some hot summer's noonday. The bright sky is pleasantly stimulating, the hills are purple and blue and green, the heather is both soft and prickly to the body, whose chill is warmed deliciously by the hot sun. The scents of heather and bracken, the sounds of the insects, of rustling trees, of birds and of a distant stream, the very taste of the air, combine together to form the complex content of a very definite experience of a nature which expresses something to us. We feel, but our feeling is not all. We are vividly aware of an objective nature with its real characters, which speak to us through our senses. The quality of its sensuous vividness as a whole is in striking contrast to the limitations of sensuous experience when, say, we look at pictures or listen to music. From his own point of view, well may the nature-lover feel contemptuous of the stuffy occupation of standing in museums or picture galleries, or of sitting in artificially lighted concert halls with windows shut. Art has its reality, and its sensuous reality, but its reality does not impinge upon the senses to the extent that 'nature' can. The naked man on the moor experiences a stimulation to all, or, at any rate, to a very large number, of his senses, which is impossible in the enjoyment of any art. We *may*, at dawn or at dusk, or even at midday, regard the distant hills or the distant trees without much organic thrill, as we would a picture. But even the enjoyment of landscape is commonly accompanied by light and colour many times more stimulating than the brightest colours of any picture—apart from the smells and sounds of earth and air and animals and the things that grow from the earth and fly in the air.

The markedly sensuous character of much aesthetic experience of nature is seen if we contrast the different effects of an aesthetic medium, like sound, in art and in nature. The nearest correspondent in nature to music is, perhaps, the song of birds. Bird-song undoubtedly possesses a certain structure, but it is so slight as to be incomparable with human music. The sounds of nature appeal to us, when we attend to them, chiefly through their *timbre* and their volume (these having of course their organic effects). The entrancing sweetness of the blackbird's song resides not so much in the music which he makes, which is slight, as in the amazingly expressive sounds he produces, the quality of which delights us. So too it is the expressive *timbre*, of the wind soughing or whispering, of the breakers upon the beach, or of the "murmur of innumerable bees", which is fascinating to us, rather than the musical constructions of sounds. Again, the great volume of the thunder of the heavens, or of the stormy ocean, or of the falling cataract, gets its expressive effect largely through sensation, and contains little form.

In the aesthetic experience of nature, too, certain sensa may come into active prominence which have little or no place in art. In speaking of the *number* of the sensa which are present in the experience of nature we referred in passing to tactual sensa. These, however, may not merely contribute to a general experience, but may themselves, as distinct objects, yield significant aesthetic experience.

Tactual sensa in art are of little *direct* importance, though in an art like violin- or piano-playing touch may be an important instrument. *Indirectly*, on the other hand, touch does, of course, play a very important part in art-appreciation. The significance of tactual imagery in painting, or sculpture, or poetry, is familiar. But in the aesthetic experience of nature, not only may tactual sensa have an *indirect* importance, as when the moss 'looks' soft. They may also have a *direct* importance. The moss (as opposed to a

picture of moss) not only looks, but *is* soft. We touch it
and enjoy touching it. The down of the fledgling is soft and
gently warm. The contours of a peeled chestnut are deli-
ciously cool and smooth and firm. Brooke writes of "the
rough male kiss of blankets", and the "cool kindliness of
sheets". The 'feeling', again, of the texture of an apple or
peach or plum, or of jelly or caviare or wine, or of velvet
or of a cat's fur, or of the petals of a crocus, may yield
a delight which is sensuous, but which is aesthetic also. A
friend tells me of the profound and far-reaching joy she had
when a child through touching ferns and feeling the contrast
between the soft green parts of an unfolding fern, and the
rougher brown parts. Even snails and worms and, to little
bare feet, hot tarry roads "like the flesh of a warm chicken
that has just been plucked" have their aesthetic gifts to
offer.

## VIII. The 'Conviction' Again

We spoke, in Section VI, of the conviction of some nature-
lovers that beauty is in some sense *in* nature, as beauty is
not *in* the work of art. The work of art is an aesthetically
significant *appearance*, but works of nature, to such nature-
lovers, are aesthetically significant *realities*, whose beauty
is immanent in them. And we referred to theoretical assump-
tions involved in this conviction.

The predominantly sensuous experience of nature involves,
too, a powerful conviction of reality. In our aesthetic ex-
perience of nature we are sensuously in contact, not with
some artificially arranged expressive medium, but with a
real nature which we know to be interconnected with a
system which is nothing less than the whole natural cosmos.
We do not, of course, necessarily *think* consciously of this
in all our contacts with nature. But the indefinite, the
(relatively) infinite, context of natural objects, is unques-
tionably a notable factor in our experience of nature. It is

part of the basis of the 'cosmic' feeling of which we shall speak in a moment, and it becomes fused into the aesthetic experience. Again, as we have seen, nature in stirring our senses, stirs them often more urgently than do works of art. And she makes her assaults not merely through this or that sense, but through many at once, thus building up a consciousness almost of being rooted and embedded in the tissue of nature as plants and trees are rooted and embedded in the earth.

At the lower end of the scale, we said, our experience may not be *much* more than sensuous. At the upper level there may arise, through sensuous experience of nature, an awareness which is nothing less than mystical. Even the scent of a spray of honeysuckle may seem to embody, not only the deep secret good of the physical earth, but a transcendent and unearthly meaning which could never be conveyed, even in the language of poetry, to anyone who had not already known the strange thrill of it. And, when nature is assaulting not one sense only, but many, this ineffable conviction of a speaking spirit of nature may be almost inescapable.

This conviction that nature is, in some obscure way, a Spirit expressing herself in the bodies of natural objects, revealing herself through "the language of the sense", is, once again and as before, a kind of religious conviction with an attached theology or philosophy which becomes assimilated into aesthetic experience. Vaughan has the conviction. Seeing the moonlit heavens, he *sees* the infinite:

> "I saw Eternity the other night.
> Like a great ring of pure and endless light,
> All calm as it was bright;
> And round beneath it, Time, in hours, days, years,
> Driv'n by the spheres
> Like a vast shadow mov'd, in which the world
> And all her train were hurl'd."

For S. T. Coleridge, the clouds and lakes and mountain crags are

> "The lovely shapes and sounds intelligible
> Of that eternal language, which my God
> Utters. . . ."

But the classic, and the most perfect, expression of all is of course in Wordsworth's *Tintern Abbey*. It is continually quoted, and is in that sense hackneyed, but even popularity can hardly destroy its appeal.

> "   .   .   .   I have felt
> A Presence that disturbs me with the joy
> Of elevated thoughts, a sense sublime
> Of something far more deeply interfused
> Whose dwelling is the light of setting suns
> And the round ocean, and the living air, and the blue sky,
> And in the mind of man; a motion and a spirit which impels
> All thinking things, all objects of all thought,
> And rolls through all things. Therefore am I still
> A lover of the meadows and the woods and mountains,
> And of all that we behold of this green earth,
> Of all the mighty world of eye and ear,
> Both what we half create and what perceive.
> Well pleased to recognise
> In nature and the language of the sense,
> The anchor of my dearest thoughts, the nurse,
> The guide and guardian of my heart. . . ."

Here is the creed of the nature-lover at one peak of its highest development, and complete as any brief statement could be. Even when nature is regarded in a more negative way, as that which is effortless, even when the mountain is felt to be beautiful "because no one has built it, the forest because no one has planted it, the snow-flake because no silversmith has touched it with hammer and file",[1] it is difficult for the lover of nature not to conceive such effortlessness as a positive value. The effortlessness is not

[1] Collingwood, *Outlines of a Philosophy of Art*, p. 54.

a mere negative, it seems rather the expression of an immanent, omnipresent, omnipotent being who is so great that effort is no effort.

Such convictions, once again, show the discerning lover of nature to be more than *merely* an aesthetic experient. The unsympathetic critic may therefore say that since his aesthetic experience is not a 'pure' one at all, we should not here be troubling ourselves overmuch about the 'lover of nature'. It is, of course, true that aesthetic experience is not philosophy or theology or religion, and that aesthetics is not directly concerned with the nature-lover's opinion about these. But it is indirectly concerned, for theories (like many other factors) enter by assimilation into the content of aesthetic experience. We need not, therefore, in considering the nature-lover's convictions, trouble ourselves by conscientious scruples about 'purity'.

It is not suggested that the creed of the nature-lover is always, or purely, optimistic, or that the manifest evil in nature is not a practical and theoretical difficulty, and a difficulty which may inspire in some cases a pessimistic philosophy. But it has to be kept in mind that the values which may be aesthetically expressed can be negative as well as positive. On the other hand, a strongly naturalistic conviction would render impossible—as will be seen in the next paragraph—the belief that nature is beautiful, is aesthetically expressive, apart from our minds. It is for this reason, and because it is important to consider the question of the independent existence of natural beauty, that I shall here lay so much stress on the non-naturalistic, or 'idealistic', assumptions of the nature-lover of a certain type. An additional reason, of course, for considering these assumptions is that they are involved in an attitude to nature which is of the greatest importance in itself, and which is represented by Wordsworth.

IX. The Claim that Nature is beautiful independently
    of our Minds, and its Philosophical Implications

In this section there will necessarily be some repetition of
former arguments, and a good deal of condensation of new
ones.

We know that in order that a thing shall appear beautiful
it must be imaginatively perceived. And we know that some
perceived objects have to be imaginally[1] selected and other-
wise modified by us in 'seeing' them, in order that they
may appear beautiful. The artist, for example, sees not
every detail of a landscape, but attends to such of its forms
as seem essential for the picture. When a perceived
object, as it stands, appears, without imaginal modification,
to be beautiful, we say commonly that *it* is beautiful. This
means, or ought in theory to mean, not of course that it
is beautiful apart from all relation to aesthetic imagination,
but that, precisely as it stands, it *is* satisfying to aesthetic
imagination and is therefore 'beautiful'. Works of art which
we happen upon, sometimes possess this beauty, and works
of nature which we happen upon sometimes also possess
it, though they do not always do so. They must be objects,
for example, like a crystal or a wild-rose, which are
not too complex to apprehend all at once in a single
view. And we know that the fuller the understanding
of nature, the greater (aesthetic conditions being equal)
the possibilities of nature appearing beautiful to us. Cloud-
formations to the aesthetic meteorologist, land-formations
to the aesthetic geologist or geographer, the turbot to
the aesthetic zoologist, may appear beautiful, whilst they
may appear ugly to the uninitiated.

When a perceived object is made for the very purpose
of satisfying aesthetic imagination, we call it a 'work of art'.
We know that what we call works of art are made for this
purpose, but we do not know with any certainty at all that

[1] As distinct, of course, from imaginatively.

natural objects were made for this purpose, though in aesthetic experience itself of course we *feel* natural objects to be in themselves beautiful, just as we feel works of art to be in themselves beautiful. Although, however, we do not know with any certainty whatever that works of nature were, like works of art, made for an aesthetic purpose, we have seen and we are assuming that the nature-lover frequently believes that nature *in some sense is* a 'work of art'. If he put his experience into words he might say that, just as when we happen on a work of art we enter (in some rough and approximate sense) into an experience which has already been experienced by the expressing artist, so in the aesthetic experience of nature we seem to enter 'somehow' into an experience of some spirit of nature or possibly of some Supreme Artist.

Now, if it were the case that nature is the "art of God" in exactly the same sense that a work of art is the product of an artist, then nature (or at any rate some parts of nature), like the work of art, might be beautiful in the now obvious sense of being, without imaginal modification, aesthetically satisfying. But it would not literally, in itself, apart from us, and from its relation to the supposed mind of the Supreme Artist, be *in itself* beautiful. Like the 'bodies' of works of art in isolation, physical nature might be a 'body', but it could not be, out of relation to the imagining Mind external to it, an *embodiment*.

We have tried to show, however, that the difference between our semi-analytical attitude to art, and the attitude to nature of the nature-lover whom we are now considering, is just that the nature-lover *does* believe the beauty to be, somehow, *in* the body of what he perceives. He not only feels it at the moment of aesthetic experience, but he will defend it as a conviction. Now, if we are still to hold that beauty is dependent upon mind, as we must, and if the semi-analytical conviction of the nature-lover is that not only does physical nature *appear* to be expressive, but that nature is literally expressive, that nature is, in fact, a kind

of artist and art all in one, then of course it will immediately follow that the imagining mind must be 'somehow' *in* the very body of nature herself. The relation of the body of an ordinary work of art to the artist is an external or transcendent relation; the relation, on the given assumption, of the 'work' of nature to the hypothetical Artist is in *some* sense an 'internal' or 'immanent' relation. The difference is very faintly analogous to the difference between the beauty of a picture and the beauty of a dancer, whose beauty in some sense is *in* her body because her mind is in some sense *in* her body. But the analogy must not be pressed. The difference is, in more abstract terms, something like that between the relation to his world of the purely transcendent designing God of Deism and that of the immanent God of Pantheism. Indeed, there is probably something more than analogy here, as we shall see.

If, then, nature can in any sense be conceived as the "art of God", the relation of the body of natural "art" to the mind of the artist must be peculiar, and very different from that of the relation of the body of man-made art to the mind of the finite artist. It must be an immanent relation. Yet, on the other hand, although (following out the nature-lover's assumptions) the expressing Mind must be immanent in the body of nature, it cannot be *merely* immanent, for mere immanence means blindness. If Mind were wholly merged, as it were, in the body and process of nature, it would be difficult, if not impossible, to conceive of the perfection of natural bodies, such as plants or animals, to be expressive as they appear to be expressive. If we suppose, for example, the Mind which produces the beautiful body of the wild rose or the orchid or the star-fish or the tiger to be some finite "mind" (if we can use such a term), the mind, perhaps, of the plant or animal, or even the mind of some purely natural system, such a mind will be blind, fumbling, dark, purposeless, or all but purposeless. It is difficult, if not impossible, to account, on such an hypothesis, for the

extraordinarily delicate structures which to the aesthetic percipient seem to be expressive of real beauty. This is, of course, just a form of one main difficulty of pantheism, the arguments for and against which are many, and which we dare not begin to enumerate. Sliding over these and connected problems rather dangerously, I am going to be content here with assuming that transcendence alone, or immanence alone, is inadequate. Mere transcendence would not give our particular nature-lover what he wants, since he believes that nature literally and through and through, is 'expressive', and not in herself dead and meaningless as is the lump of matter which is the statue when no one is seeing it. Mere immanence is inadequate, too, for the quality of mind allowed by immanence is not sufficiently high, and cannot be sufficiently detached, to account for the marvellousness of the beauty which the nature-lover believes that he apprehends. Since both transcendence and immanence, however, are up to a point necessary, he must take refuge in the familiar compromise of theism, and assume that if there is a Mind or Spirit expressing aesthetically in nature, it must be *both* immanent and transcendent. If for short we call this the spirit God, then it will be correct, on the given assumption, to say that in one sense God is literally and actively expressing in, or within, physical nature, and that in another sense God is the mind of the artist distinct from and transcending all natural process. This is a familiar mystery of theistic theology: it would be dogmatic to assert that it is true. But once again, following the method of this chapter, I shall assume that it is true; for, on our general assumptions, nature could by no other hypothesis be said to be beautiful independently of our minds. And I shall now go on to consider one or two problems involved in the idea that there is a beauty of nature apart altogether from our experience of it, and in the idea that this beauty is, directly, the expression, or the "art" of a God conceived after the manner of theism.

## X. Some Objections to these Claims

For this notion is not without certain obvious difficulties. In the first place, the body-aspect of natural beauty might be said to be, from God's point of view, totally different from physical nature as we perceive it, or at least so vastly different as to make any common meeting-ground impossible. If physical nature literally is the aesthetic expression of God, how can we appreciate its beauty? For we do not perceive it as it is. The shapes, it may be said, which we perceive and from which we get aesthetic experience, are essentially perspectives determined by our location in this or that place. The 'point of view' of a God whom we may suppose, in theistic manner, to be omniscient, could not be a point of view in the finite sense, but would be utterly different from anything which we can imagine. A similar argument could be put forward as regards temporal forms such as rhythms. These again, it might be argued, are partially functions of finite beings located in a certain span of time, and having, as Bergson might put it, certain subjective 'durations'. When we apprehend beauty of natural rhythms it cannot be God's beauty. Again, our perception, which is the basis of aesthetic experience, is competent to apprehend only certain aspects of the external world, whilst God's 'perception'—if we may speak at the moment of such —will presumably include the 'perception' of things which lie outside our perceptions,—the colourless, soundless structures of physical objects, the working of electro-magnetic systems, and so on. How then will the beauty we perceive be his? Another argument which concerns but a different aspect of the same thing is one regarding the secondary qualities. If secondary qualities, as some believe, and as is suggested by facts like that of colour-blindness, come into existence only when perceiving organisms (and *possibly* their minds) are in relation to certain other physical objects, then

it might be said that for a Divine Mind the qualities would not characterise physical objects. And if they did not characterise physical objects they would presumably not enter into Divine aesthetic experience. So that, once again, natural beauty for us and for God would be profoundly different. Generally speaking, if we are thinking of an aesthetic object as a perceived object, it will be difficult to think of nature as God's aesthetic expression. For perception seems to involve certain finite conditions and limitations, and these being what they are, it is difficult to conceive of God as 'perceiving'.

## XI. POSSIBLE ANSWERS TO OBJECTIONS

These are not, on the face of it, insuperable difficulties. Two general problems emerge. One is, How, God's world being so different from our world, can God share in 'our' natural world and our experience? The other is, How can we share in God's natural world and God's experience?

1. The first is easily answered if we assume, as we did assume, God's omniscience. For if God is omniscient, his knowledge will include all that we know, will include all perspectives which are determined by our special points of view. On this assumption, God will not know nature only *sub specie aeternitatis*; he will know it also *sub specie temporis*. And, in particular, he will know not only the world which we call the world of physical objects (independent of our organisms); he will also know the secondary qualities which we are supposing to be dependent partially on our organisms. Again, if God is omniscient, he must know also all the contents of our minds.

2. The question, How can we know God's world? involves, in the present context, two further distinguishable questions. (*a*) How can we be said to perceive the physical world which is the 'body' of natural beauty for God? (*b*) How can we

share in God's experience so that we apprehend God's beauty of nature?

(a) The total content of our perception includes qualities such as secondary qualities which, we are presuming, do not literally belong to the physical world, and the physical world contains things which are not perceivable by us. And the world which we perceive is the 'body' of natural beauty for us. How then do we apprehend the *same* physical world that God apprehends?

The only general answer to this question is the answer of a certain brand of realism which seems to me, rightly or wrongly, and for many reasons, to be the true answer. Put dogmatically, it is the answer simply that we *do* perceive the physical world, but partially, imperfectly, and in many respects erroneously, and in terms of secondary qualities. The secondary qualities may be in part dependent upon the organism (or even conceivably upon the mind), yet they are, realism asserts, in no sense mental, but are part of the physical world. We do not perceive electromagnetic systems plainly and as such; electro-magnetic systems appear to us as coloured and resonant and solid. But though our perception is distorted, and is far outstripped by our scientific knowledge (which is derived in the first instance from perception), it is still the physical world of which we are partially and imperfectly aware, through a medium and in perspective. The content of our perception and the content of God's knowledge are obviously different, but they do not constitute two totally different worlds. One is an aspect of the other. If, then, these contents are respectively the bodies of 'our' natural beauty, and 'God's' natural beauty, our aesthetic experience of nature will be experience of the *same* nature (though partially and imperfectly seen) as God's nature, which is beautiful for him.

(b) But the 'body' of beauty is an abstraction from its embodied content. Physical nature, which is the body of 'God's' natural beauty, cannot be beautified except as

expressive of a content to God's mind. The remaining question then is, If nature's literally existent beauty is only beauty as expressive of a content of God's omniscient Mind, how can we, being finite, and not omniscient, in any sense 'share' in that expressiveness, that beauty? How can we, in other words, share in the expressed content of God's experience?

We have seen that in the case of finite minds, experiences are, *strictly* speaking, unshareable and incommunicable, although for practical purposes we may speak of sharing and communication. These are possible because of the likeness of finite minds to one another. We can, approximately, share in the experience of the artist because he is a being like ourselves: "But God is not a man. . . . To whom then will ye liken God?" How can we share in God's experience?

This would be unanswerable if we assumed that God's mind is related to our minds in exactly the same way as one finite mind is to another. But it is not necessary to assume this. A familiar and not an altogether impossible way out is to say that, since we are creatures, God shares in our experiences, and that we his creatures in special communion with him share in his experience—though in a poor and limited way.

If this were true of our experience in general, it would be true of aesthetic experience. If nature, therefore, is the active expression of God's aesthetic imagination (and also, of course, of his joy in aesthetic imagination), it may be that in our 'discovery' of natural beauty we are sharing, in imperfect measure, in the content of divine aesthetic experience, with its joy.

Such arguments are all, of course, speculative in the extreme, and every single assumption that has been stated would have to be tested and criticised by a whole system of philosophy. The naturalistic philosopher has his point of view, and is inclined to make light of all arguments which

savour of theism. But whether these are valid or not, they are not quite wholly fantastic, in the light of the experience of the lover of nature. For certainly the latter is known to say that in his passionate love of natural beauty he achieves a peace and joy which *feels* like a sharing in the joy of a larger Spirit which is not himself. It is an experience which has no perfect analogy in the experience of the work of art.

## XII. INTUITIONS AND REASON

It is but an experience, an intuition. Yet if the claims of intuition must be sifted by philosophy, philosophy in turn must pay respect to intuition. The intuition of the nature-lover contains a conviction which every serious ontology must take into consideration, for it is a conviction, not of the morbid and the diseased and the fanatical, but of the wisest and sanest human minds. A familiar argument which is frequently applied to mystical experience holds good here, for the aesthetic love of nature in its profoundest form is a kind of mysticism. If the claims of the mystic were the claims of the fanatic or were like the claims of the man who is drugged by hashish, we might safely ignore them. But we know that it is not so, that the greatest mystics have discovered in their intuitions what harmonises with and illumines the living of life in its most inclusive sense. Intuitions prove nothing, and they should try to prove nothing, for the method of proof is the method of reason. But sound employment of reason is not to be found in a rationalism which refuses to admit the existence of what has not, perhaps what cannot, be proved. Indeed, the most extreme rationalism does in fact always admit *some* intuitions, and it is only a question of how far we are to go. Surely we must allow that any fundamental conviction, of those who on other grounds have proved themselves generously sane and wise, has a right to be considered? This is obvious

justice, and is obvious truth. But it is sometimes overlooked by those who—rightly intolerant of speciousness and emotionalism and humbug—go in fact, without recognising it, to the opposite extreme, the extreme of acting on the absurd assumption that because nothing can be *proved* except by reason, therefore nothing is *true* which has not been reasoned out. But this is sheer pragmatism. Truth is not made by proof. Nor is truth necessarily what can be proved. Further, it is certain, not only that we live by faith to an immeasurably greater extent than we live by reason, but that faith is, on the whole, a very much more reliable basis of life than is often in effect realised by a strict rationalism. It may very well, therefore, give us truth, though it is unable to prove it. And the faith of the aesthetic experience of nature is certainly one of the fundamental moments of faith in the span of human life.

# INDEX